# LANDSCAPE
## PHOTOGRAPHER OF THE YEAR

**10 YEAR**

**SPECIAL EDITION**

Editor: Donna Wood
Art Director: James Tims

Produced by AA Publishing
© AA Media Limited 2017

Published by AA Publishing (a trading name of AA Media Limited,
whose registered office is Fanum House, Basing View,
Basingstoke RG21 4EA; registered number 06112600).

A05352

ISBN: 978-0-7495-7845-9

A CIP catalogue record for this book is available
from the British Library.

Printed and bound in China by Leo Paper Group

theAA.com/shop

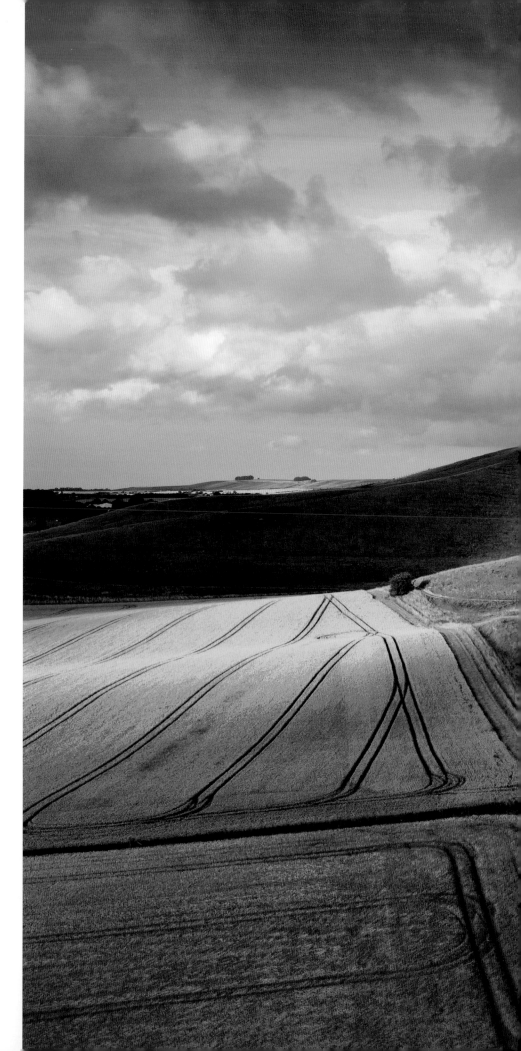

**MARK BAUER**                                    **2011**

**The White Horse**
*Cherhill, Wiltshire, England*

Wiltshire is famous for its white horses carved into the hills, and I find the
one at Cherhill particularly photogenic. For this shot, I waited in the rain for a
while, having seen a break in the clouds moving slowly in the right direction.
As the rain stopped and the clouds broke up, the sun spotlit the white horse
and highlighted the folds of the hills, creating a layering of light, which helps to
add a sense of depth to the scene. I took a series of shots, of which this – the
first one – was the most successful.

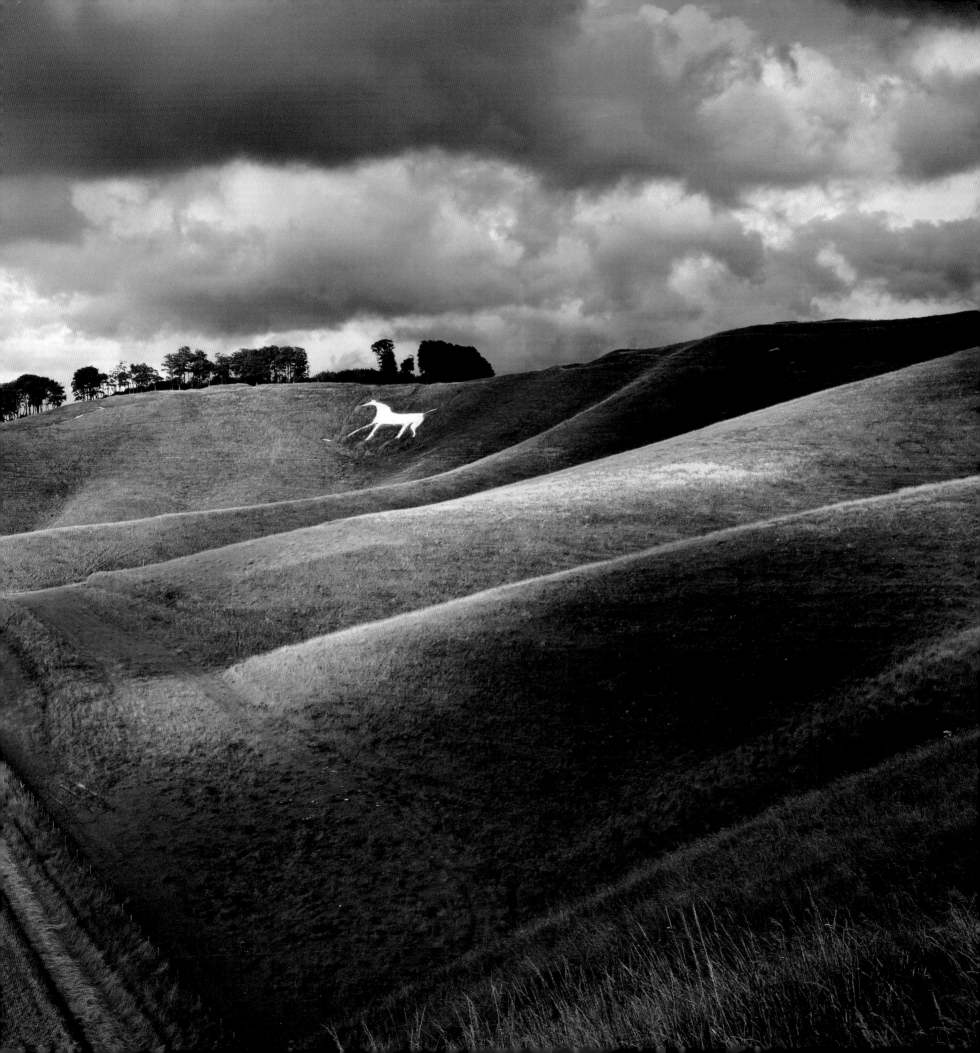

# CONTENTS

**IAN TAYLOR**                                                    **2015**

**The Ref's an Angel**
*Gateshead, Tyne & Wear, England*

A foggy November morning on the football pitch behind the Angel of the North, where these lads were setting up the nets for a Sunday league game. The match did kick off and, as you can imagine, it was very difficult for the teams to see the ball so the ref had to suspend play until the sun eventually burned off the fog and play resumed.

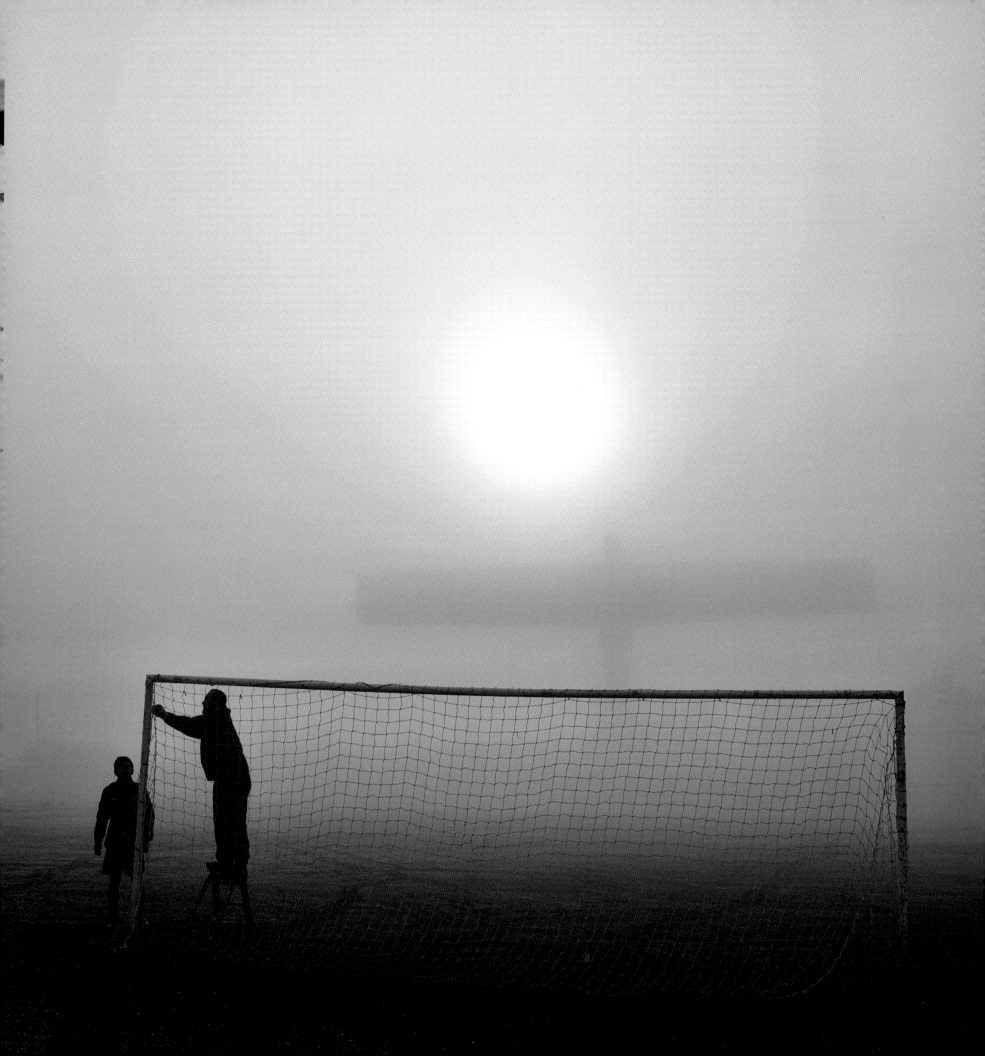

# FOREWORD

BY AWARDS FOUNDER,
CHARLIE WAITE

I have always felt that investigation, exploration, engagement, discovery, joy and understanding are just some of the host of human reactions that come with the often complex processes behind the making of a photograph.

Evidence of all of these responses is amply and positively demonstrated within the many wonderful images that I have seen in all ten years of the Landscape Photographer of the Year Awards. So many fine and sensitively executed photographs have come from the hands of photographers who have fully engaged and immersed themselves in their art. The images that they have made convey to us much of their emotional response, their sense of wonder or their need to explain. With an understanding of their craft, their achievement has been to preserve and own their experience so wholeheartedly that it can be successfully shared with us, and this is powerfully demonstrated within the pages of this celebration of *Landscape Photographer of the Year*.

All of the photographers whose work has been chosen for each of our ten annual Awards books have my admiration and gratitude.

I will never forget the suggestion by a friend, years ago, that using a camera can step in between the full engagement that the individual is having with the landscape and interrupt the complete understanding and absorption of place. His claim was, of course, that the camera gets in the way and that non-photographers experience far deeper enrichment through seeing with their eyes and heart. Needless to say, I strenuously refute this assertion. I would say that the very opposite is the case.

In the last ten years, much has happened in the huge visual industry, with digital technology developing and extending into all areas. In movies, cartoons have enjoyed a resurgence greater than their previous heyday, with extraordinary computer-generated imagery being able to induce tears of happiness or fear from the audience. Movies and multiple TV networks are now more widespread than ever, yet making a still image, mother photography's firstborn, continues to provide thousands of people with the opportunity to release their creative impulse. The

photograph remains capable of informing and moving the viewer as much as any other visually creative work.

In previous introductions, I have maintained that the camera is more than a means to just record a scene or an event and have spoken of it as a wonderful, almost magical, creative device that can help those of us who perhaps feel dislocated from our natural world to re-engage with it. I have talked of the landscape providing both spiritual fulfilment and aesthetic enjoyment and that is as true today as it has always been.

Landscape photographers in particular will know of the great reward in identifying their subject, defining their objective and then, with all the tenacity they can muster, finally producing their photograph.

I hope that Landscape Photographer of the Year, with its different categories, will have been seen to successfully accommodate both the photographers' and audiences' taste in subject matter. I hope that our competition and each year's book have contributed to raising awareness, not just of the diversity of our fine country but of the value that photography gives each individual. I know one photographer who says that his happiest moment is when he is standing in the landscape with his camera atop his tripod, waiting, simply waiting. I am sure that many a photographer will identify with that experience.

But while for some the business of landscape photography is a calm process, there are others who enjoy the fast response of perhaps a parkour somersault in an urban landscape setting. Both are equally valid. The camera as a creative device knows no bounds.

It is fascinating how one's appreciation of a particular photograph can change over time. Quiet pictures that start off at risk of being overshadowed by their more colourful siblings may come to the fore after greater contemplation. Photographs that one can live with forever may differ from those that challenge and are memorable at a specific moment. Appreciation of a photograph is a subjective thing – every human will bring different, very personal experiences to their viewing.

This book is a celebration, a varied selection from among many equally deserving photographs. It does, of course, contain all of our overall winners, together with the category winners from our Adult class, but the rest of the collection is of images which will hopefully represent the 1,500 or so breathtaking photographs of Britain that have appeared in the ten Awards books in the Landscape Photographer of the Year series to date. Each deservedly won a place within a previous book and each has been chosen to contribute to the whole: a book that hopefully will evoke an emotion in the viewer akin to that felt by the photographer at the time of creation. If we were making the choices again tomorrow, or next week, or next month, they may well vary; and that is the joy of looking at photography over time. As your life experience changes and as fashions change, your emotional response evolves.

One thing is for certain: there are many very talented photographers who have been successful in the Awards since they began and who appreciate the beauty and variety offered by the landscapes of Britain. The Awards book collection has already started to form a record of our times, reflecting stormy seasons, snowy winters and changing cities, and we all hope it will continue to do so for many years to come.

Looking again at all ten volumes in the Landscape Photographer of the Year series, I am able to reaffirm that our country, with all its extraordinary diversity, offers some of the finest rural, coastal and urban landscapes of any nation in the world.

# INTRODUCTION

## THE COMPETITION

Take a view, the Landscape Photographer of the Year Award, was the idea of Charlie Waite, one of today's most respected landscape photographers. Each year, the high standard of entries has shown that the Awards are the perfect platform to showcase the very best photography of the British landscape. We would like to thank all our supporters, whose help and support have made the annual competition possible.

Open to images of the United Kingdom, Isle of Man and the Channel Islands, the competition is divided into two main sections, the Landscape Photographer of the Year Award and the Young Landscape Photographer of the Year Award. With a prize fund worth a total of £20,000 and a major exhibition of winning entries each year, Take a view is a desirable annual competition for photographers from all corners of the UK and beyond.

The images within this book and the annual editions were judged by the panel as Commended or above – a high accolade and a very small percentage of the total entry.

www.landscapephotographeroftheyear.co.uk
www.take-a-view.co.uk

## THE CATEGORIES

### Classic view

For images that capture the beauty and variety of the UK landscape. Iconic views, from paths winding through dunes, redolent of childhood memories, to the wonders of the sky at night and mystical woodlands of twisted ancient trees, all showing the drama of our seasons.

### Living the view

Featuring images of people interacting with the outdoors – working or playing in the UK landscape. From weekend football with the family and days out at the zoo to energetic mountain biking and the joys of glamping, these images illustrate the many ways in which we connect with our outdoor environment.

### Urban view

Statistics suggest that up to 80 per cent of the UK population lives in towns or cities. That's a huge number and this category highlights the surroundings that many of us live in every day. Busy landscapes simplified by snow, dramatic modern museums and sweeping all-encompassing views from the highest places sit side by side and show us that all landscapes matter.

### Your view

What does the UK landscape mean to you? Sometimes intensely personal and often very conceptual, the parameters of this category are far-reaching, with images showing a whole range of emotions and perspectives. More digital manipulation is allowed in this category and images may not be precise representations of the physical landscape in every case.

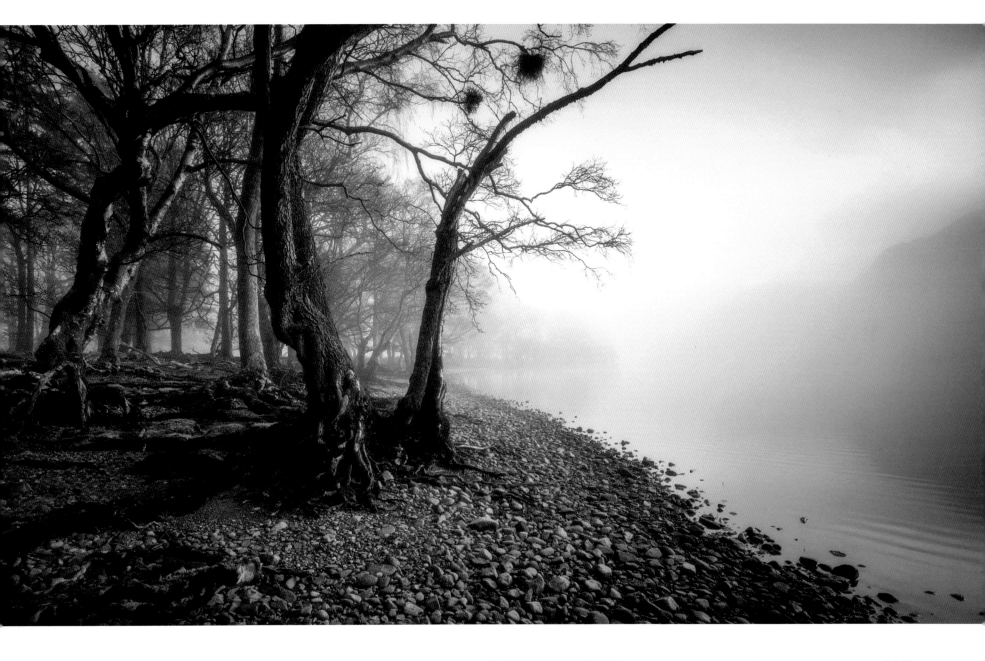

**MARK LITTLEJOHN**      **2015**

### Aira Point in Mist
*Ullswater, Cumbria, England*

I drove down to the far end of Ullswater to find a lovely late mist rolling down past Aira Point. By this time, the sun was starting to rise over Place Fell, giving me the perfect combination of light and mist. These old, weather-worn trees made the perfect focal point for the shot.

# JUDGES

Ben Fogle

Bill Bryson

Celia Imrie

Charlie Waite

Colin Prior

Damien Demolder

David Noton

David Watchus

Eddie Ephraums

Helen Brocklehurst

Janet Ibbotson

Jasmine Teer

Joe Cornish

John Langley

Jon Jones

Julia Bradbury

Keith Wilson

Kos Evans

Madeleine Penny

Martin Evening

Monica Allende

Nicholas Crane

Nick White

Nigel Atherton

Patrick Llewellyn

Paul Hamblin

Professor David Macdonald

Robin Bernard

Rupert Grey

Russ O'Connell

Steve Watkins

Tracy Hallett

Valerie Singleton

# WITH THANKS TO OUR SPONSORS

**2016**

VisitBritain

The GREAT Britain #OMGB 'Home of Amazing Moments' Campaign

**2014 to 2015**

VisitBritain

The GREAT Britain 'Countryside is GREAT' Campaign

**2010 to 2013**

Network Rail

**2009**

Natural England

The English National Parks

**2008**

VisitBritain & the UK's leading tourist agencies

**2007**

The AA

**Also:**

*The Sunday Times Magazine*

The National Theatre

# OVERALL WINNERS
adult class

**JON GIBBS**  2007

### Storm over Scroby Sands Wind Farm
*Great Yarmouth, Norfolk, England*

Gazing out of my kitchen window, I could see some amazing clouds forming in the sky to the west. Something made me head towards the sea, which was actually to the east, and I was lucky enough to witness a storm brewing out to sea to the north of the wind farm. The lightning started to appear directly behind the turbines – enabling me to capture two very different power sources in the one shot.

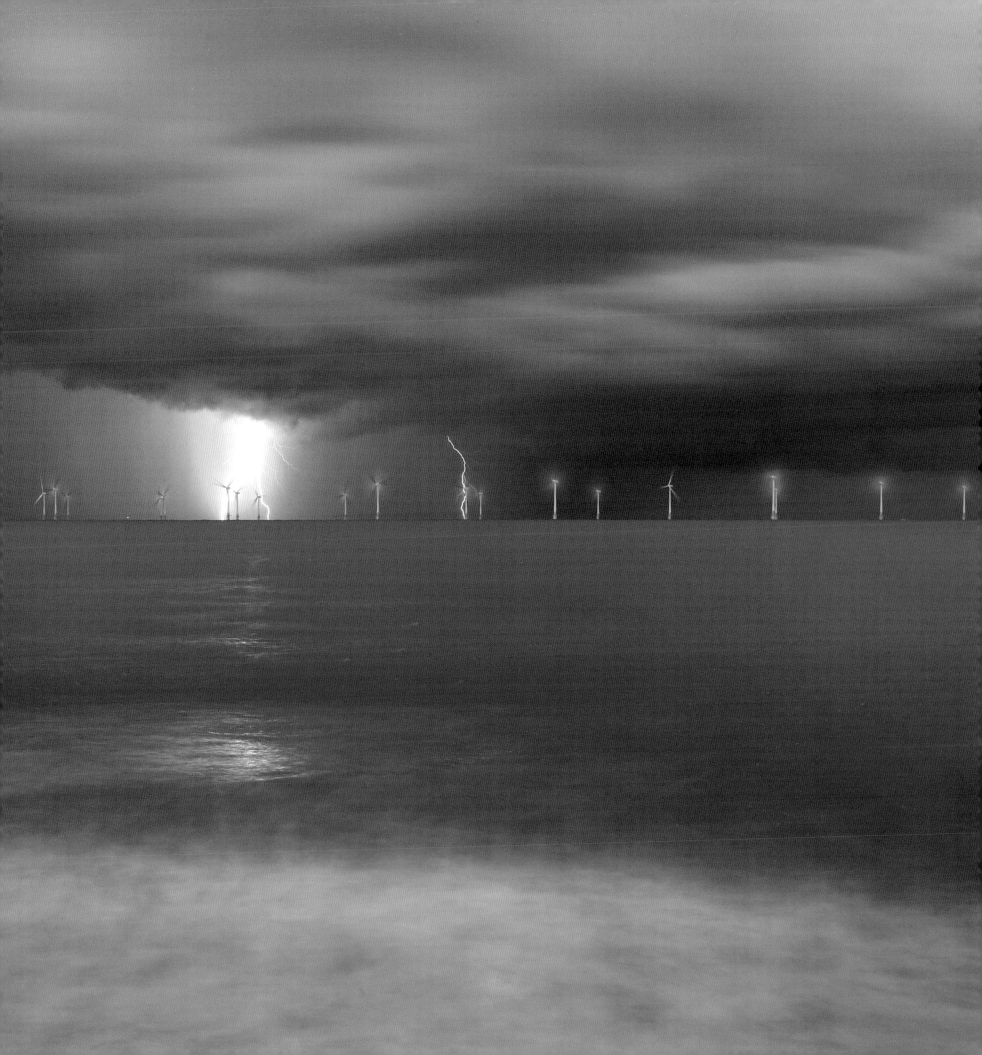

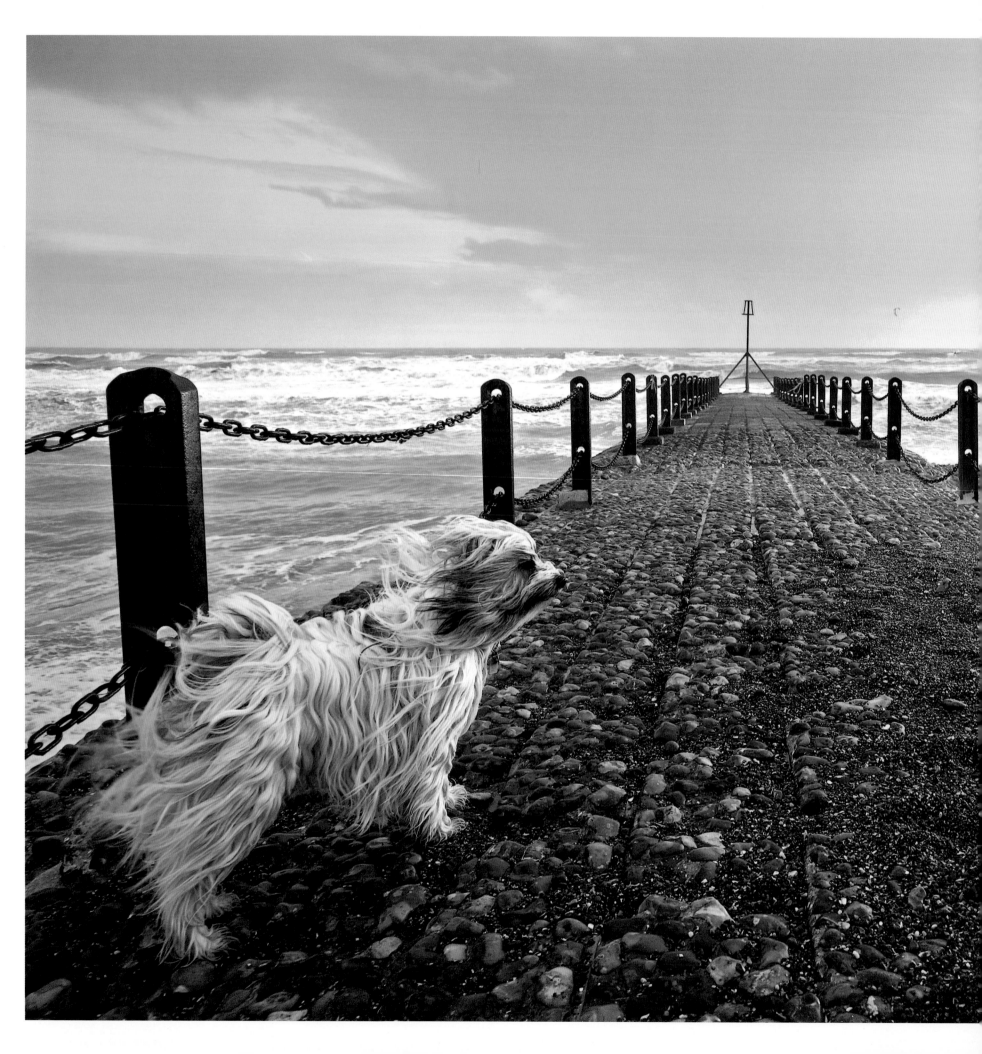

**GARY EASTWOOD**                                                **2008**

### Barney on a Jetty in December
*Hove beach, East Sussex, England*

This shot was taken at 4.30pm on a stormy December afternoon. I was walking along the beach with my dog Barney in unpromising grey and windy conditions when the sun broke through the clouds and bathed everything in a glorious amber light. I quickly tried to capture the jetty and some nearby windsurfers (one of whom can be seen in the distance) but Barney kept wandering into the frame and standing in that particular spot! It's now one of my favourite images as it encapsulates the best aspects of living by the sea in winter.

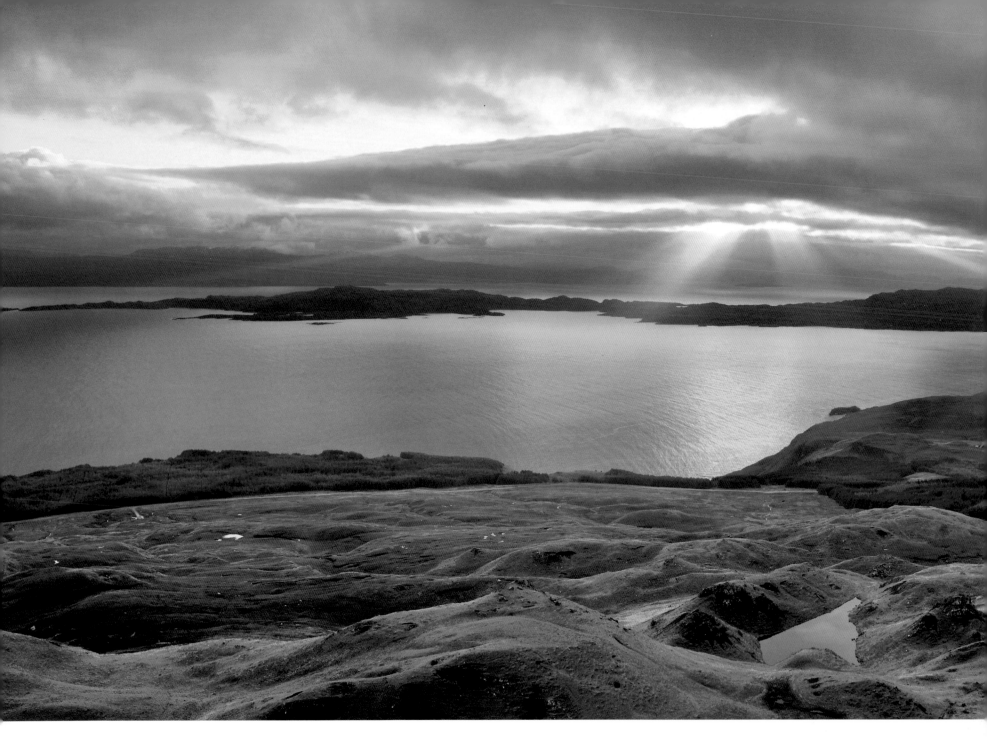

## EMMANUEL COUPE                                        2009

### Sunrise over the Old Man of Storr
*Isle of Skye, Scotland*

I reached the Old Man while it was still dark, hoping that there might be some interesting light later on, but I surely did not expect the light show that ensued. Shortly after sunrise, and while the sun was still at a low angle, rays started to pierce through the clouds, spreading all across the Sound of Raasay, completing this classical Skye view in the most dramatic way.

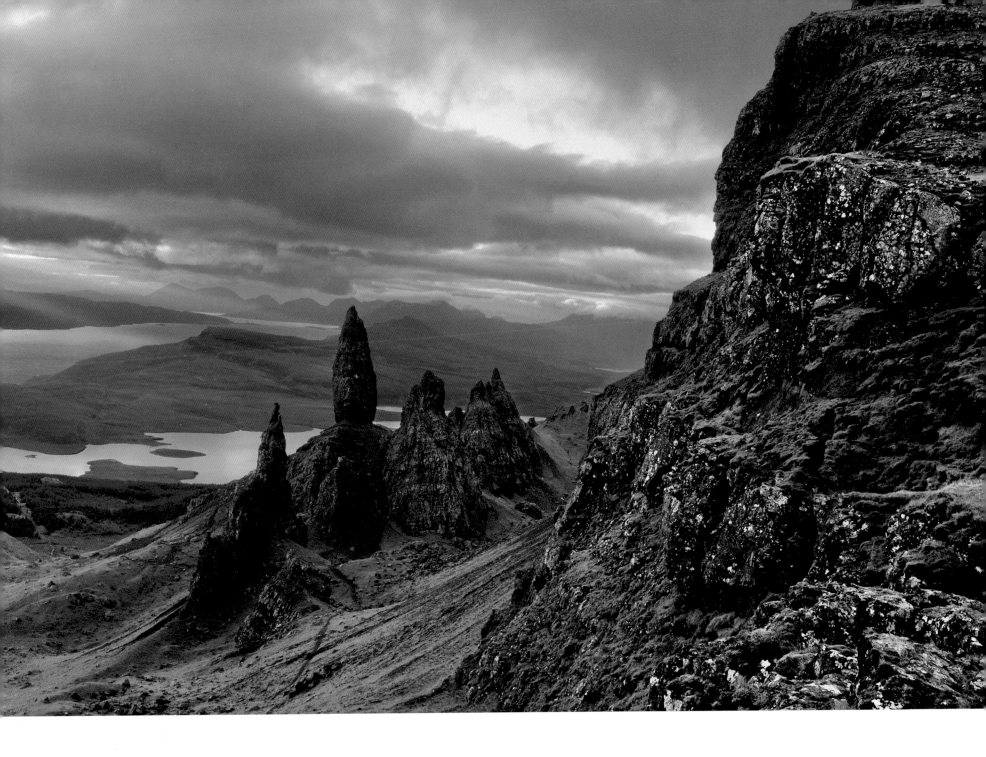

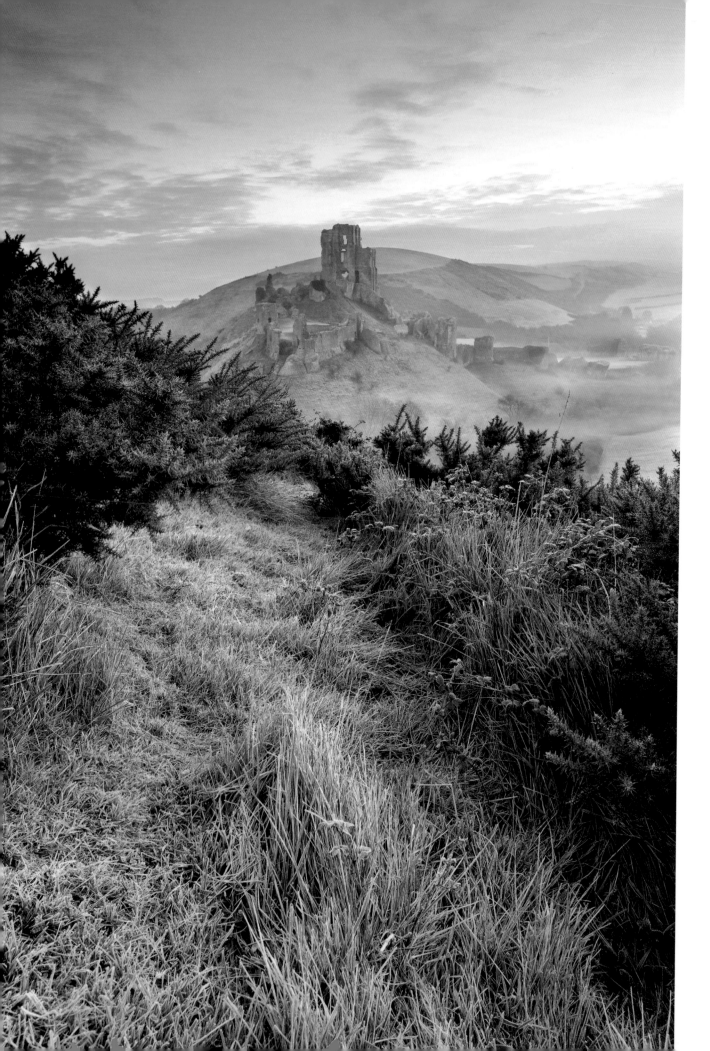

**ANTONY SPENCER**          2010

### Winter Mist at Corfe Castle
*Dorset, England*

I wasn't actually heading for this location on this particular morning but couldn't resist it with the gentle mist rolling in from Poole Harbour. As the clouds started to display these subtle colours I couldn't believe my luck. I really loved the frozen textures and tried to make the most of them in the foreground whilst using the path as the leading line towards the ancient hilltop ruin.

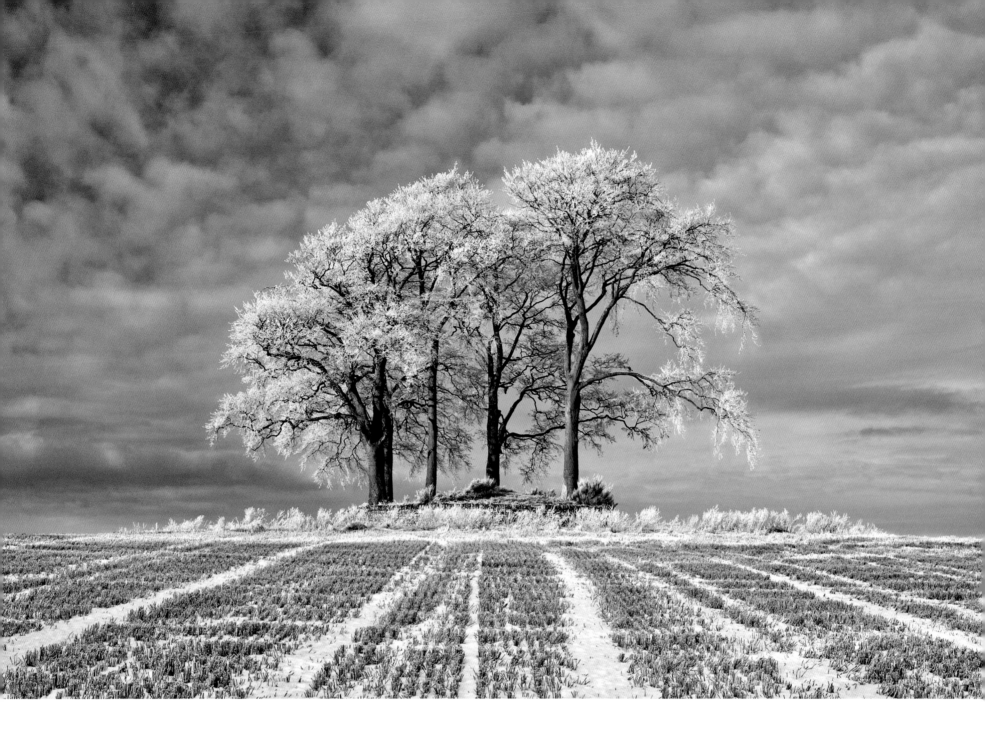

**ROBERT FULTON**                                                              **2011**

**Winter Field**
*Stirlingshire, Scotland*

I discovered this copse of trees about a year earlier and although I took some pictures on that occasion, I felt that I wasn't making the most of the scene. The following winter, when the conditions I had envisaged prevailed, I returned and waited until the light came over the top of the trees to the left, which are out of shot, and caught the main trees in the image. I decided to break with convention and place the focal point near the centre of the picture in order to make use of the crop lines, which draw the viewer's eye to the trees.

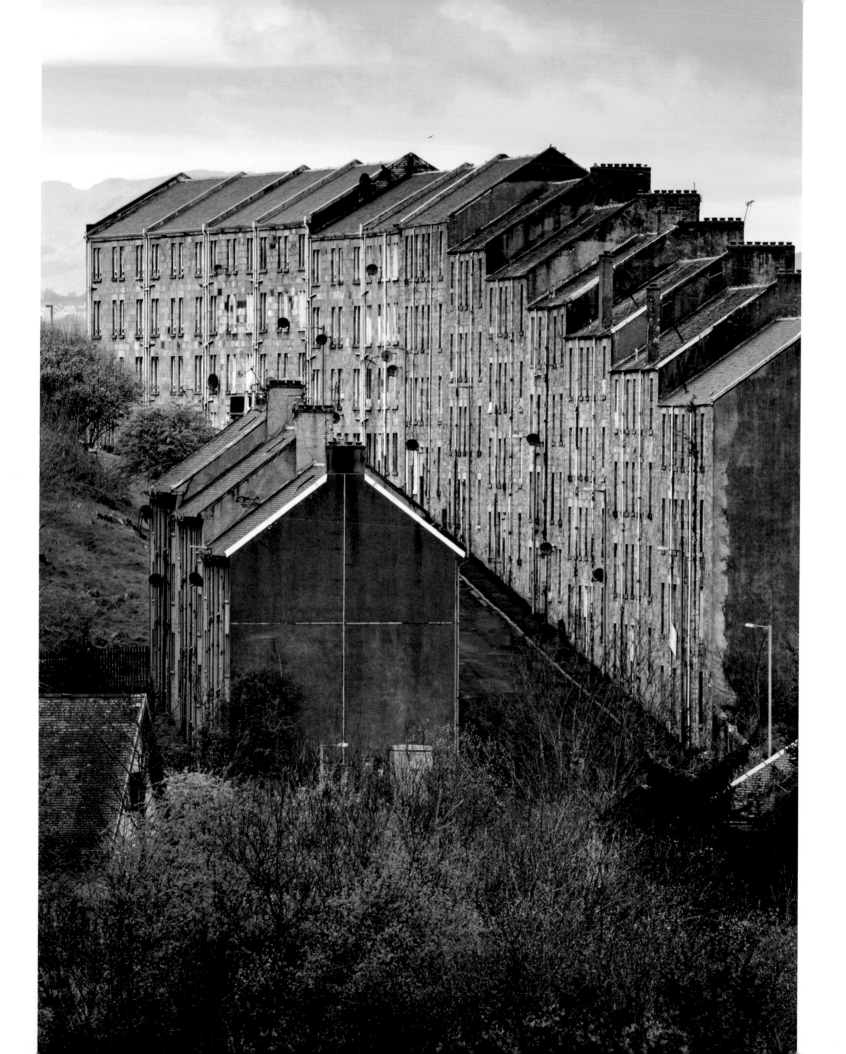

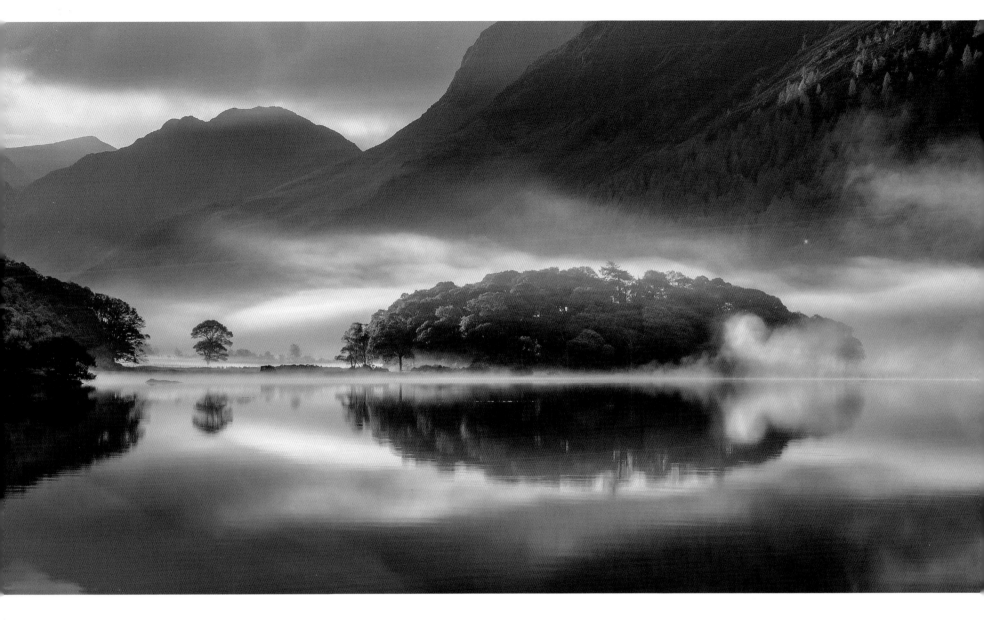

## SIMON BUTTERWORTH ◀      2012

### Condemned
*Port Glasgow, Inverclyde, Scotland*

An imposing row of traditional Scottish tenement buildings. The opposite side of the street was demolished by German bombing in World War II.

## TONY BENNETT ▲      2013

### Mist and Reflections
*Crummock Water, Cumbria, England*

This photograph was taken during those magical minutes of an autumn dawn when the rising sun began striking the tops of the trees and breaking through to the surface of the lake. Every second the scene was changing, creating a hundred memorable images, but this moment particularly caught my attention. The still night mist began rolling and tumbling, as if in protest, as the heat of the sun vaporised and dispersed it forever. Within a minute it was over: a moment in time, never to be repeated but always remembered.

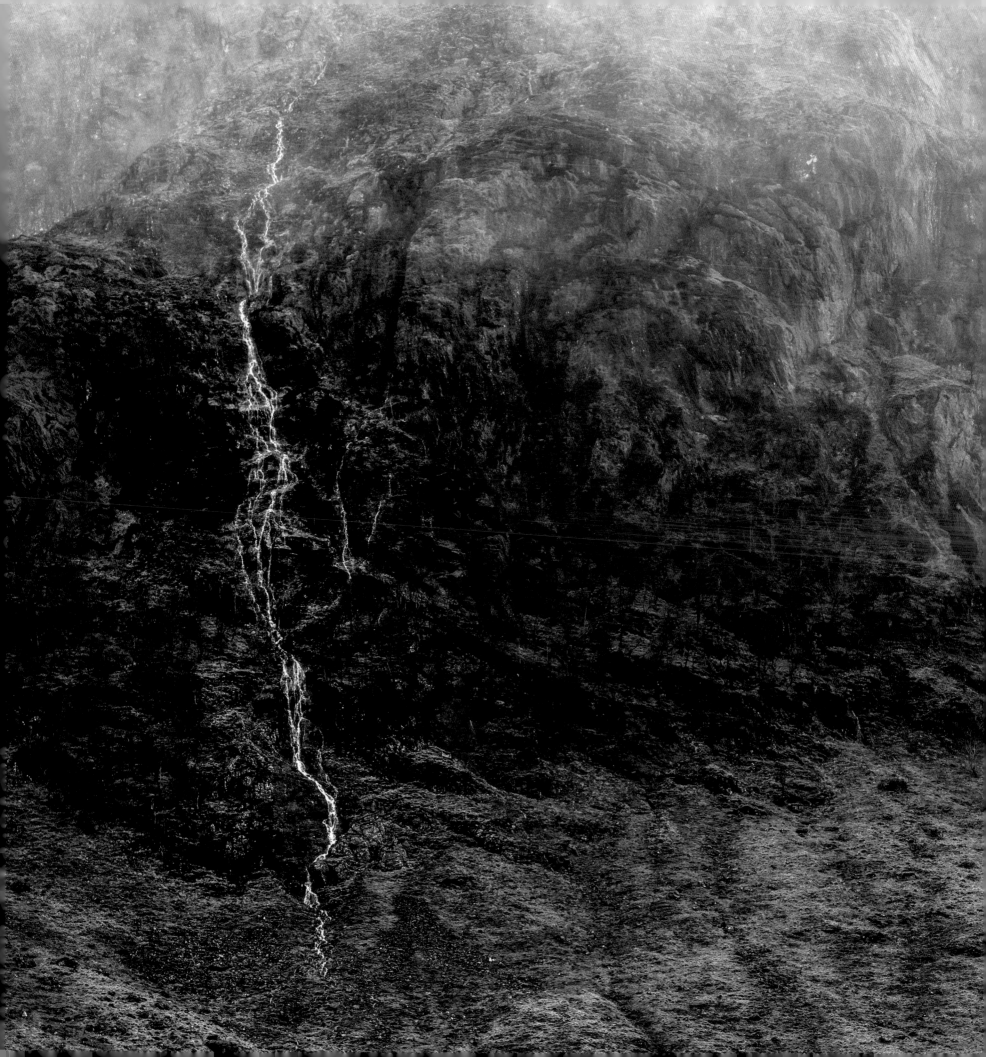

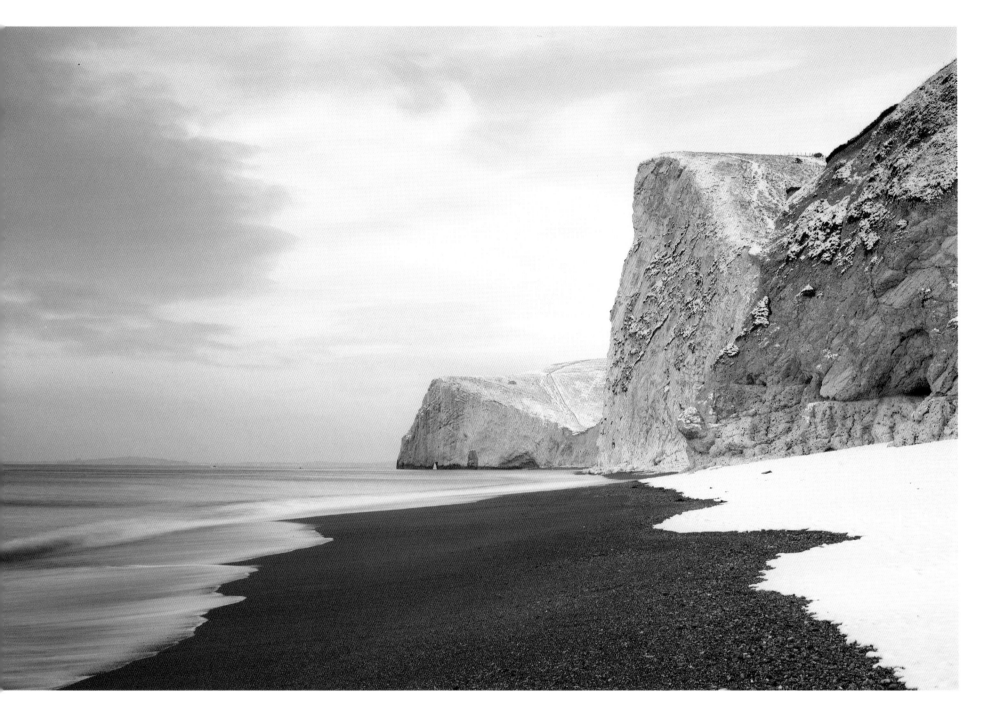

**MARK LITTLEJOHN ◀**                                        **2014**

### A Beginning and an End
*Glencoe, Scotland*

I'd got up at 1.30am to drive to Glencoe, meeting a couple of pals en route. Unfortunately, the rain was torrential at dawn and the water levels were the highest I'd ever seen them. We wandered about waiting for gaps in the weather and as we did, I saw this wee stream form high up on Gearr Aonach. It tumbled steeply down the slopes before vanishing again near the base of the mountain. With more squalls coming through I decided to take this image as the light became slightly more diffuse. It had to be a quick handheld shot due to the sideways rain and I therefore raised the ISO and used a larger aperture to keep the speed up slightly.

**ANDY FARRER ▲**                                           **2015**

### Bat's Head
*Dorset, England*

Snow this far south on the Jurassic Coast is a fairly uncommon event and it was not until February 2015 that I managed to reach some of my favourite parts of the coast when snow had fallen. As incredible as it was to see the arch of Durdle Door covered in snow, this view, looking in the opposite direction, was every bit as captivating. The encroaching tide, revealing the warm shingle beneath, provided an enjoyable distraction for a few minutes.

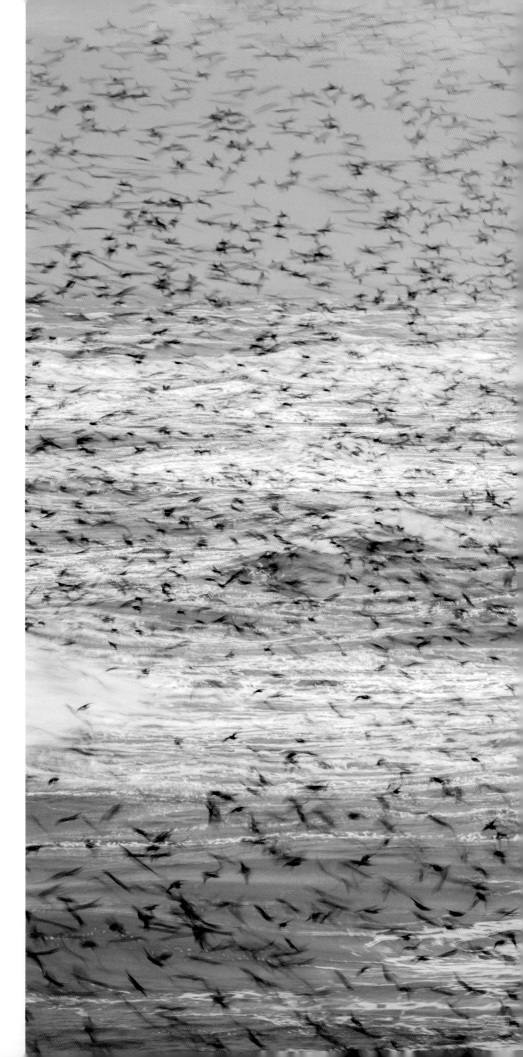

## MATTHEW CATTELL                    2016

**Starling Vortex**
*Brighton, East Sussex, England*

During the winter months hundreds of thousands of starlings assemble at Brighton Pier to roost for the night. The birds gather in large flocks and perform beautiful aerial displays before dropping down to the relative safety of the structure below. Standing on the pier allows the viewer to witness these murmurations from within as the birds flow and cascade around you. The windy conditions had whipped up the foam on the surface of the sea and I liked the way the motion of the incoming tide mimicked the movement of the birds. Rather than 'freeze' the action I used a longer exposure to exaggerate this vortex of motion. I retained the ruins of the West Pier to help locate the image.

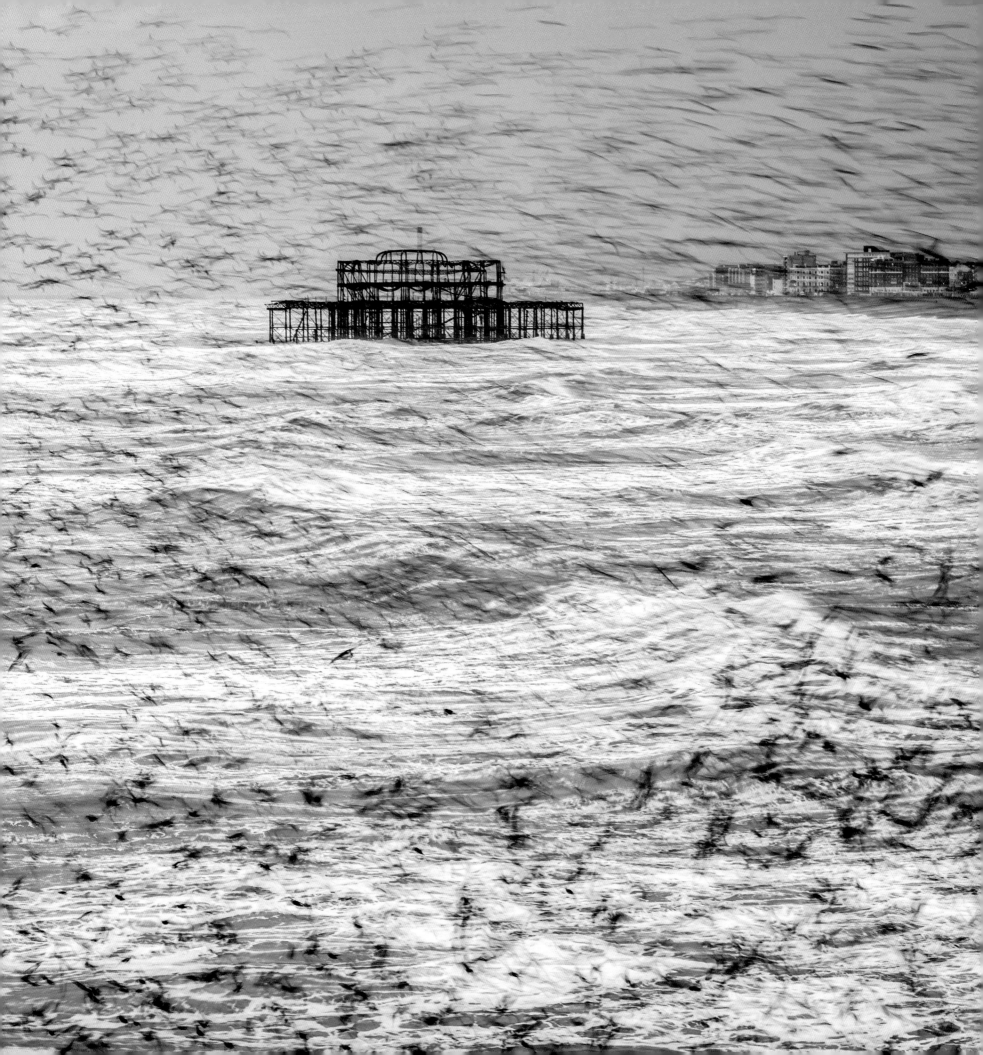

# OVERALL WINNERS
## youth class

## LIAM LESLIE ▼      2007

### Ben Arthur
*Darroch Park, Gourock, Scotland*

I walk past this view every morning on my way to school and have often thought about photographing it. One day, after a heavy snowfall, it seemed like the perfect opportunity to do so. It must have looked an odd sight though, with me standing at the top of a hill, camera tripod-mounted in front of me, waiting for the right cloud patterns across the mountain. All around me were people having fun in the snow – snowballs flying through the air! I think it just shows the lengths you have to go to for the perfect picture.

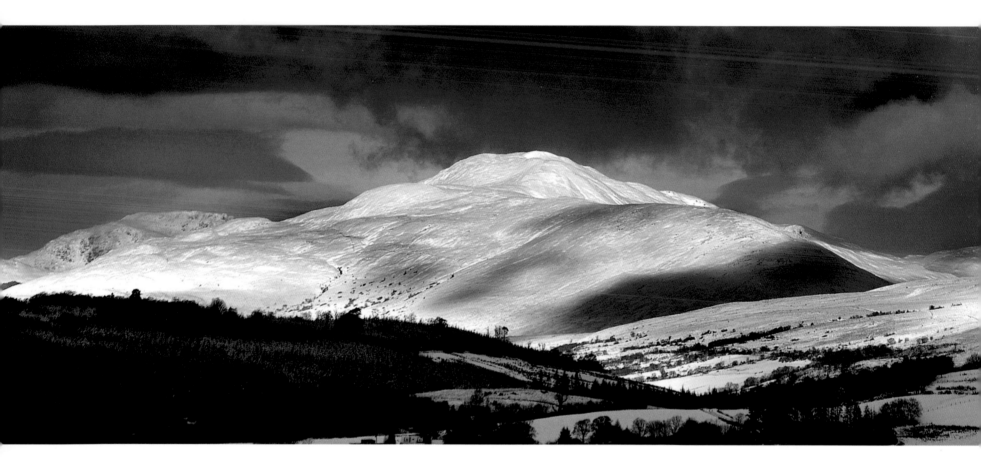

## GABRIELLE BARNES ▶      2008

### Poppies and Maize at Sunset
*Handley Down, Dorset, England*

I had been looking for a great composition for my school art project and on this particular evening was out with my Dad who was taking pictures. I chose to stop in a field slightly off the path I normally take and saw this field that had been cut, all except for one long strip made up of poppies, maize and some wild flowers. The light was really lovely and I was lucky enough to capture this moment.

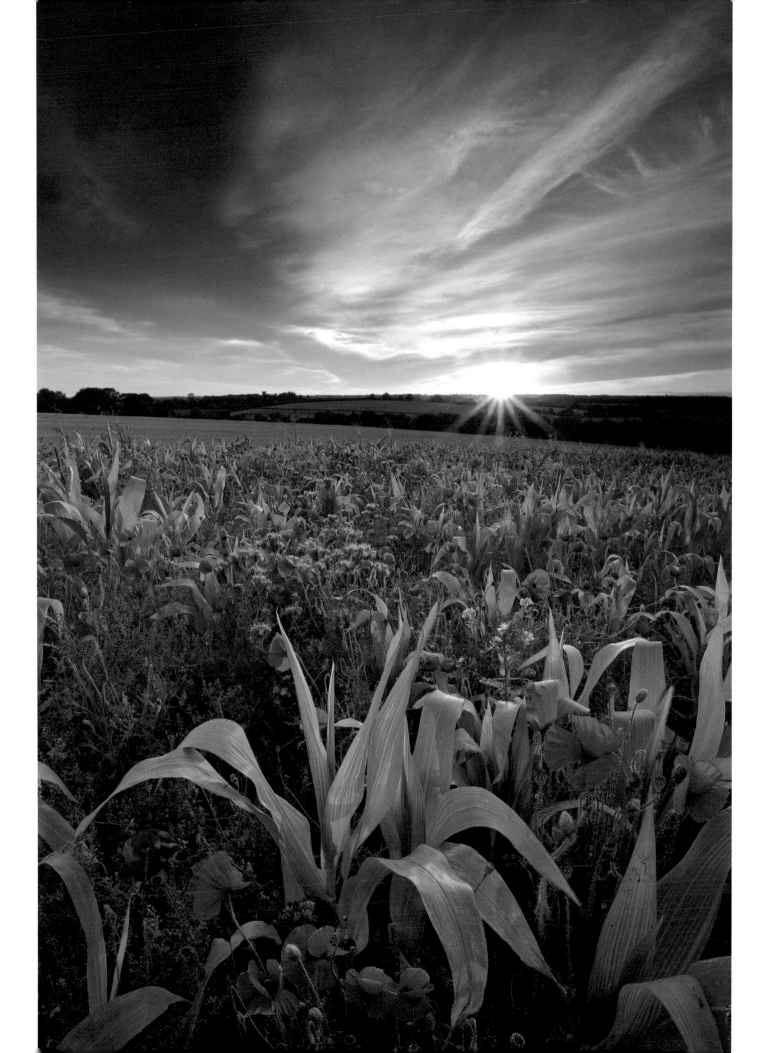

**JON McGOVERN**     2009

### Wheat Field at Dawn
*Derby, England*

I woke up and saw this amazing sky from the window, so I went to a nearby wheat field to create this photo. I've always loved the sweet lighting at dawn, so the mackerel sky was an added bonus.

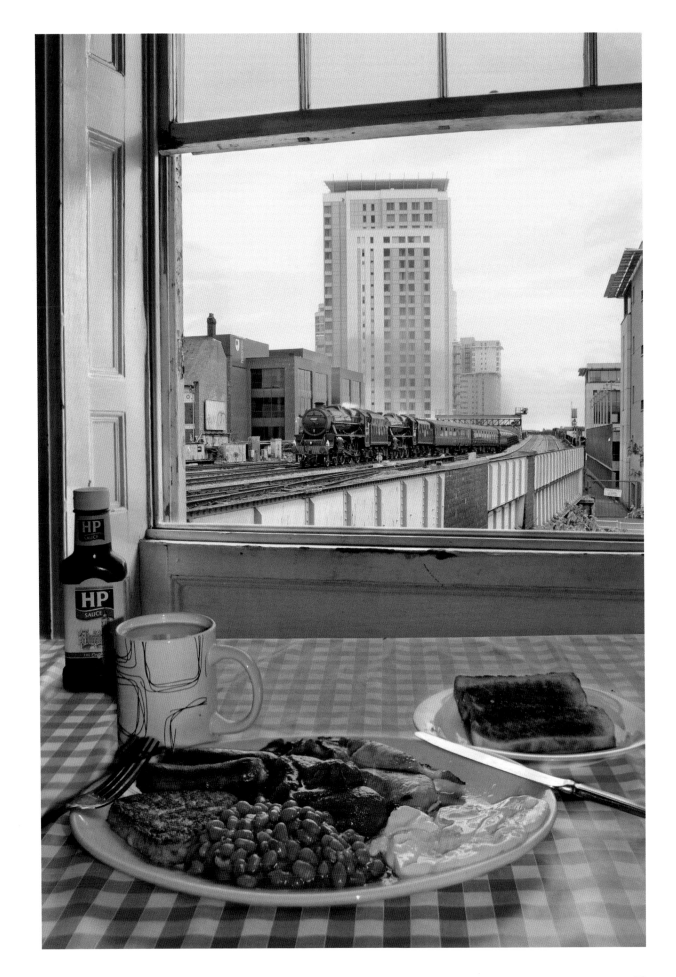

## TALIESIN COOMBES · 2010

### Breakfast View
*Cardiff, Wales*

I wanted something different from the traditional view of a steam train so went to a local café, which looks out over the approach to Cardiff Central Station. While waiting, we ordered a Great British Breakfast, so it seemed natural to put it in the foreground. Fortunately, the train was running early and the breakfast had only just arrived, so I was able to get the shot and enjoy the breakfast. The train was a charter to mid-Wales.

### Armchair
*London, England*

This armchair, in a derelict house in northwest London, is from a school art project. I decided on a theme of 'urban decay'. I live in London but my school is out in the countryside. I knew the sites I wanted to visit and photograph. This picture was taken in an empty house a couple of streets away from where I live and I often pass it on my walk home from the tube. I'd visited the house a week before on a wet evening; this time it was a sunny afternoon.

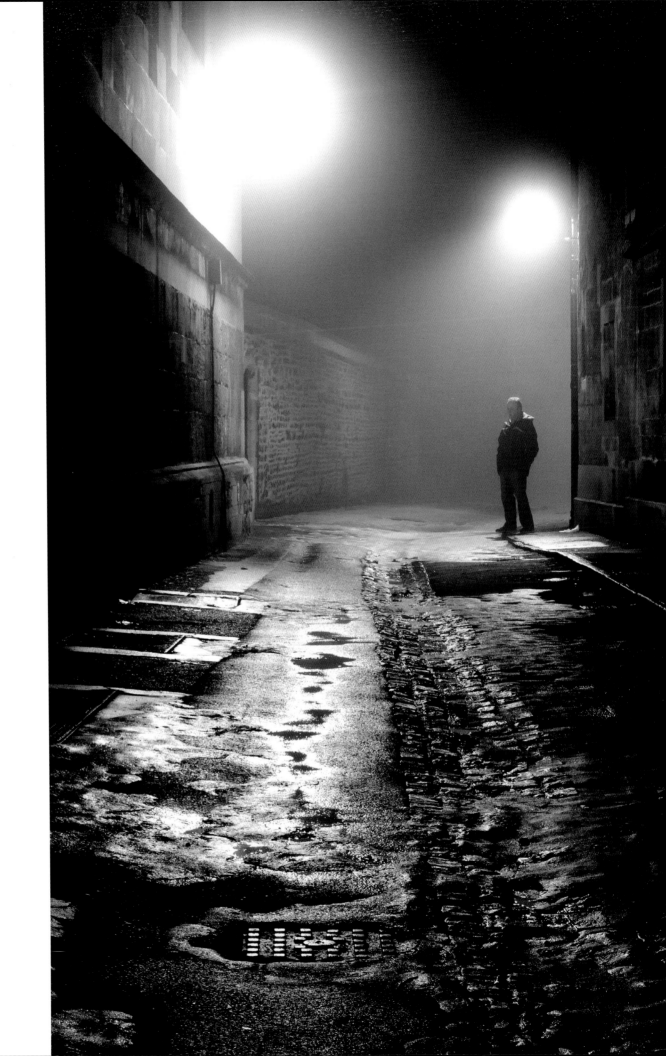

**STEPHEN COLBROOK    2012**

### Man in the Fog
*Oxford, England*

I love the mysterious and unusual effect that fog creates. This photograph was taken while exploring the city of Oxford in an especially dense covering. The old architecture of the city took on a different, more ominous look from its usual romantic, picturesque appearance. The old-style street lamps looked particularly eerie and added drama by creating deep shadows. The diagonal lines of the buildings, combined with the focal point of the lone and distant man, help to draw the viewer in.

**CHRISTOPHER PAGE**                                    **2013**

**Autumn Colour at Polesden Lacey**
*Surrey, England*

The colour of the autumn leaves was pitch-perfect and the low, golden light created a blaze of colour. All that was needed now was a focal point to ground the composition and luckily the hard lines of the gate perfectly complemented the golden leaves.

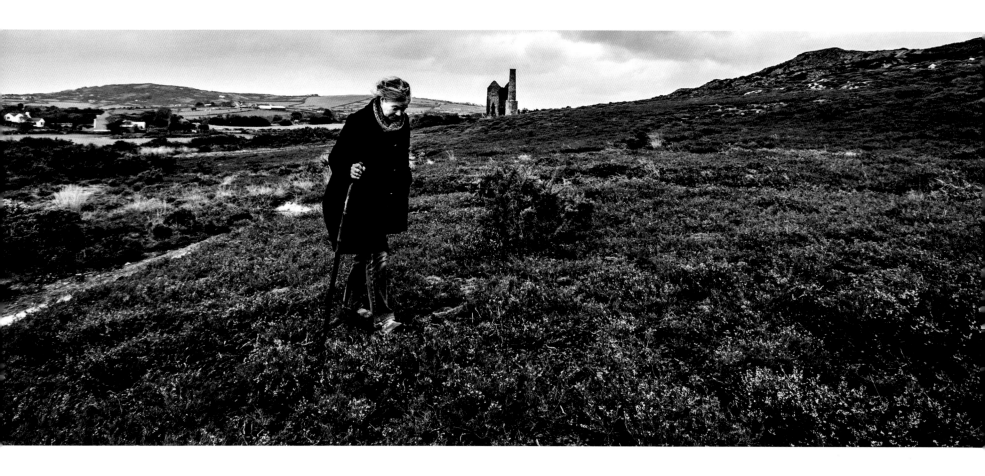

**SAM RIELLY**                                                                    **2014**

Parys Mountain
*Anglesey, Wales*

This image was taken on a particularly wet and windy day on Parys Mountain, the site of a former copper mine. The subject of the image is my mother, who was unaware that I was taking the picture.

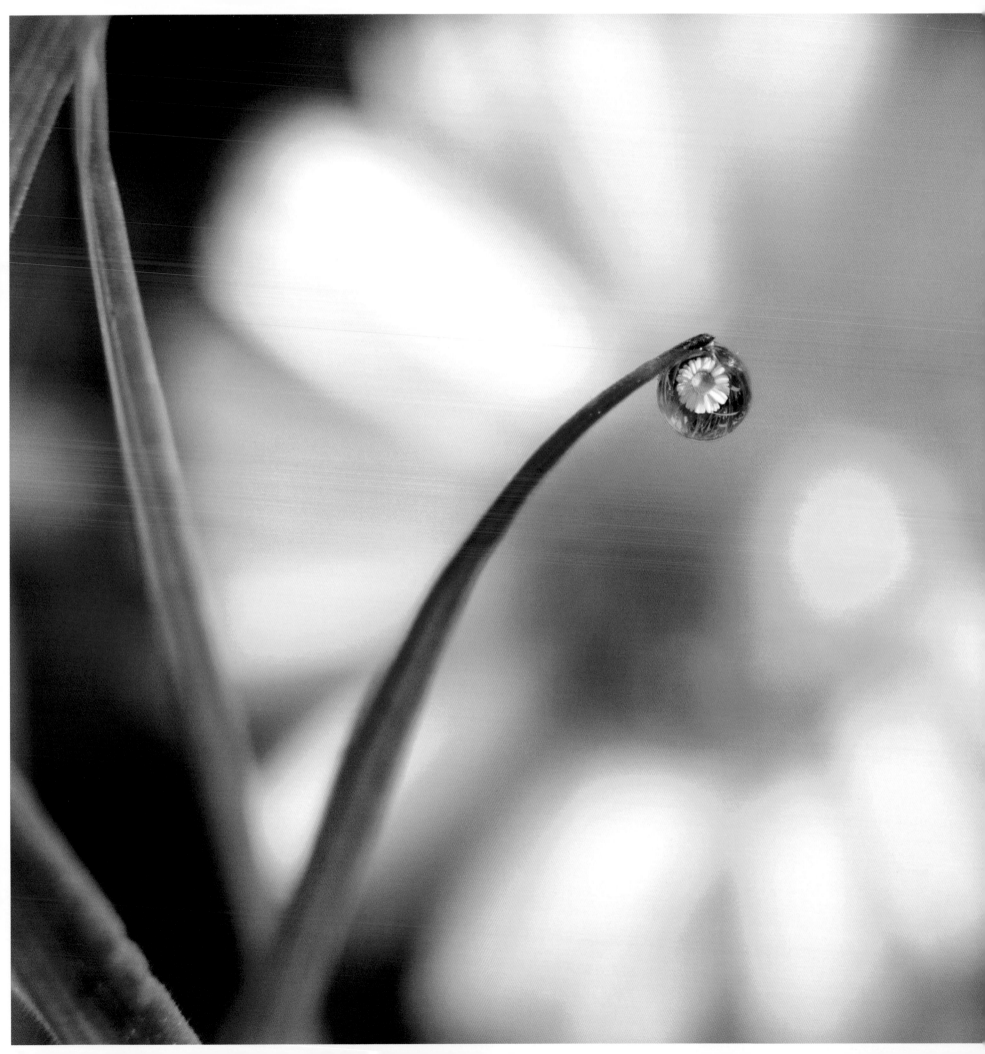

### Through a Water Droplet
*Powys, Wales*

When I was experimenting with my extension tubes one morning, I tried photographing the dew that had settled during the night. I discovered that if I got close enough I could capture an image inside the water droplets but it was often so small and fine that it was hard to tell what it was. I found that the daisies on the lawn were a simple enough shape and the right size to be seen clearly within the droplets. I like the way the daisy in this picture appears to be in a tiny world of its own but the real one is still out of focus in the background.

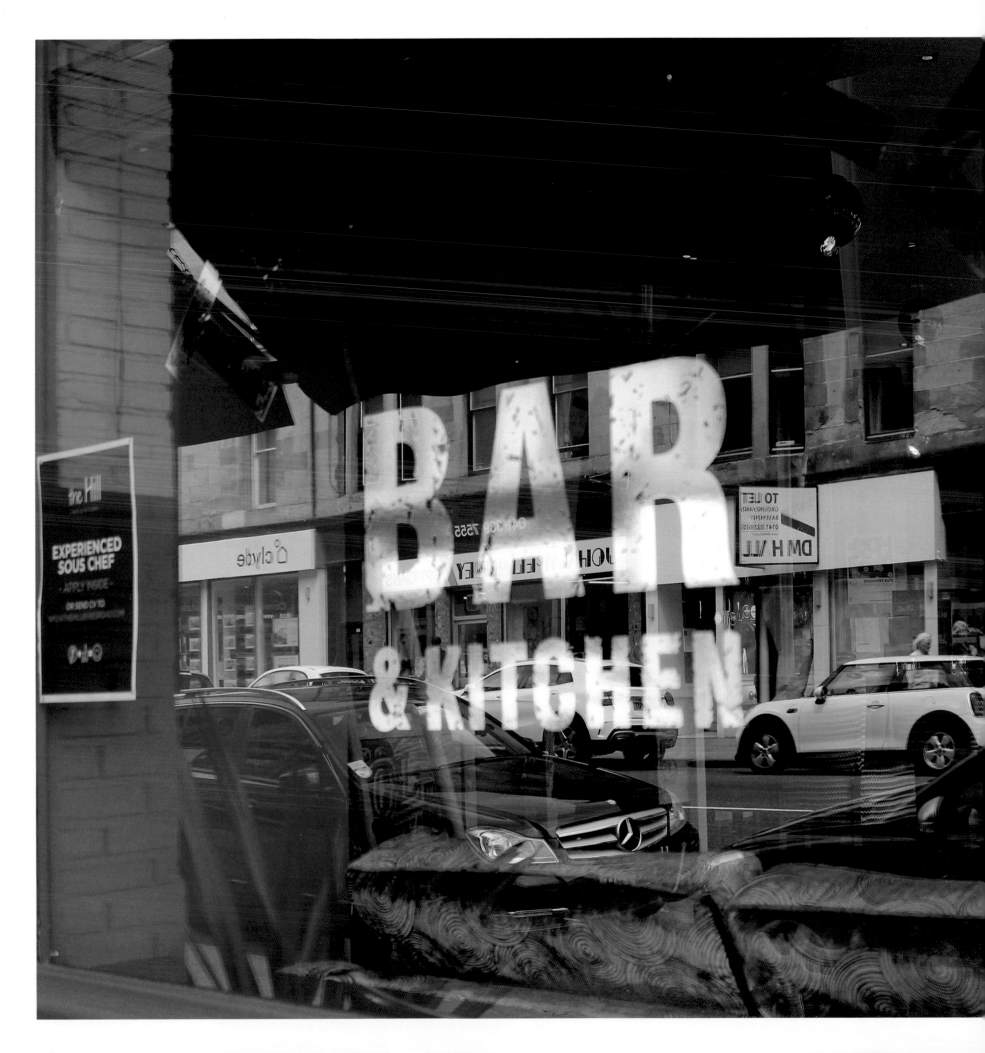

## HANNAH FAITH JACKSON

### Mirror Bar
*Glasgow, Scotland*

Glasgow is a city of two worlds: the relaxed atmosphere of the bar and the vibrant life of the street. I took this photograph just as the dark van approached and the couple appeared deep in the bar. I love the positive and reverse images created by a sea of glass.

CLASSIC VIEW

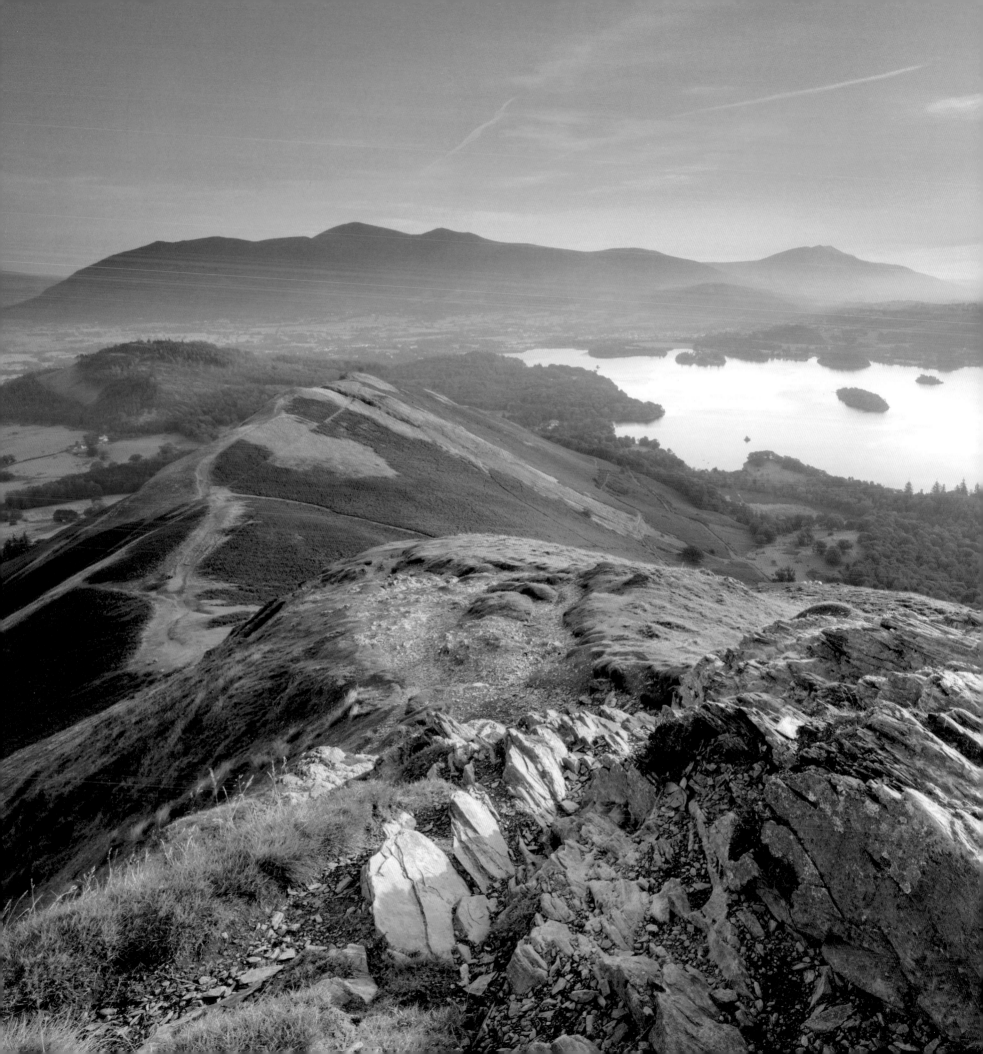

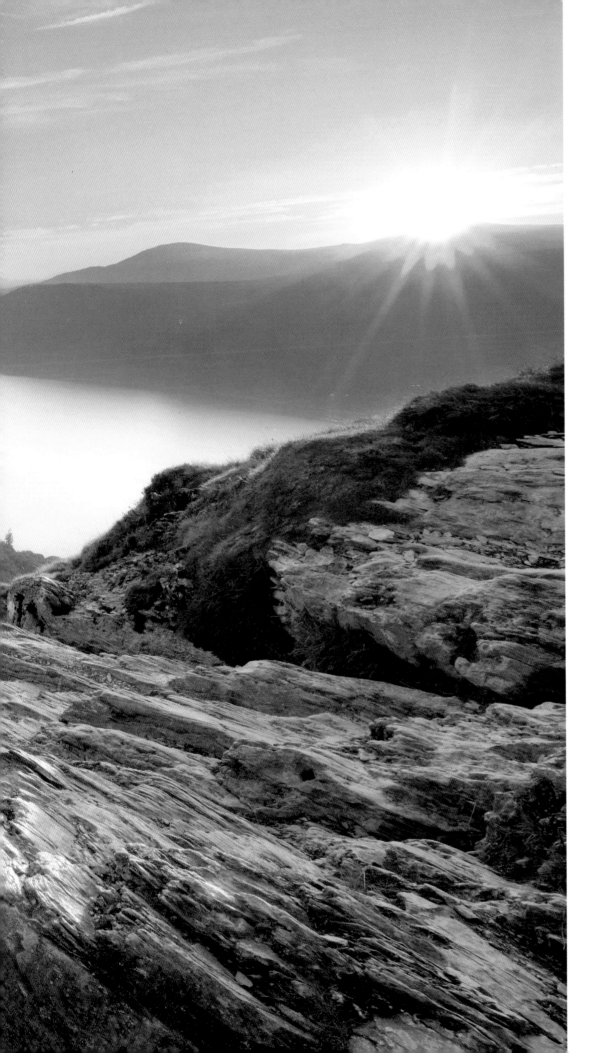

## BART HEIRWEG                                        2013

### Catbells Sunrise
*Cumbria, England*

Although many photographers had already done this before me, the
summit of Catbells, overlooking the famous Derwent Water, was one of
those viewpoints I definitely wanted to photograph when visiting the Lake
District for the first time. It's a fairly easy climb and the view from above
is breathtaking. I placed a large rock in the foreground and, with the path
leading the eye towards Skiddaw in the far distance, this turned out to be the
most pleasing shot of the trip.

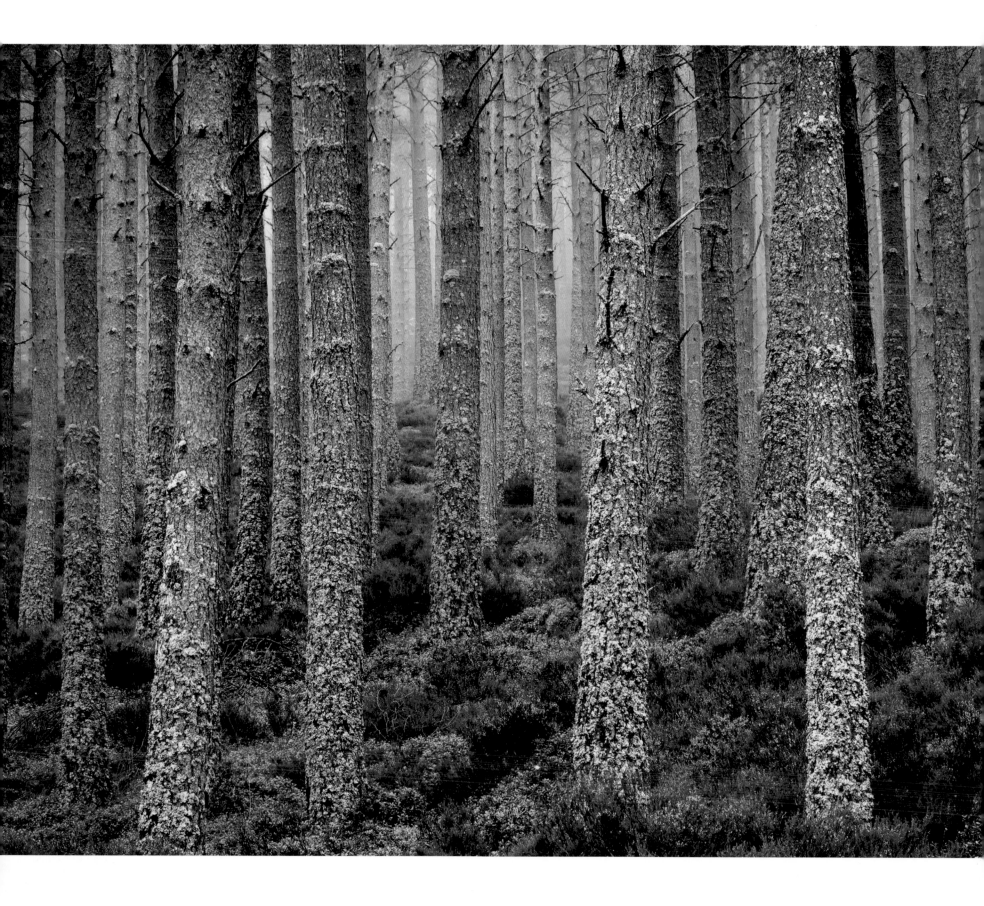

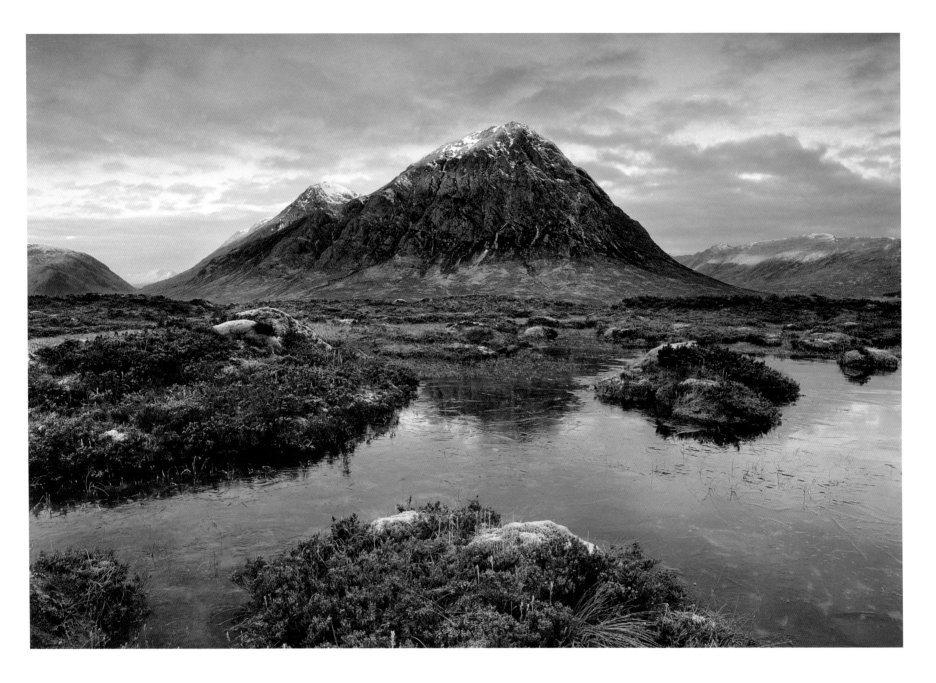

**DAVID SHAWE** ◀ · 2015

### United They Stand
*Glenmore Forest, Cairngorms National Park, Scotland*

During a damp week of autumn photography in the Cairngorms, I was exploring the Glenmore Forest Park, hoping to capture a range of images of the magnificent Caledonian pine forest. Persistent drizzle on this particular day provided ideal conditions, with soft mist forming between the distant trees to add a haunting mood to the scene. I was drawn to the cool colours and captured a variety of compositions. In this location, the texture of the forest floor and the crusty lichen on the foreground pines combined to add contrast and a sense of depth to the scene.

**JOHN PARMINTER** ▲

### Divided Glens
*Buachaille Etive, Rannoch Moor, Scotland*

You can't help but be impressed by the bulk of Buachaille Etive Mor as you travel north across Rannoch Moor towards Glen Coe. It stands guard at the entrance to Glens Etive and Coe and I remember, as a 17-year-old on my first Scottish camping trip, how taken aback I was at my first sight of it. I've passed it many times now, en route to other destinations, and always get a feeling of grandeur from it.

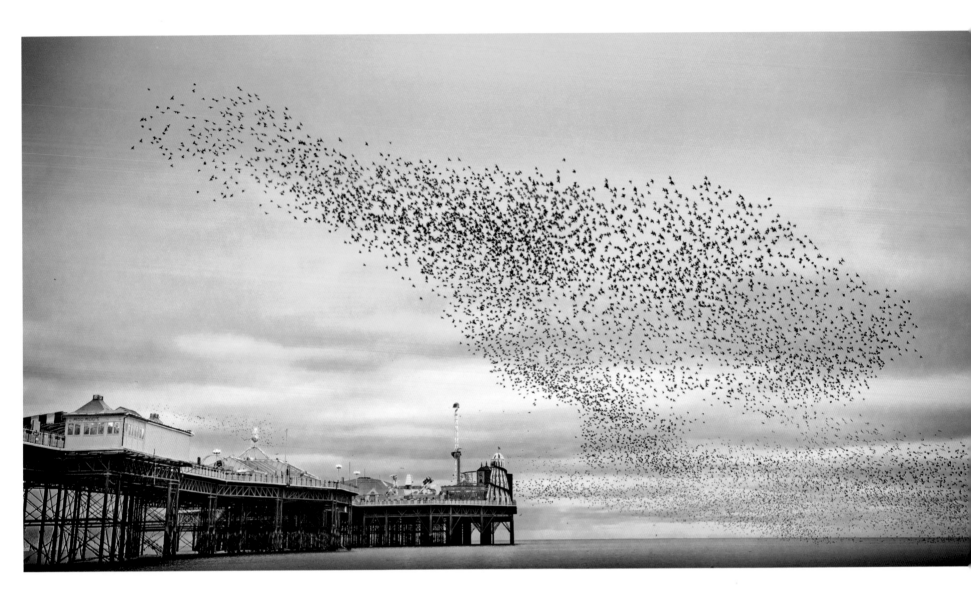

**PETER STEVENS**                                              **2015**

### Murmurations over Brighton Pier
*East Sussex, England*

It was impossible not to stop and stare at these starlings as they performed their murmurations. They came together and moved apart, they swooped and soared, turned and dived, and in so doing formed the most amazing shapes. I took many images but I chose this one because the shape formed appears to be a running animal leaping over the pier.

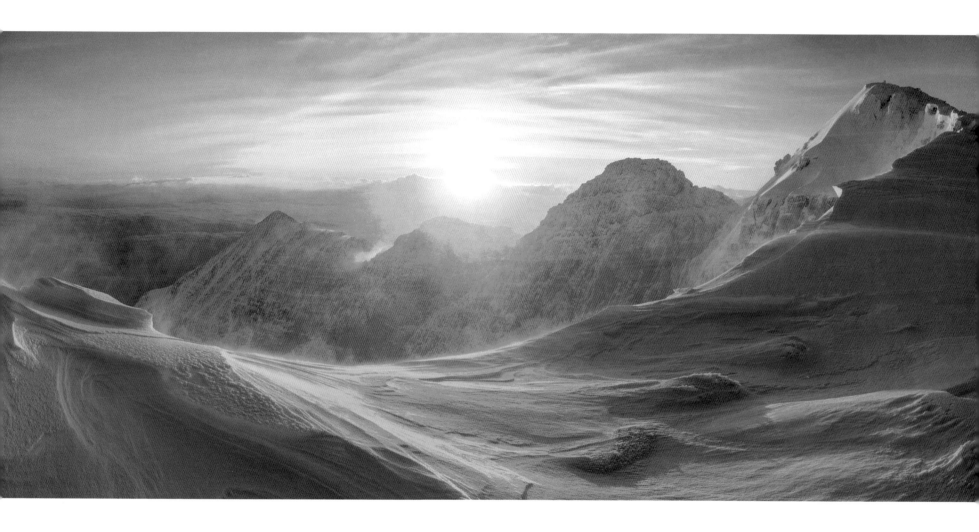

**GUY RICHARDSON** <span style="float:right">**2015**</span>

**An Teallach from Bidein a'Ghlas Thuill**
*Highlands, Scotland*

An Teallach is arguably one of the UK's best mountains and it certainly didn't disappoint. After a night in the tent in sub-zero temperatures and strong winds, the prospect of reaching the summit for sunrise began to look unlikely. Reaching the mountain's highest summit, Bidein a'Ghlas Thuill, with moments to spare, I was able to capture a few frames of the rising sun and the spindrift flying over the ridge before continuing on to an event-filled day in the mountains.

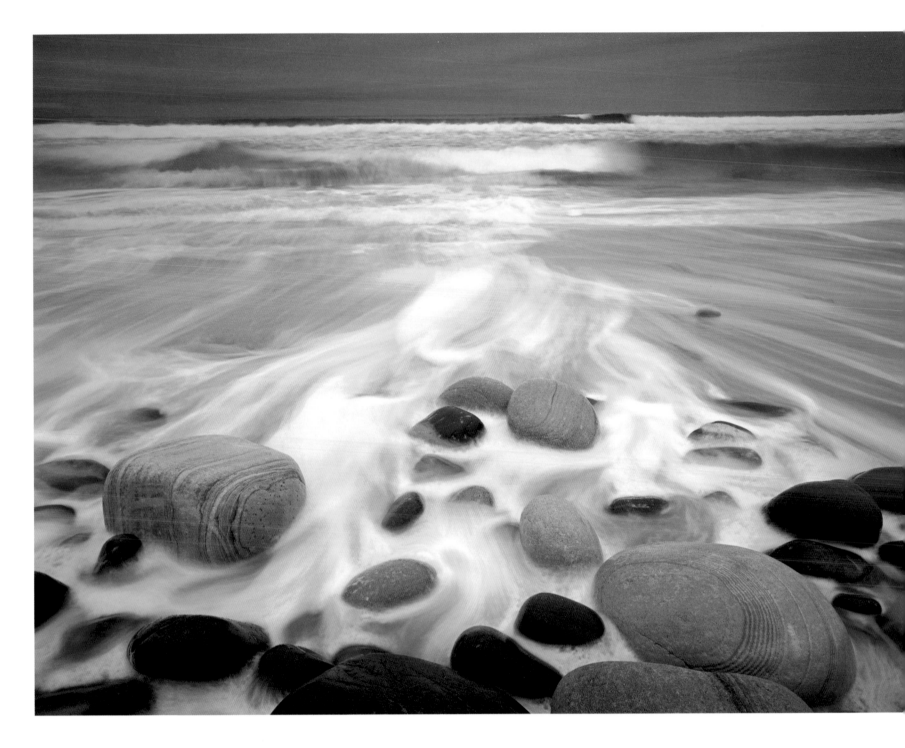

**VERENA POPP-HACKNER**                                     **2008**

**Boulders in Surf at Rackwick Bay**
*Orkney Islands, Scotland*

It is pretty impossible (I think) not to be attracted to and impressed by these boulders, which are strewn all around Rackwick Bay. Since rain, along with cloudy skies, was the usual weather during my stay here, I focused on more detailed or intimate landscape shots. I lost myself for hours in framing images and looking for compositions as tides were rising and falling. I stumbled upon this group of boulders a couple of times, but felt that it would be the best time to expose some sheets of film only when the tide was high enough for the waves to wash over the most colourful rocks. Still, I could not be sure about the final outcome until I was back at home, weeks later. One of the (few) things I envy about digital shooters is being able to see the desired effects right away on the monitor.

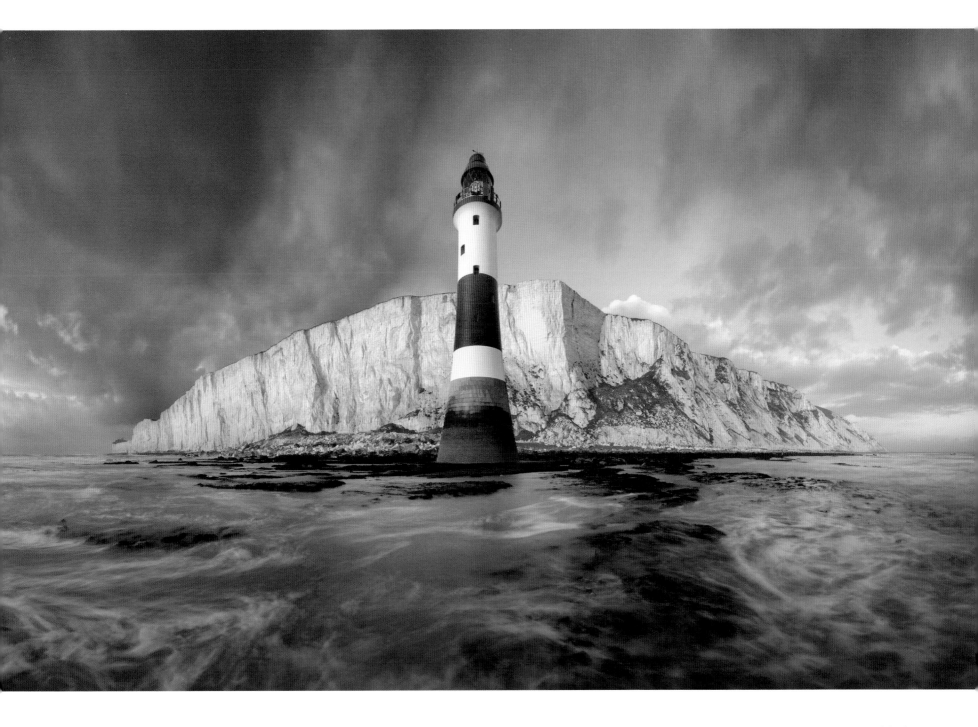

## MIREK GALAGUS

### The Guardian of the Island
*Beachy Head, East Sussex, England*

I had this image in my head for almost four years. I made several attempts to capture it but, every time, a tiring journey down the cliffs ended up with poor results. Finally, on the day before Christmas Eve 2015, all the elements came together. Although I was caught by the rain on my way down, the weather settled. The conditions were good, the tide was low and the light played to my advantage, illuminating the cliffs in the most favourable way. I was standing waist-high in the water, fighting off the waves and trying to avoid the water splashing my camera, but managed to capture the full view with 11 vertical shots.

**PETER RIBBECK**                                                           **2011**

**Knapps Loch**
*Bridge of Weir, Scotland*

This was my first time at Knapps Loch and I stumbled around looking for a decent composition in the half-light as the sun began to rise. An eerie glow began to appear in the mist behind the trees and lasted for about two minutes before it slowly started to fade. This gave me just enough time to take this shot and a few more of different compositions. When I saw this image in the back of my DSLR camera I was very excited and left for home a happy man.

**COLIN GRACE** 2010

### Bridges across the Dart at Bellever
*Devon, England*

The early morning sun and the deep overnight frost lend an overall pastel feel to this scene of the two bridges spanning the East Dart River at Bellever on Dartmoor. This is one of my favourite spots on the moors and I like to visit at least once every season if I can. This particular Sunday morning was one of the coldest I have encountered on Dartmoor but the feeling of peace and tranquillity that I experienced was well worth it.

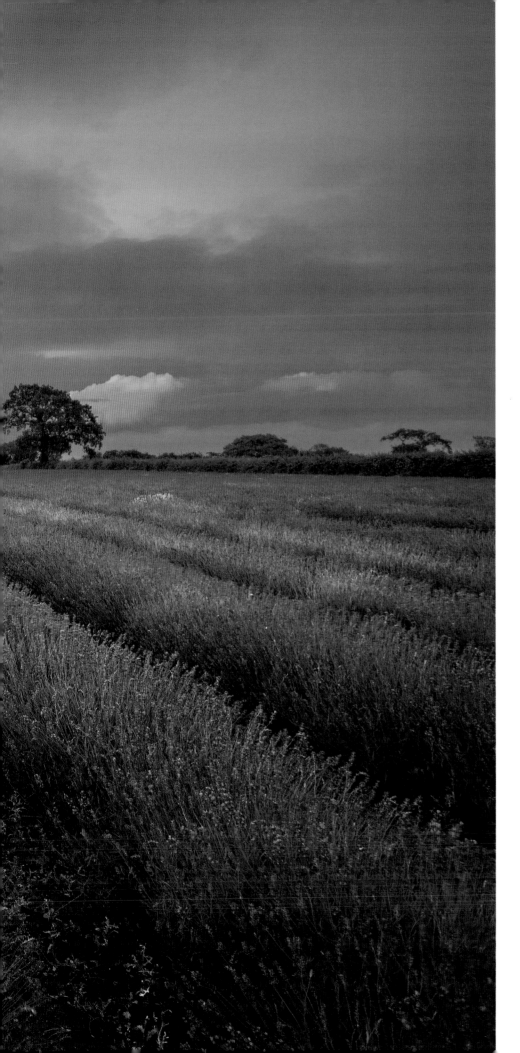

## GRAHAM McPHERSON                                      2012

### Lavender at Faulkland
*Somerset, England*

For this image, I got up an hour and a half before the July dawn and drove for 40 minutes. Despite the pelting rain making it hard to see through my windscreen at times, I had a feeling that the lavender field would yield something good. Sure enough there was a gap in the clouds. An hour after this image was taken heavy rain set in again for the rest of the day. It was a great window of opportunity that surpassed my expectations and I was glad I went with my heart instead of my head on this one.

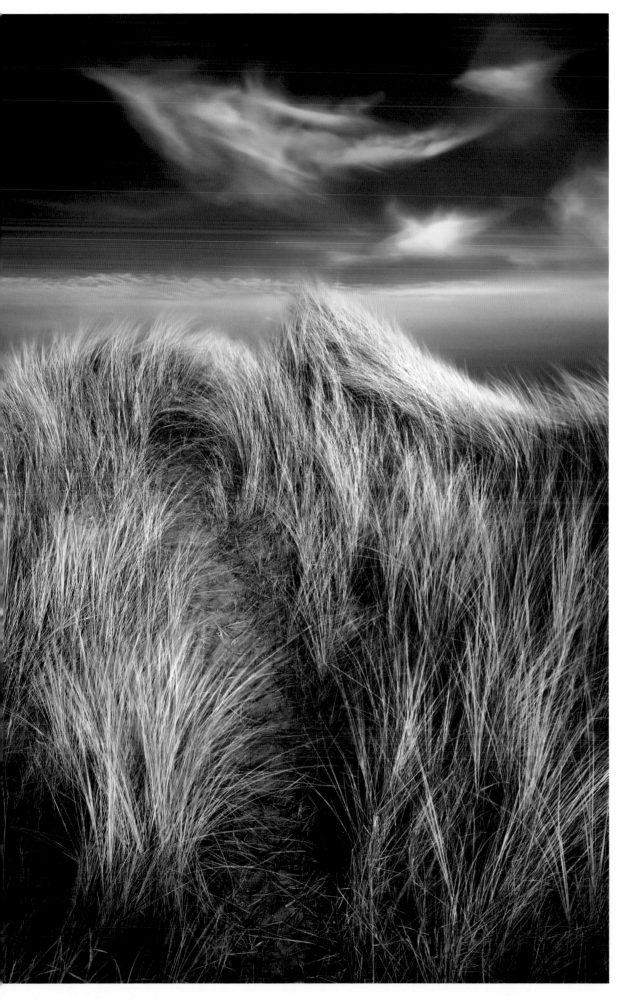

## JEREMY BARRETT

### Dancing Marram
*Thornham, Norfolk, England*

This image was taken in the Holme Dunes nature reserve. While composing the frame I noticed some wispy clouds coming into view. With an exposure of six seconds, the flowing marram grasses echoed the cloud patterns.

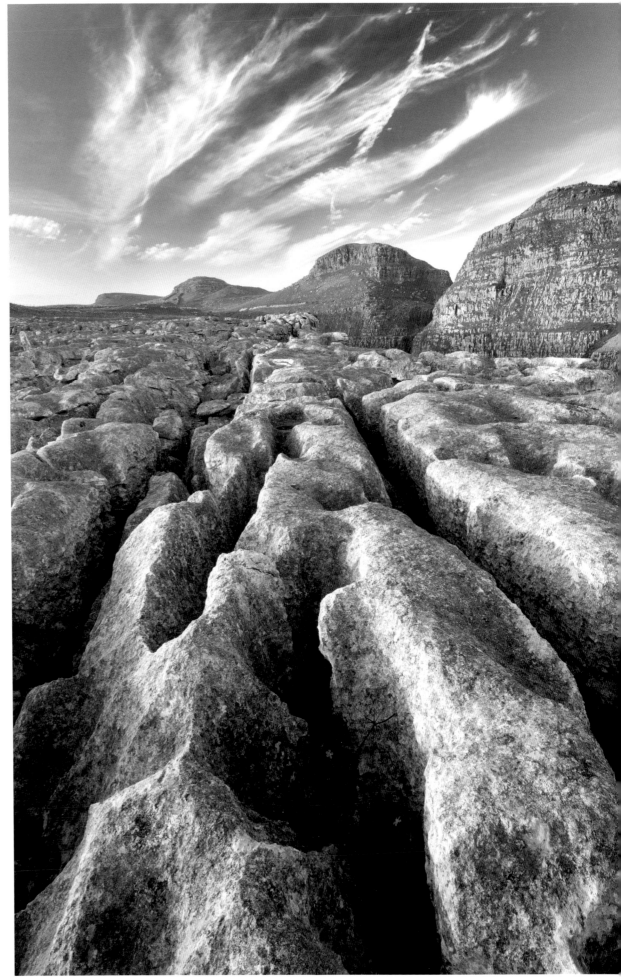

## DAVID SPEIGHT                    2009

### Watlowes Dry Valley
*Malham, Yorkshire Dales, England*

I had arrived at Malham in the late afternoon with this kind of shot in mind. I planned to have a wander around trying a few different compositions and then hopefully settle on one and wait for the sun to drop. However, having taken a few test shots, I noticed that the jet contrails overhead and the small trace of cloud were rapidly burning off. By sundown, the light had faded and the sky was quite uninteresting so I headed off home disappointed. It was only a few months later when I revisited the shots that I wondered why I had never processed this shot, which was one of the 'test' shots I had taken.

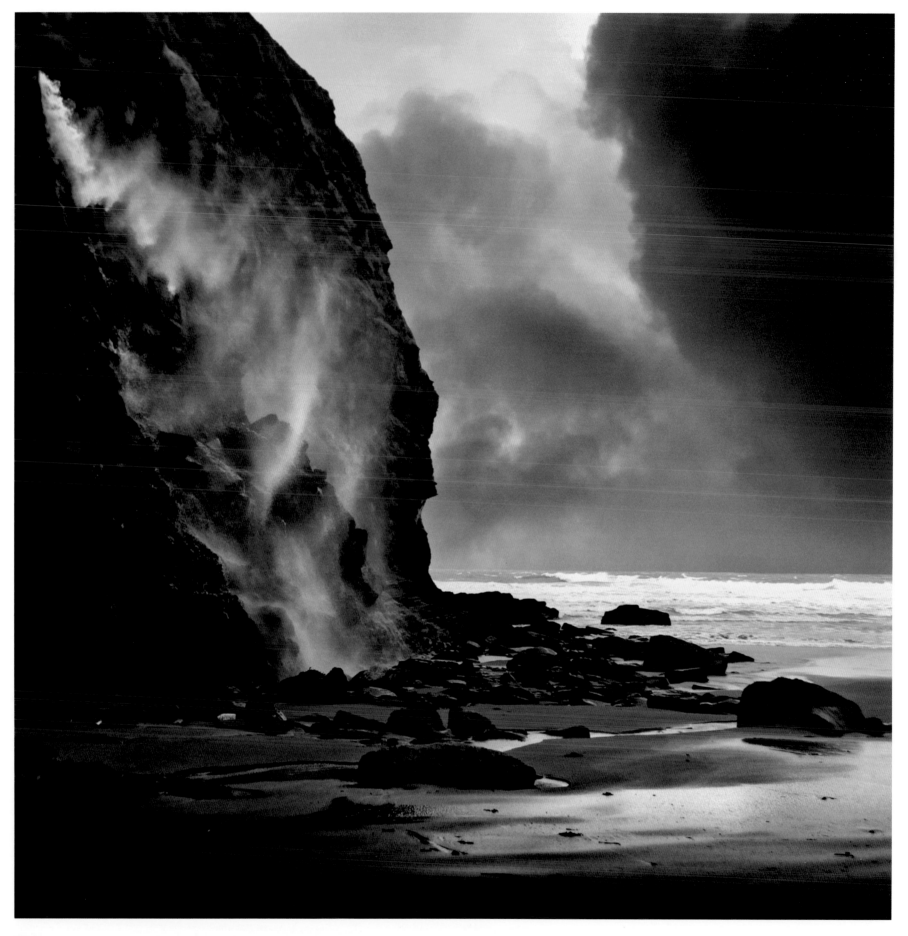

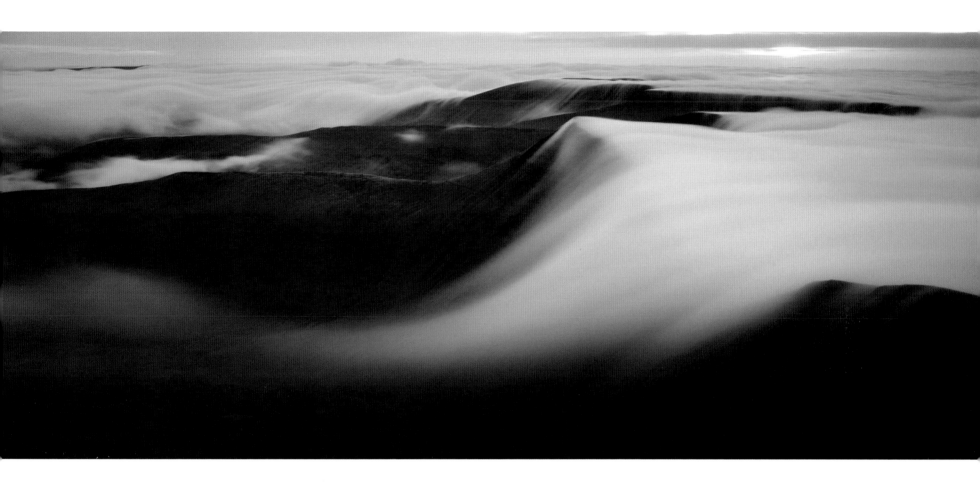

**CHRIS TANCOCK** ◄                         **2007**

**Druidston Haven in Winter**
*Pembrokeshire, South Wales*

On this day we had really high winds blowing out to sea. The waterfall was falling about six feet and then blowing at right angles for about five feet before cascading away. It was so windy I had to add pebbles to my rucksack and hang it on the tripod.

**GRANT HYATT** ▲                         **2016**

**Dragon's Breath Dawn**
*Cribyn, Brecon Beacons National Park, Wales*

Fog had been building in the Brecon Beacons National Park for several days, culminating in this breathtaking November dawn with the dragon's breath pouring over Cribyn like water down a river.

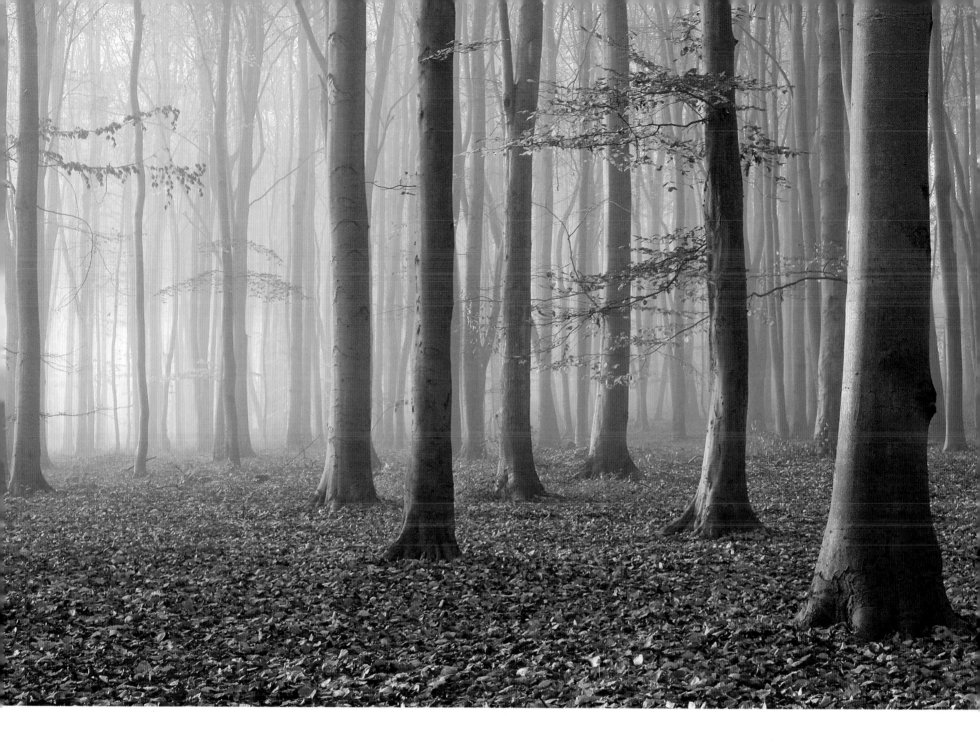

**CRAIG DENFORD**                                          **2012**

**Beech Trees**
*Surrey, England*

I'd noticed this location the year before, marginally too late, and so resolved to return the following year. As soon as mist and fog were forecast, I set the alarm and made my way over. Conditions were great but things improved further when the sun started burning through the fog, giving form to the trees and creating a beautiful range of tones. Combined with the lovely oranges and browns of the leaves it created the perfect scene.

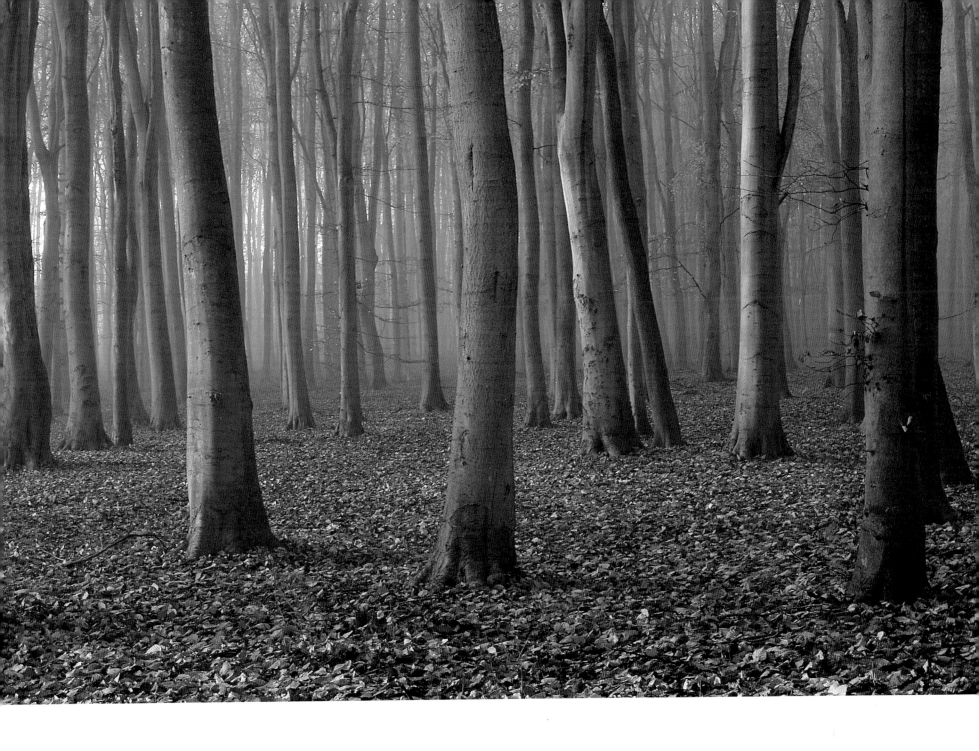

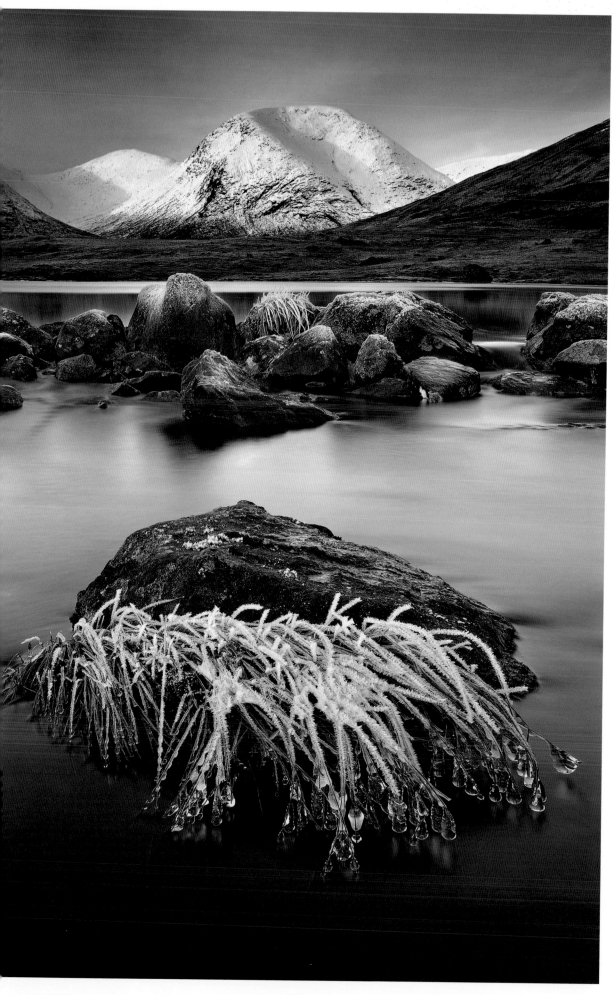

## SIMON BUTTERWORTH ◀

### Diamonds Aren't Forever
*Loch Dochard, Scotland*

I kept to my golden rule of wearing wellies when photographing near water, but the level was within millimetres of my boot tops while capturing this image. Every time I moved I felt the trickle of freezing cold water run down to my thick, woolly socks. I had a very cold and squelchy 90-minute walk back to my car as the cold winter night settled over the glen.

## TIMOTHY SMITH ▶        2014

### Macclesfield Forest
*Cheshire, England*

I had the snow-covered forest to myself; snow was still falling, silence all around. I was back in my home town of Macclesfield to capture some winter images. Walking up a path through the forest towards Shutlingsloe, a local high point, I came across a small clearing and immediately noticed the dead yellow grasses set against the fresh snow. The small conifer added to the interest and I placed it centrally to take the view from the foreground right through into the forest.

## ROB SCAMP                                          2014

**Witness – Sunrise**
*Black Hill, Malvern Hills, England*

This was my second or third dawn visit to the Malvern Hills to capture a sunrise over the valley. The previous visits had been a washout, but this time on the drive there I could feel the tingle of anticipation as the sky was shaping up nicely in the pre-dawn glow. After a short time on the hilltops a cloud bank moved in, leaving a narrow slot for the sunrise. I thought the moment had passed once the sun rose behind the clouds, but then an incredible scene appeared with a blast of light across the landscape – long shadows created by rays of light through the trees and buildings below – and I decided to capture as much as I could by creating a panorama of the scene.

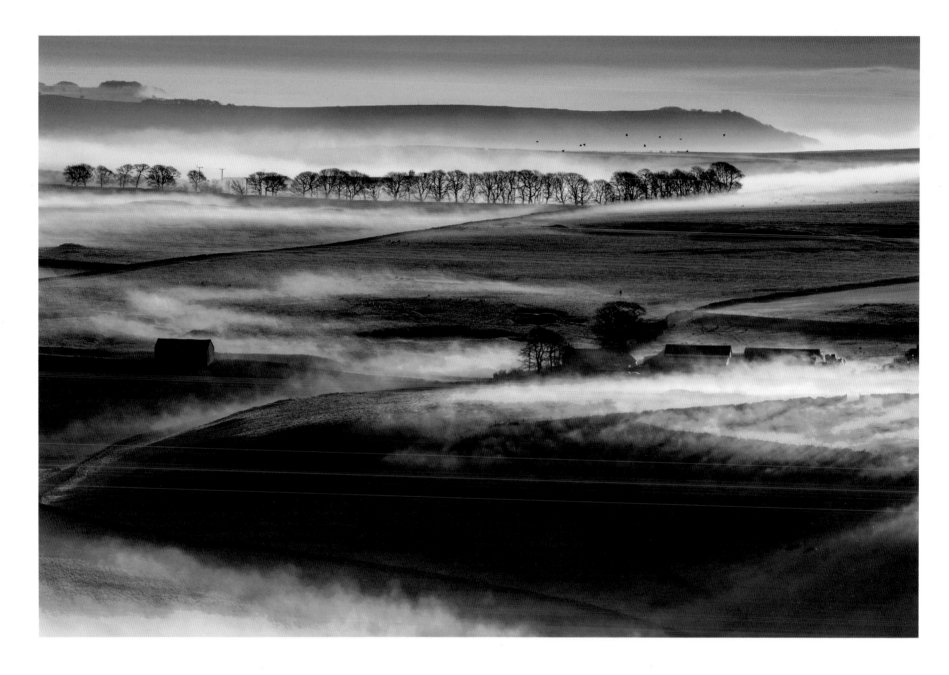

**JOHN FINNEY** ▲                     **2013**

Windy Knoll
*Castleton, Derbyshire, England*

I set off from home in the dark and headed to Rushup Edge for sunrise in the Peak District, about a 20-minute drive from my house. The weather forecast was nothing special – just a small chance of mist. To my surprise, the conditions were much foggier than I was expecting. As I climbed Rushup Edge, the curtain of fog suddenly cleared to reveal a golden sky from the rising sun, with mist rolling along the hills on the other side of the valley. In this shot you can see the farmer just setting off to feed his livestock.

**GERRY GAVIGAN** ▶             **2007**

Chanctonbury Ring
*West Sussex, England*

I usually try to 'recce' my shoot locations beforehand. I had spotted the potential for this image one year previously, but had to wait until I liked the light and it all came together.

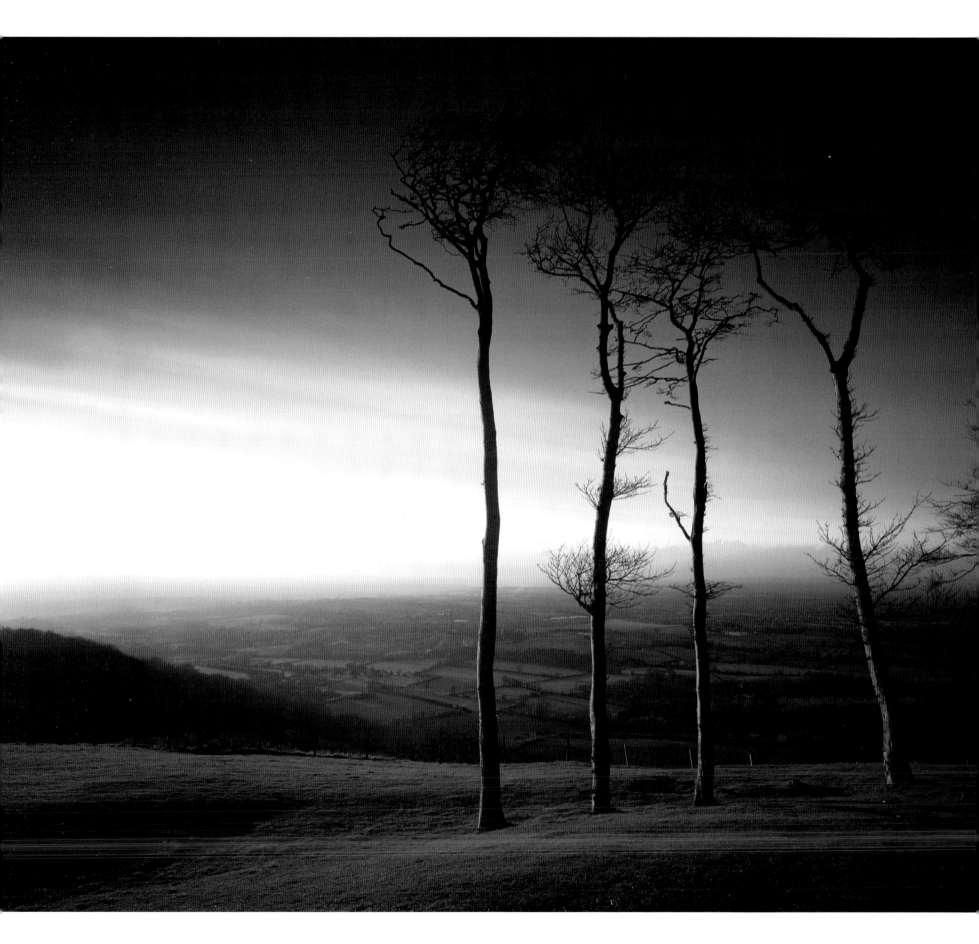

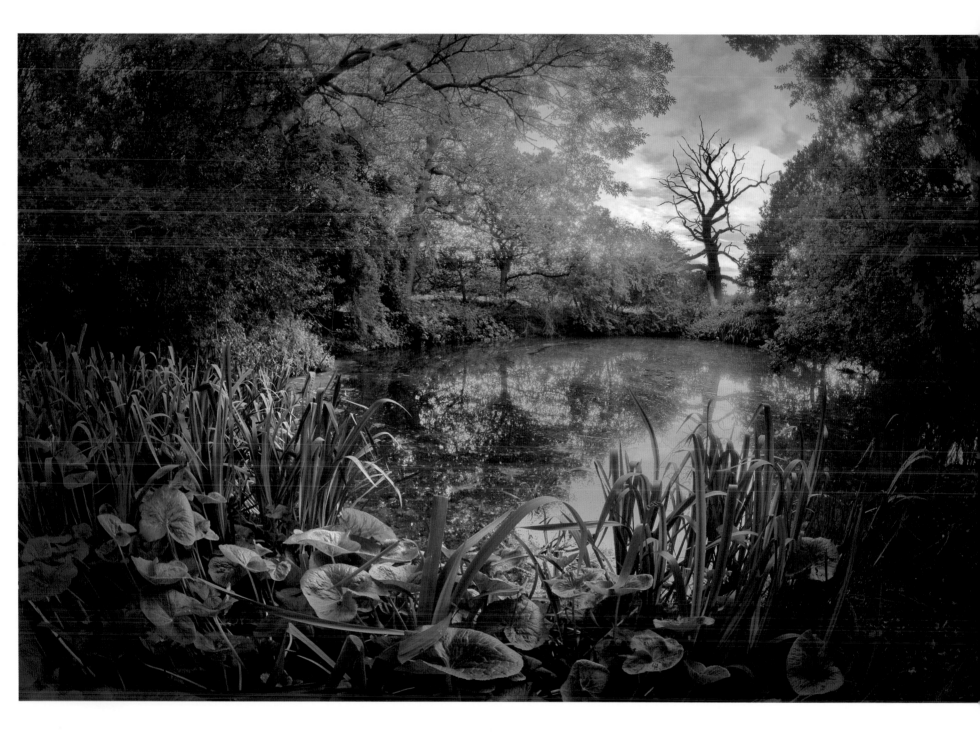

**SERGEY LEKOMTSEV**                                          **2010**

## Potters Bar
*Hertfordshire, England*

Hertfordshire has some great countryside to explore. This picture was taken at the edge of London on the cycle route called the Great North Way, which I use to cycle to work.

### Grazing Cattle
*Marleycombe Hill, Wiltshire, England*

This image is a result of using home advantage. I'd got up early for a dawn outing but, once out of the house, some unexpected but welcome early mist called for a change of plan. A quick rack of my brains provided plan B, which was shortly replaced with plan C on realising the mist was very localised. So I headed to one of my favourite spots on nearby Marleycombe Hill, where I knew I could make the most of the conditions. When I arrived the sun's rays were just beginning to reach into the valley. As a bonus, the grazing cattle had thoughtfully arranged themselves to give some scale to a very pastoral scene.

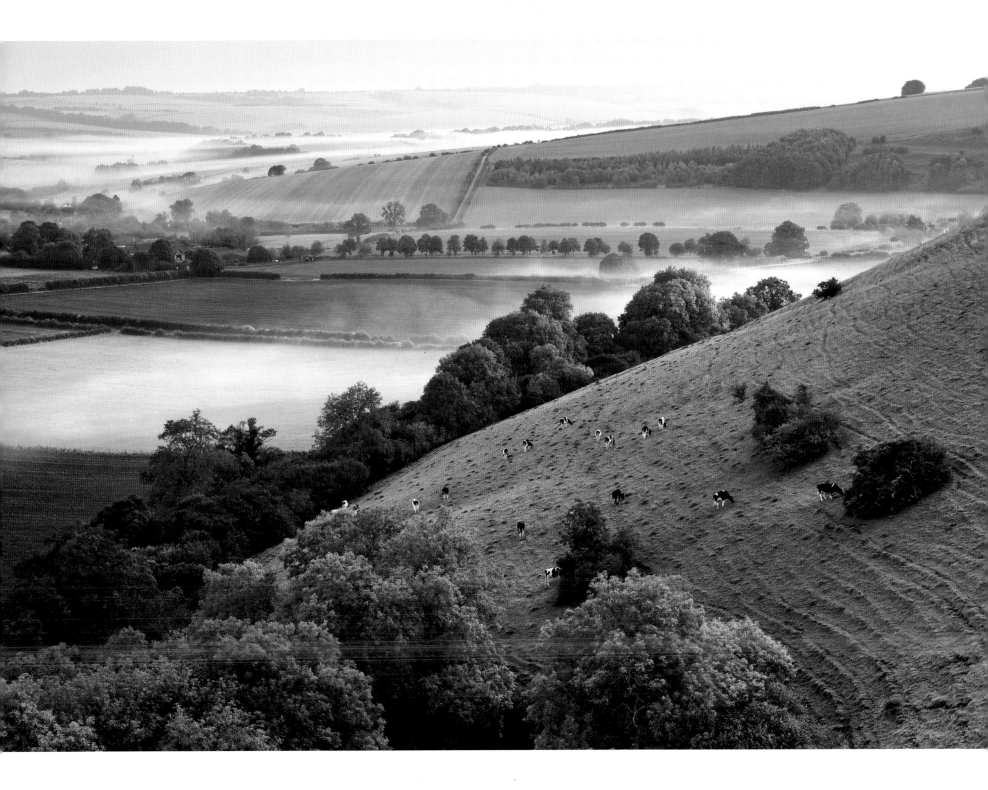

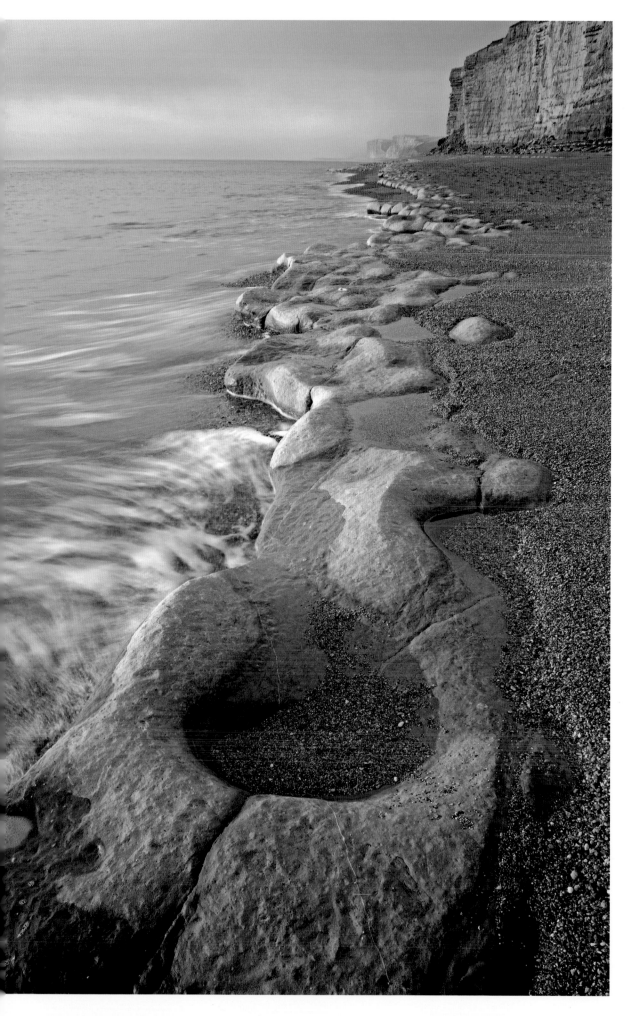

## Burton Bradstock Coastline
*Dorset, England*

The light attracted me to this location late one afternoon, there being no activity in the sea. I had not noticed this particular rock formation previously, so it proves that it pays to visit and revisit your local area.

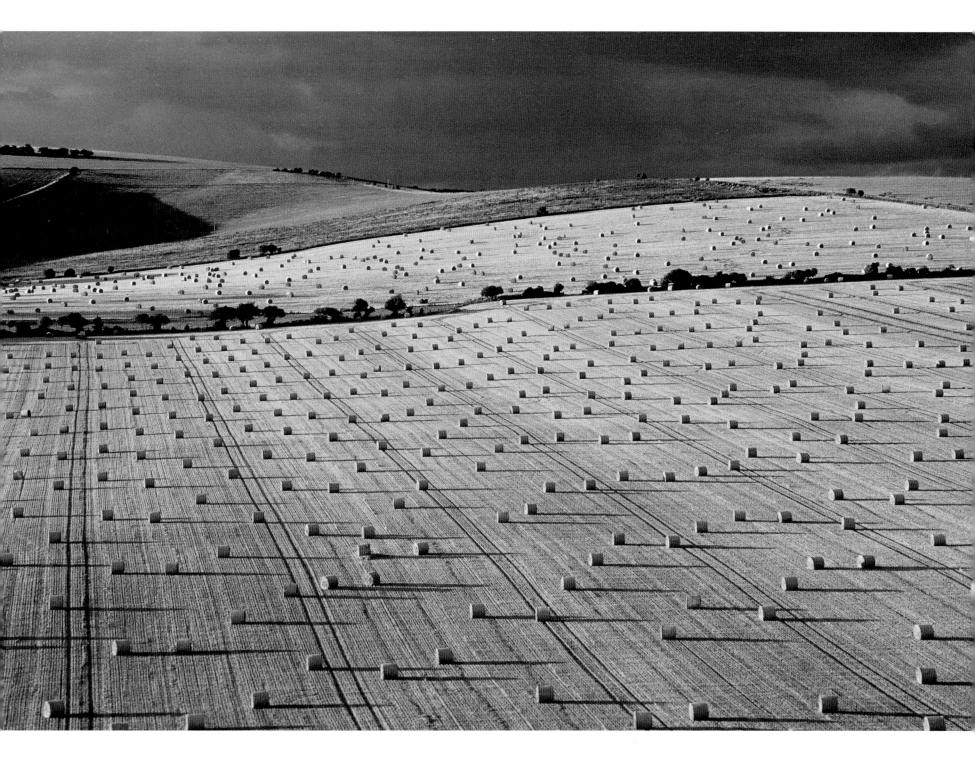

**STEVE BARKER**                                                            **2008**

### Field of Bales
*South Downs, West Sussex, England*

This photo was taken at Long Furlong Farm, just below Black Patch Hill, on the South Downs in West Sussex. As the storm was approaching I was waiting for a break in the clouds and for the low evening sun to break through and light the field of bales.

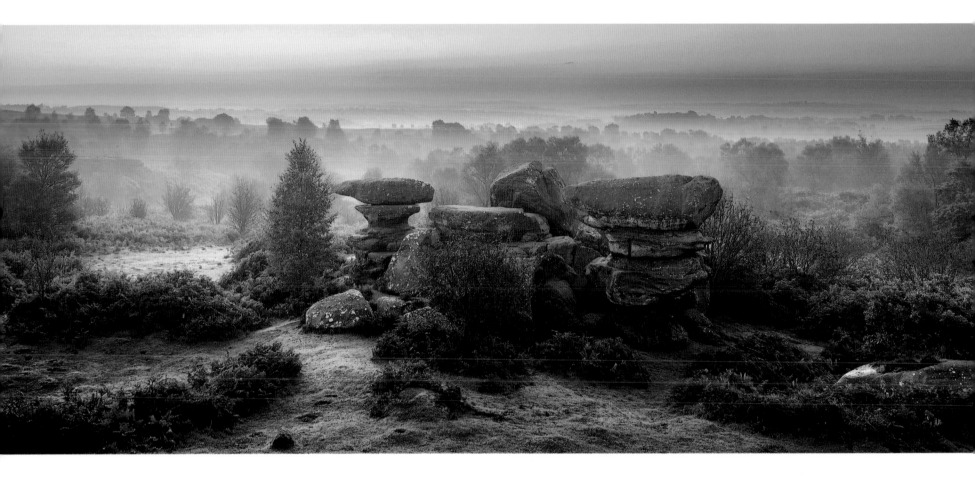

## TIM PARKIN ▲                                                     2008

**Before the Morning**
*Brimham Rocks, North Yorkshire, England*

For a couple of months, my wife Charlotte and I would take the hour's drive to Brimham Rocks every Saturday at around 5am. Having navigated by torchlight and found a perch that looked over this fantasy stage set, we would sit with our flasks of tea and coffee, eat breakfast and wait for the light to arrive. On this morning, a faint glow on the horizon gradually brought a fantasy scene to life and the frost and mist lent it all a mystical glow. Although I now have a variety of different sunrises captured from this location, it is this pre-dawn glow that I keep coming back to. I often get asked why on earth anyone would get up that early in the morning just to take a photograph – this photograph is now my standard response.

## DAVE FIELDHOUSE ▶

**Bright Eyes – Hope Valley from the Great Ridge**
*Derbyshire, England*

This was not the photograph I had in mind when I left the house at 3.30am. Having watched the sun rise over Mam Tor, I decided to follow the path towards Hollins Cross. This view, and the fallen gate in front of it, appealed to me, so I set up to take the shot. Satisfied with the image, I turned away to get my flask of coffee when I noticed out of the corner of my eye that I wasn't the only one enjoying the view this particular morning. I quickly took a second shot, with my new friend in just the right place.

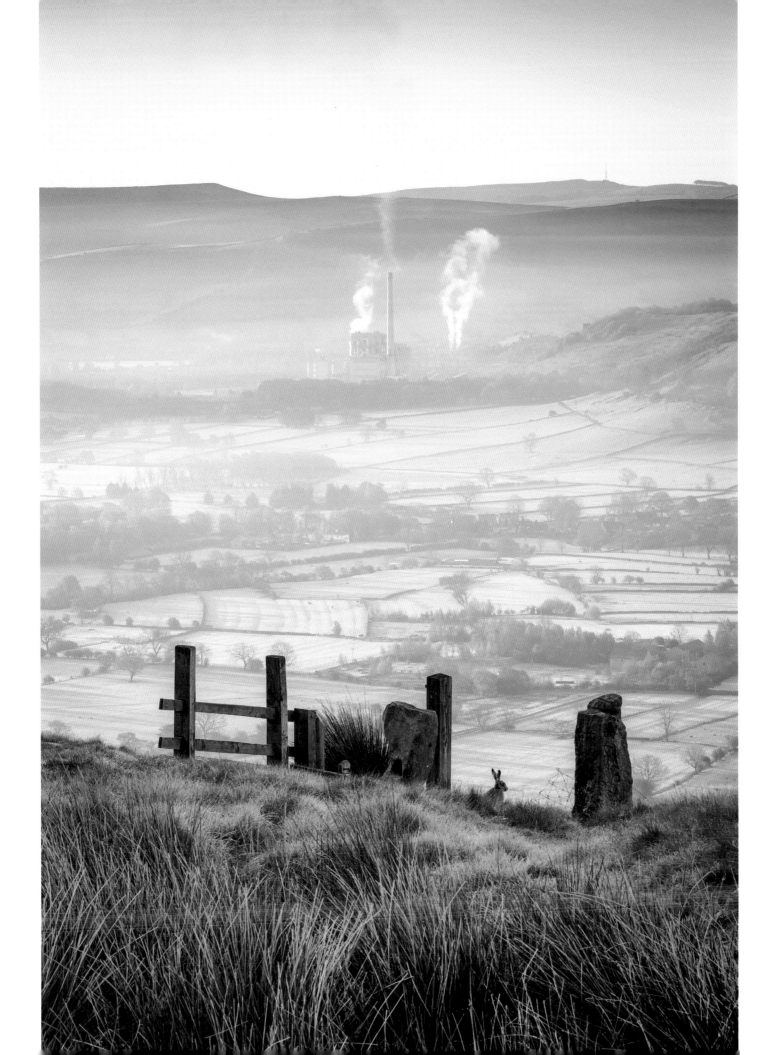

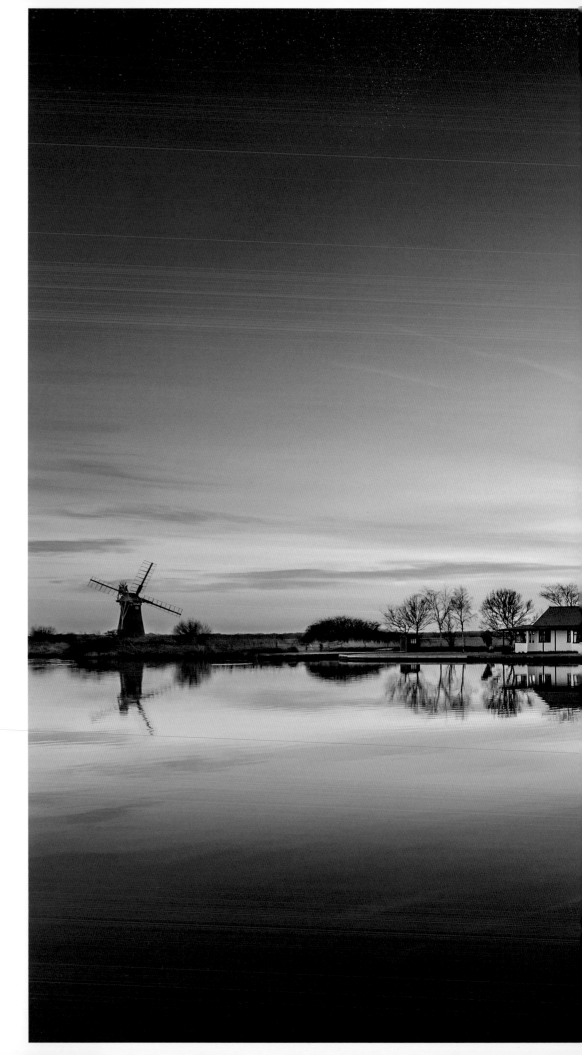

## BILL ALLSOPP                          2015

### View of the River Thurne at Sunset
*Norfolk, England*

This is the final image from the last full day of the very last landscape photography trip I was able to make in my camper van before heading down the long road to diagnosis and treatment of cancer. I am pleased to say I feel well, the indications are good and I shall be back out there in my camper with my camera very soon!

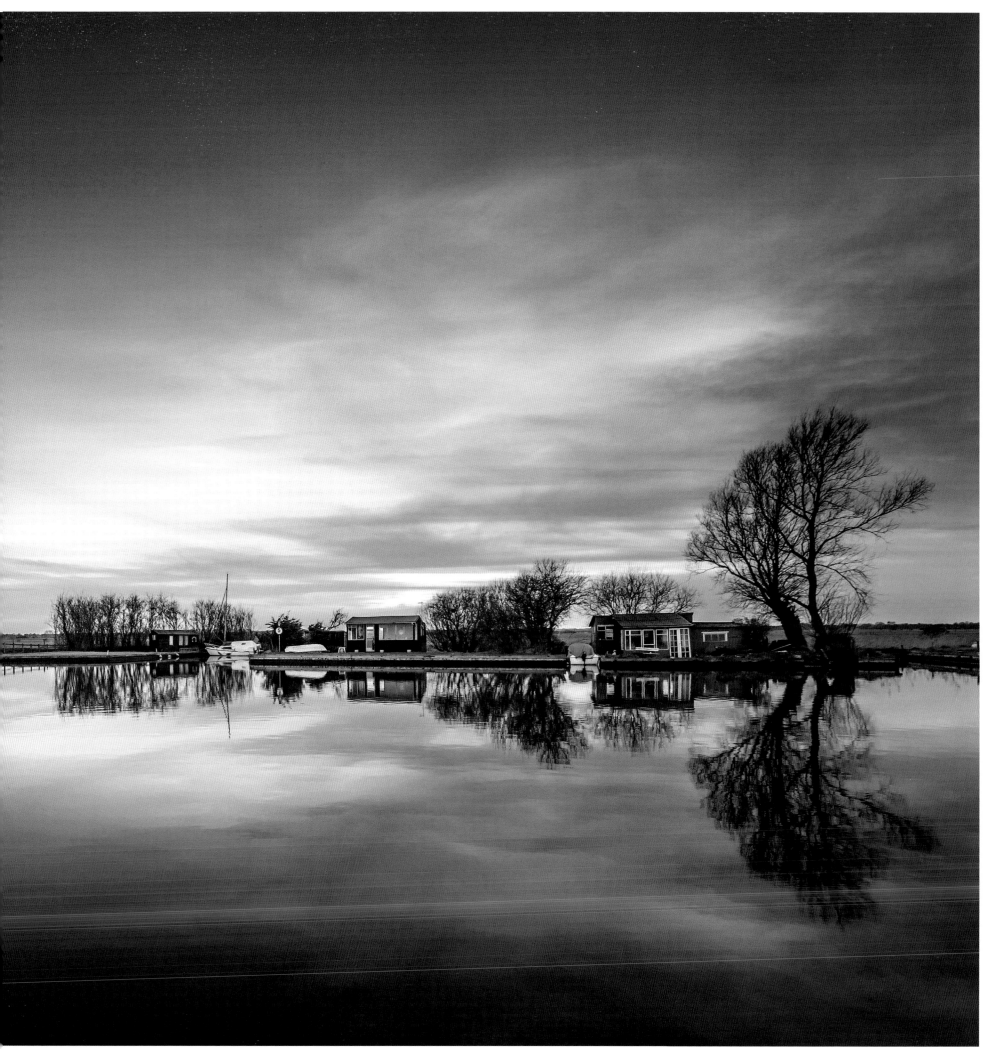

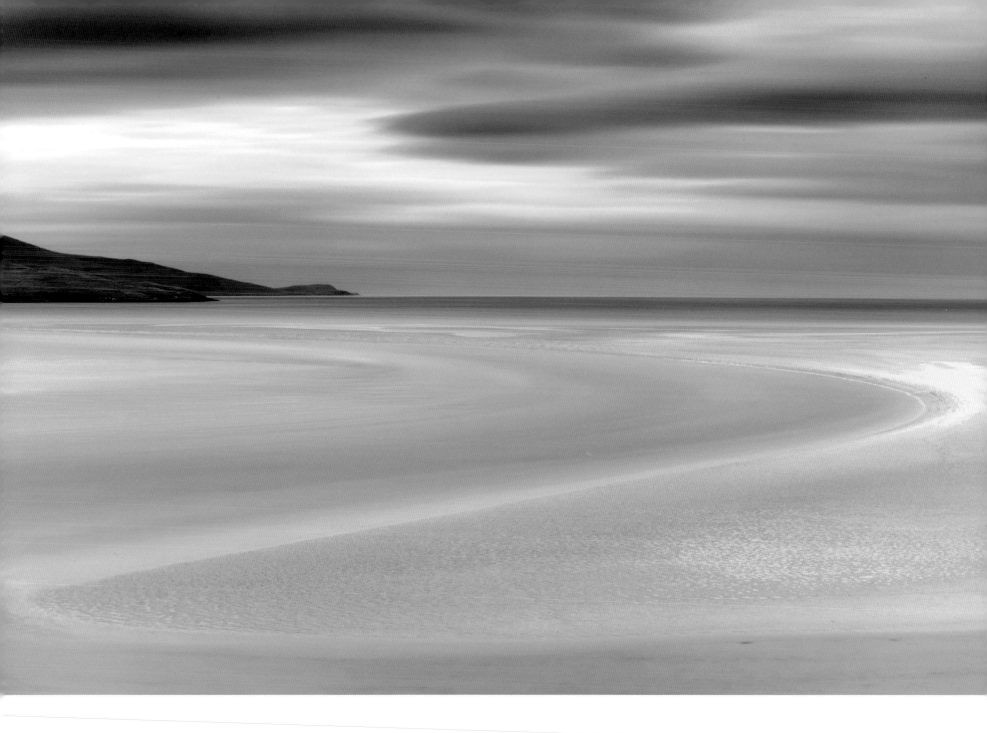

**ROBERT BIRKBY**                                    **2013**

Curves
*Luskentyre, Isle of Harris, Scotland*

The light was fading but I was determined to catch a shot of the sweeping sands whilst the tide was at optimal position. The first couple of frames showed promise, with the stunning pastel tones of the water and sand, but the sky looked slightly less impressive. I fitted a neutral density filter to dramatically increase the exposure time and smooth out the whole scene. There was just enough movement in the clouds and the resulting shapes in the sky seemed to complement the curves in the sand below.

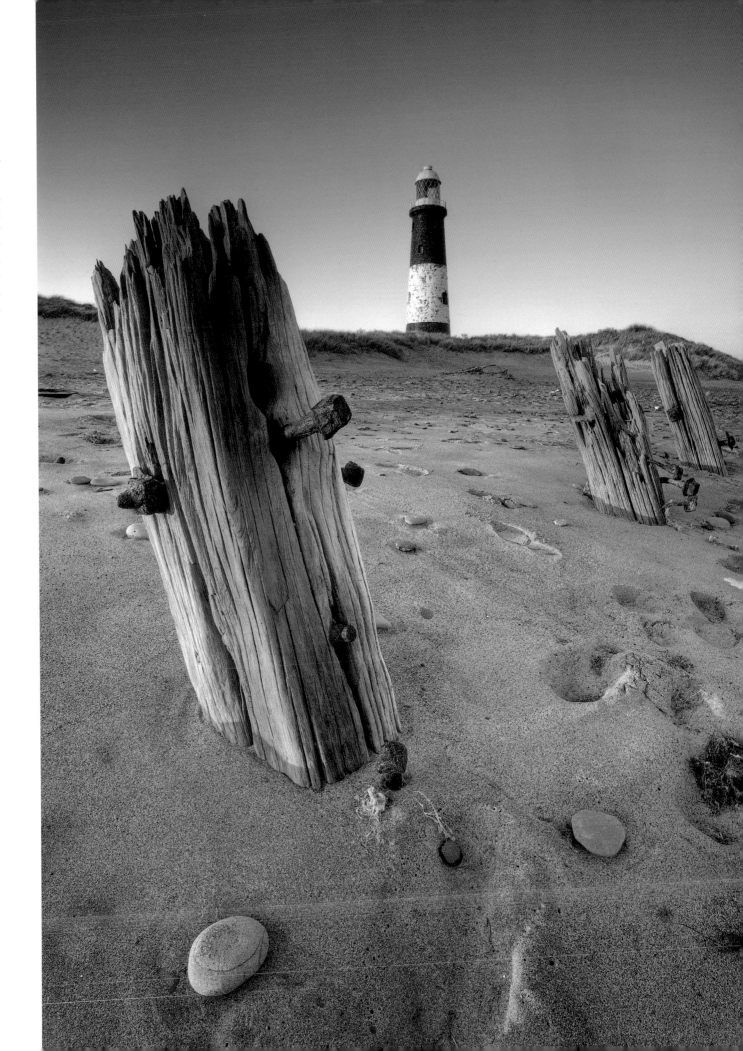

**MARK TIERNEY**                2008

### The Lighthouse at Spurn Point
*Yorkshire, England*

The lighthouse is situated on the north bank of the entrance to the River Humber, near the end of the narrow sand spit of Spurn at Spurn Point. Now just an empty shell, the lighthouse has not been used since it was closed down in October 1986. As the sun began to lower one February evening, I noticed the light striking the lighthouse and the weather-beaten groynes. My aim was to capture the groynes and colourful pebbles strewn across the beach, to add depth to the scene with the lighthouse as the focal point.

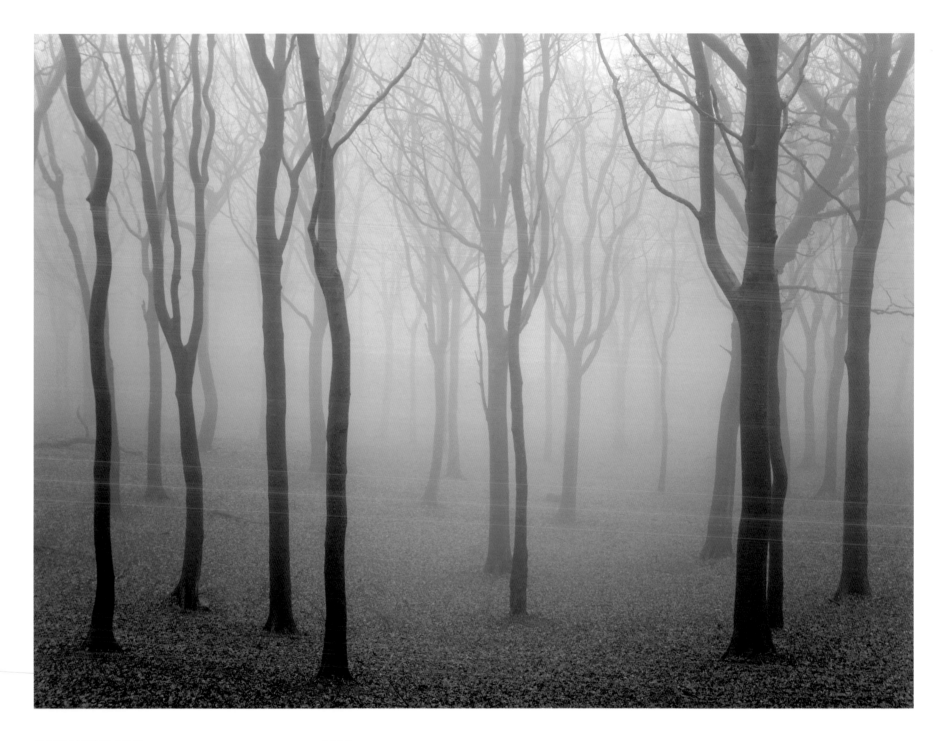

## GARY WAIDSON                                              2008

### Yule Morn
*Tandlewood, Lancashire, England*

I had spotted the potential of this location some time before but the conditions had never been right. Taking our dog, Skadi, out for a walk on the morning of Yule, I noticed a heavy fog had risen up overnight. I grabbed the camera and we headed, full of hope, straight for this spot. The dense mist drifting between the mature beech trees wreathed the wood with a sense of mystery and magic perfectly in keeping with the day.

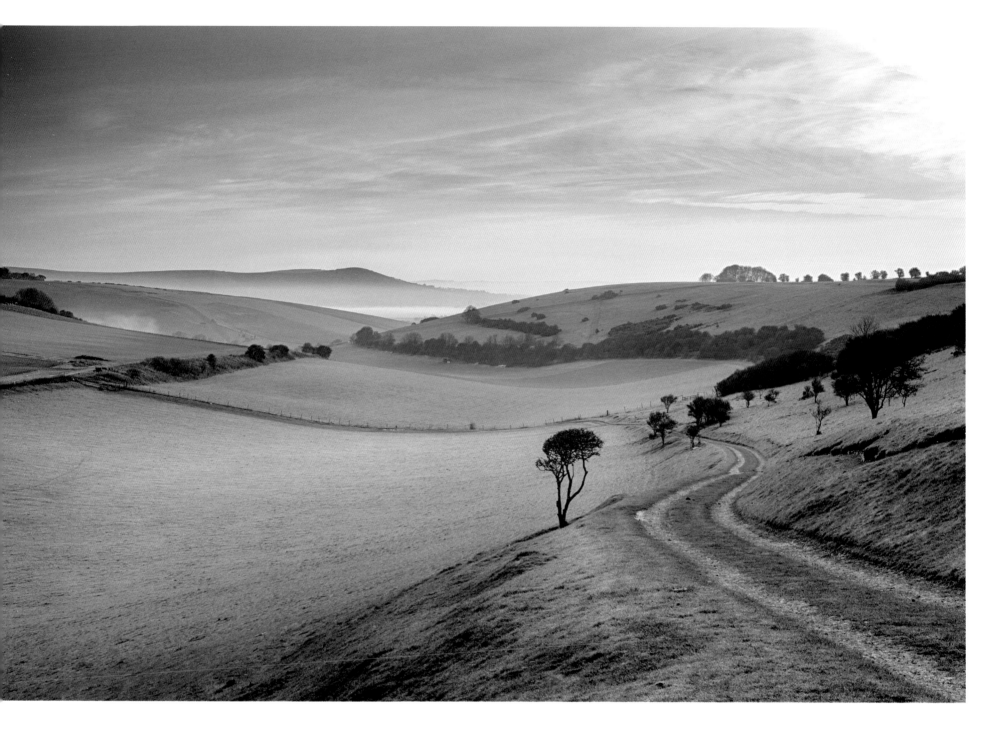

## PHILIP BEDFORD                                    2016

### Fields near Telscombe
*East Sussex, England*

This photograph was taken shortly before sunrise on an April morning. These fields sit just to the north of a small village outside Brighton and look towards the Ouse Valley, where a blanket of mist had risen in the dawn hour over the river. I wanted to use the tracks as a leading line through the fields to the hills in the background and I spent a while trying to get the positioning of the foreground tree just right.

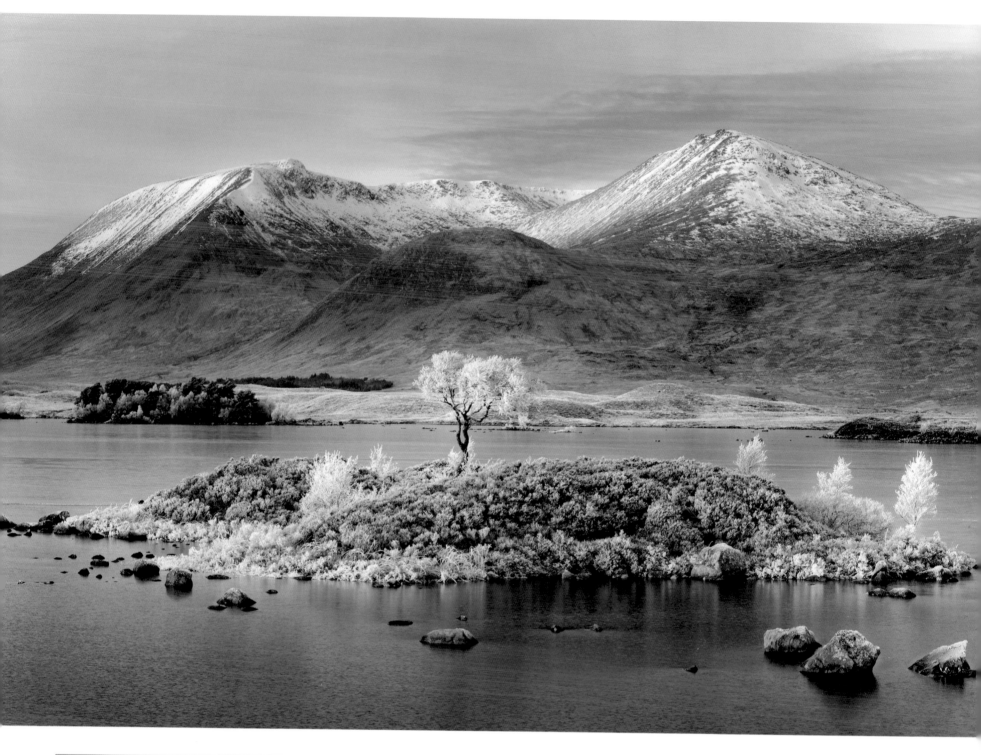

## DAVID BREEN ▲

### Ghost of Rannoch Moor
*Scotland*

The 'island tree' of Rannoch Moor stands as a ghostly reminder of what is no longer present on a perfect, freezing morning with clearing skies.

## STEWART MITCHELL ▶              **2009**

### Corgarff Castle
*Strathdon, Scotland*

This image was taken in late January and the low winter sun adds a touch of warmth to the cold and barren surroundings. The castle sits just off the A939 Cock Bridge to Tomintoul road, which is notorious as it is inevitably the first road in the UK to be blocked by snow every year!

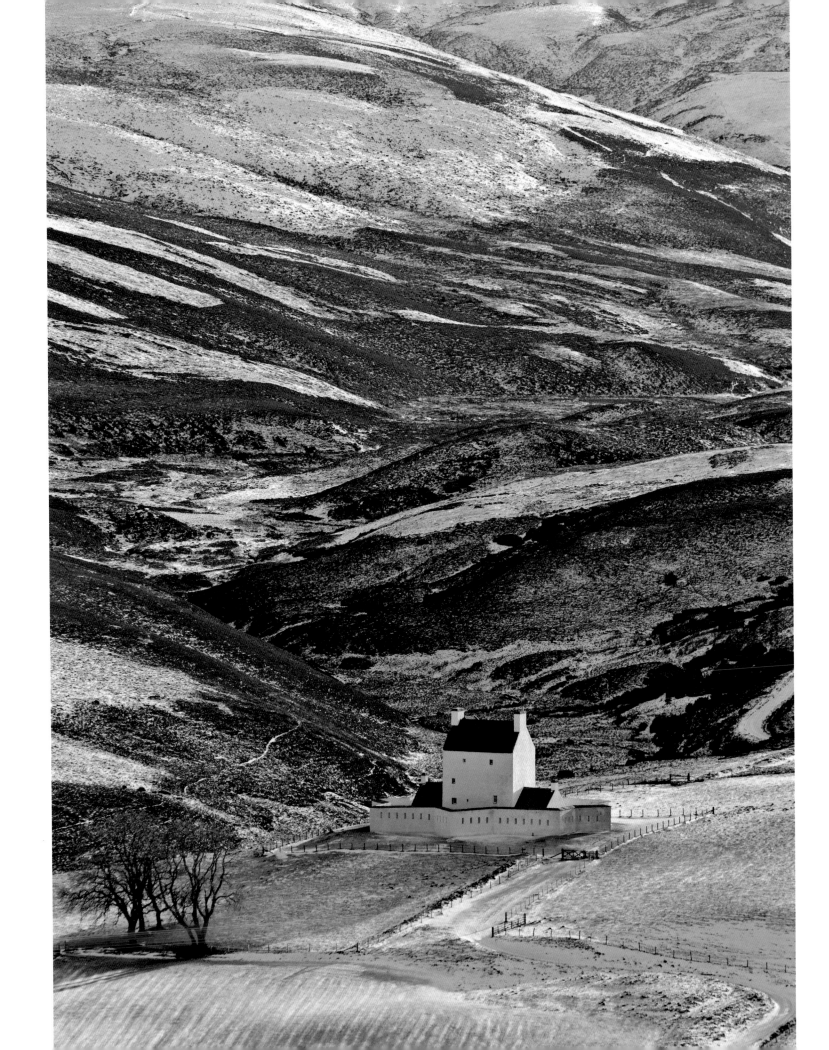

## ROBERT FRANCE                                              2015

### Freightliner Coal Train
*Ribblehead Viaduct, North Yorkshire, England*

A Freightliner 'Merry-Go-Round' (MGR) coal train approaches Ribblehead Viaduct heading for one of the Aire Valley power stations. I have been after a shot from this high viewpoint for a while. However, on my previous two attempts the sun went in when a train passed. On this day, the light dipped as the train approached, but not too much.

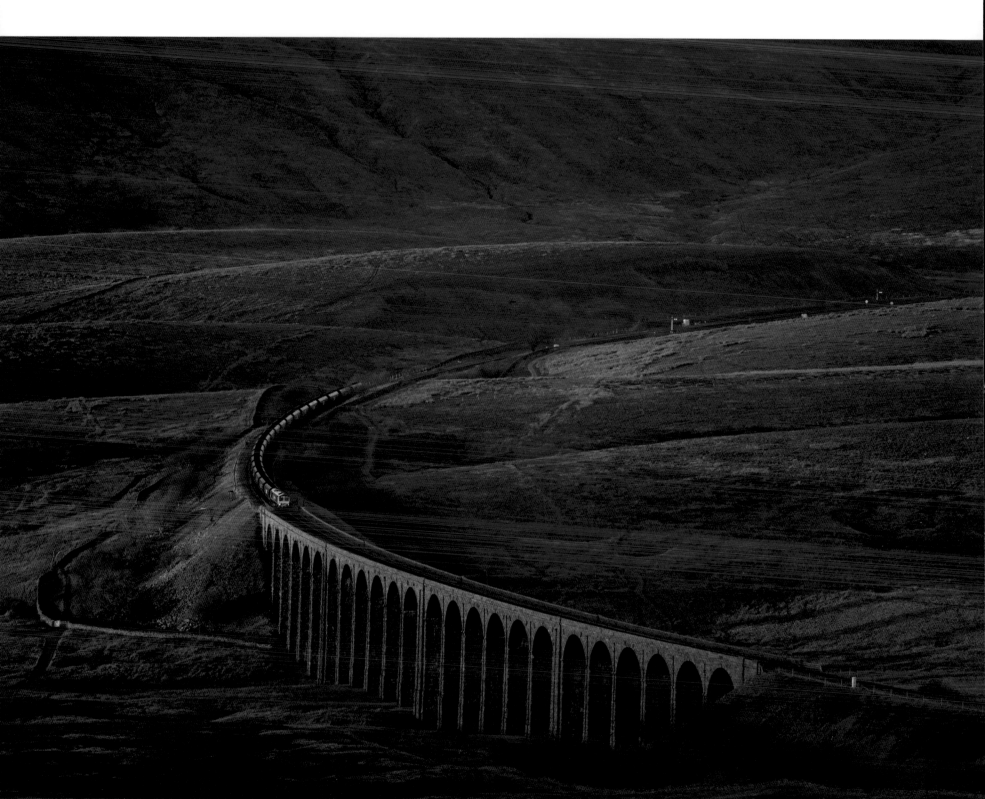

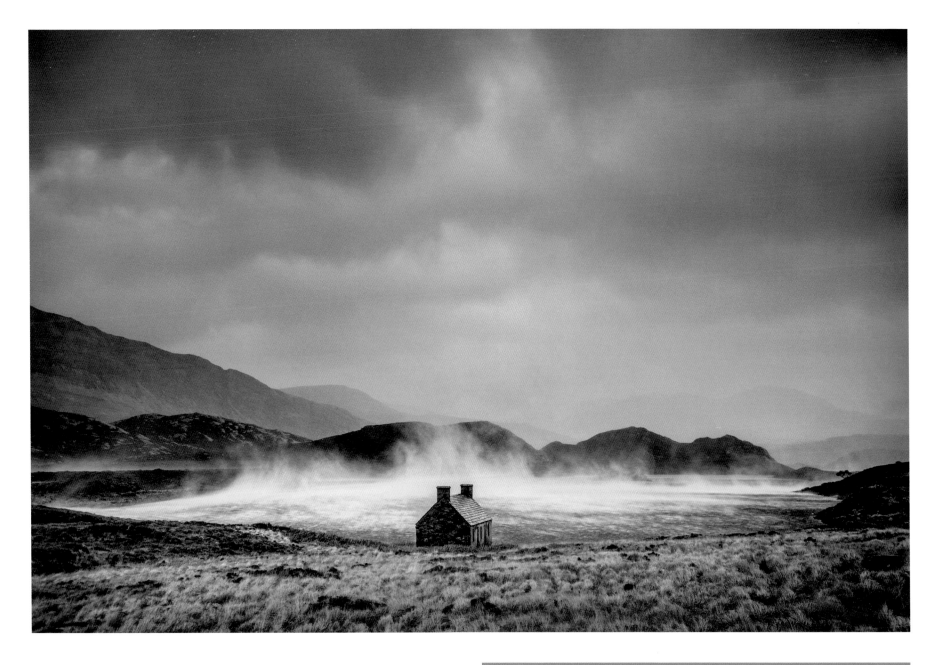

## DOUGIE CUNNINGHAM

### Shelter from the Storm
*Loch Stack, Sutherland, Scotland*

This was a once-in-a-lifetime scene. Driving through Sutherland during Storm Desmond, I was passing Loch Stack when the wind whipped up a huge waterspout and I pulled in to watch the wind toying with the waters of the loch. With the glen funnelling the storm towards the loch, it was too windy to stand outside, so I repositioned myself in the lay-by for a good composition and set up the tripod in the back of the van. With the shot framed through the side window, each time a big gust ripped the water from the surface of the loch I'd pop the door open for a couple of seconds in the relative lull that followed its passing ... Then I'd dry my kit and try again with the next gust! This was one of only a handful of frames not spoiled by rain on the filter.

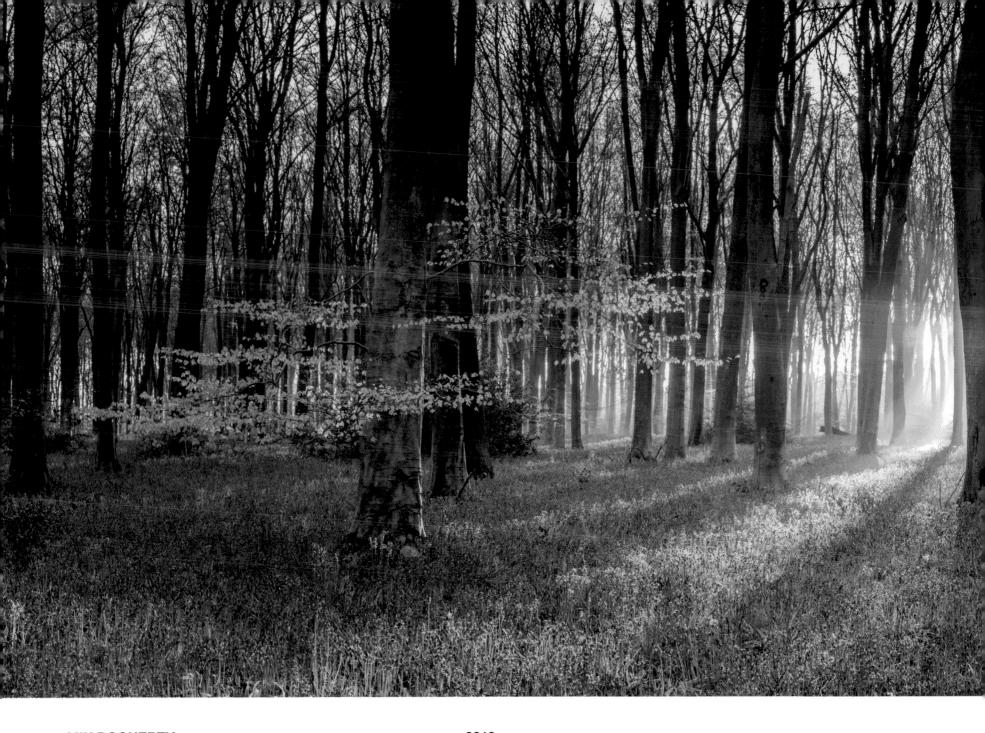

**MIK DOGHERTY**      **2016**

**Morning Bluebells**
*Micheldever, Hampshire, England*

An early morning in Micheldever Wood in Hampshire, about an hour's drive from my home and a well-known hotspot for bluebells every spring. This year was no exception and I thought I wouldn't be the only one there, but, strangely, I was. I headed into the wood and was greeted by this amazing carpet of blue capped off by the sun rising from behind the trees, which created these great long shadows across the forest floor. Brilliant.

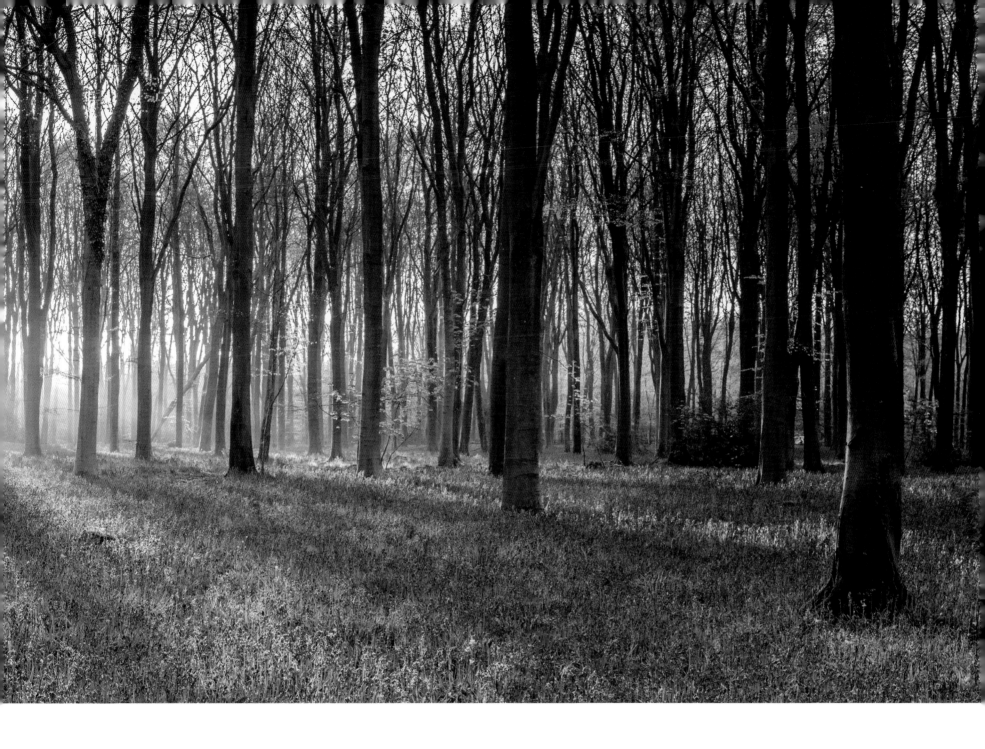

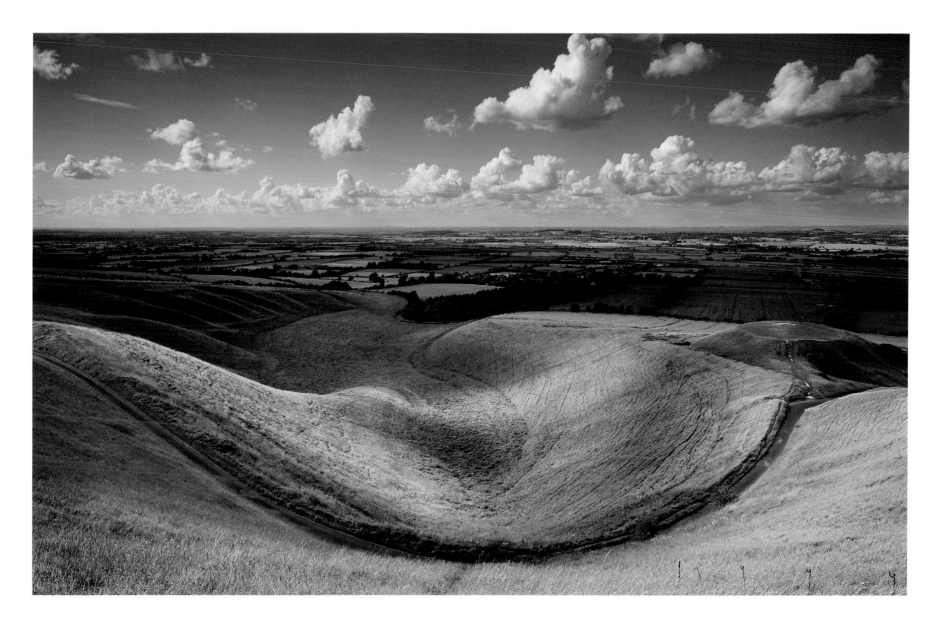

## DAVID J WHITE                                                    2008

### The Manger and Dragon Hill
*Uffington, Oxfordshire, England*

This is a site I know well as I live just down the road in Wantage. It's probably more famous as the site of the ancient chalk carving of the Uffington White Horse, but it is the Manger with Dragon Hill on the right-hand side (where legend says that St George slew the dragon) that has always attracted me. This picture was taken on a warm, clear August afternoon when the clouds were bubbling up, creating a wonderful sky, with the resultant shadow patterns crossing the landscape.

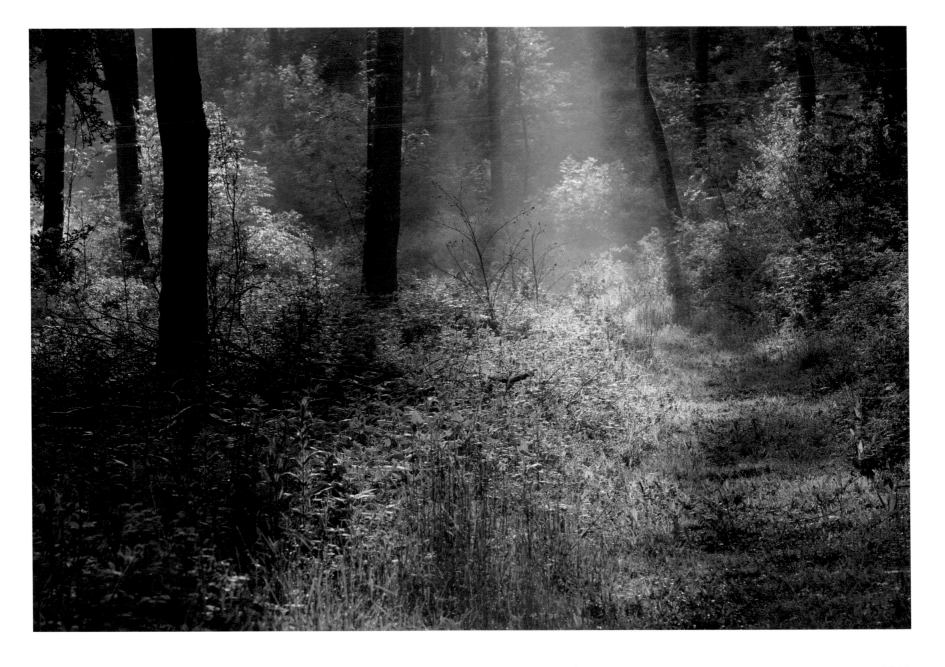

## RUSS BARNES

### Speak to Me
*North Cotswolds, Gloucestershire, England*

I spend a lot of time photographing trees, often returning to the same locations throughout the calendar. Although many landscape photographers might think autumn is their time to really concentrate on arboreal matters, I find them a constant source of inspiration for my imagination through the year. This particular photograph was taken early on a June morning and I think the lush summer greens really sing here. I use landscape photography as a form of escapism from the day-to-day world; to me there is nothing like reconnecting with the planet by really studying the environment. So when I'm lucky enough to get conditions which yield occasional light beams punching through a woodland canopy, they feel like individual messages, almost spiritual in their nature, hence the title of this composition, 'Speak to Me'.

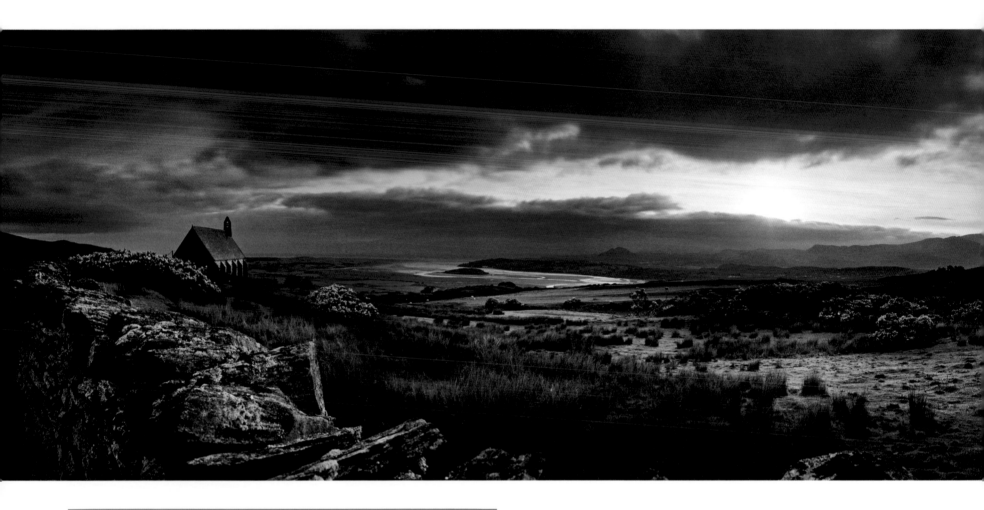

## JAMES CALLAGHAN

**Hillside Chapel near Talsarnau**
*Gwynedd, Wales*

I happened upon the location while on a car shoot, and knew that I had to return in the evening. After taking a few different angles, I 'homed in' on the final, then waited for a cloud to soften the light. It was a beautiful evening, evoking a sense of peace.

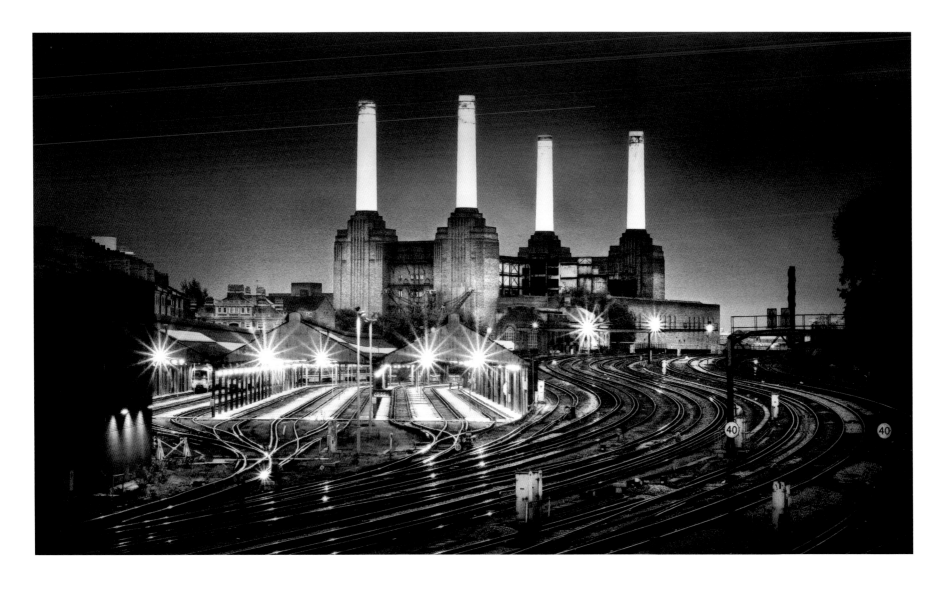

**NEIL WILLIAMS**                                                                           **2008**

### Battersea Power Station from Victoria
*London, England*

I've photographed Battersea Power Station hundreds of times, but this unusual view from Victoria Station is my favourite. It was a hot, stormy August evening and just starting to rain with a low sun just catching the chimneys. The clock in the picture reads 20.55.

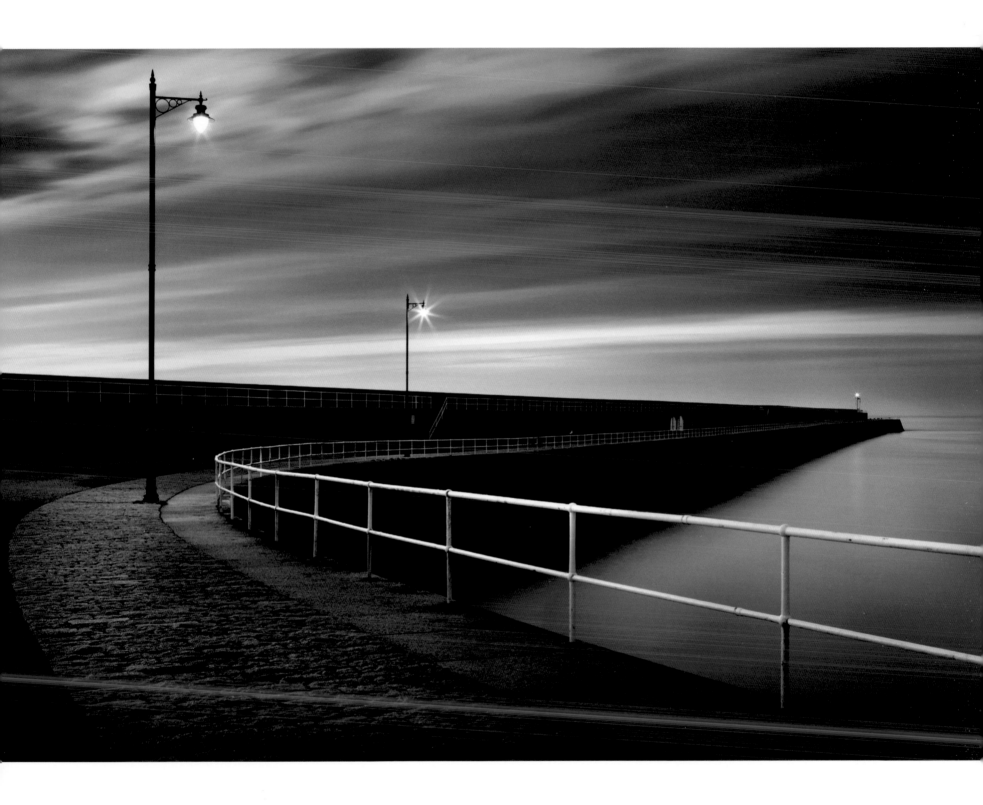

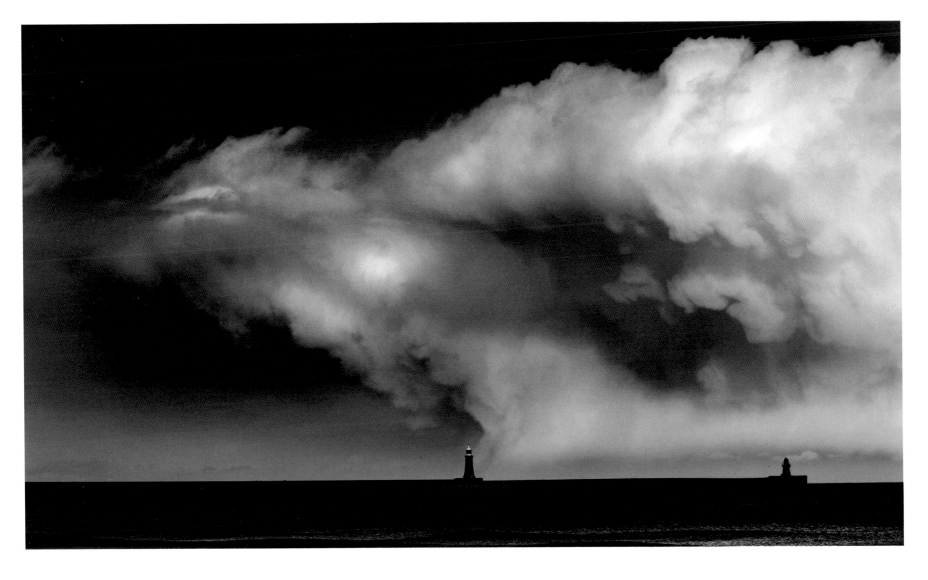

## ANDY LE GRESLEY ◀        2013

### Early Morning at St Catherine's Breakwater
*Jersey, Channel Islands*

St Catherine's Breakwater is on the east coast of Jersey, 10 minutes from where I live. After visiting it a few times with lots of walkers about, I decided that the best time to shoot it would be early morning when it would be quiet and the contrasts would be more profound. I positioned myself in the right place to show off the long pier and its dramatic perspective. I decided on a long exposure so that the viewer would not be distracted by the different textures in the clouds and the ripples in the water.

## FAN FU ▲        2008

### Storm Brewing
*Tynemouth, England*

After travelling up to Tynemouth, with the hope of fine weather to photograph the lighthouse, I approached to see this amazing cloud formation. In a light rain and a very strong wind that saw me leaning against a lamp post to try to maintain my balance, I was very fortunate to be able to capture the drama of the clouds over the sea before they quickly dissipated. Truly, one of those rare moments of being in the right place at the right time.

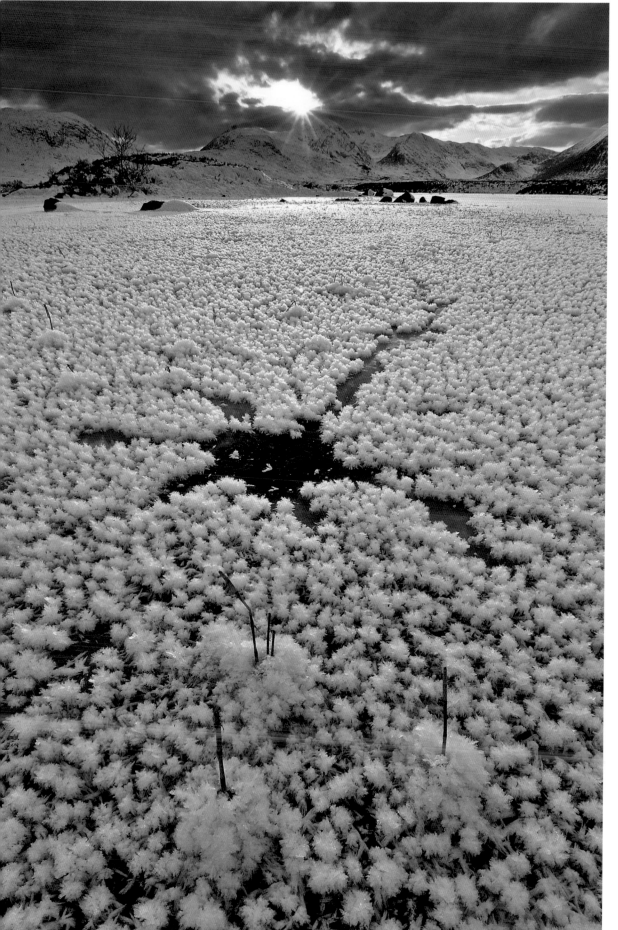

## BRIAN CLARK

### Ice Flowers
*Rannoch Moor, Scotland*

Several days of freezing weather produced this field of ice flowers on Rannoch Moor. The cloud cover enabled me to shoot into the light, which revealed much of the detail on the ice crystals. The star-shaped ice pattern in the middle ground leads the eye towards the mountains in the distance. By the following morning, the frozen loch was covered by 18 inches of snow.

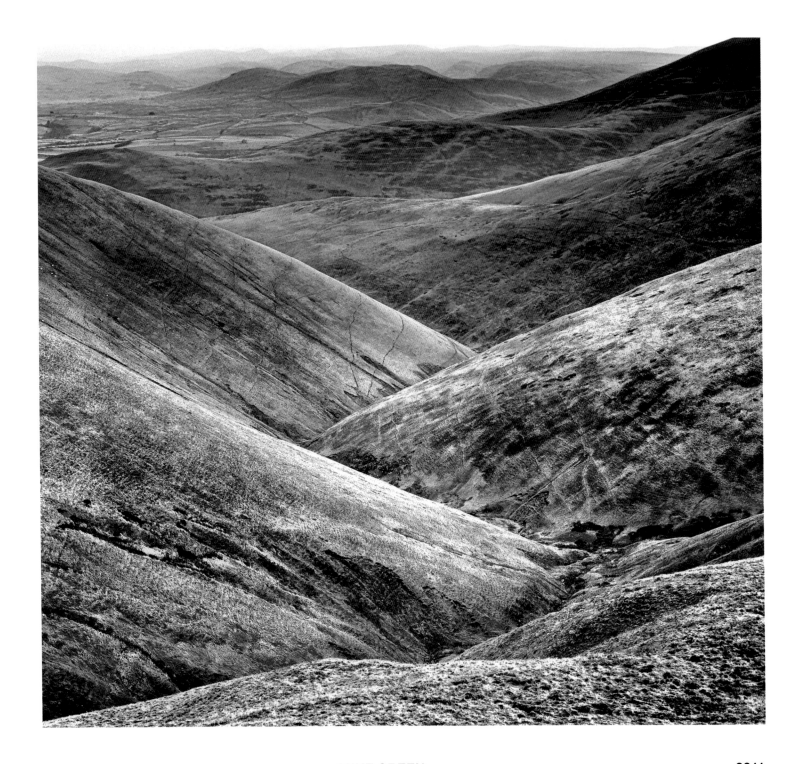

**MIKE GREEN**                                                            **2011**

### Looking West from the Howgill Fells at Dawn
*Cumbria, England*

My aim was to capture the two most distinctive features of this ancient, rounded group of hills: the velvet, wall-free surface of the fells, with their muted, variegated colours, and the criss-crossing geometry of the interlocking spurs which characterise several valleys within this landscape. I was fortunate to find a firm frost on the grass when I arrived at my pre-planned location, somewhat before dawn; this emphasised the texture and gave some luminosity to the hillside.

## PAUL KEENE ▼ <span>2012</span>

### Frosty Sunflowers
*The Chilterns, Buckinghamshire, England*

This picture was taken in the Chilterns, near to where I live. The owners of the field had turned it into a nature reserve, planting sunflowers in summer and leaving them to seed over the winter. This was clearly a great success because the area was awash with migrant finches when I took this picture. The sunflower heads also made an interesting foreground, as we had a marvellous hoar frost.

## ANGUS CLYNE ▶ <span>2012</span>

### Beech Trees
*Kinclaven, Perthshire, Scotland*

This beech tree is not far from home in a spot I visit frequently: great for bluebells in spring and also good for autumn colours. I went there to get this picture, having waited weeks for the right combination of fresh falling snow, bright morning sunlight and mist that would even out the light in the forest. The biggest problem I had was getting my tripod steady without disturbing the thick carpet of beech leaves.

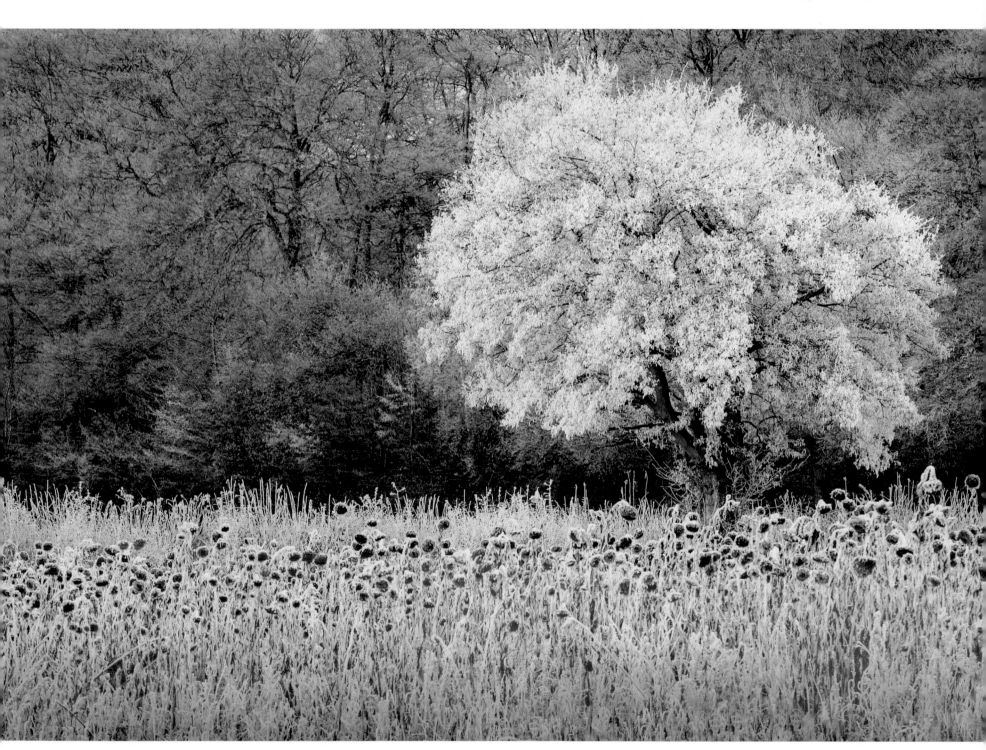

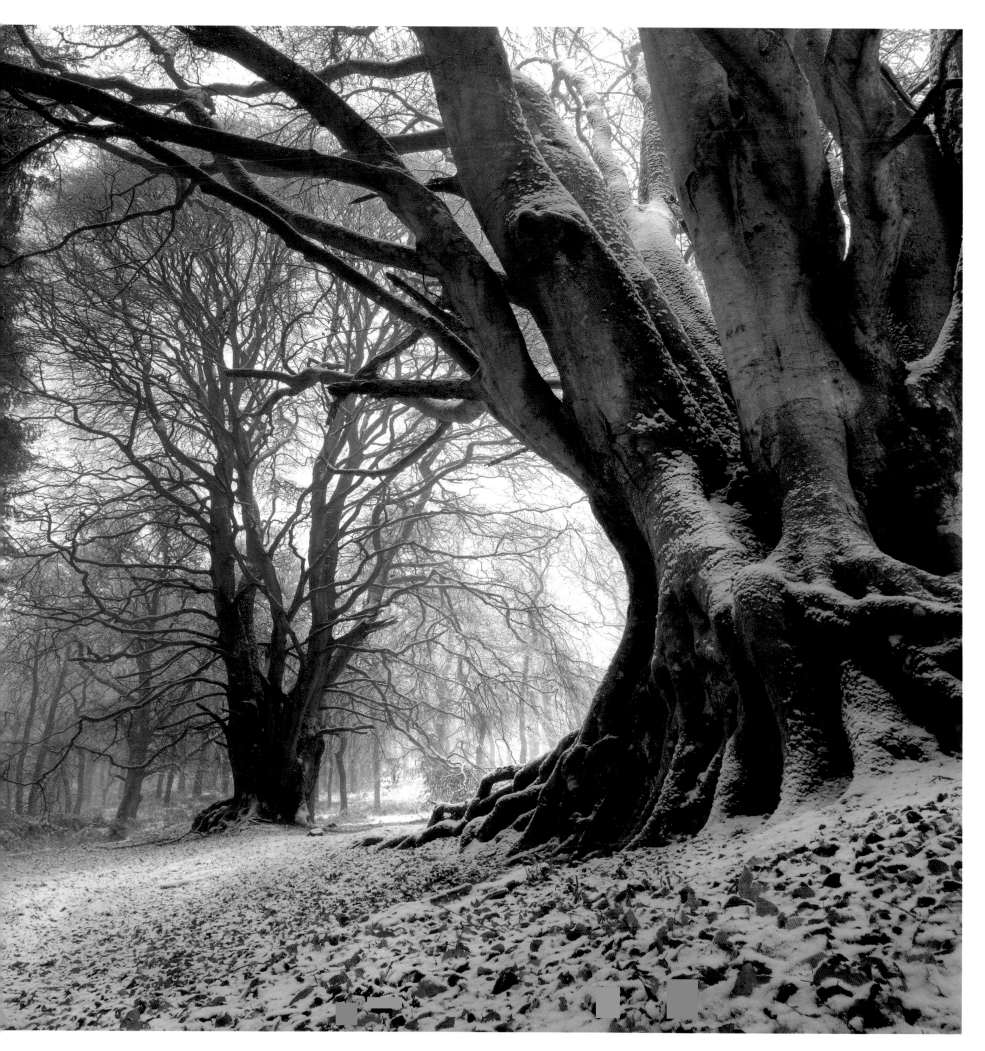

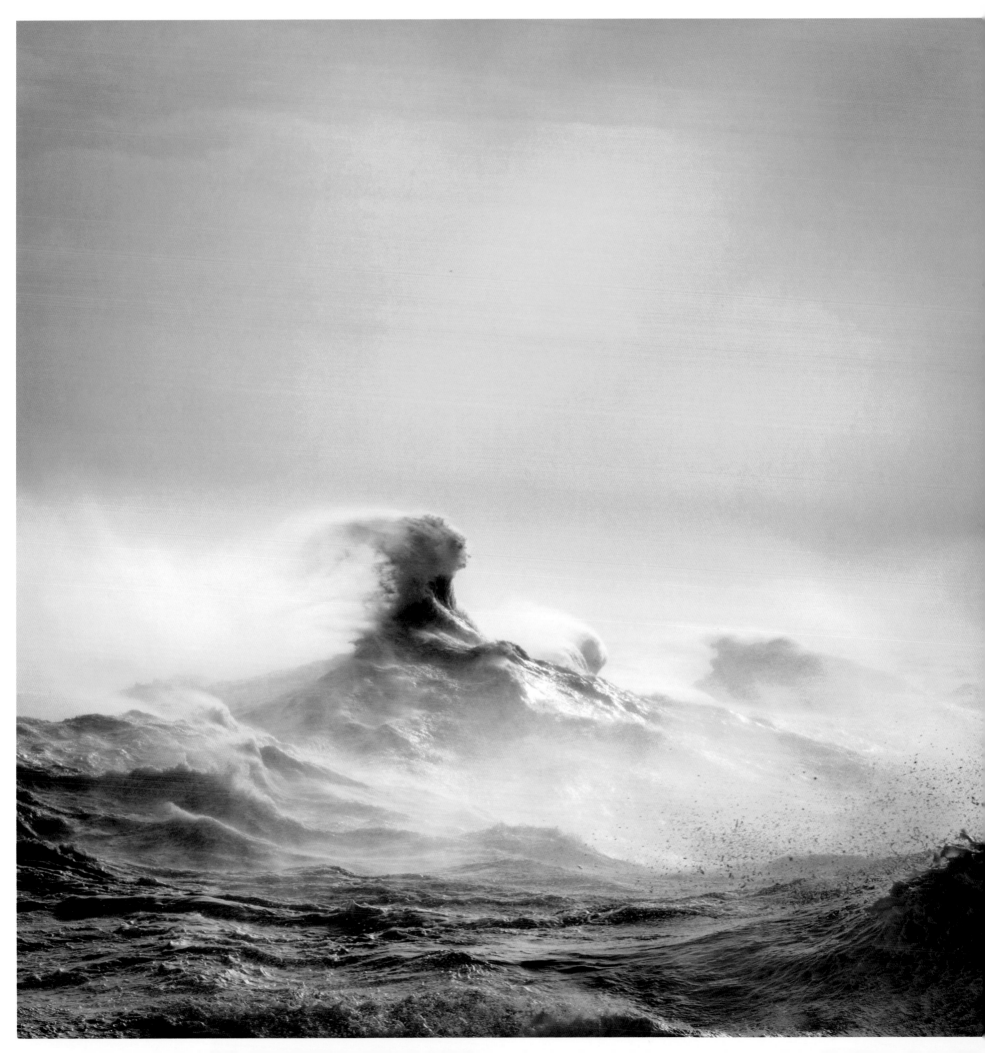

## RACHAEL TALIBART ◄ 2016

### Poseidon Rising
*Newhaven, East Sussex, England*

During weekly shoots at the coast over winter 2015–16, I had the idea to create a series of pictures of waveforms called *Sirens*. I wanted to capture natural shapes in the waves that looked like creatures and name them after sea gods or monsters from myth and legend. Newhaven was a great location because the prevailing wind makes waves rebound from the quay and crash back into incoming waves, creating interesting shapes. This picture was captured during Storm Imogen, which brought especially good surf and that extra essential: interesting light.

## TIM HARVEY ▼

### Rocquaine Bay During a Winter Storm
*Guernsey, Channel Islands*

The power of a large winter storm crashing into the west coast of Guernsey on a high spring tide is a truly inspiring force of nature. I waited many months for suitable conditions as this combination of events occurs only infrequently, and even then often only during the hours of darkness. The main technical challenges with taking this photograph were the gale-force winds and large amounts of salt water, seaweed and stones being hurled inland by the storm. I overcame these difficulties by using a waterproof cover for my camera, a heavy tripod and a telephoto lens. However, I still got thoroughly soaked!

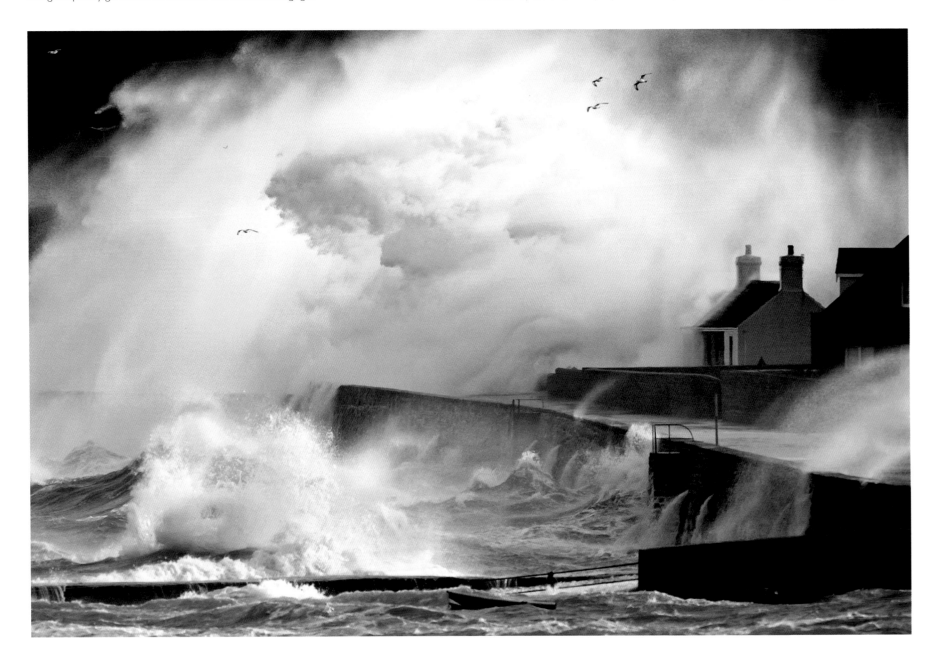

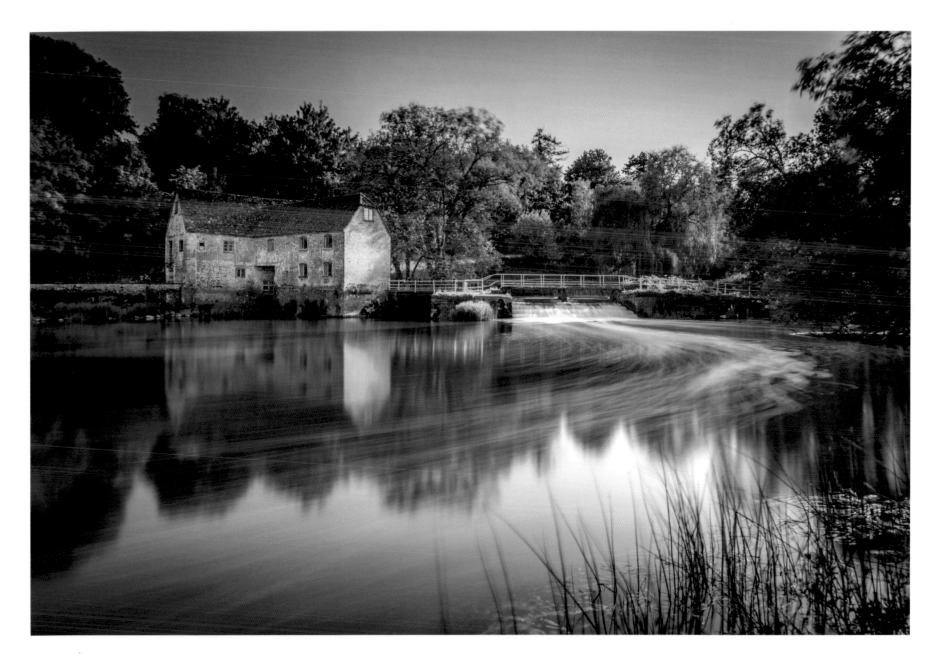

**MARK SIMPSON** ▲ 2013

**SIMON BAXTER** ▶ 2016

### Sturminster Newton Mill
*River Stour, Dorset, England*

I took my sister out on her birthday for a day of photography in Dorset and Wiltshire and Sturminster Newton Watermill was one of the locations. I'd had this image in mind for a while, with the late afternoon sun highlighting the mill and the long exposure smoothing the fast-flowing water of the River Stour, creating some nice lines and reflections.

### Guardians of the Forest
*Llanrhychwyn, Snowdonia, Wales*

When wandering through unfamiliar woodland, I'm always on the lookout for trees that look out of place: perhaps old and wise-looking trees that were probably there well before those that now surround them. I found this imposing pair one afternoon in Snowdonia and decided to return early the following day in the hope of capturing some morning mist, light and the atmospheric experience that I always crave. It was a splendid scene to witness as the light caught the fading mist and lit the gap between the almost symmetrical trees that form a gateway into an environment where I feel most content and at ease.

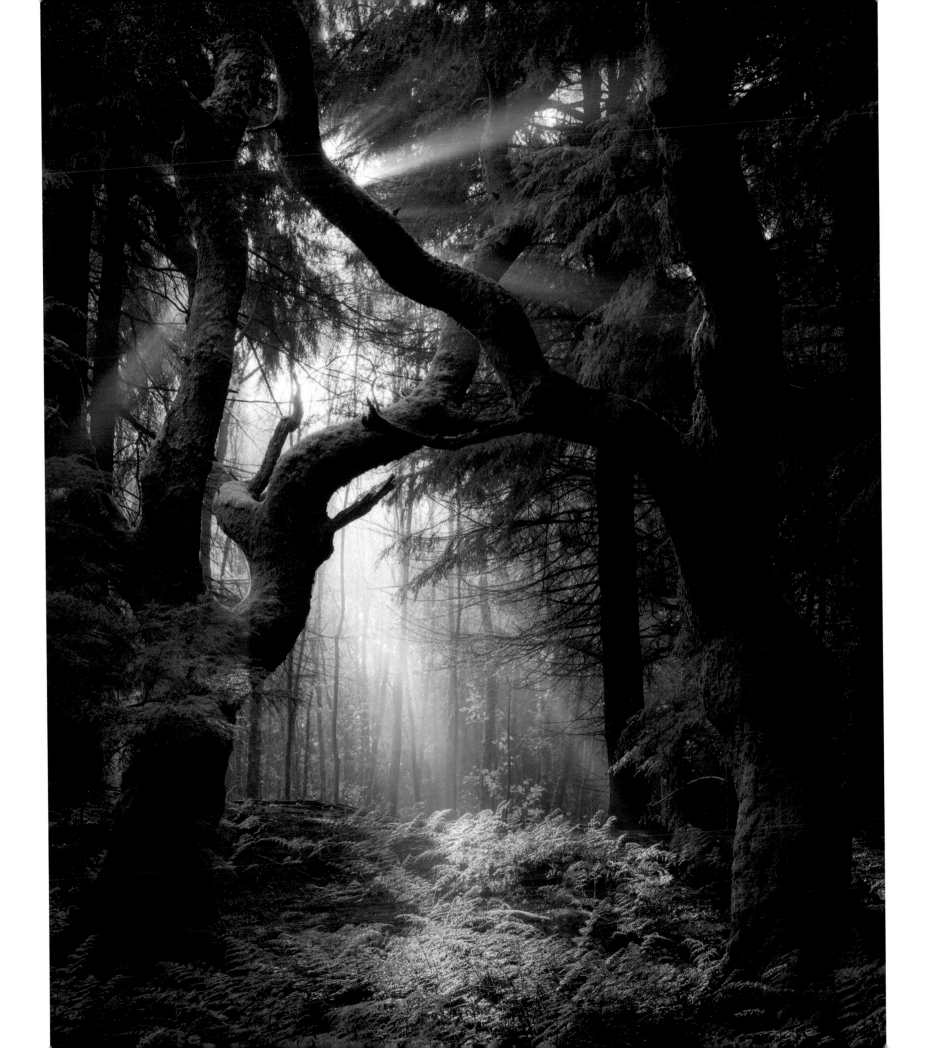

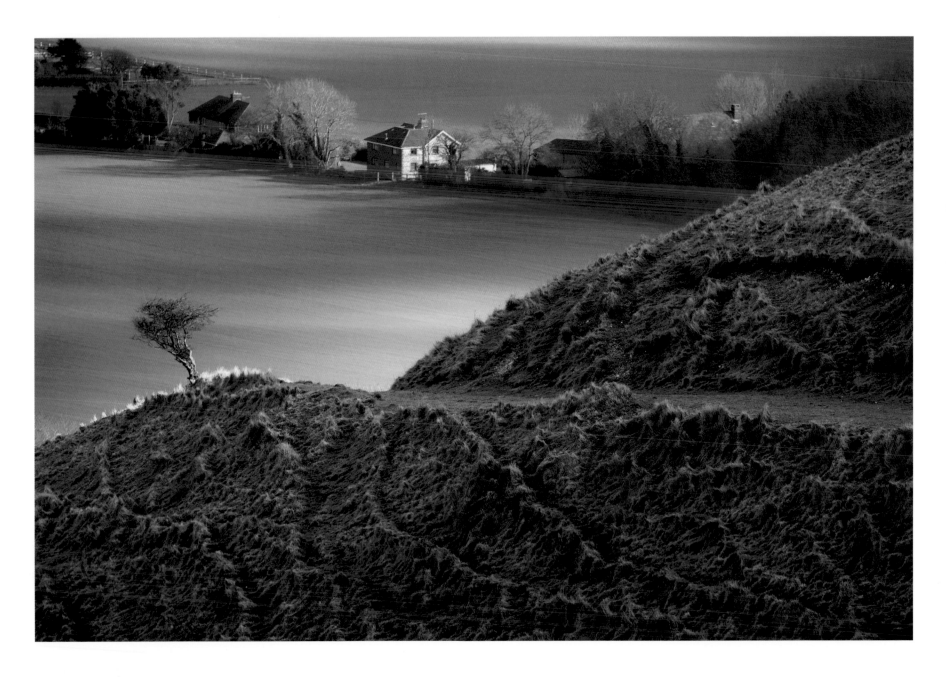

## SŁAWEK STASZCZUK                                   2010

### South Downs near Kingston
*East Sussex, England*

It was an extremely windy, winter's day on the South Downs, which posed a challenge when taking photographs, especially with a long lens. The wind was chasing clouds across the sky incessantly and the consequent play of light and shadow on the ground allowed me to take some decent pictures even around noon, of which this is a good example. Later, when the sun was much lower and the wind had eased, I took more successful pictures in the area. It proved to be an exceptionally fruitful day.

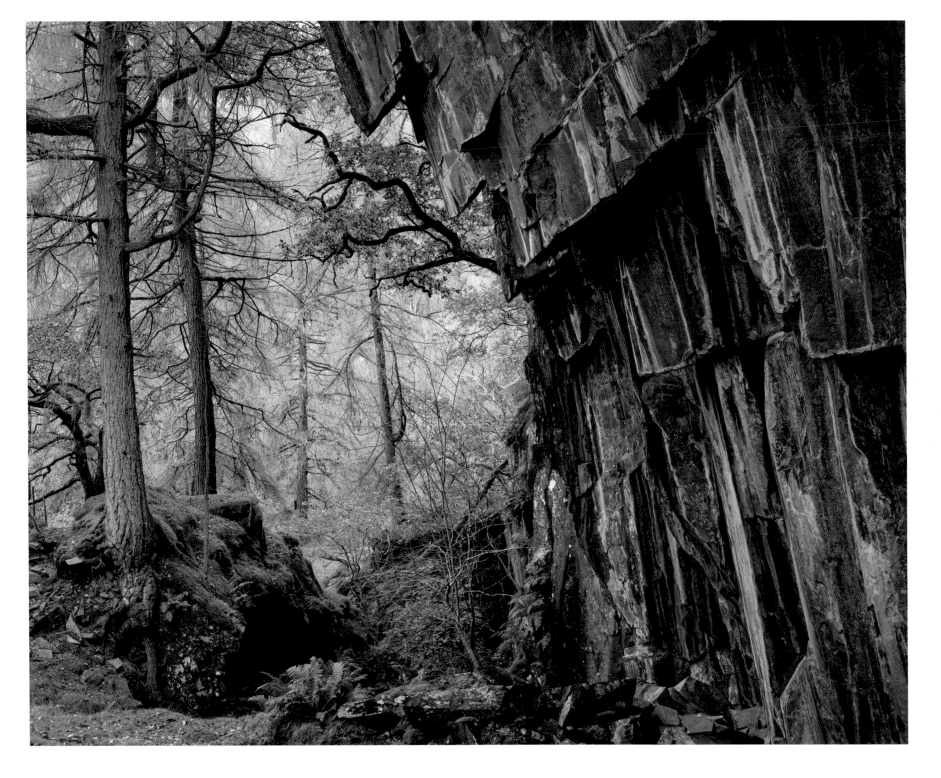

**JOSEPH WRIGHT**                                                              **2015**

### Abandoned Quarry in Low Hows Wood
*Borrowdale Valley, Cumbria, England*

An image from a series of work that explores places in the countryside where, even when close to humankind, you can experience a sense of wildness and at times still enjoy solitude if you so choose. Here, on a typical damp, misty Lakeland day, capturing the nature of the place; the omnipresent tension between man and nature, with non-native species trees wilding the long-abandoned quarry, creates a new, modern nature.

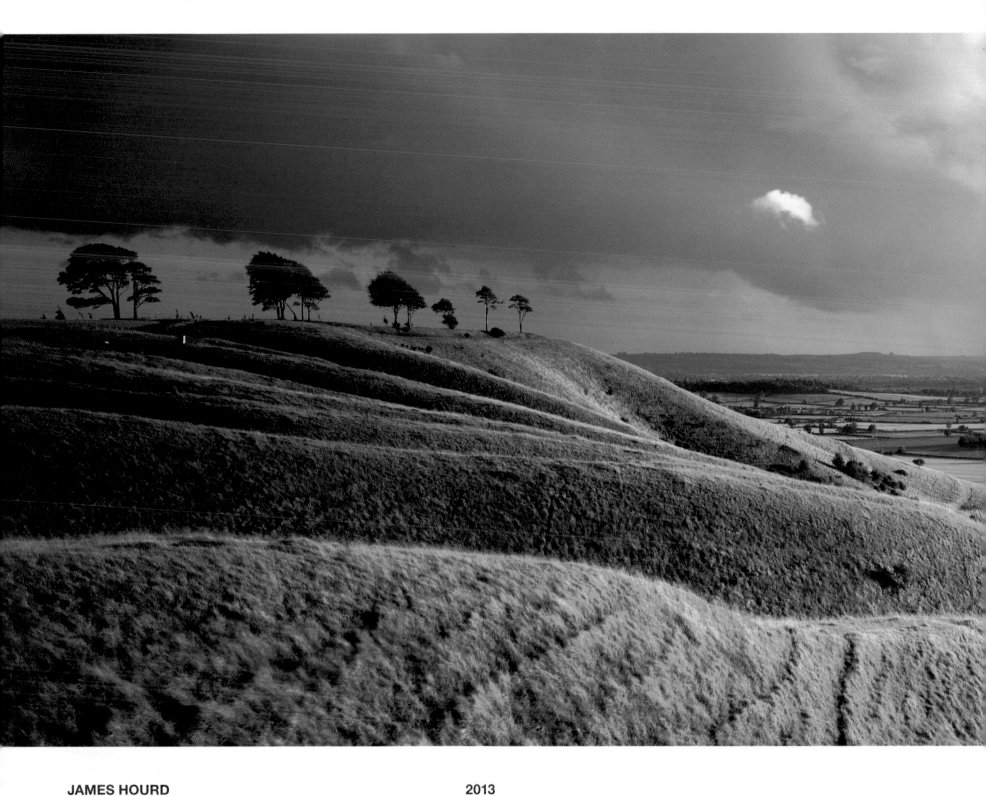

**JAMES HOURD**          **2013**

### Roundway Hill
*Wiltshire, England*

I had visited this location a number of times previously but, on this occasion, dark storm clouds hung overhead with heavy showers in the distance. The edge of the weather front was clearly visible on the horizon and a strong wind made the lighting unpredictable. As the sun slowly dipped, a break in the clouds illuminated the hillside, which shone golden from long grass waving in the breeze. This was an impressive contrast to the dark, ominous sky above. I only had a few exhilarating minutes to record the scene before the sun finally dropped behind a ridge.

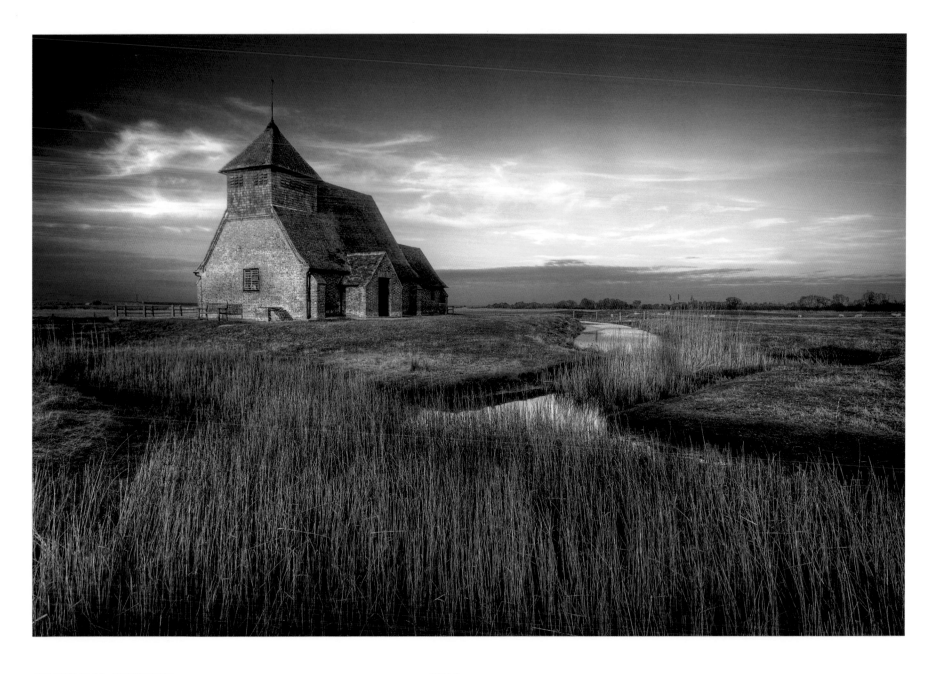

## MARSHALL PINSENT                                              2010

### Fairytale at Fairfield
*Romney Marsh, Kent, England*

This picture is of the church of St Thomas a Becket at Fairfield on Romney Marsh, taken in late February. We'd been out all day, photographing in the area, and had left Fairfield until last, so we almost missed it. I usually like to take my time planning and considering the shot, but here we had to race across the marshes in the dying moments of a beautiful sunset. I had only a few minutes to decide on the best position and to set up before we lost the light. I have tried to capture the strong sense of history and magic about this place.

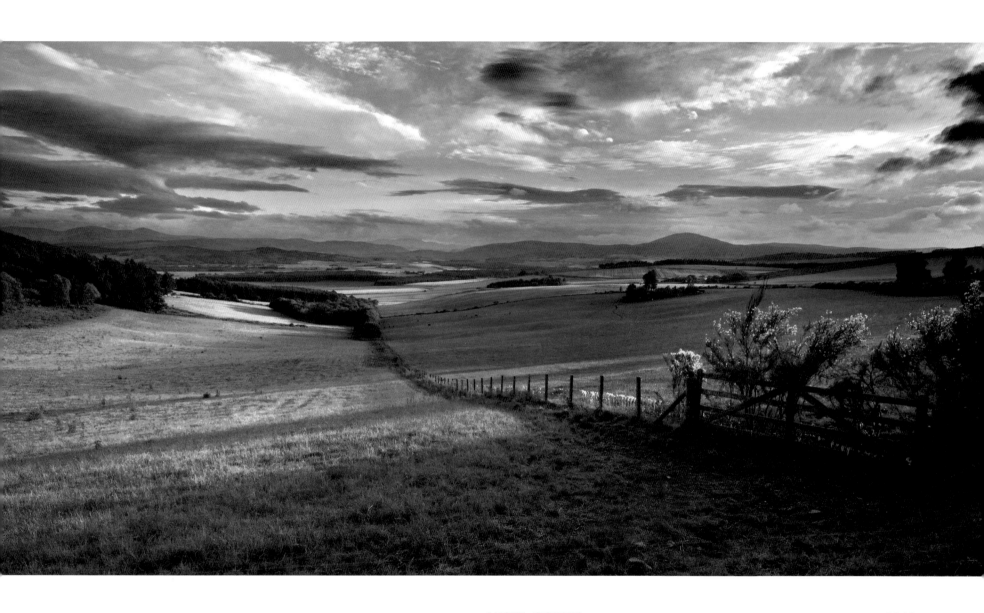

**NIGEL CORBY**                                                                2011

### Evening at the Queen's View
*Near Tarland, Aberdeenshire, Scotland*

This was a favourite place of Queen Victoria when she stayed at nearby Balmoral Castle. It has since been known as the 'Queen's View'. The photograph was taken on a particularly splendid evening in July. At this time of the year, the sun sets in the northwest and provides sidelight. In the distance, beyond the valley of the River Dee, are the Munro hills of Mount Keen and Lochnagar. To the right is Morven, the hill which dominates the agricultural landscape of Mid Deeside.

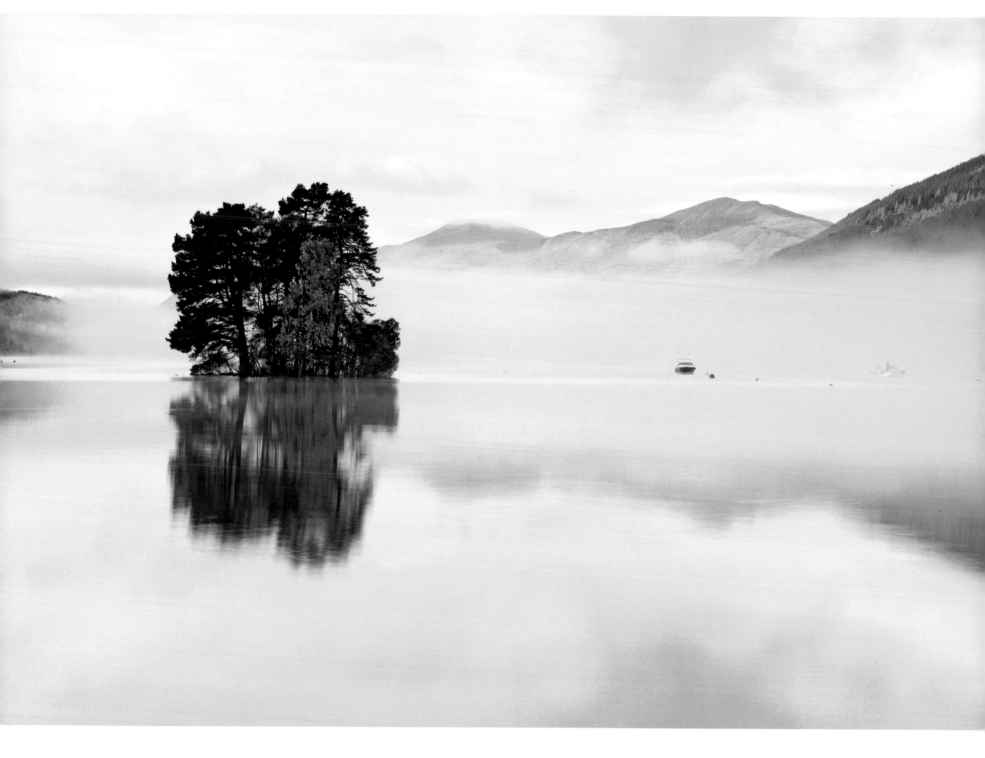

## PAUL SUTTON ▲      2011

### Tay Trees and Mountain Tops
*Scotland*

The mist kept coming and going all morning. Only as the temperature rose did it begin to retreat, allowing the distant mountain tops to become visible. I used a graduated neutral density filter to slow the overall exposure, allowing me to smooth out any ripples on the water's surface; not that there were many to begin with.

## DAVID CLAPP ▶      2011

### Rodel Saltmarsh on the Isle of Harris
*Outer Hebrides, Scotland*

This wonderful rounded mountain, Ceapabhal, was the subject of many images on a winter trip to the Outer Hebrides. Standing on some salt flats, it struck me how well kept this scene was. The grass looked mowed, fringes clipped and there were no weeds whatsoever. Add in the perfectly landscaped curves and I was half convinced that this was the work of a landscape architect.

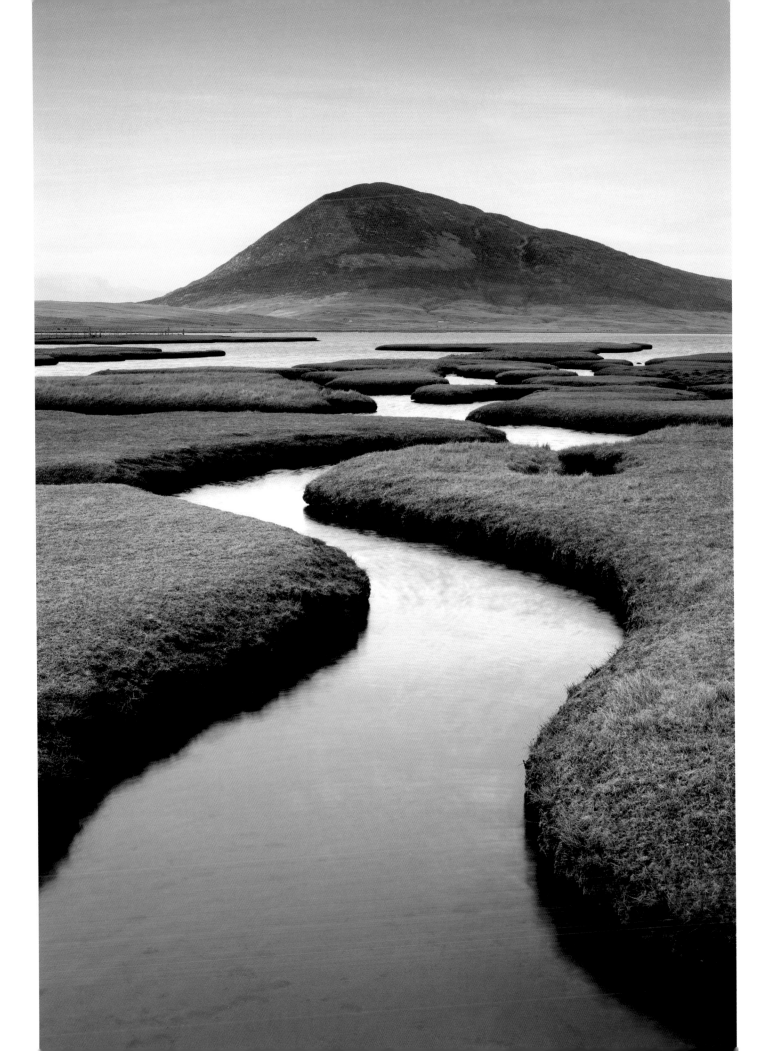

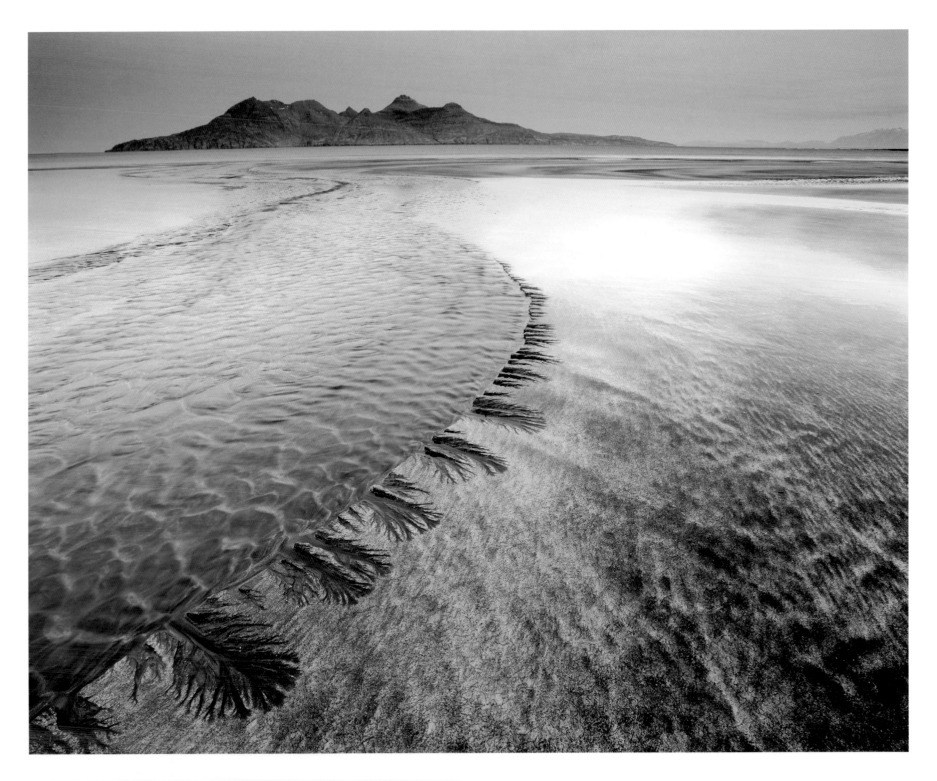

**WINNER**

**WINNER**                                                    **2010**

## DUDLEY WILLIAMS

### Sand Patterns
*Isle of Eigg, Scotland*

A freshwater run-off across the beach created these interesting patterns in the sand. The soft tones are
provided by the late-winter dawn.

### Castle Cornet
*St Peter Port, Guernsey*

A long exposure captured the cool, blue tones of dusk and the lights illuminating the castle half an hour after sunset. I used the lines of the steps in order to lead the eye out towards the lighthouse on the end of the breakwater.

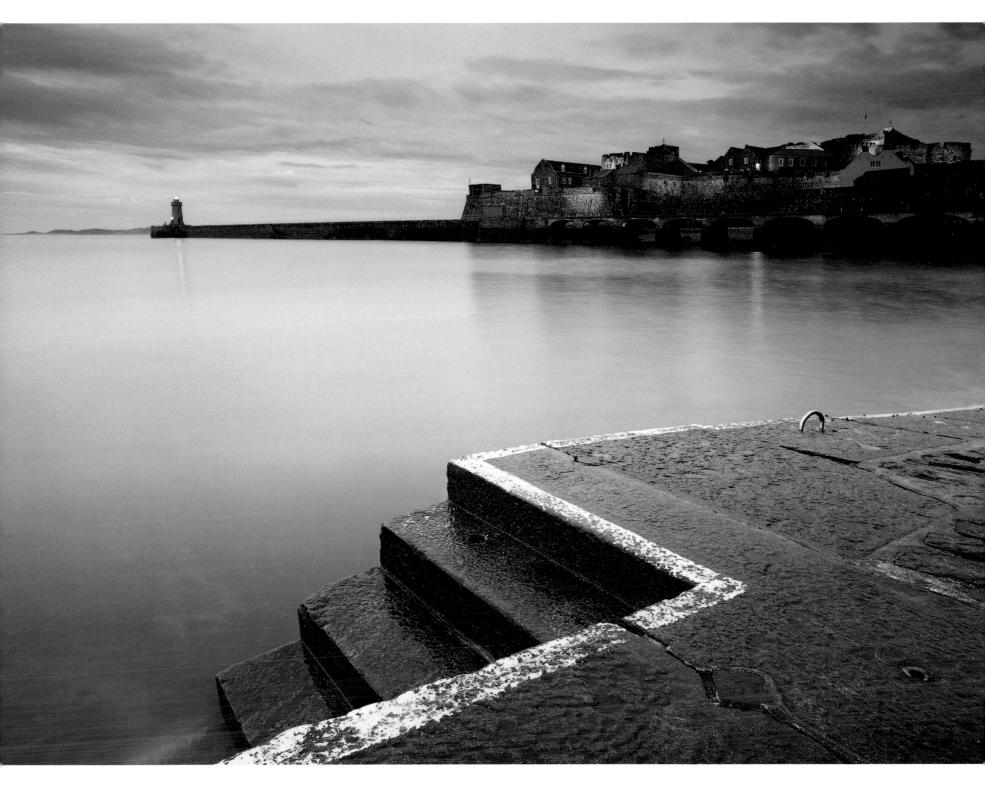

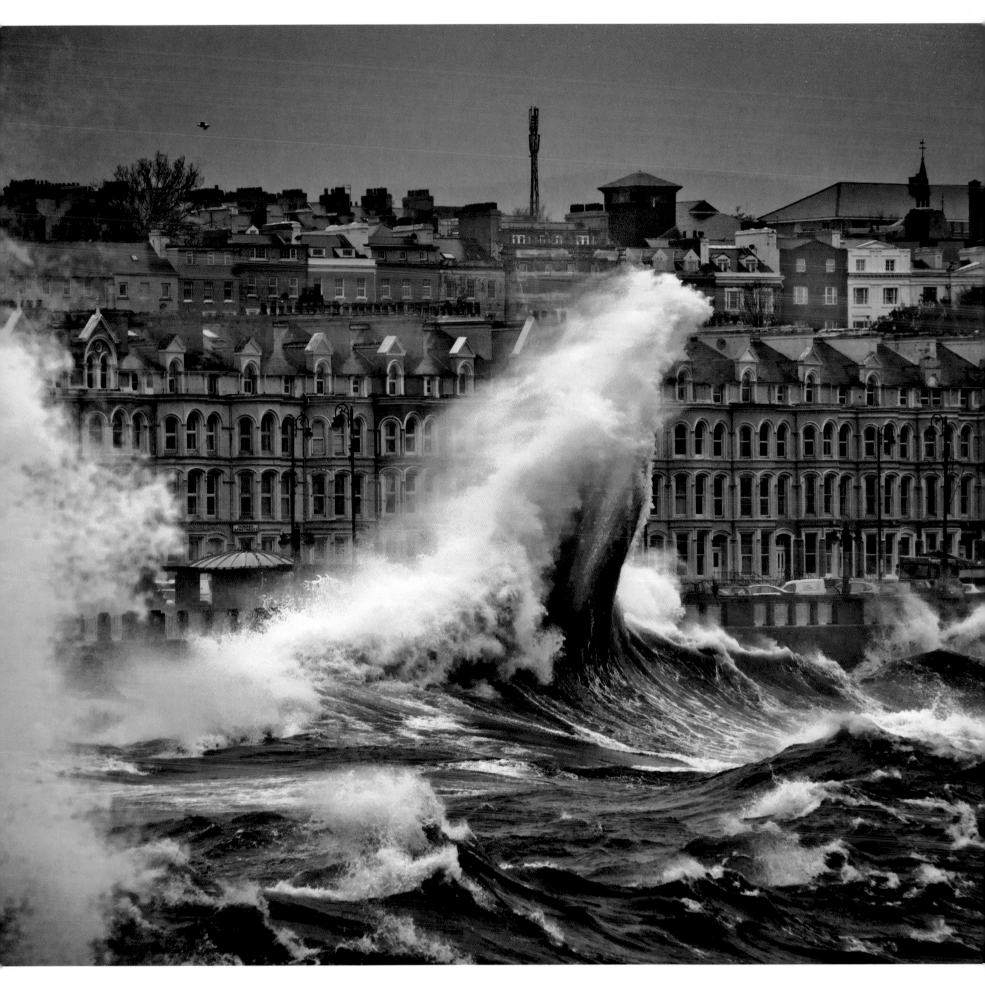

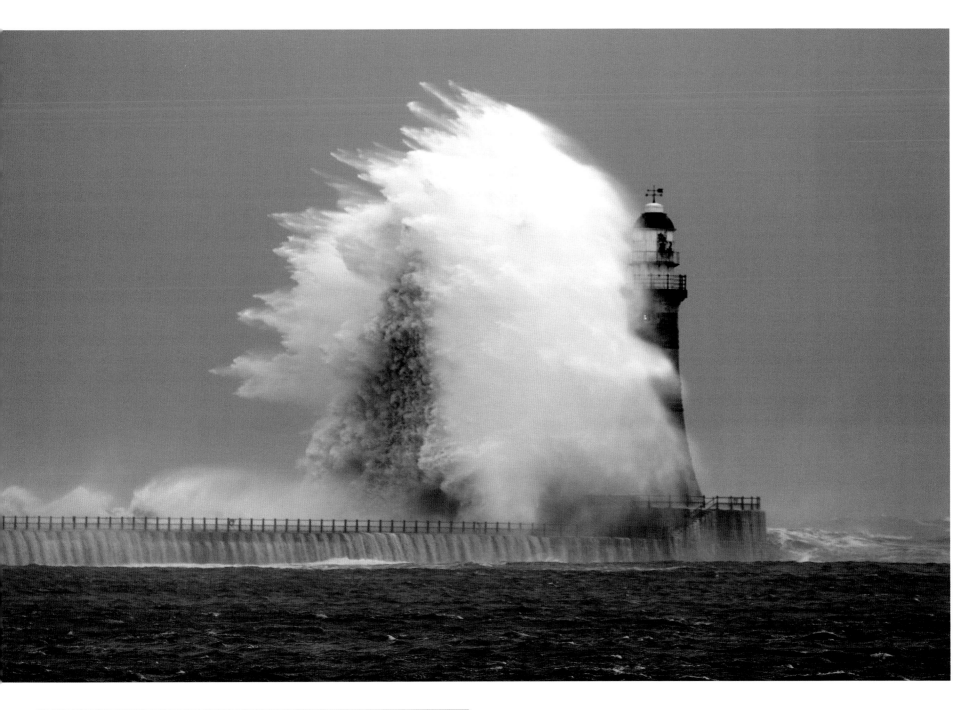

**SIMON PARK** ◀

### The Wave
*Douglas, Isle of Man*

This is Douglas Promenade and the energy and movement of the sea on this particular day was amazing. I was ready and waiting and got many good frames before I heard a thunder clap and reacted instinctively, tripping the shutter.

**GAIL JOHNSON** ▲          2008

### Rough at Roker
*Sunderland, England*

I had to hide behind a wall in order to take this photo as the wind was so strong it was blowing the tripod over. This event only happened once in the hours I was there and I just roared with laughter as it happened, luckily keeping my finger on the remote shutter throughout the sequence.

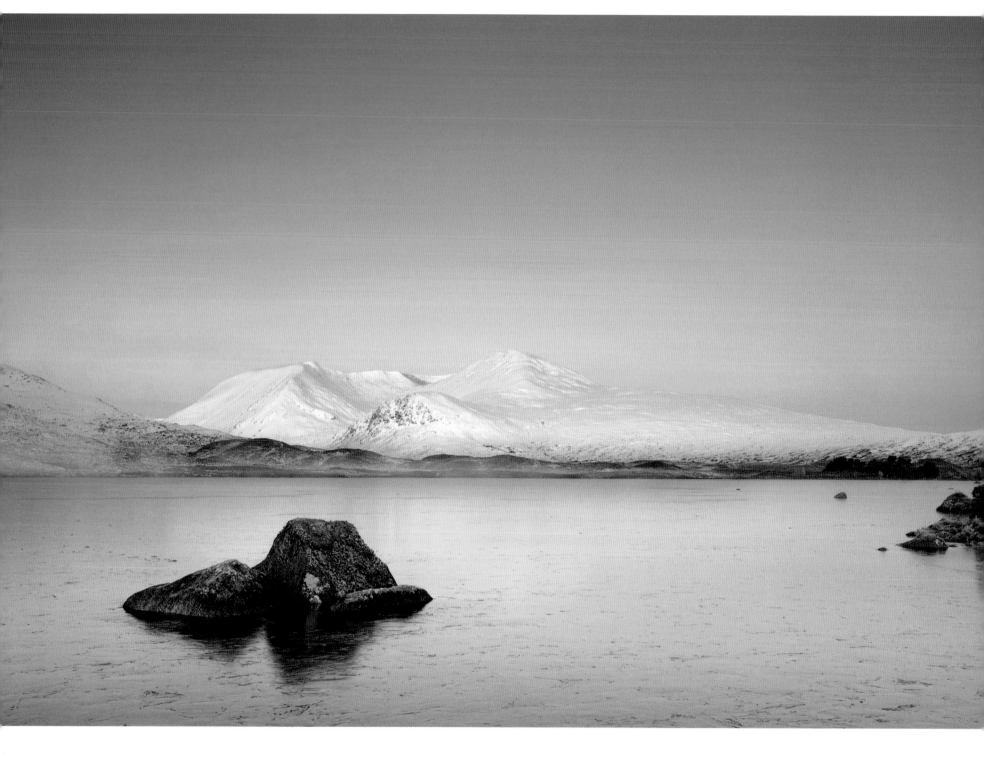

**RICHARD JOHNSON** ▲ 2008

**Am Monadh Dubh**
*West Highlands, Scotland*

A frozen Lochan na h'Achlaise at my feet, I was losing the battle to keep warm while waiting for the pink sherbet colours to appear pre-sunrise. I had visualised this view so many times before, only to be disappointed. On this occasion, lady luck was on my side.

**IAN CAMERON** ▶ 2012

**Loch Achanalt**
*Strathbran, Scotland*

A sliver of caramel light at sunrise turns the frosted birch trees at the edge of Loch Achanalt to powdered ginger, a colour that contrasts warmly with the cool reflected hues of an arctic blue and cloudless sky. Temperatures dipped to −20°C, which ironically gave me firm-footed access to areas I would be unlikely to be able to reach at any other time of year.

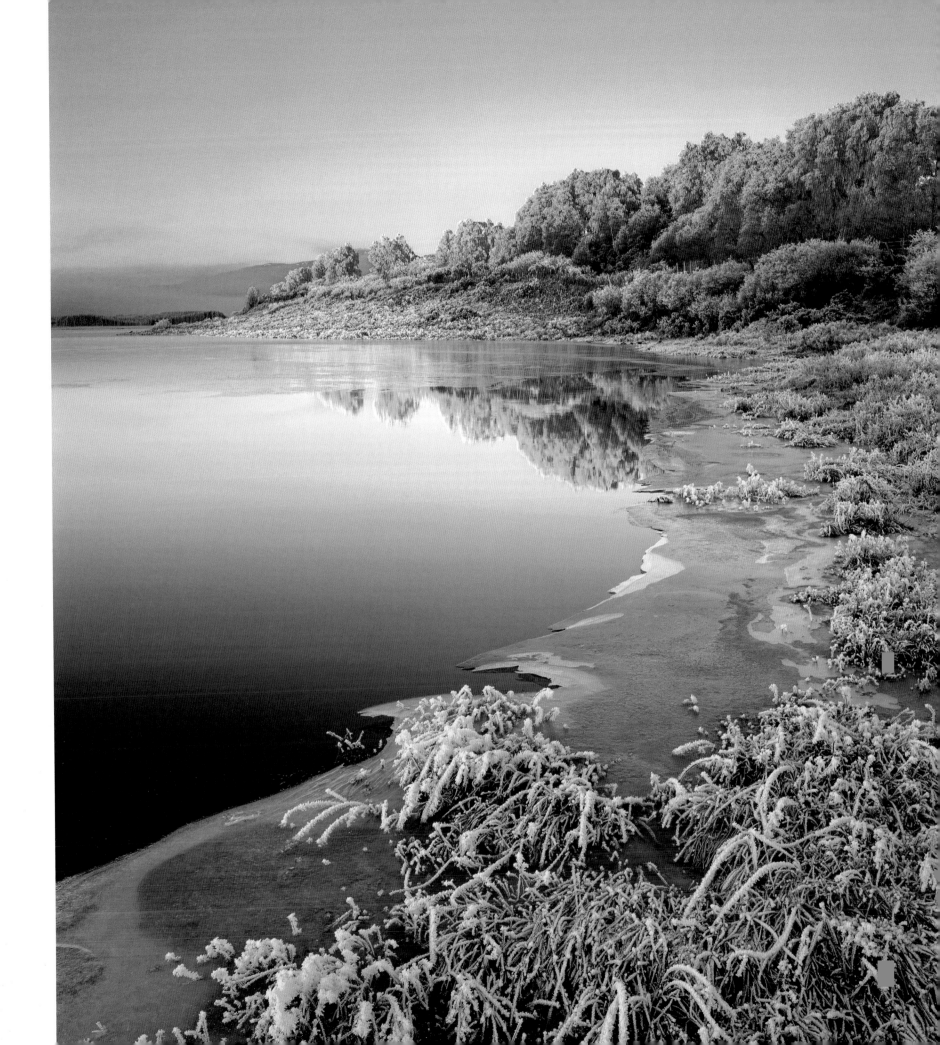

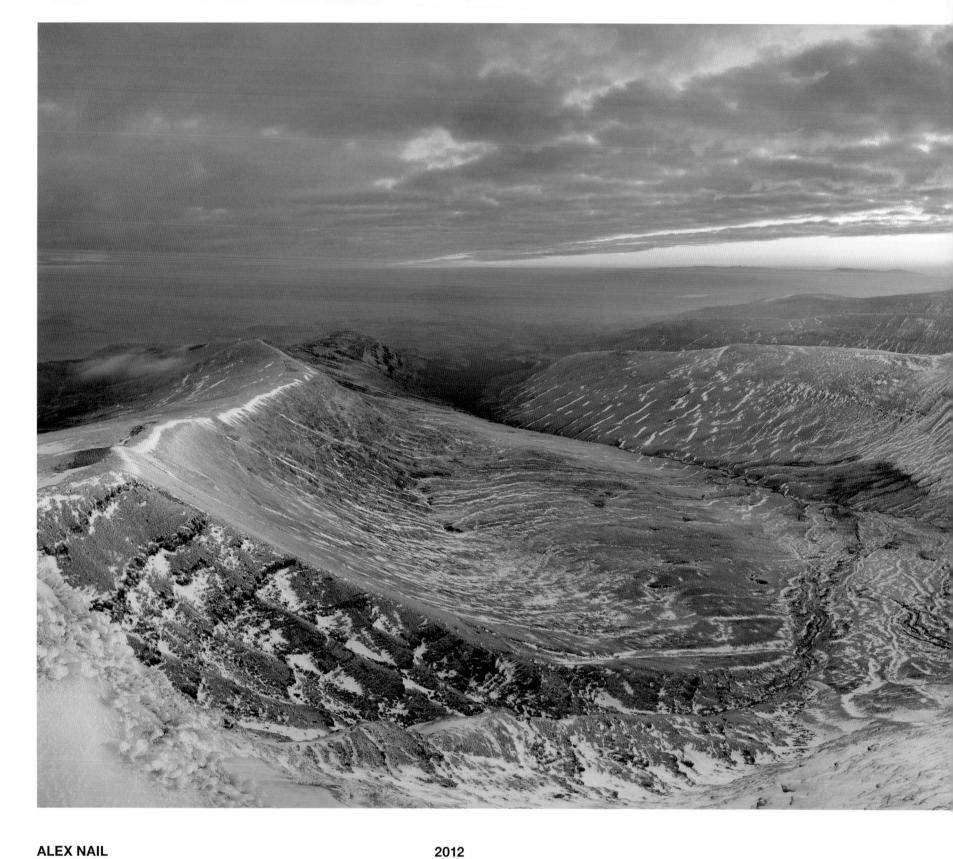

**ALEX NAIL**                                        **2012**

Pen y Fan
*Brecon Beacons, Wales*

Pen y Fan is the highest peak in southern Britain. I walked up the mountain the night before in very
unpleasant conditions. I set up camp on the snow-covered summit. A windless night passed and I awoke
to see high-altitude clouds and a gap on the horizon. At that point I knew I was in for a good sunrise.

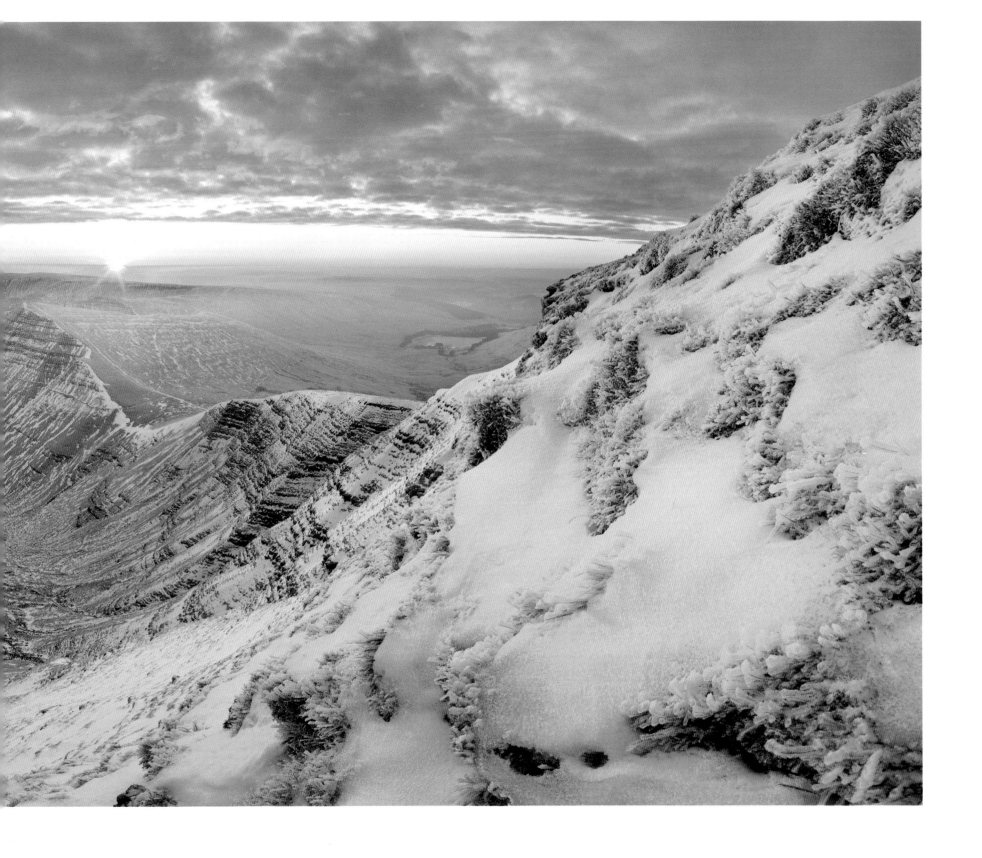

## Enchanting Skies over Bamburgh Castle
*Northumberland, England*

The weather forecast had not been as accurate as indicated and I had almost given up. On the way back to the car a slight break in the clouds hinted that the evening light may be worth hanging around for. Minutes later, Bamburgh Castle was bathed in glorious evening light as the clouds swirled above. With the slow shutter speed, I was able to attain extra movement to the clouds and grasses whilst the sun soaked Bamburgh in its warm evening light. Worth waiting for.

## Milky Way over Corfe Castle
*Dorset, England*

The ruins of Corfe Castle stand on a small hill, guarding a gap in the Purbeck Hills of Dorset. During th summer months, on exceptionally clear nights, soldiers stationed there would have gazed in wonder the central core of our own galaxy, the Milky Way, rose slowly above the horizon to form a great ar across the sky.

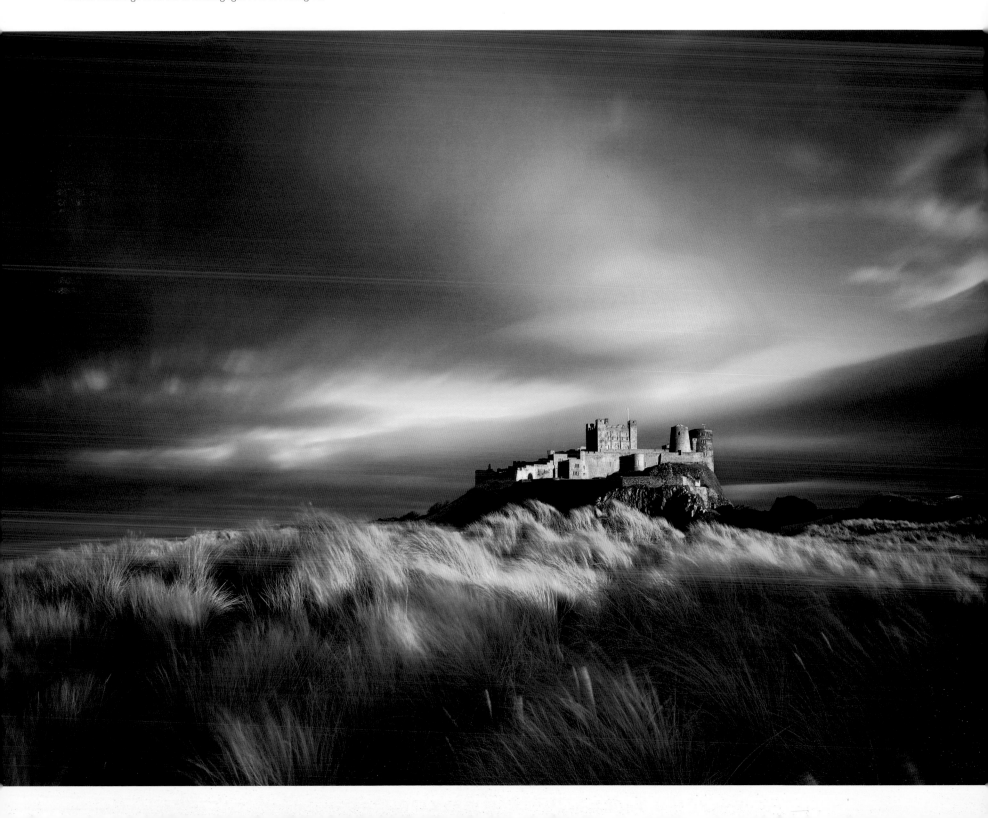

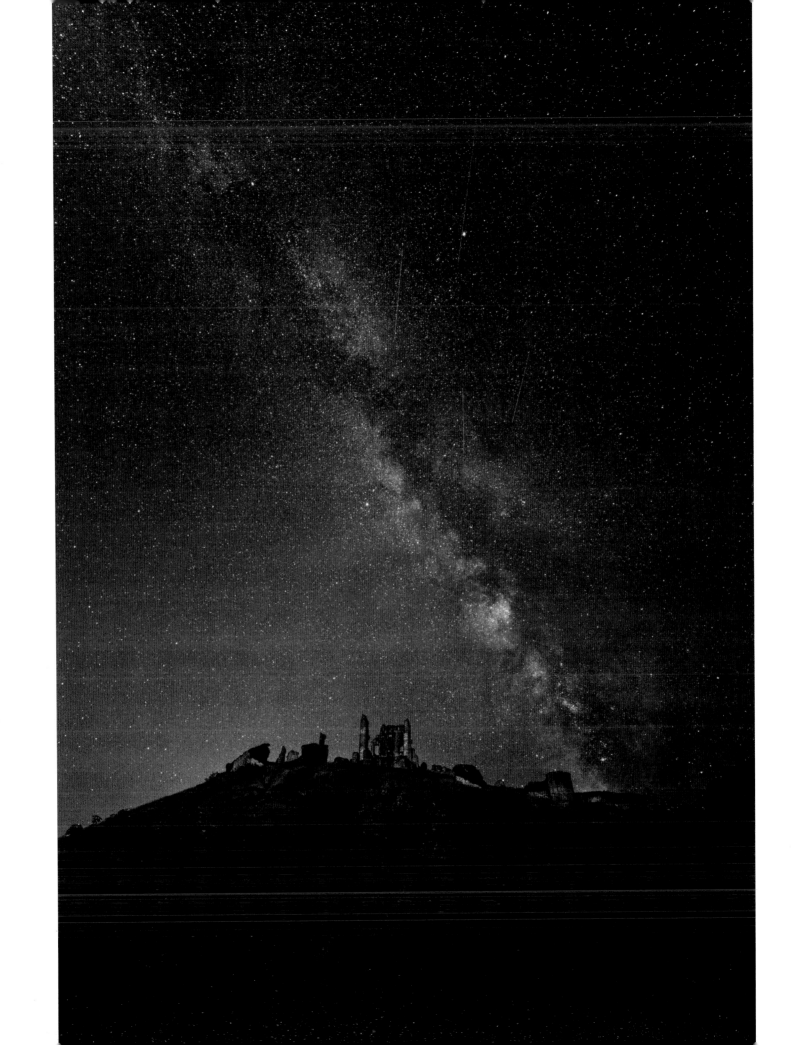

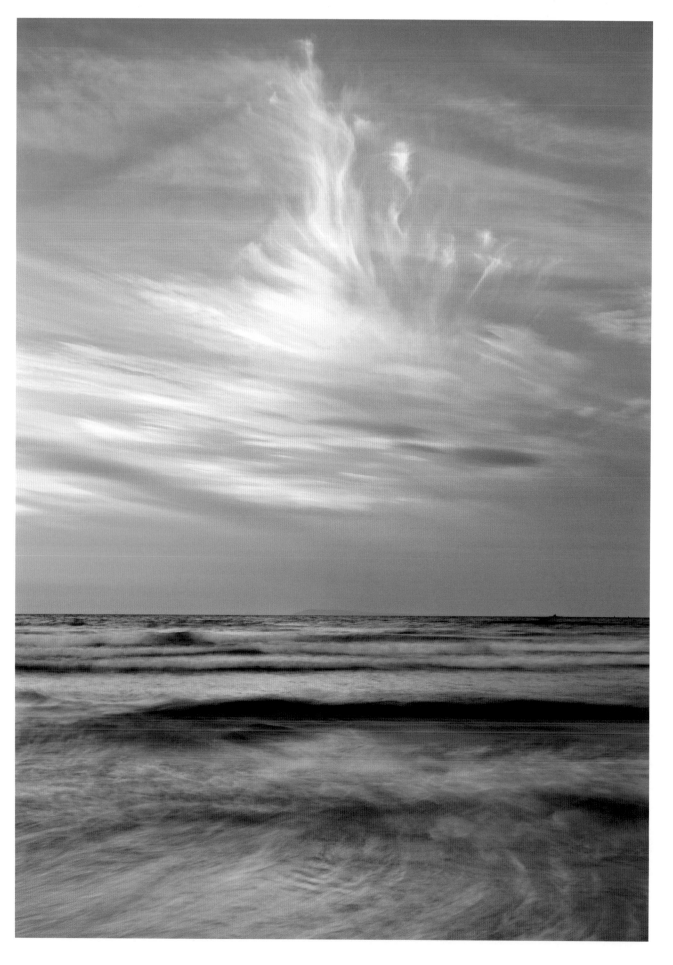

**Browns Bay**
*Islandmagee, County Antrim,
Northern Ireland*

Taken during an evening when the intention was to photograph a local set of cliffs. However, as usual, the plans didn't work out but on my way home I turned to a local beach where I spent time as a youngster. I'm glad I went for the walk, as a wonderful cloud pattern appeared above me. The resulting image is as I hoped.

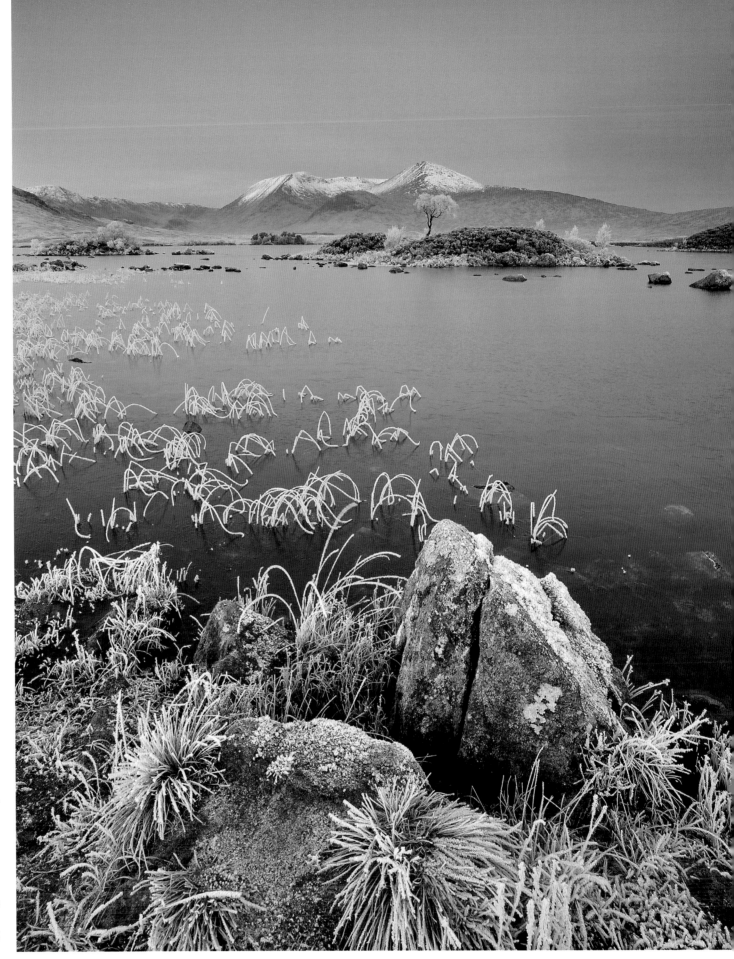

## NEIL MacGREGOR          2010

### Winter Dawn
*Rannoch Moor, Scotland*

The weather forecast predicted a cold, clear December night with sub-zero temperatures. Next morning, I found myself on Rannoch Moor with a small group of Kirkintilloch Camera Club members. In the dark at 6.45am we set up cameras and tripods, sipped coffee from flasks and waited for the light. A prolonged spell of cold weather had frozen the loch and hoar frost coated the vegetation and trees of the moor. The stage was set and as dawn broke the sky turned a deep shade of blue. Unfortunately a cloud bank in the east occluded the rising sun, so no direct light fell on the distant Black Mount Hills. However, for a brief moment, some thin cloud above the mountains was lit by the rays of the sun, giving some warm colour to the cold, blue scene.

**NIGEL MORTON**                                                          **2014**

**Seven Sisters Storm**
*East Sussex, England*

A few years ago I made several visits to Hope Gap, the vantage point from which this image was made. The plan was always to try to capture the scale and drama of the cliffs in the most striking conditions possible, but either the light or weather never seemed to play ball. I eventually stopped visiting and concentrated on other photographic projects. At the beginning of 2014, the UK was battered by a series of storms, so I decided to revisit the location at dawn one morning. I managed to make several photographs I am very happy with, including this panoramic image encompassing all seven of the sisters.

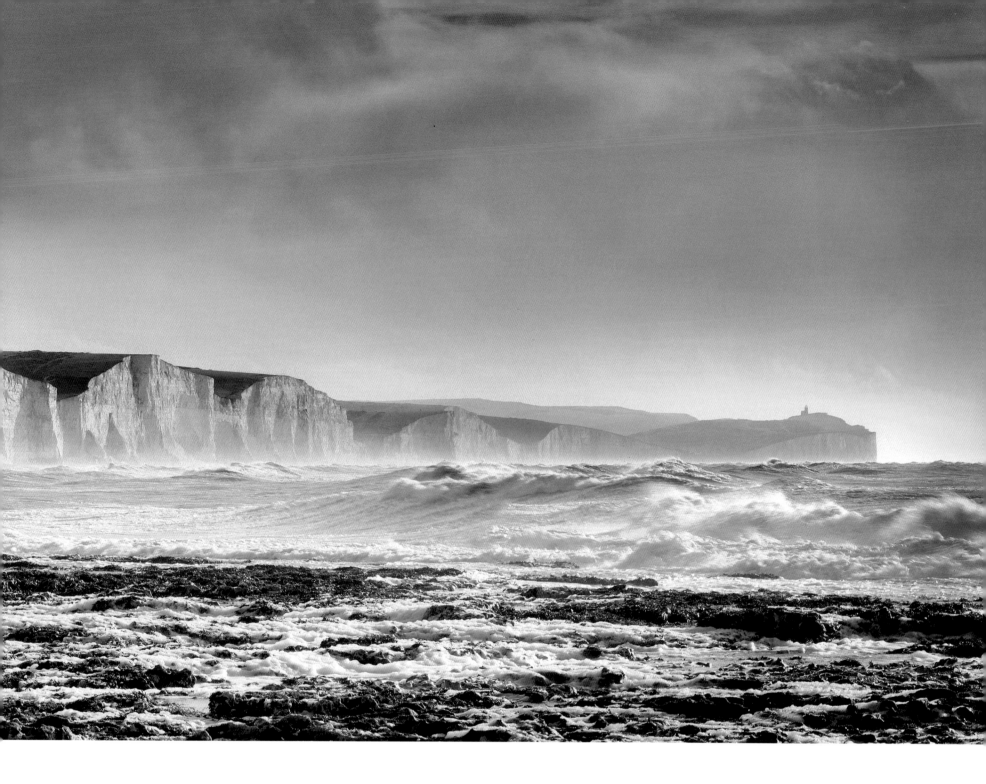

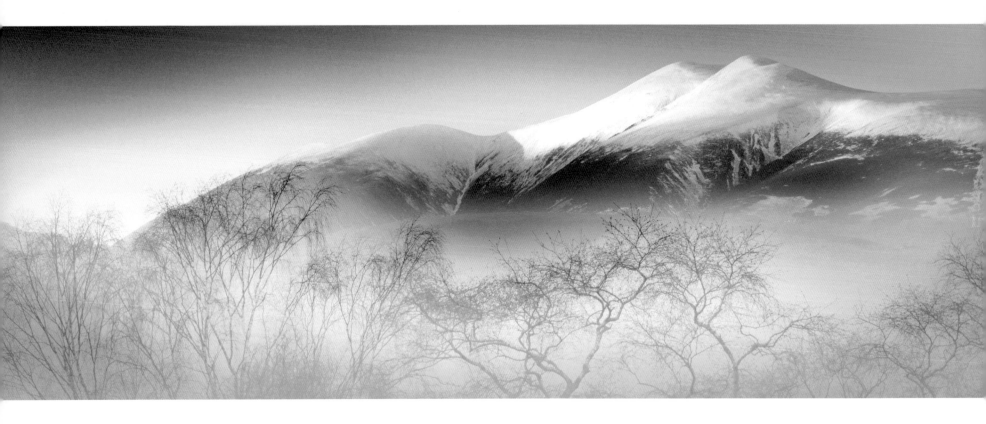

## MIKE SHEPHERD                                                                    2011

### Skiddaw in Winter
*Cumbria, England*

I will never forget the taking of this picture. It was an extremely cold winter's evening and freezing fog hung in the air, which made the prospect of a photograph improbable. I climbed to the top of a small rise and realised that the mist was little more than a few feet deep, and despite only a short climb I found myself completely above it and looking at a wonderfully clear view of Skiddaw with the sun setting in the west. I used classical techniques, translated from my college days spent in the darkroom into Photoshop, to achieve the black-and-white image.

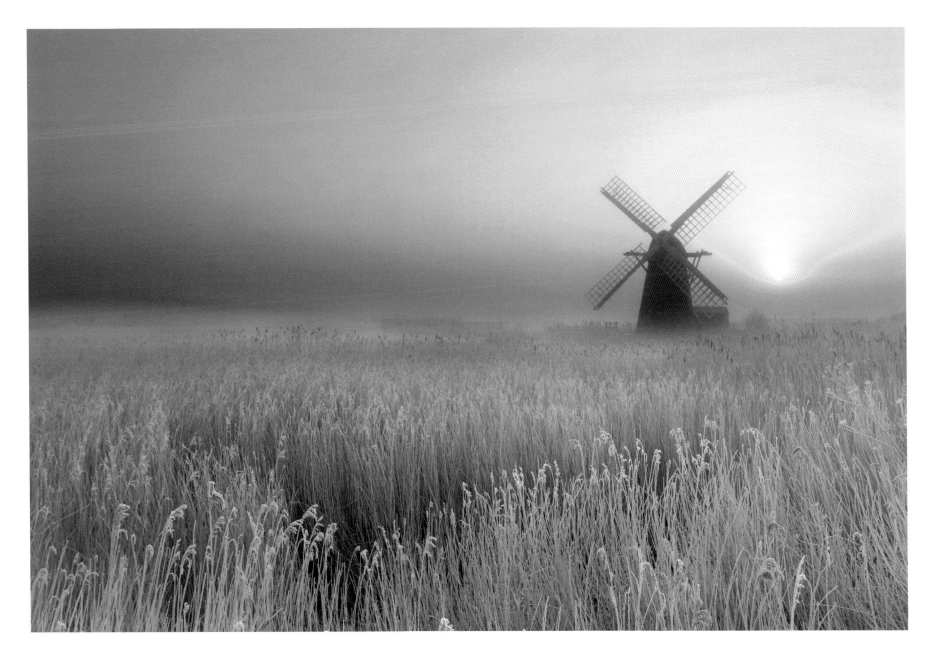

**GARY HORNER**                                                    **2016**

### Winter Sunrise
*Herringfleet Smock Mill, Suffolk, England*

I decided to head down to Herringfleet Mill early one February morning. Arriving before dawn, the marshes and mill were covered in mist and there was a lovely frost on the reeds, which are brown at this time of year. I positioned myself further up the marshes looking down towards the mill, so that I could catch the sun rising behind it. The break in the reeds added a great bit of foreground interest and, in my opinion, worked towards a better image than if I had included the full reed bed. Later, the mist lifted to give a clear view across the marshes under the dense mist shroud, which was a first for me.

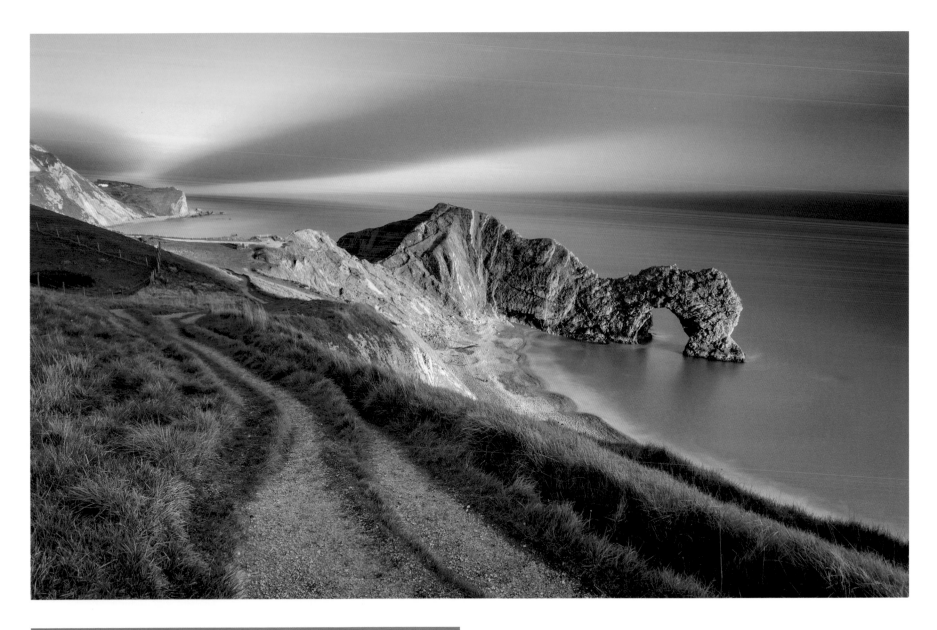

## JAKE PIKE

### The Last of the Evening Light on Durdle Door
*Jurassic Coast, Dorset, England*

Durdle Door is an iconic landmark of the South West Coast Path and of the Dorset countryside. In this image, I waited for the late evening sun to shine on the natural archway and included the coast path in my composition to add perspective. The long exposure allowed me to show some movement in the clouds and to smooth out the sea.

## Oak Tree and Potato Field
*Cronkhill, Shropshire, England*

I found this field several weeks earlier. Having travelled hundreds of miles over three previous visits, I was desperate for the weather to produce something other than dense cloud and torrential rain. I hoped to convey the sense of isolation I felt for this lonely tree and knew it would only be a short time before the potato plants emerged to transform the scene completely. I couldn't have been more thrilled when my perseverance was rewarded with a few brief moments of magical light before the sun, once again, disappeared behind heavy cloud, something we had become accustomed to this springtime.

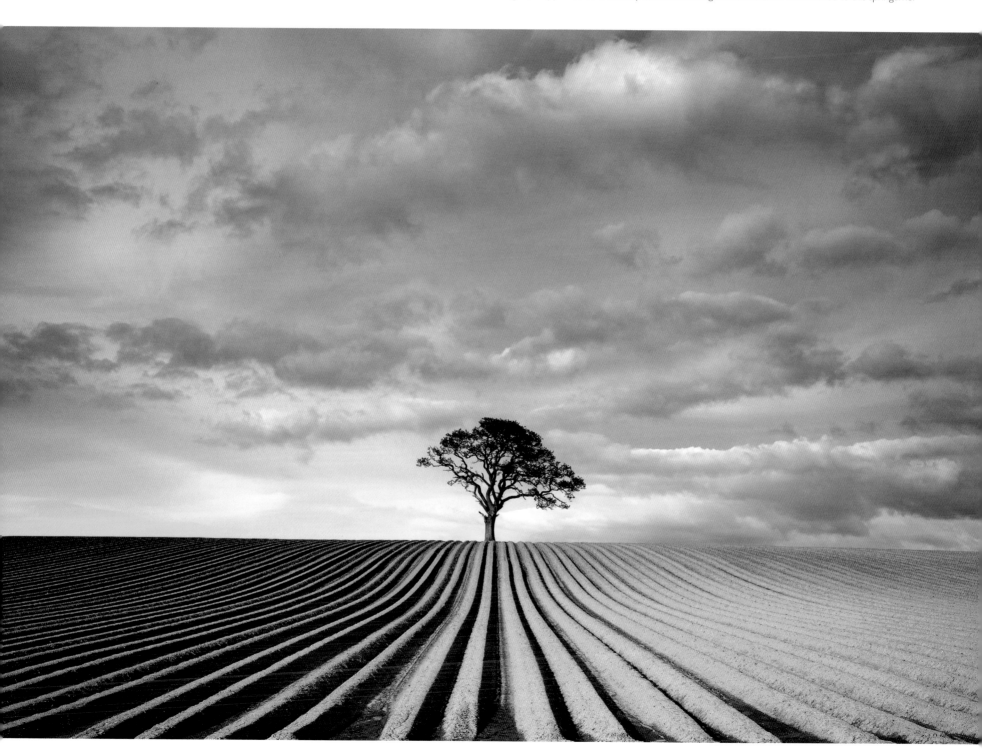

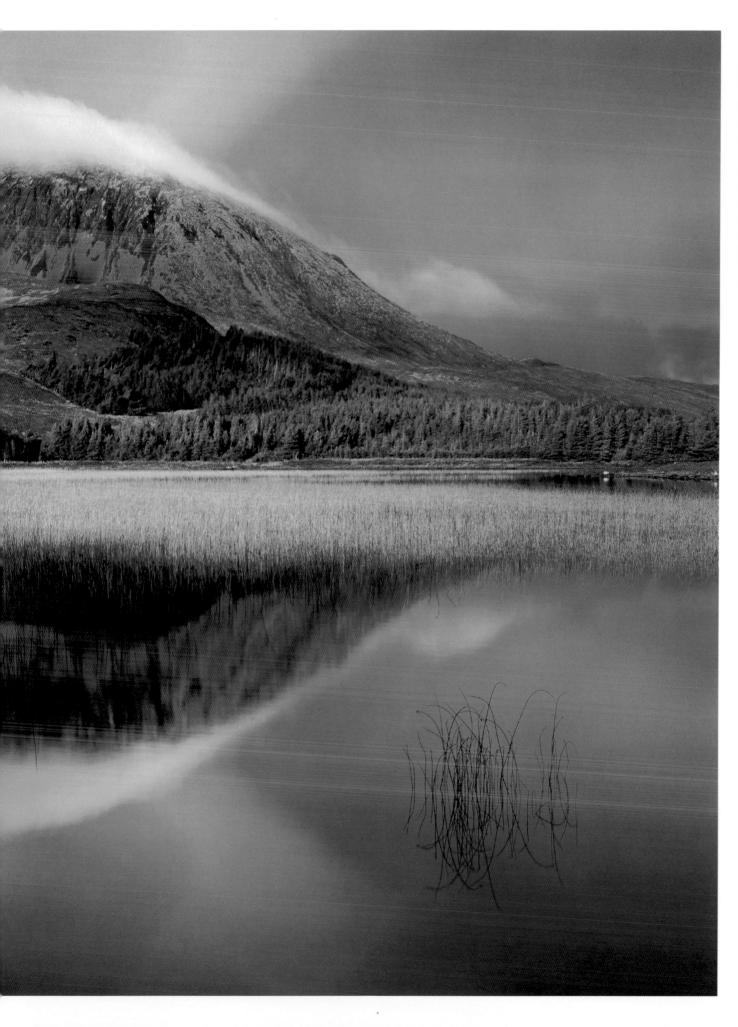

**DIMITRI VASILIOU**     **2010**

## Loch Cill Chriosd and Beinn na Caillich
*Isle of Skye, Scotland*

As a regular visitor to the Isle of Skye, I had tried to take similar pictures before. However, the reeds never came out with that golden colour when the low sun was on them. I decided that it might be a 'digital thing' so gave it a try with Fuji Velvia medium format film and I am pleased I did. The low sun had turned the reeds to pure gold and Velvia managed to capture the beauty of it.

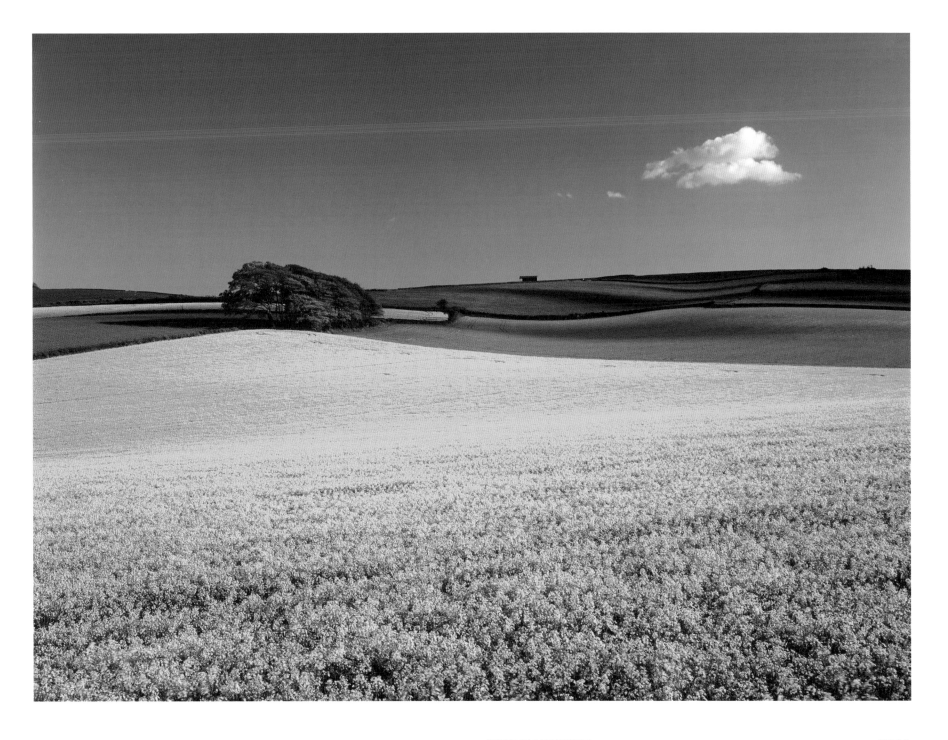

**ADRIAN BICKER**                                                                 **2008**

**Fields of Rape near Weymouth**
*Dorset, England*

I have admired the shape of this field beside the main road to Weymouth for many years. I love its gentle slopes and the clean lines of its boundaries, leading to the group of trees that breaks the horizon. All the elements came together with a crop of oilseed rape in the main field and another behind the trees, set off by the fresh green of newly germinated cereal crops all around. Late morning put the sun at right angles to the view and coincided with the appearance of fair weather cumulus clouds, adding interest to a plain blue sky. This is the first cloud of the day but others are closing in from the right, casting their long shadows across the undulating green fields. I always find this image uplifting. It seems so positive, so vibrant and uncomplicated. So optimistic!

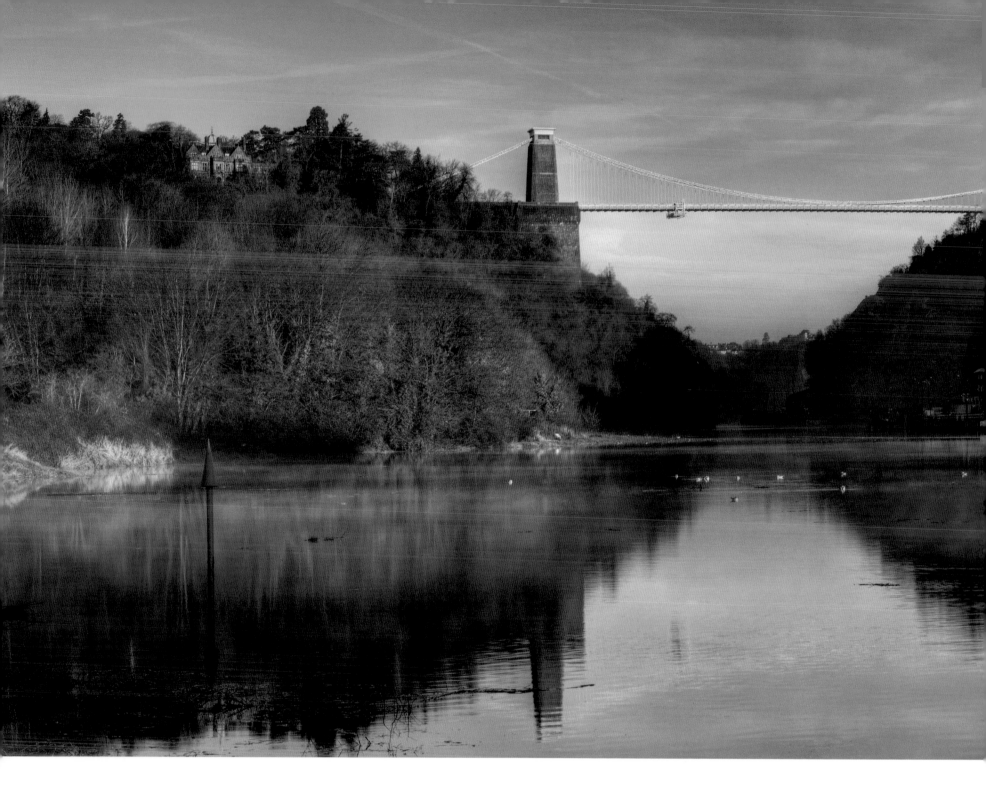

**RICHARD EDWARDS**                                                    **2008**

### The Clifton Suspension Bridge
*Bristol, Avon, England*

The quintessential view of Bristol – the Avon Gorge and the docks, with the Georgian splendour of Clifton and Brunel's Suspension Bridge above. This shot was a challenge and was taken on my eighth trip to do it. Despite all the modern kit that enabled me to combine exposures, it was a tricky job. One botched element and the picture would be ruined. While a far cry from my Grandad's plate camera, I find that this technique captures realistically what you would actually see if you had been standing with me on the banks of the Avon.

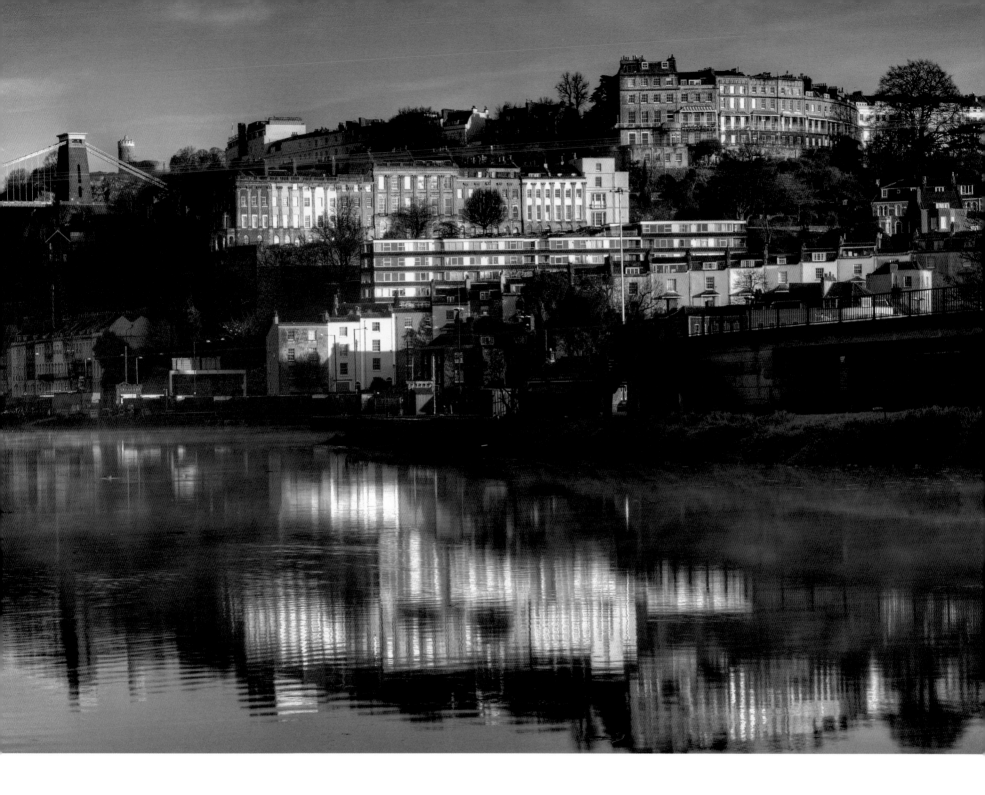

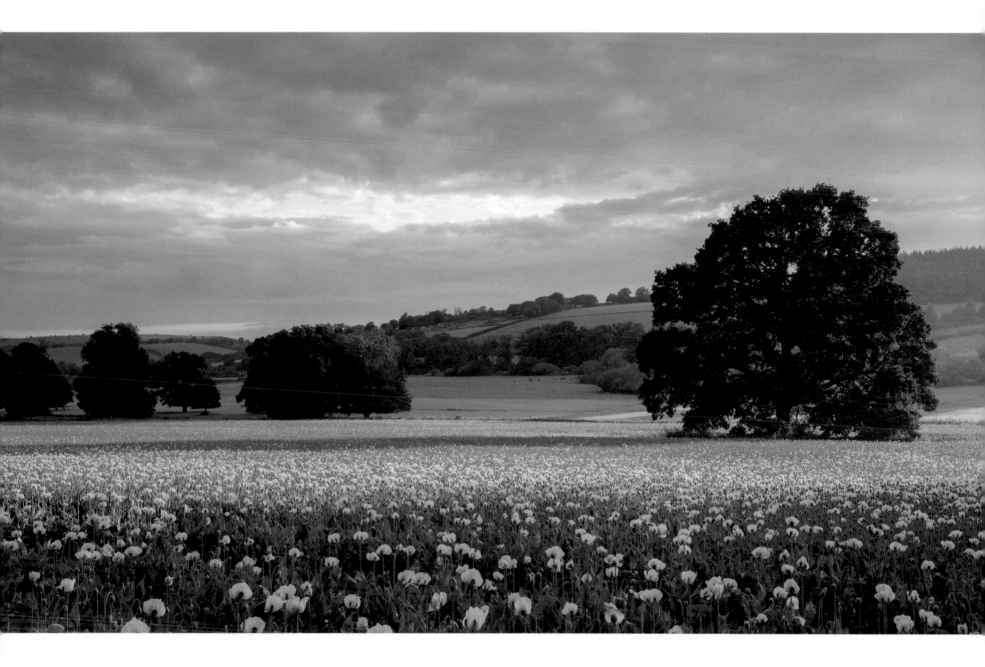

**JAKE TURNER**                                                2016

Opium Poppies
*Durweston, Dorset, England*

Glorious early morning side light on a field of opium poppies growing in the Dorset countryside.
A 1.45am alarm call seemed crazy, but I sure am glad I got up as the conditions were fantastic.

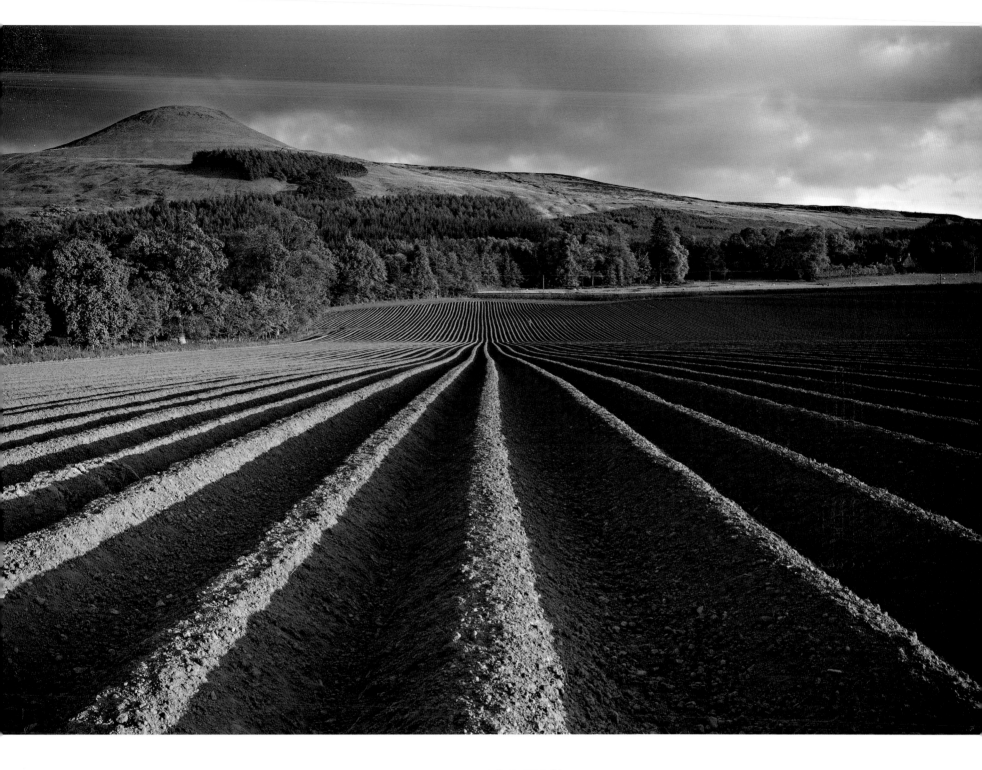

**RON WALSH** 2008

### A Spring Evening in Falkland
*Fife, Scotland*

Having discovered this recently ploughed field, I made the decision to return that evening, hoping for a sunset and some cloud. I was fortunate enough to get both. The hill in the background is East Lomond, beside the historic town of Falkland in Fife. I positioned my tripod to get a good angle on the rows of newly prepared stitches as well as to give more prominence to East Lomond. Overall, a thoroughly enjoyable hour or two spent on my knees in a field.

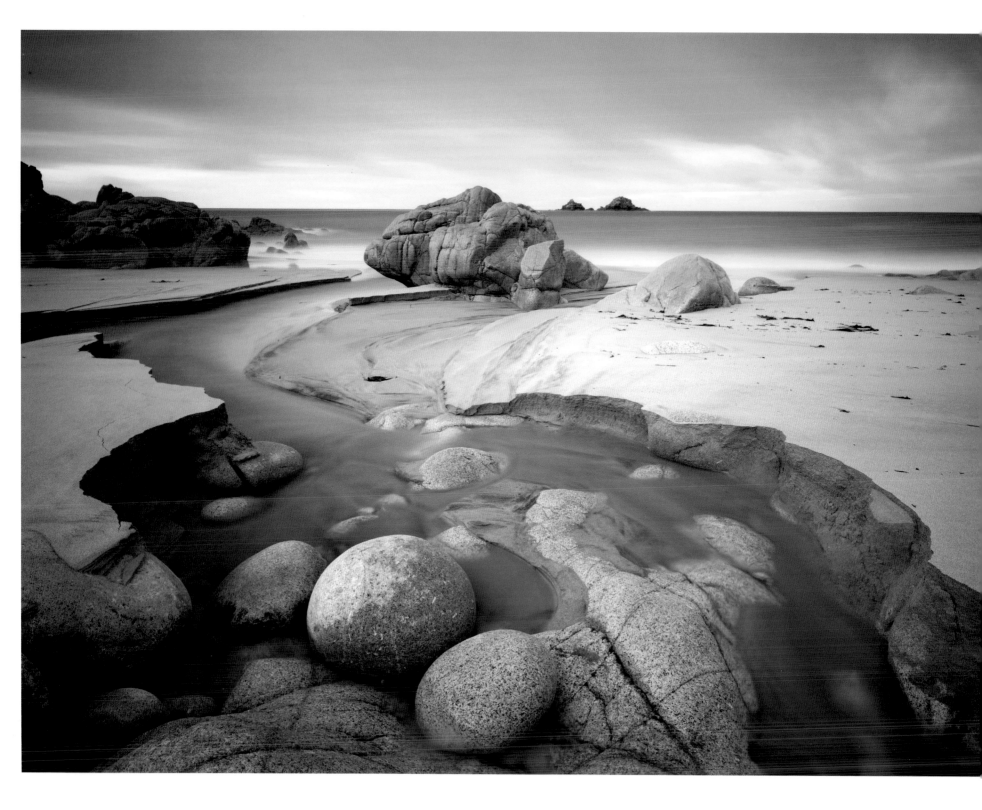

**ADAM BURTON**                                                         **2011**

**Nature's Artistry**
*Porth Nanven, Cornwall, England*

The geology on show on this beach is nothing short of remarkable and demonstrates the incredible creativity of nature. Over countless aeons, water from both the stream and Atlantic Ocean have sculpted the granite cliffs, boulders, pebbles and sand into the shapes that make up Porth Nanven.

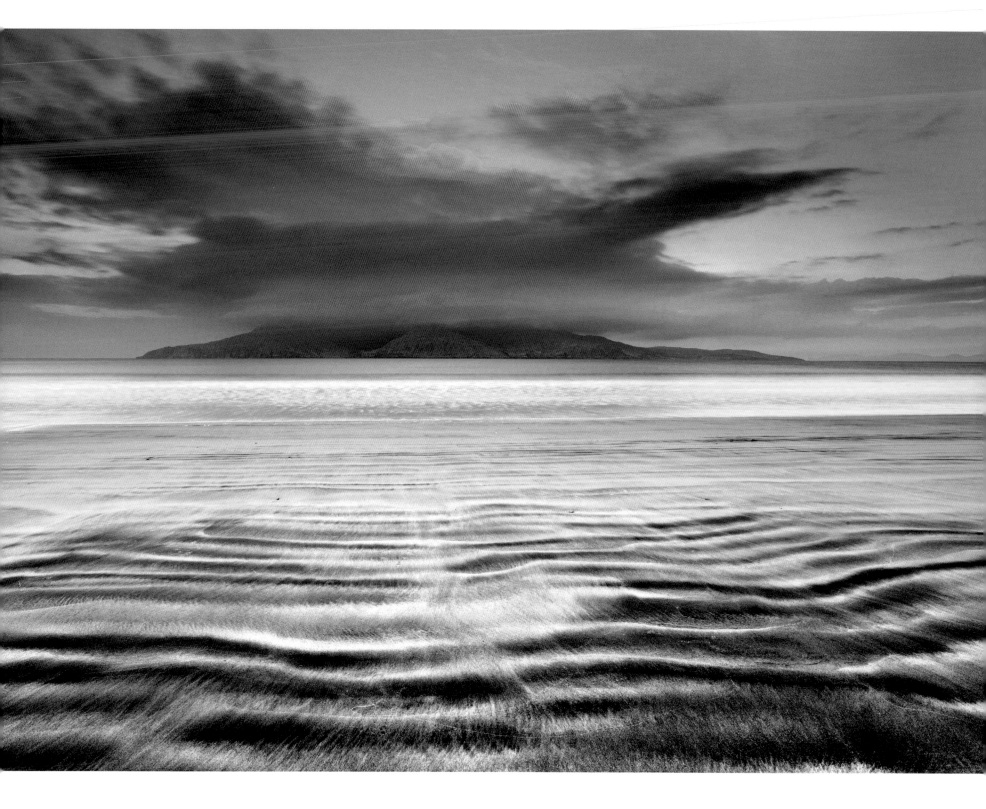

**FORTUNATO GATTO**                                                                        **2011**

**Earth, Wind & Fire**
*Isle of Eigg, Scotland*

The Isle of Eigg is one of the most fascinating seascapes I have seen. This picture was shot during a windy dawn in February. For the foreground, I made the most of the peculiar textures on the shore, almost like a natural black and white, as opposed to the vivid colours of the background.

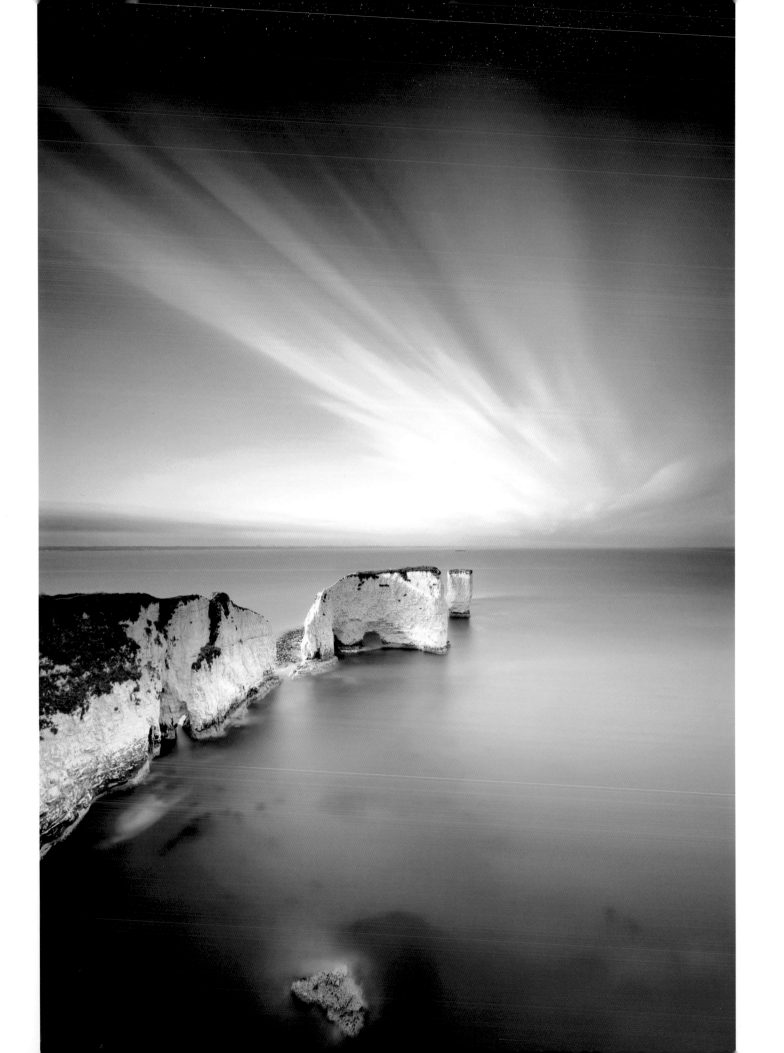

### Old Harry Can Break the Rules
*Dorset, England*

I wanted to capture some movement in the sky and smooth out the ocean to make this iconic setting look peaceful. I had to carefully set up close to the cliff edge, as I wanted a clean shot without the untidy grassy foreground that was distracting when viewed through the viewfinder at such a wide focal length. The result meant that the horizon was not in its conventional position, using the rule of thirds, hence the title here.

### Late Afternoon Winter Sun
*Kimmeridge Bay, Dorset, England*

This was my first visit to Kimmeridge Bay. I arrived early afternoon and was struggling for inspiration as the grey fossiliferous clay wasn't appealing. I wandered around for a couple of hours, looking, being and watching the scene develop as the sun slowly descended. Luckily, a beautiful patch of mackerel sky started to cut a swathe above my head and I caught a glimpse of it reflected in the pool beneath my feet. Finally I had found my golden moment shot. All I had to do was wait and watch for the sun to illuminate the bleak grey foreshore. As the sun lowered, the clouds continued to move easterly over my head, filling the sky with beautiful patterns. The golden light was only there for a matter of minutes. I knew I'd captured a special shot in a magical place.

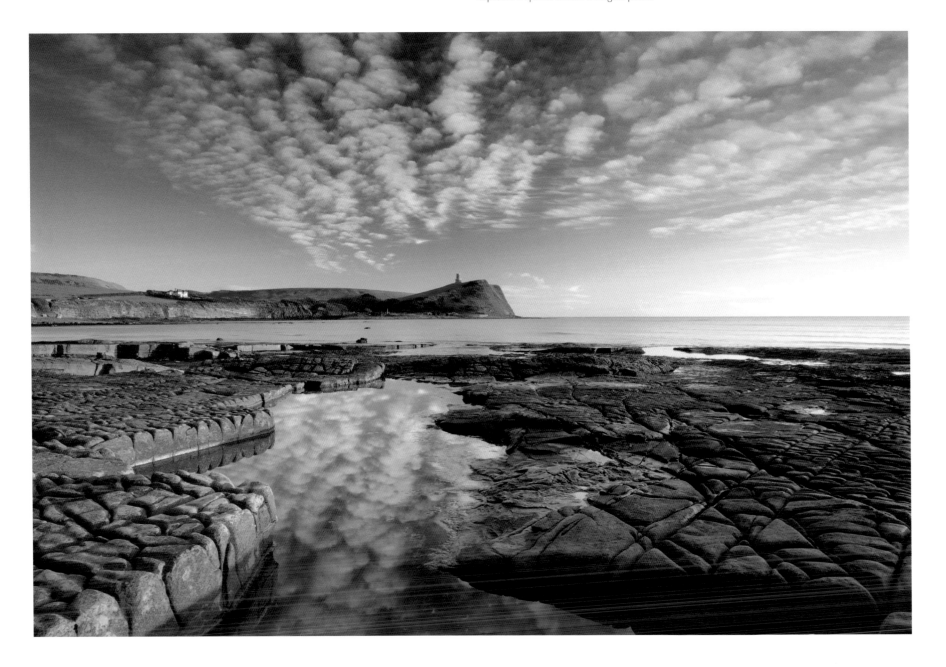

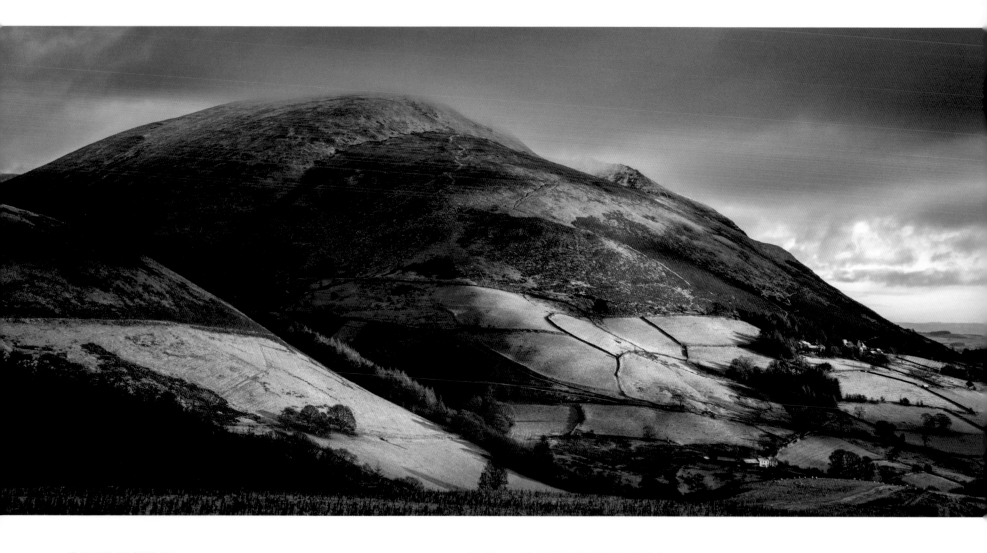

## GRAEME KELLY ▲     2015

### Derwentfold
*Cumbria, England*

Blencathra has always been one of my favourite Lakeland fells, one of the reasons being that there are many sides to it. Compare this view of Blease Fell to that of looking up Sharp Edge, or the trapeze shape of Gategill Fell to the broad expanse of Mungrisdale Common, and you could be forgiven for believing that they are not the same mountain. I took this image during a brief gap in a snow flurry in mid-December, when the sun managed to light up the flanks of this special fell.

## SCOTT ROBERTSON ▶     2016

### Binnein Beag through Steall
*Highland, Scotland*

A rarely seen aspect of Binnein Beag in the Scottish Highlands. I'd been scouting out various locations on the slopes above Steall Gorge when this scene came into view. It instantly drew my attention. The light wasn't quite right, but as I was going to descend by the same route, there'd be another opportunity. On reaching the same spot many hours later, a brief ray of light fell beautifully into the gorge below and onto the snow-capped face of Binnein Beag.

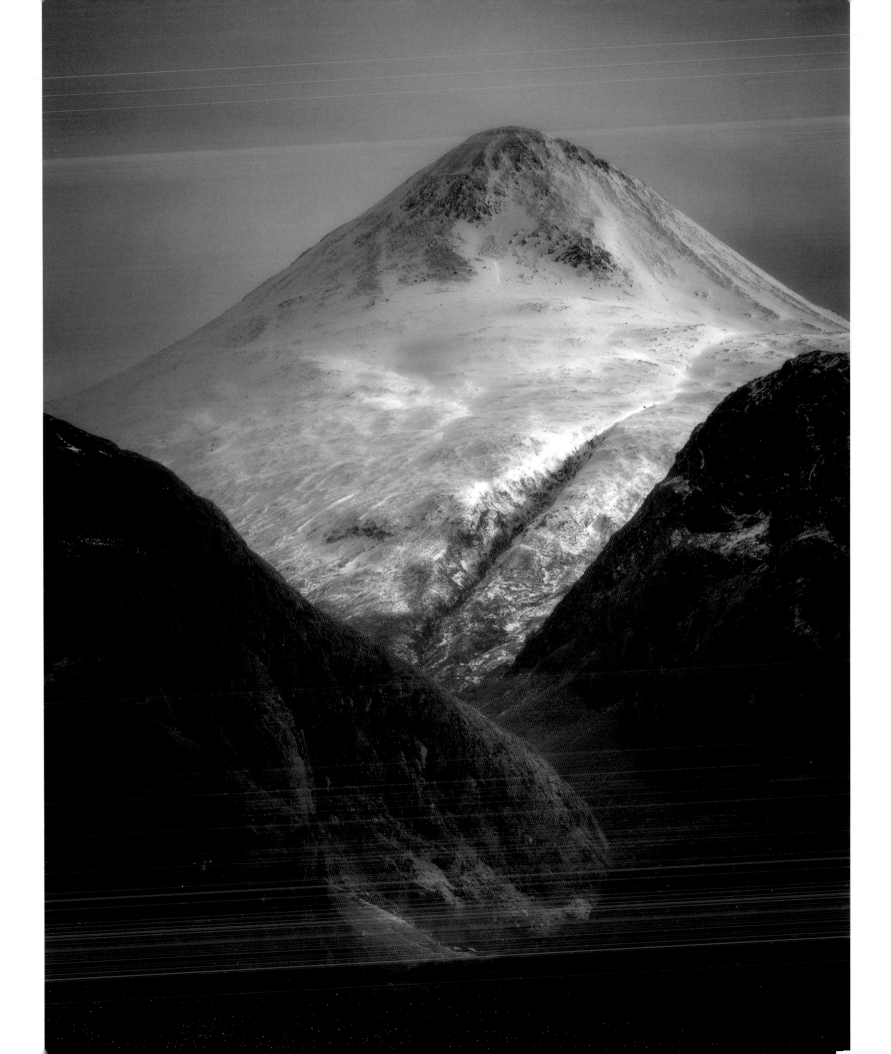

**ALUN ALLCOCK**  2013

**Y Draig Cysgu
(The Slumbering Dragon)**
*Snowdonia, North Wales*

High on Foel-fras, winter has taken hold of everything within its frigid grip. Encased in ice and in the soft light of a misty lair, a slumbering dragon lies motionless in the snow waiting for warmer times to stir again ... Built by Napoleonic prisoners of war, this wall normally stands over four feet high and, at over 3,000 feet above sea level, is the highest in Wales.

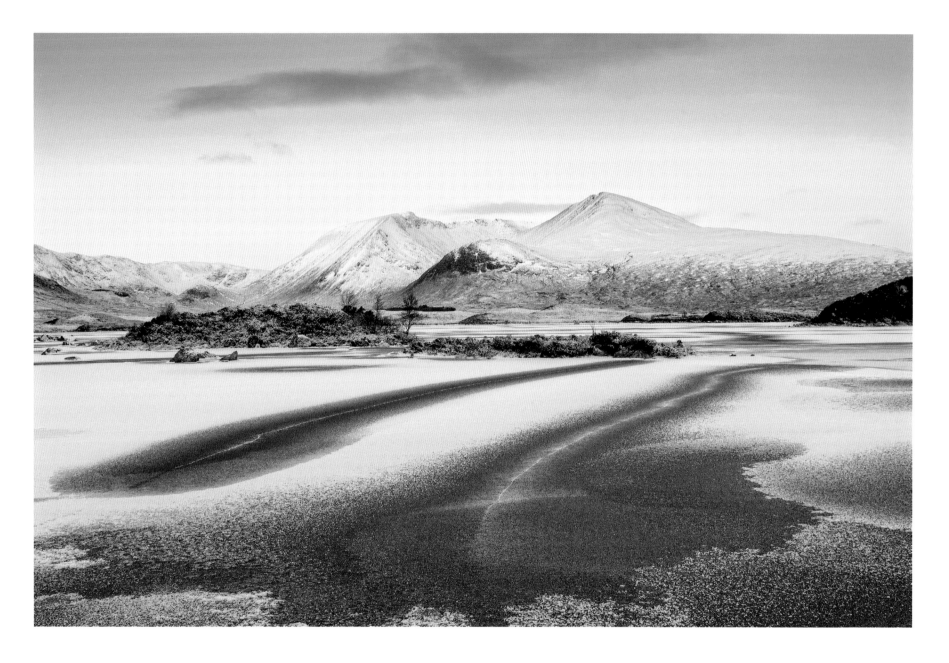

**PETER PATERSON**                                                    **2015**

**Rannoch Winter**
*Rannoch Moor, Scotland*

Taken at dawn on a cold December morning as the sun was rising behind me but before it broke over the hills behind. The sky colour was picked up in the small clear parts of the snow-covered loch.

## CHRIS SHEPHERD

### Old Man in the Trees
*Kelly Hall Tarn, Cumbria, England*

I reached Kelly Hall Tarn well before sunset and had a feeling that it was going to be a magical evening as the light was already rich and warm. As the late August sun began to set and make the landscape glow, I marvelled at the beauty of the scene that unfolded before me. Having a view like this completely to myself and capturing the essence of the scene is, for me, the real joy of landscape photography.

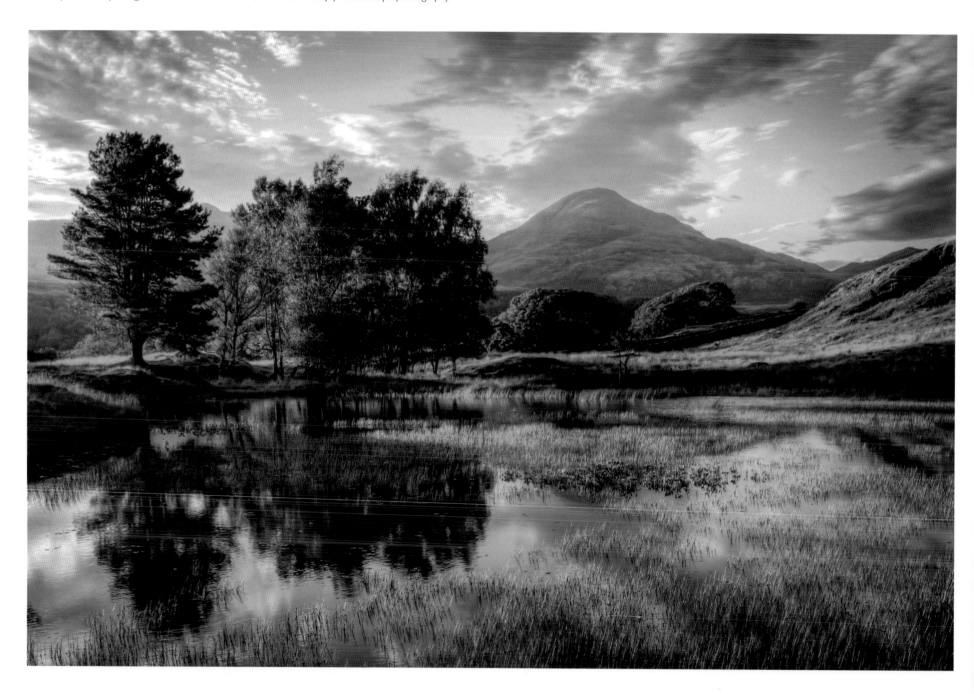

### Herringfleet Mist
*Suffolk, England*

This image was planned but the mist was a real bonus. I left Sheffield before 2am in order to be on location before dawn. As I drove across the Broads through a 10-foot layer of mist I knew there was going to be a spectacular sunrise. I arrived with 20 minutes to spare and ran to the mill with full kit: two cameras, tripod and several lenses. Who says landscape photography is not energetic? I took several hundred photos during the next hour, but this one with the sun just breaking the tree line was the pick of the set.

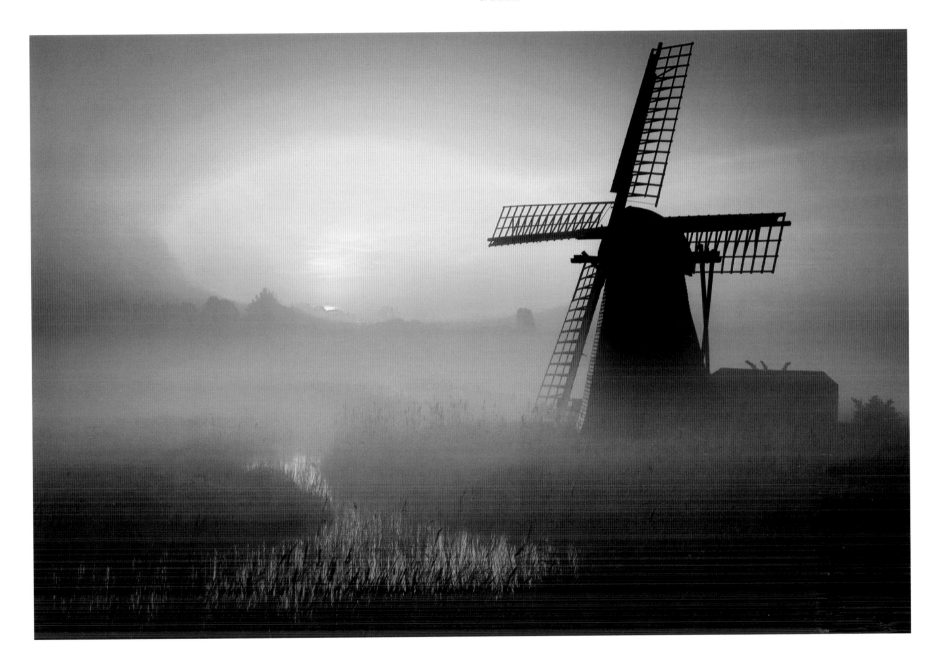

## SEYMOUR ROGANSKY ▼                    2007

### Looking to Durdle Door
*Jurassic Coast, Dorset, England*

This was taken on a hike between Lulworth Cove and Weymouth, on the Jurassic Coast of Dorset. It was one of those early spring days when one can experience every type of weather the British climate can throw at you. I wanted to capture the drama of the interplay between the landscape and the elements.

## MATT OLIVER ▶                    2016

### The Clearing
*Peak District, Derbyshire, England*

After spending a morning wandering around the peaceful Bole Hill Quarry in the Peak District, I scrambled up and out, heading back to the car. From the top of the quarry the treetops looked wonderful as the early light caught the wet leaves, and, combined with the shapely tree trunks, it made for an unusual view of the woodland below.

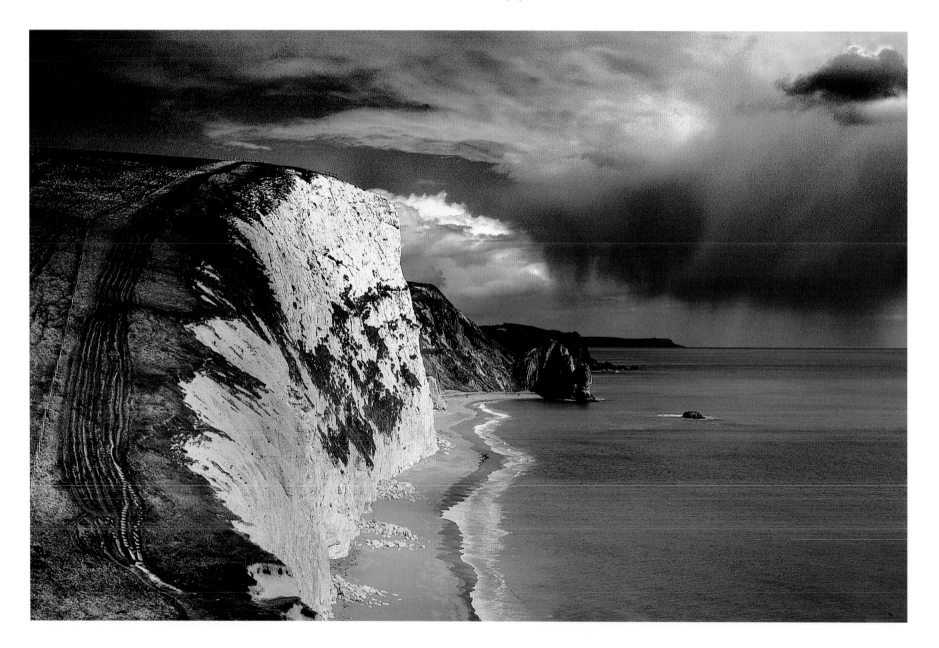

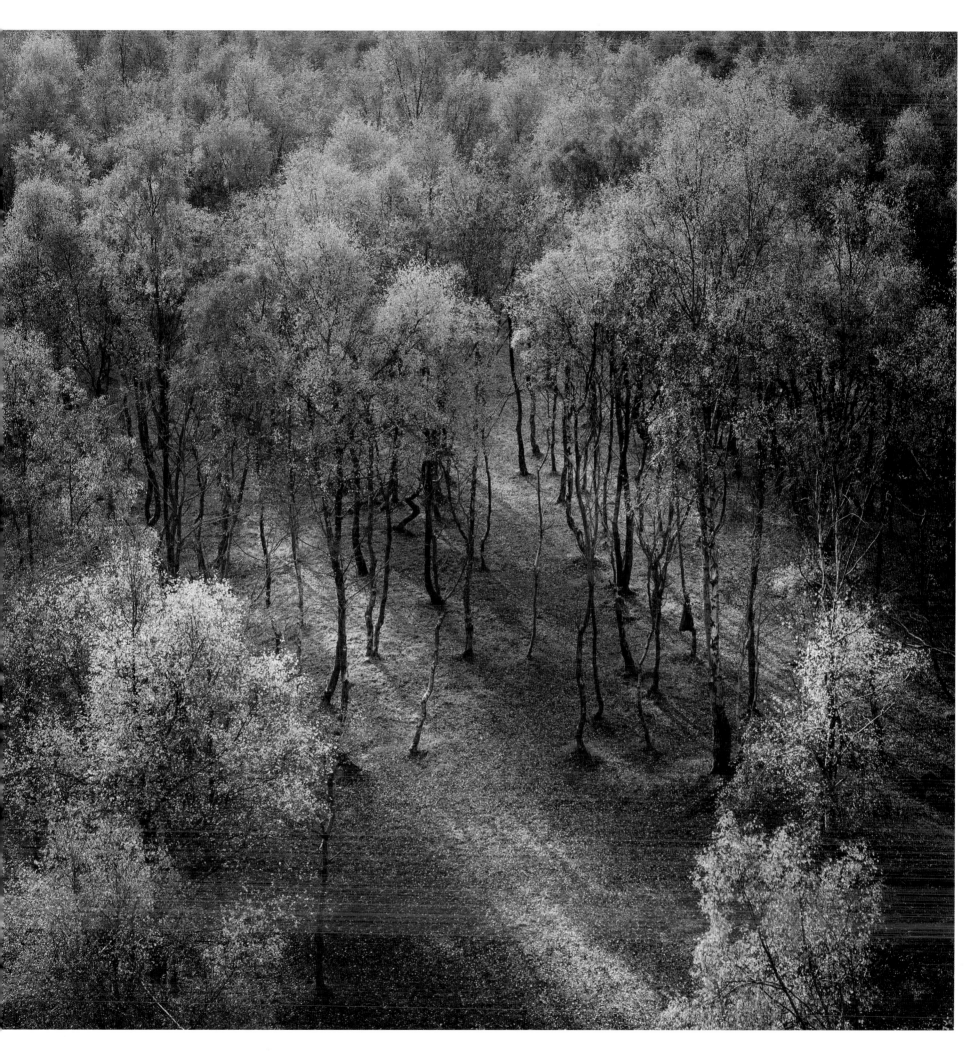

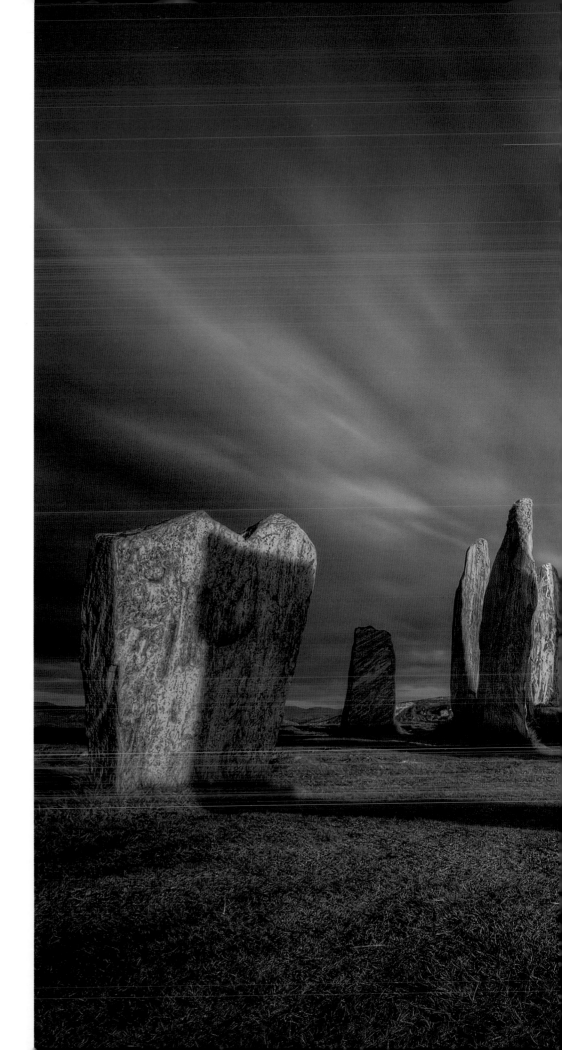

**WOJCIECH KRUCZYNSKI**                **2016**

### Callanish Shadows
*Isle of Lewis, Scotland*

It was a beautiful evening in Callanish, with perfect light and clouds. It was part of my second bicycle trip in Scotland – the Outer Hebrides this time. The long exposure that I used shows perfectly every detail of the stones against the softer background. A good photo for reflections on life and time.

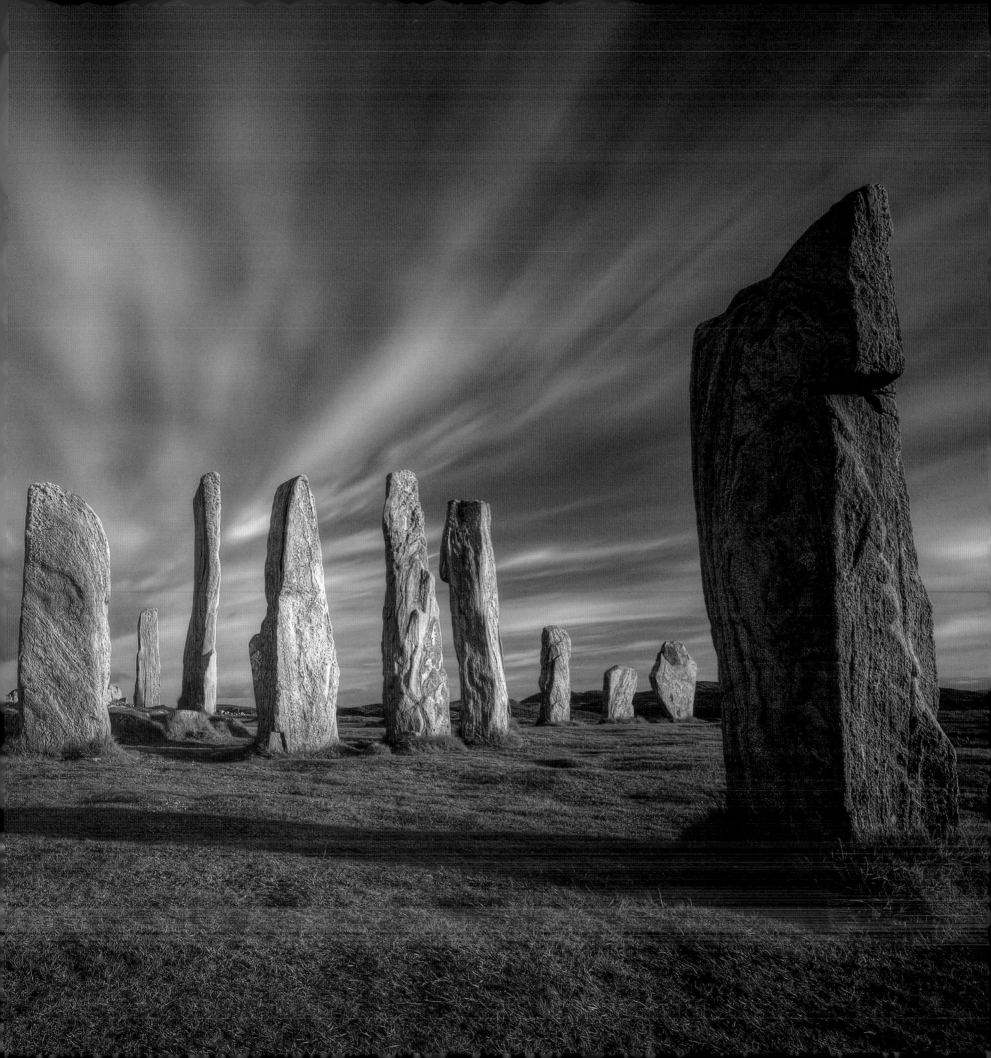

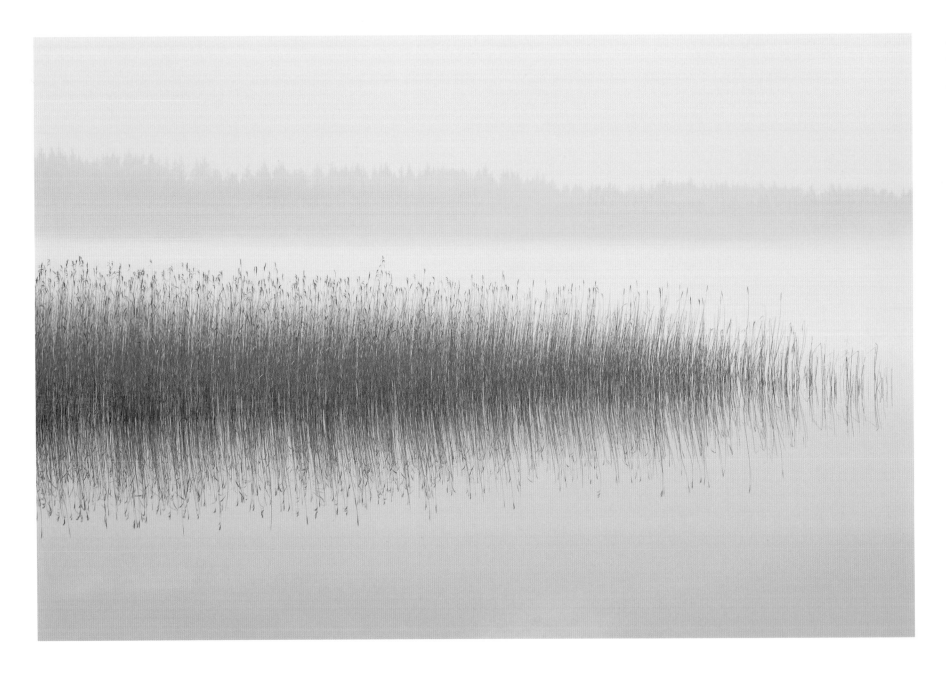

**GARY McGHEE**                                                                    **2013**

Reedflection
*Lake of Menteith, West of Stirling, Scotland*

Shoreline reeds taken at the Lake of Menteith on a foggy afternoon. Whilst looking for a composition
of these reeds, I noticed the placement of the layers – the main subject being the reeds, the outline of
which is nicely helped by the water and sky splitting the two land groups. I also noticed the shape of the
distant trees that echo the shape of the reeds.

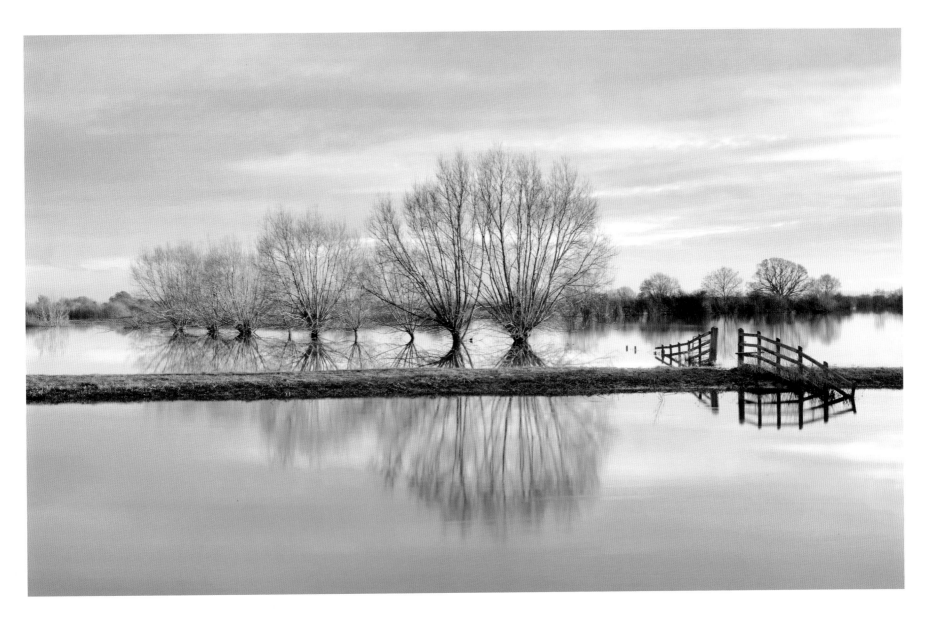

**TONY GILL**                                                          **2014**

**Flooded Water Meadows**
*Langport, Somerset, England*

At the heart of the Levels, the sleepy Somerset town of Langport saw its fair share of floodwater over the winter months. Rather than try to capture the misery the floods brought, I chose a quiet late afternoon by the burst banks of the River Parrett, the lowering sun beautifully illuminating the iconic willow trees that happily thrive here. Of course, the peaceful setting belies the awesome grip the elements have over our islands.

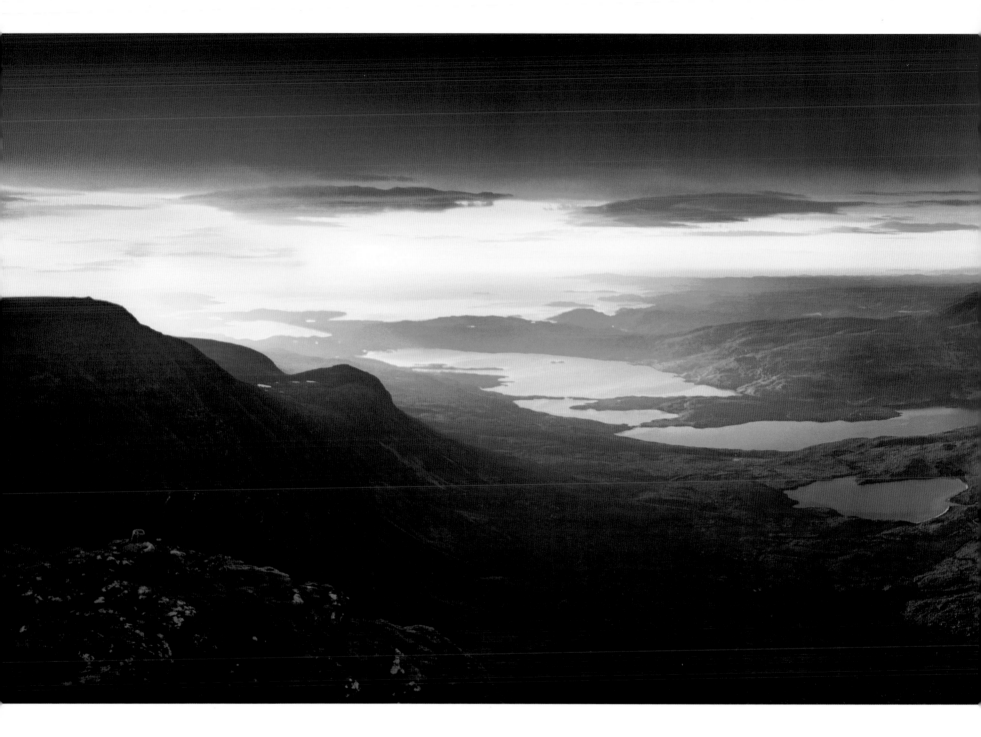

**SEBASTIAN KRAUS**                                                    **2016**

**Sgurr an Fhidhleir**
*Northwest of Ullapool, Scotland*

Scotland's landscape is simply incredible. Having been inspired by summer images of this location, I had to have a go at shooting this landmark in early spring when the sun lights up the rocks of Sgurr an Fhidhleir. After a cloudy start and in very high wind, the opportunity for decent light was unlikely – however, patience paid off. A small crack between clouds gave me magical light that I will never forget. A few minutes of perfection!

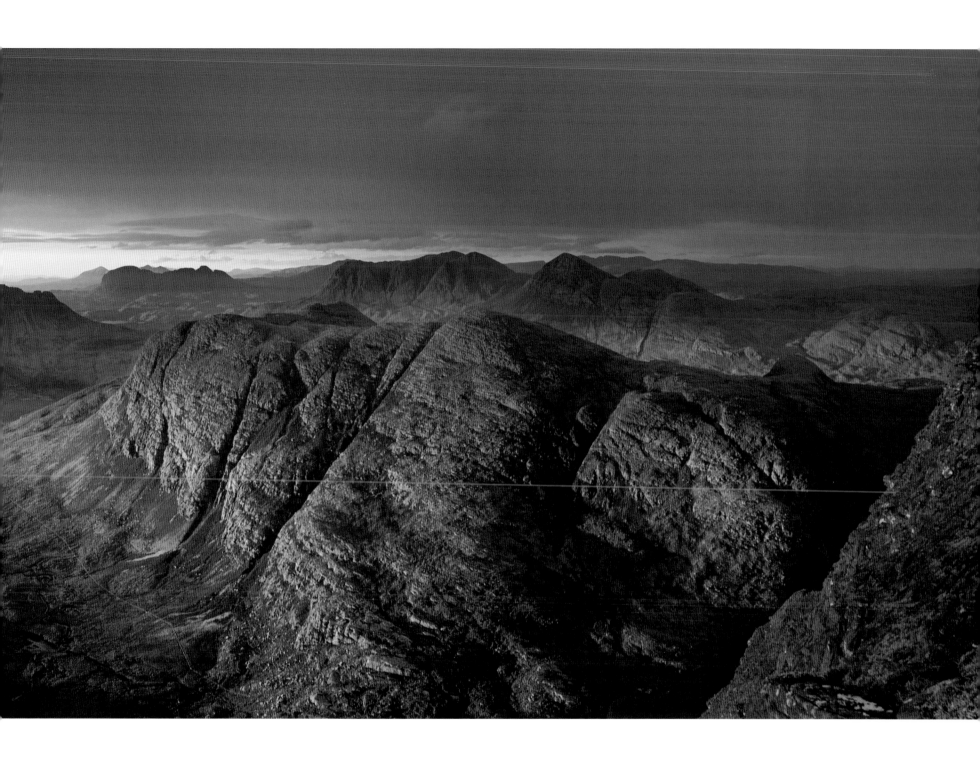

LIVING THE VIEW

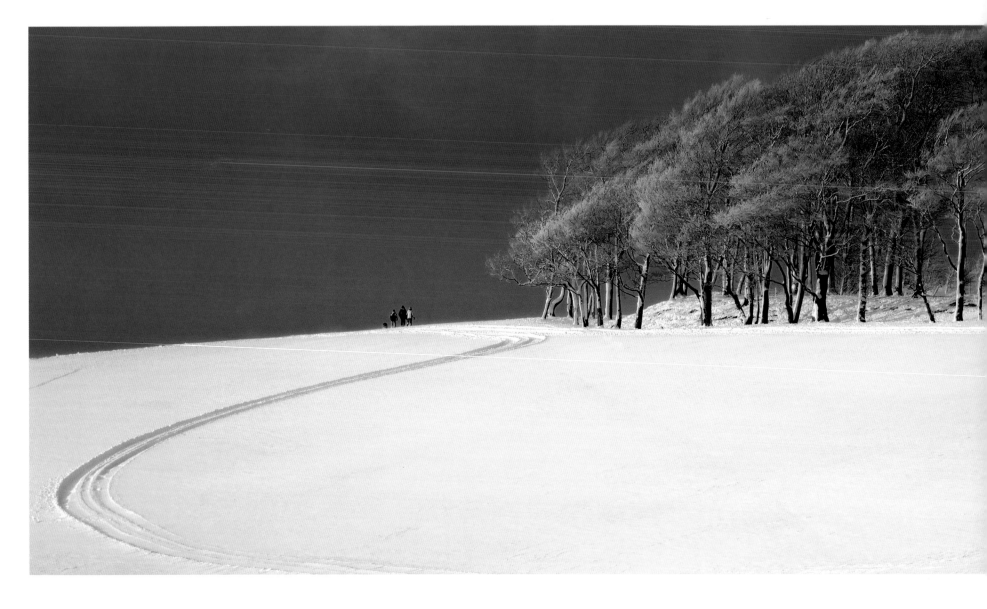

**TIM MORLAND**                                                    **2010**

Chanctonbury Ring
*South Downs, West Sussex, England*

My first visit to Chanctonbury Ring came after heavy snowfall in January. Access to my chosen car park
proved to be impossible so after just managing to get through to an alternative I trudged up to the ridge
with backpack and tripod. I found another photographer just packing up his equipment and it is him you
see, together with dog and children, disappearing over the horizon. Fresh tracks from a 4WD vehicle
completed a spectacular view. A wonderful winter's afternoon.

152

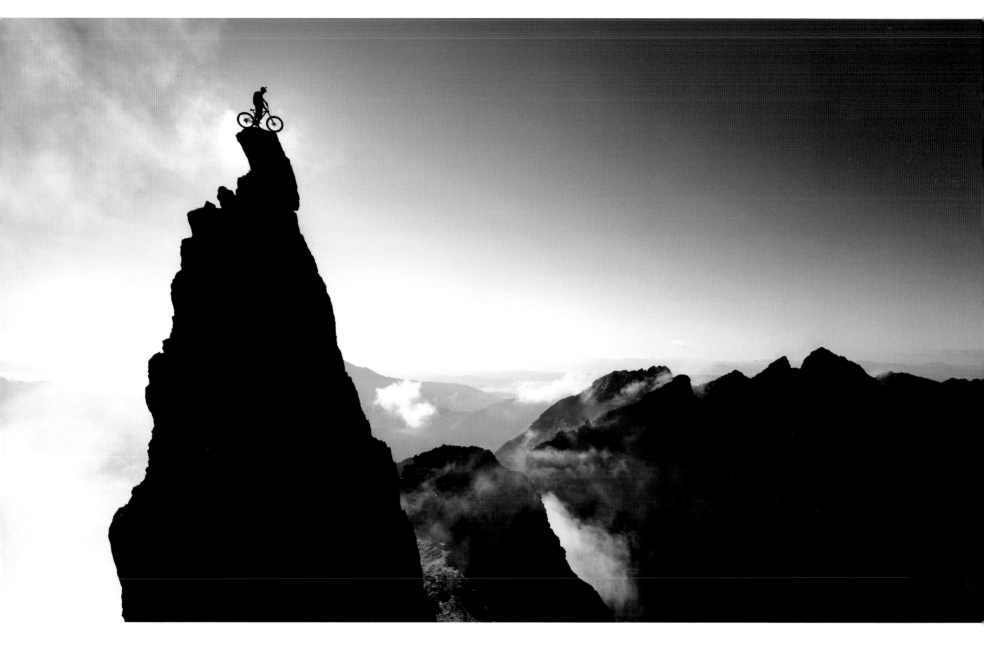

**CHRIS PRESCOTT**           **2015**

**Danny MacAskill on the Inaccessible Pinnacle**
*Isle of Skye, Scotland*

Danny MacAskill on top of the Inaccessible Pinnacle, the most difficult to access summit of the Cuillin Ridge on the Isle of Skye.

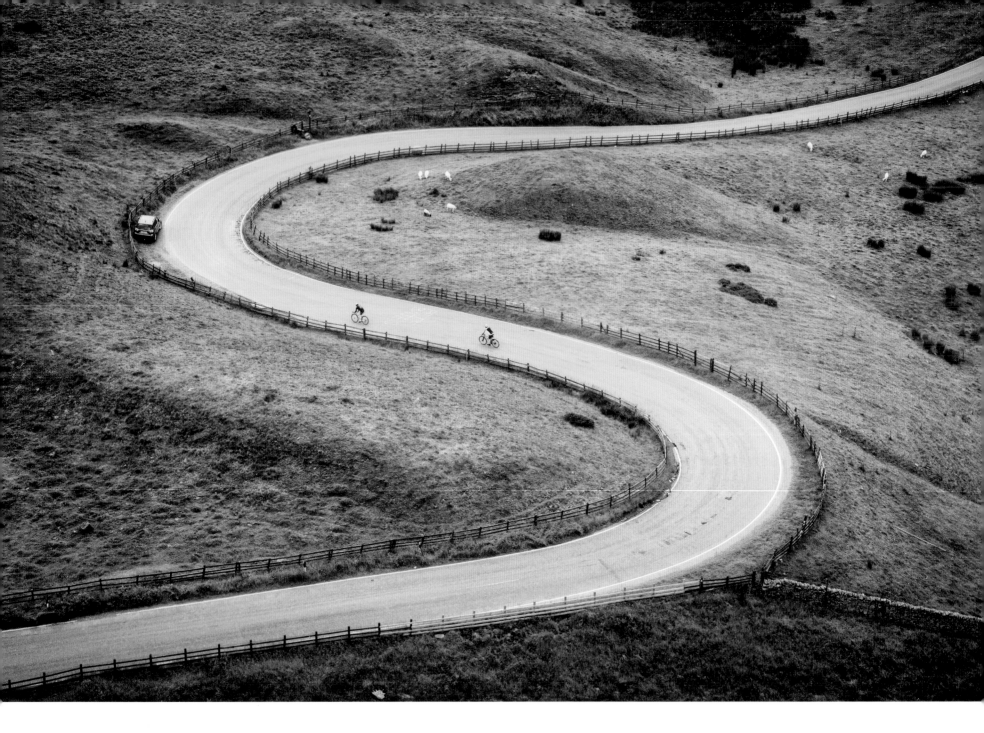

**GRAHAM DUNN**                                    **2016**

### Taking the S-bend to Edale
*Derbyshire, England*

This fantastically winding road at Mam Nick passes between Mam Tor and Rushup Edge in the Peak District. I have photographed it many times in varying conditions and, on this occasion, was delighted to find two cyclists enjoying the long descent into the Edale Valley.

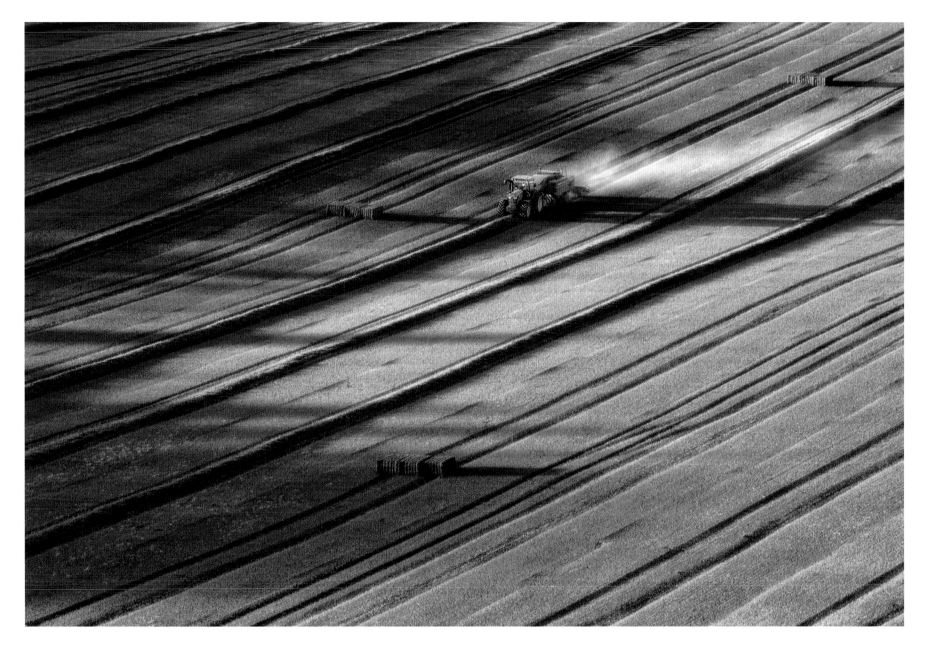

**MIREK GALAGUS**                                                                 **2013**

### Mind the Tractor
*Ashridge Estate, Hertfordshire, England*

Ashridge Estate is filled with woodlands and picturesque fields. The beauty of this landscape can be admired from the top of its many hills. I came across this particular field years ago. One day, having finished work early, I decided to visit it for a breath of fresh air. When I got there in the late afternoon the sun was still high up. I saw a tractor on the neighbouring field. I set the frame hoping that the tractor would get to the right place before sunset. I was very fortunate; it arrived just 15 minutes before the sun hid itself behind the hills and drowned the whole field in shadow.

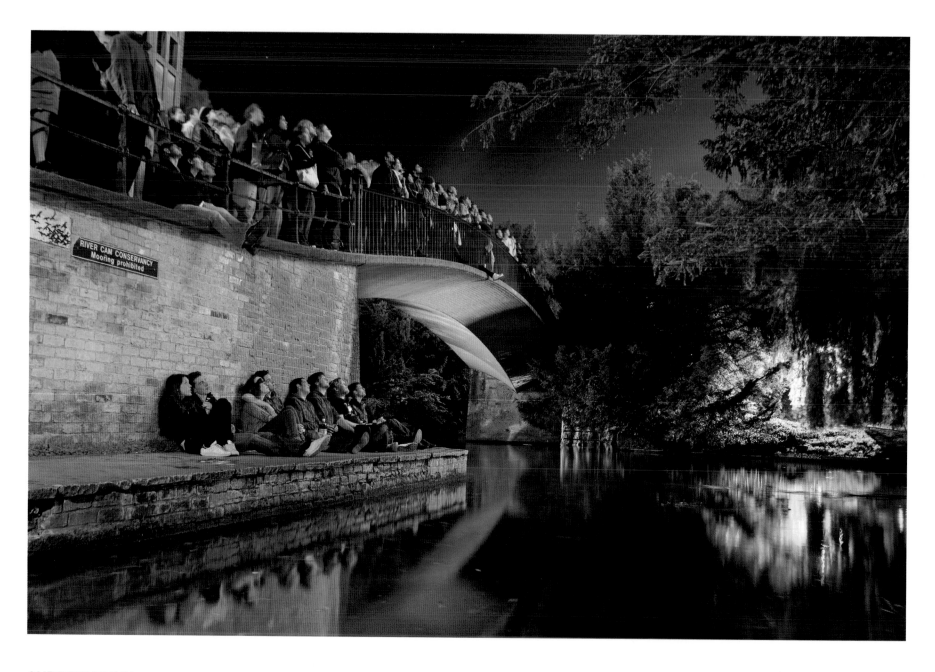

## ANDREW DUNN

<div align="right">

**2011**

</div>

### Watching the May Ball Fireworks
*Cambridge, England*

People crowd onto Garret Hostel Lane Bridge, over the River Cam, in order to get the best view of the fireworks that are part of Trinity College's May Ball, their faces illuminated by the burst of a red shell. During 'May Week' (which now lands in early June, following exams), many Cambridge colleges hold lavish balls — dancing through until dawn. The entertainments vary but, on most nights of the week, at least one of the colleges will include an impressive fireworks display.

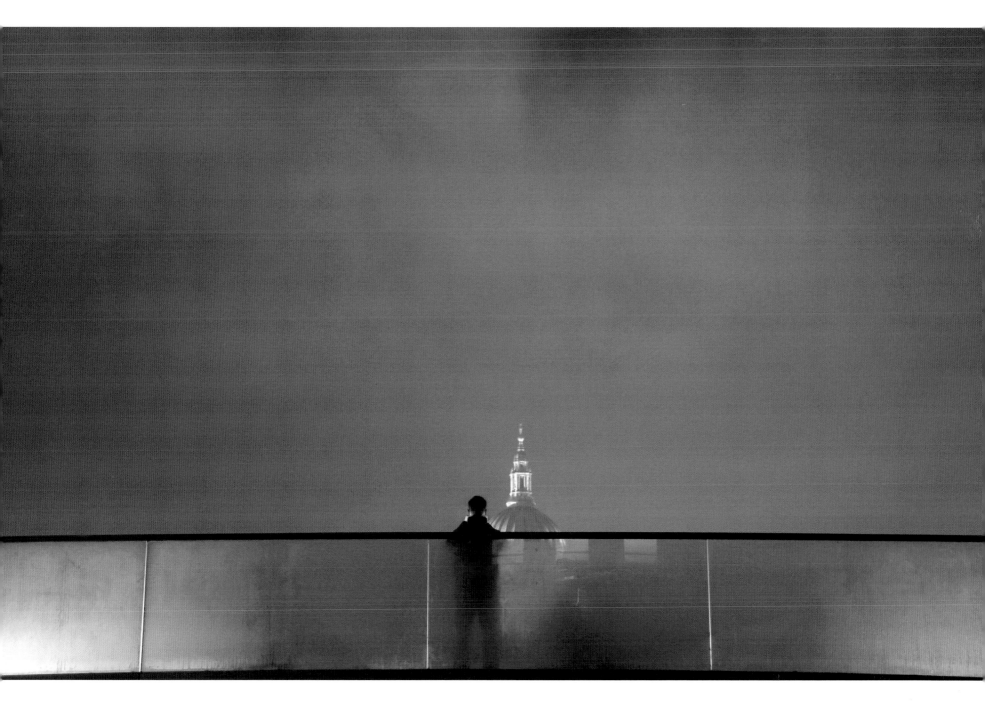

**DAN LAW** 2009

Millennium Bridge
*London, England*

A tourist pauses to take a photograph of St Paul's Cathedral from the Millennium Bridge in central London. This picture was taken in the late afternoon just a few days before Christmas.

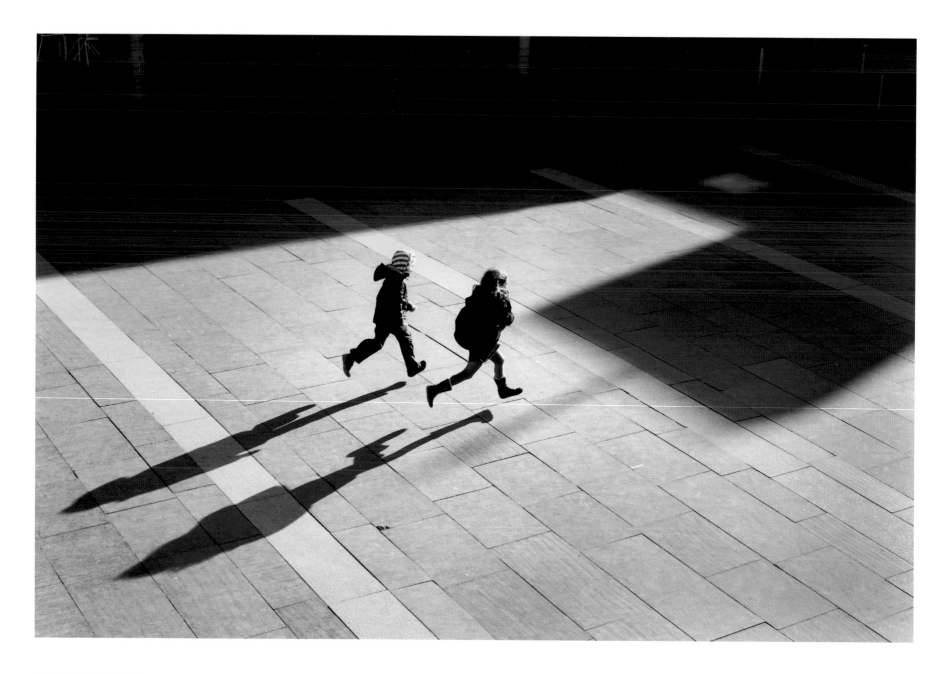

**TATIANA ZIGAR**           **2012**

Weightlessness
*South Bank, London, England*

Taken in front of the National Theatre on the closing day of the Landscape Photographer of the Year 2011 exhibition. I decided to hang around in front of the theatre to watch people, enjoy the sun and look for shots. My camera was at hand as usual. I went up the stairs near the entrance (one of my favourite positions is to shoot from above) and noticed a nice frame on the ground made by shadows. When I saw the kids running I composed the shot and waited for the 'decisive moment'.

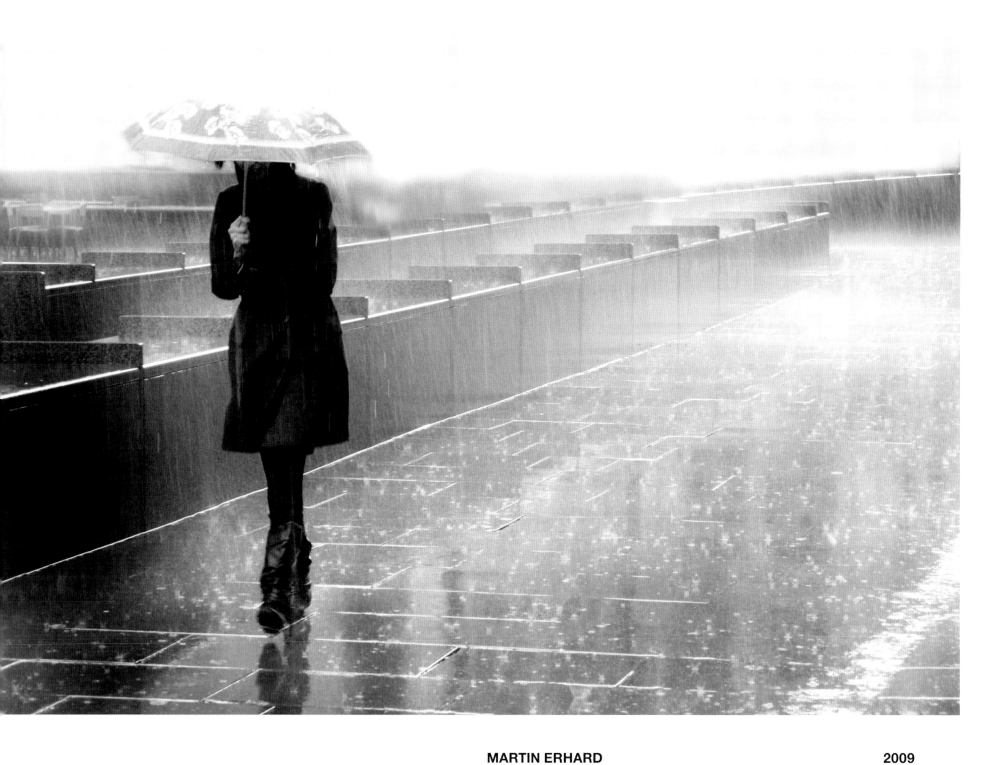

**MARTIN ERHARD**                                                                           **2009**

### Downpour in the City
*London, England*

I was making my way past the Gherkin building when there was a sudden cloudburst. I ran for shelter but looking back down the street saw this solitary girl braving the elements with just a flimsy umbrella. I grabbed the camera from my bag and just managed to capture this one image before she passed.

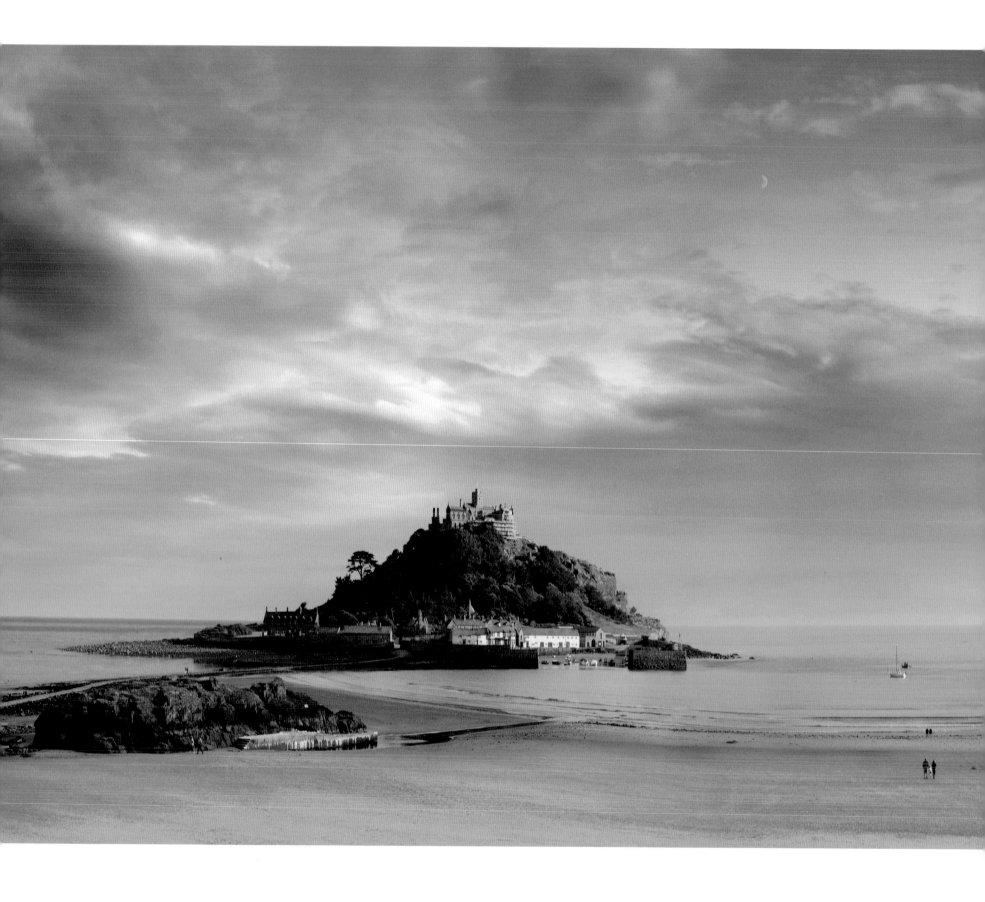

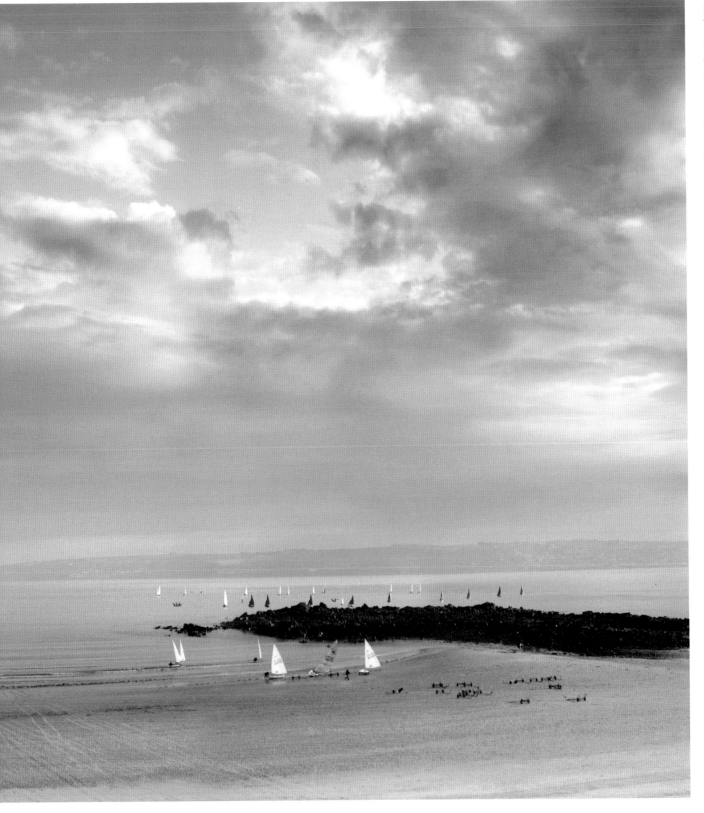

### Sailing
*St Michael's Mount, Marazion,*
*Cornwall, England*

With this image I wanted to present a different take on the often photographed view of St Michael's Mount from Marazion. The sun dipping away over to the west bathed the sands in a beautifully warm, hazy light as the boats from a sailing club launched themselves into the bay one by one. The line of rock to the right, surrounded by the little triangles of red and white, instantly caught my eye as the perfect balance to the venerable mass of the mount.

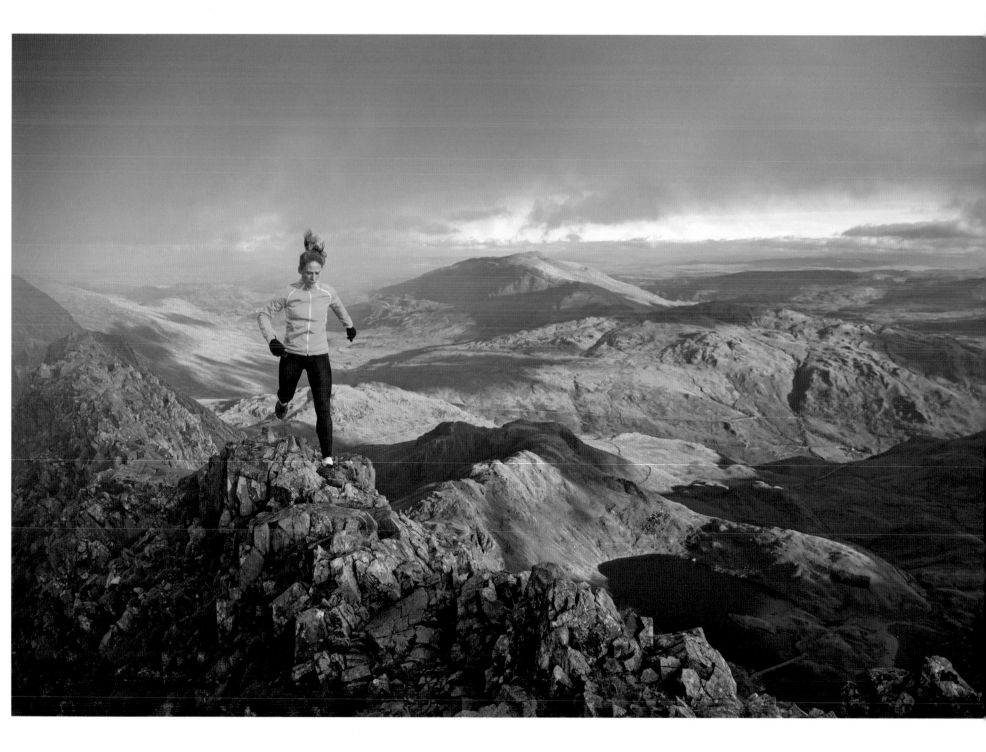

**LUKASZ WARZECHA**                                        **2016**

Running Crib Goch
*Snowdonia, North Wales*

Sarah Ridgeway during practice for her record-breaking run on the Snowdon Horseshoe in the
Snowdonia National Park. It usually takes about eight hours to complete this walk; Sarah's record time
is 1 hour 43 minutes.

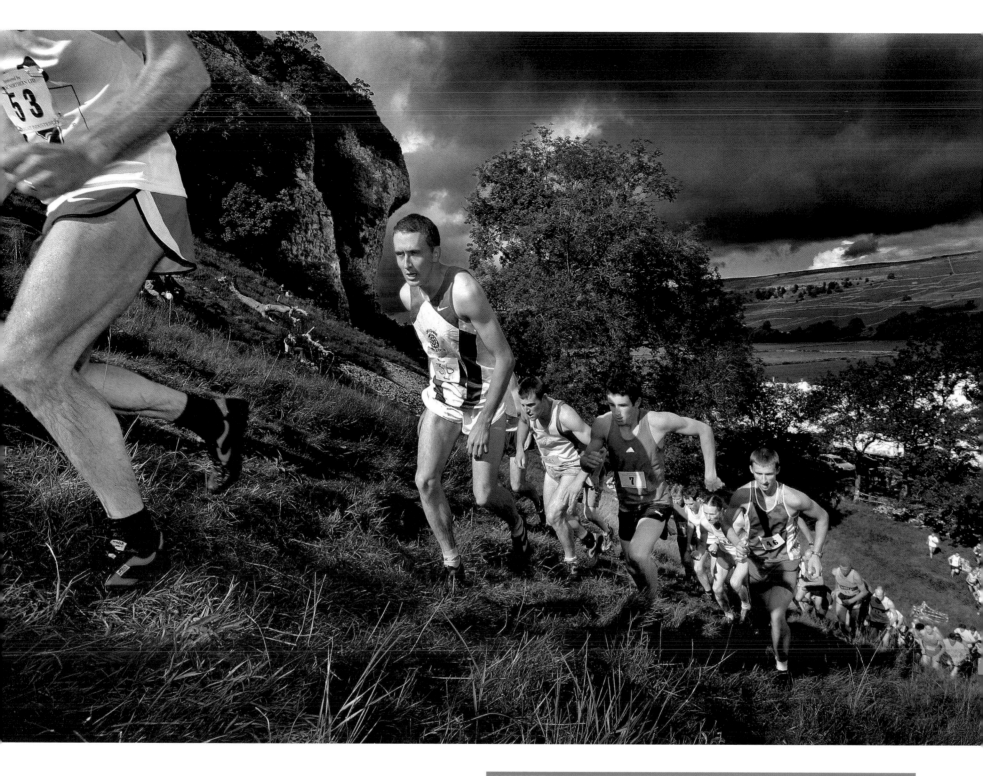

## STEPHEN GARNETT

### The Kilnsey Show Fell Race
*North Yorkshire, England*

For hundreds of years the sport of fell running has been an integral part of shows and events in northern England. Here, the Yorkshire Dales offers a stunning backdrop as these hardy runners ascend Kilnsey Fell as part of Kilnsey's annual traditional agricultural show.

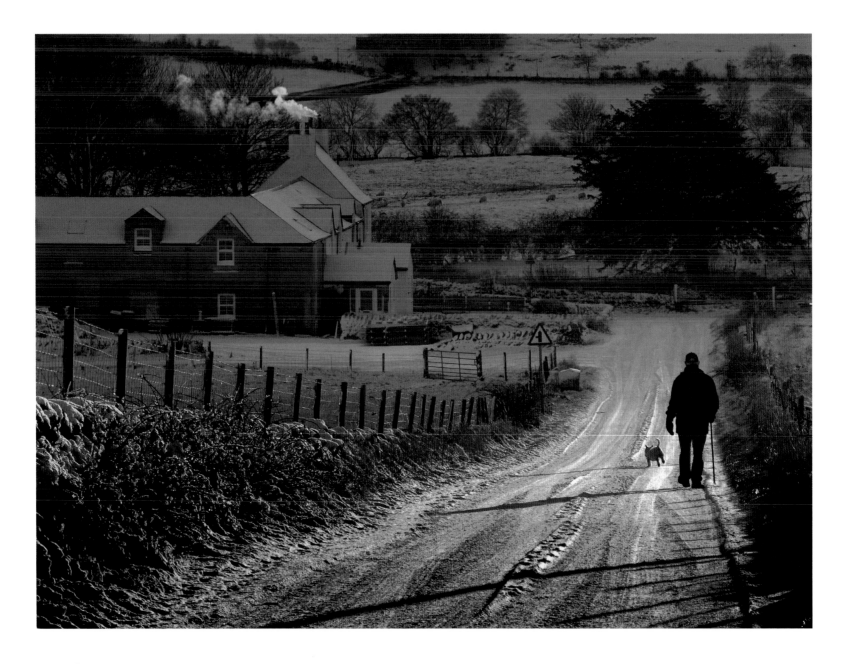

## BILL CROOKSTON                                                    2012

### Winter Evening Walk
*Near Kilmacolm, Inverclyde, Scotland*

This image only came about because it was exceptionally cold (−15°C). As we walked along the cycle path near our home, we saw the dog walker ahead of us and he turned off the path and headed down towards Auchenbothie Mains House near Kilmacolm and into the most amazing light! The truly great pictures, I believe, are the ones taken on the camera and not assembled from many sources to make up one that never existed. I've been capturing images since I was a teenager. My interest in photographing 'almost anything' has created a fascinating record of ordinary scenes that many would walk by without a second glance. I'm a self-taught photographer and find that our Scottish landscape and seascapes provide ample opportunities to capture our distinctive light throughout the various seasons. Many of my most successful images are of my local area.

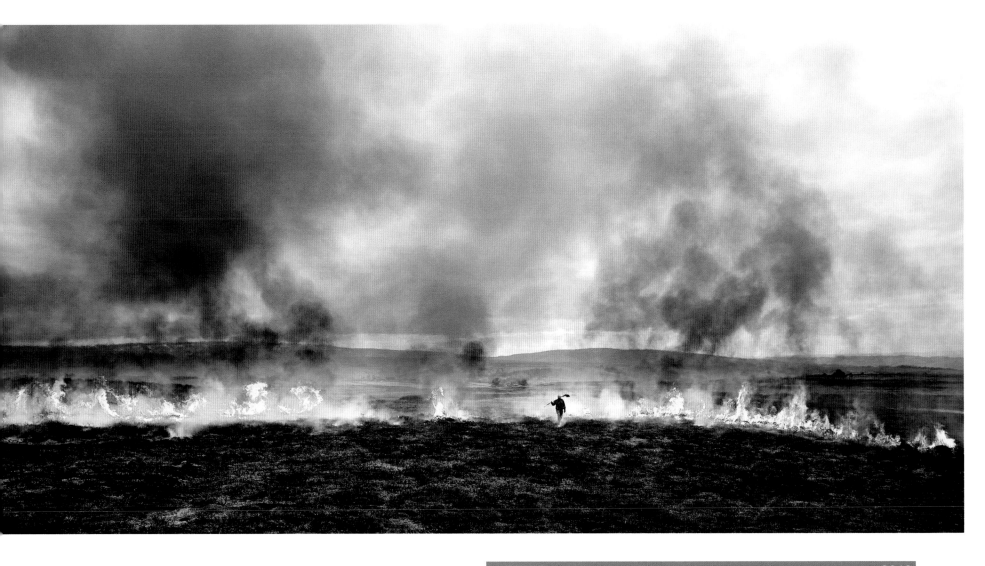

## JON BROOK

### Heather Burning
*Lancashire/Yorkshire border, England*

Heather becomes tall and woody with age and a poor source of food for moorland wildlife, particularly grouse. During spring and autumn each year, heather burning takes place throughout the upland areas of the British Isles to encourage the natural regeneration of the plants. The heather is burnt in strips approximately 30 metres wide. This gives a sufficient area for the plant's new growth, which over the next few years will provide food for the grouse during the breeding season. The areas of old heather that are left provide cover from predators for the nesting grouse and their young. This photograph is of the gamekeeper from the Fourstones Estate controlling the last burn of the day.

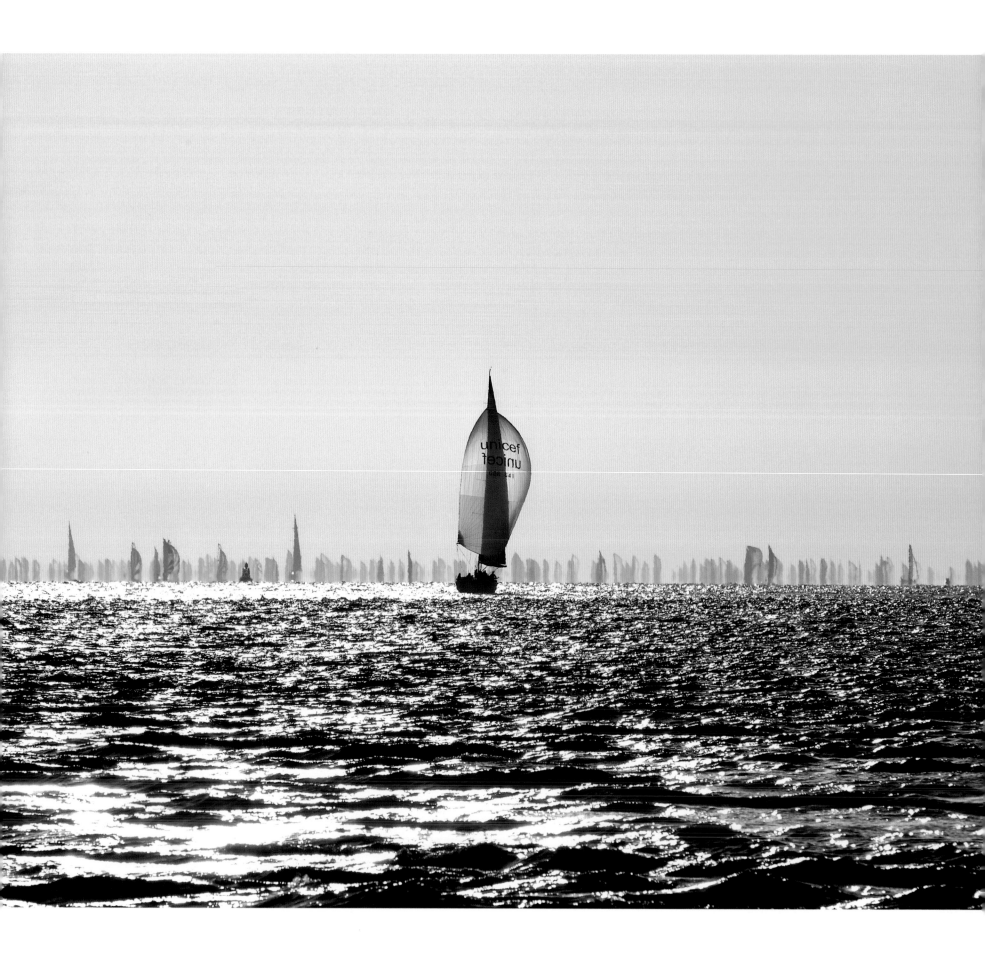

## BAXTER BRADFORD ◄

### Round the Island from Hurst Castle
*Hampshire, England*

The 'Round the Island' race involves over 1,500 boats. This was taken from Hurst Castle at just after 6am as the bulk of the yachts were making their way down the Solent. I prefer to walk out there early to get the best of the light on the first boats and then leave once it has deteriorated.

## IAN LAMOND ►                                           2012

### Evening Walk along the Pier
*Saltburn-by-the-Sea, North Yorkshire, England*

After an evening photographing Saltburn, I reached the top of the cliff as the pier lights were switched on, creating a lovely mix of cool and warm light. I will forever thank the lady who stood still in the centre of the pier as everyone else became blurred.

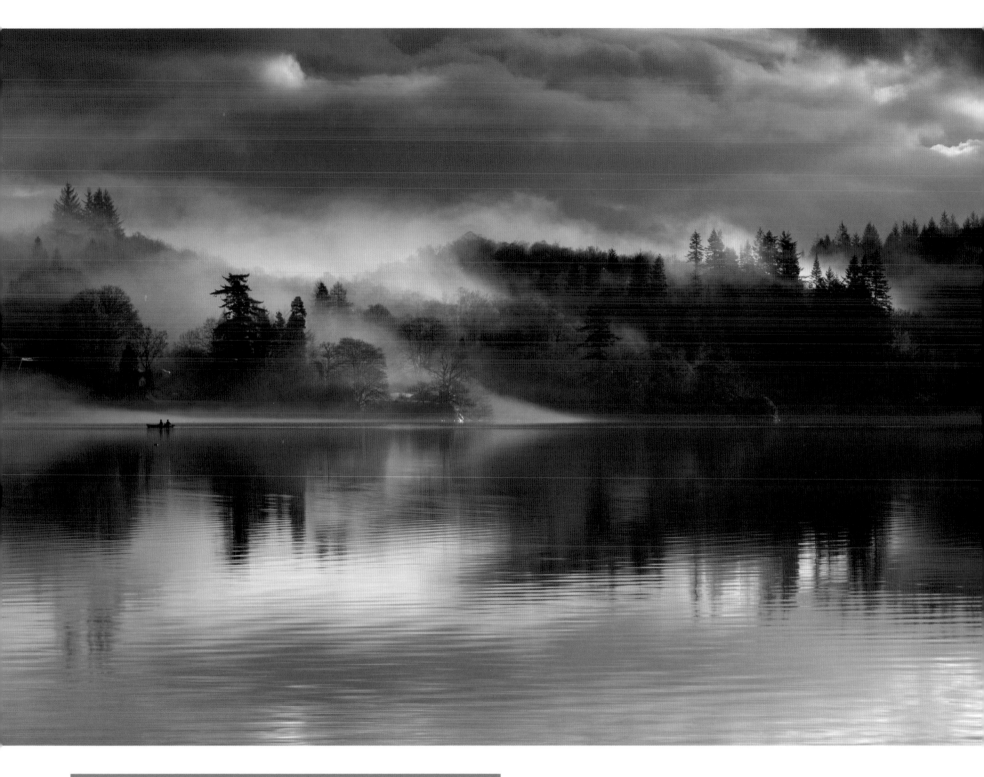

## PAUL BUNDLE

### Fishermen on Loch Ard
*Trossachs, Scotland*

Dawn in March and it was raining. For over an hour, the scene kept changing from clear views to dense mist. I had just taken a clear sunlit reflection towards the western end of the loch when at the opposite end the mist was lifting, revealing an almost monochromatic mixture of light, shadow and reflection.

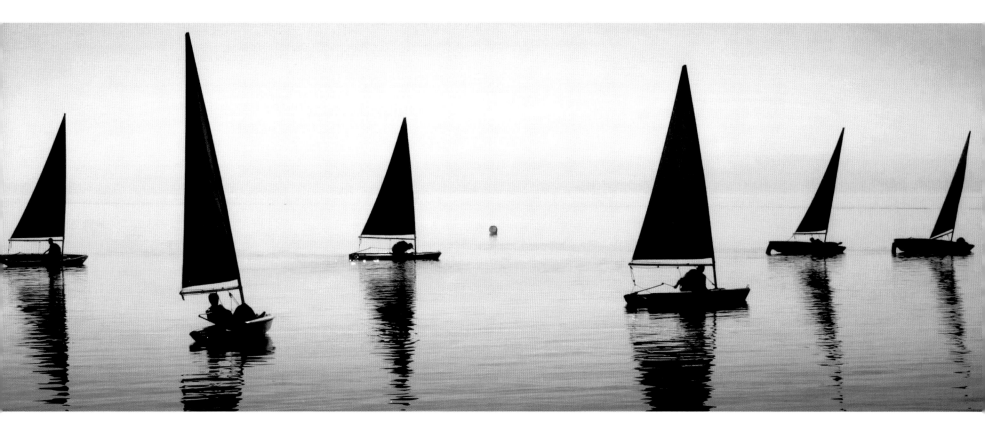

**STEVE DEER**                                                                                        **2007**

**West Kirby**
*Wirral, England*

This image was taken at West Kirby Marine Lake on the Wirral. The day was fairly calm and the graphic shapes drew me to the scene, particularly those of the hunched sailors.

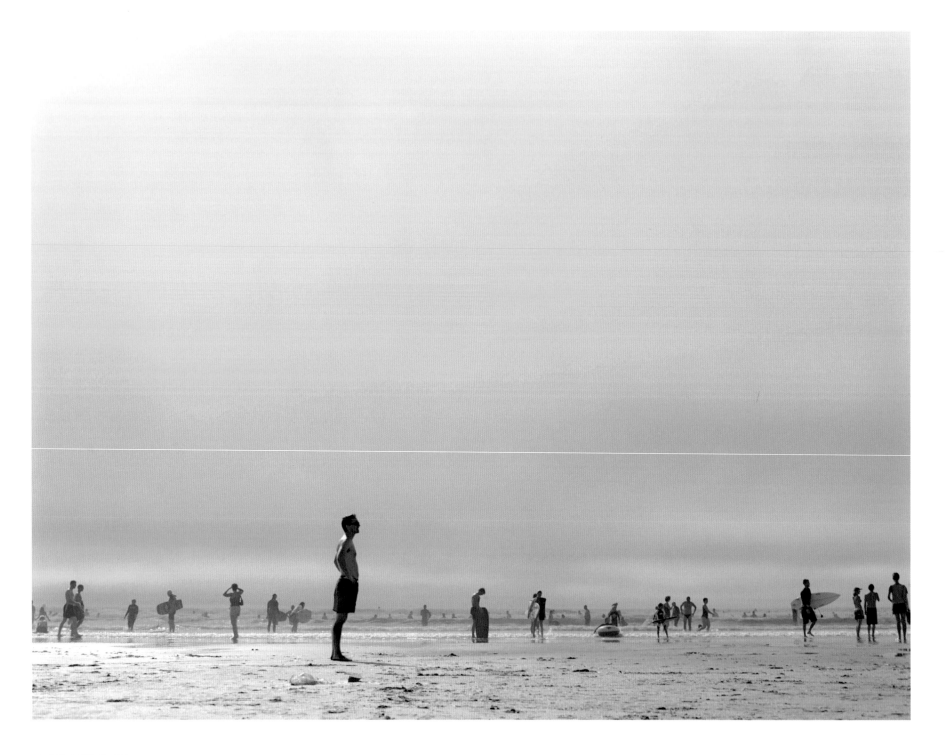

**RICH HENDRY**                                                      **2007**

**August Bank Holiday**
*Croyde, Devon, England*

This shot was taken at Croyde in Devon on a very busy August Bank Holiday weekend. I arrived at the
beach in glorious sunshine about an hour before I took this picture, but as I unpacked my kit the horizon
started to darken, and slowly a mist started to roll in.

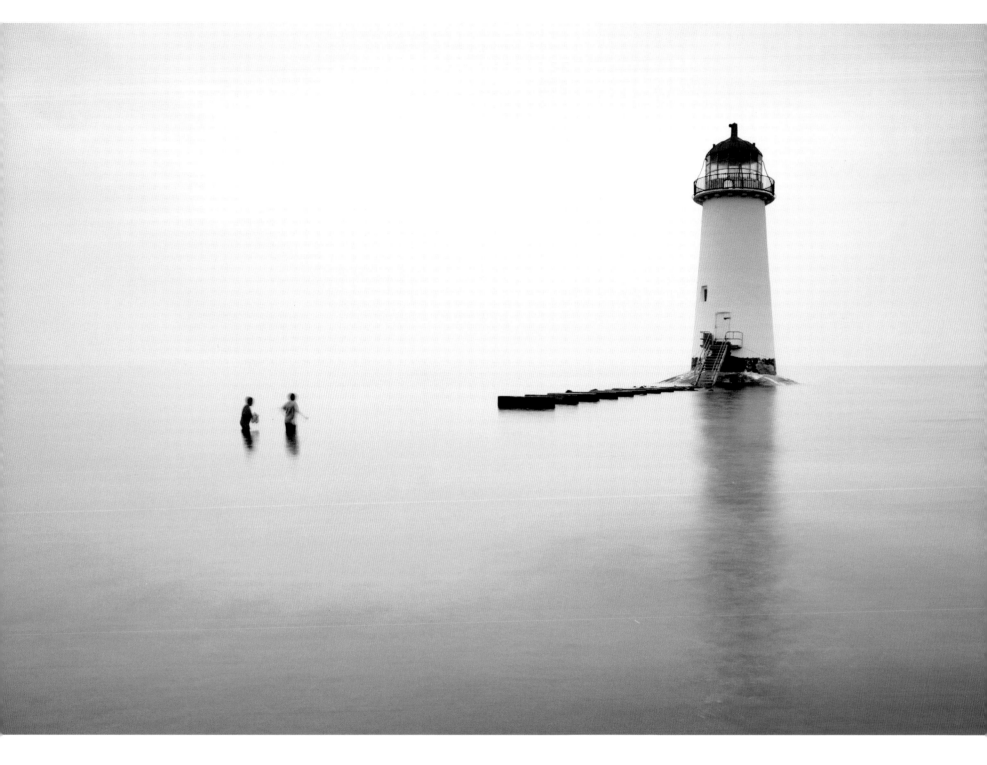

**CHRIS MILES**          **2011**

**High Tide at Talacre**
*North Wales*

'It gets warmer the longer you've been in,' that's what one lad said to the other as they waded towards the lighthouse.

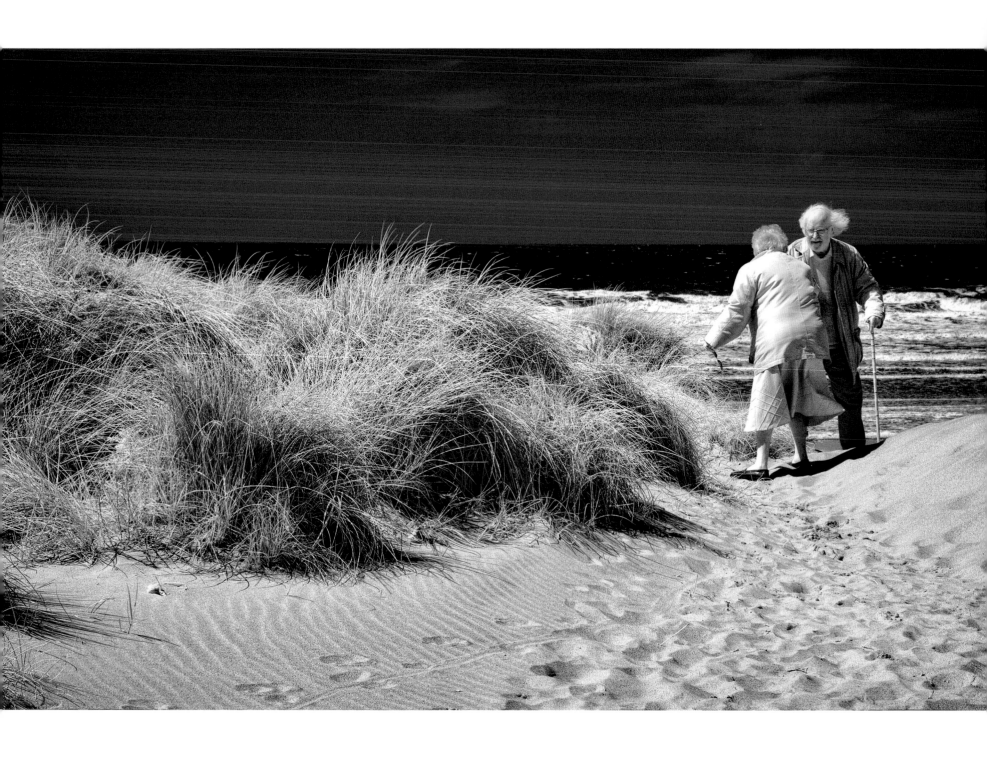

## TONY WINFIELD ◀       2015

### The Encounter
*Llangennith Bay, Gower Peninsula, Wales*

I spotted two elderly people at the edge of the dunes at the entrance to the beach. The man turned round to the lady to tell her that it was too windy on the beach, his hair blowing about wildly. The encounter was a 'decisive moment' that was too good an opportunity to miss.

## WINNER       2014
## JO TEASDALE ▶

### Fred 'n' Sue
*Brighton, East Sussex, England*

This image was captured during a blizzard on the Hove Lawns seafront in Brighton. Sue had to walk for miles with her bike, snow encrusted upon her back and her fingers frozen to the bone. Meanwhile her dog Fred ran alongside enjoying the snow. Sue just wanted to get back to the warmth of her home but Fred had other ideas ... all he was interested in was having a social with his friends on the lawns. Home wasn't on his agenda.

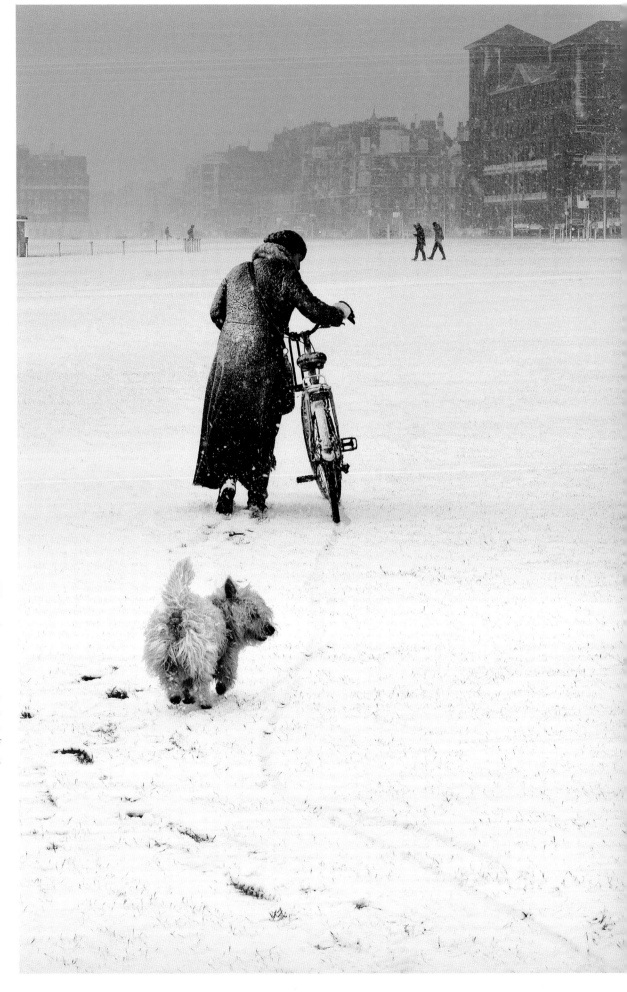

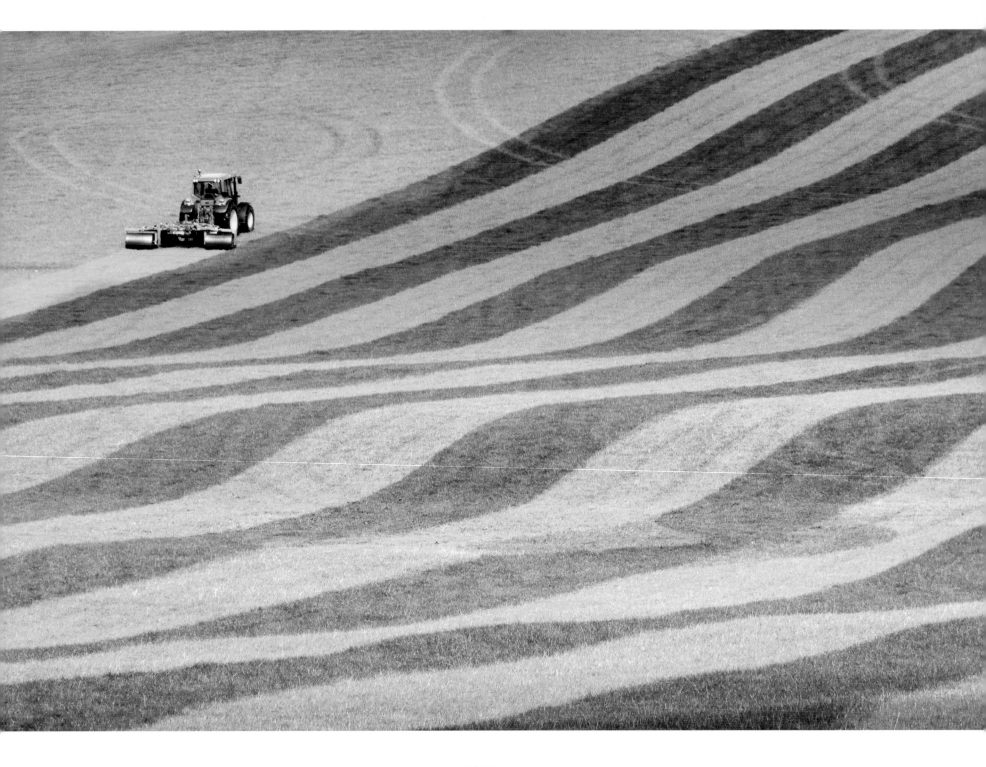

**ANNA WALLS**                                                        **2009**

One Man Went to Mow
*Kimmeridge, Dorset, England*

I was on my way to Kimmeridge Bay with a group of friends one evening in April when this beautiful
field caught my eye. I particularly liked the way the undulations of the land distorted the stripes and the
evening light warmed the whole scene.

## Ballintoy
*Northern Ireland*

I noticed some sort of religious service going on high up on the bank beside the little harbour. I realised this would make a great photo as the ceremony adds a bizarre touch to the magnificent scenery. In this frame, it looks like the sea was dividing and rising up as described in the book of Psalms 78:13.

*He divided the sea and caused them to pass through, And He made the waters stand up like a heap.*

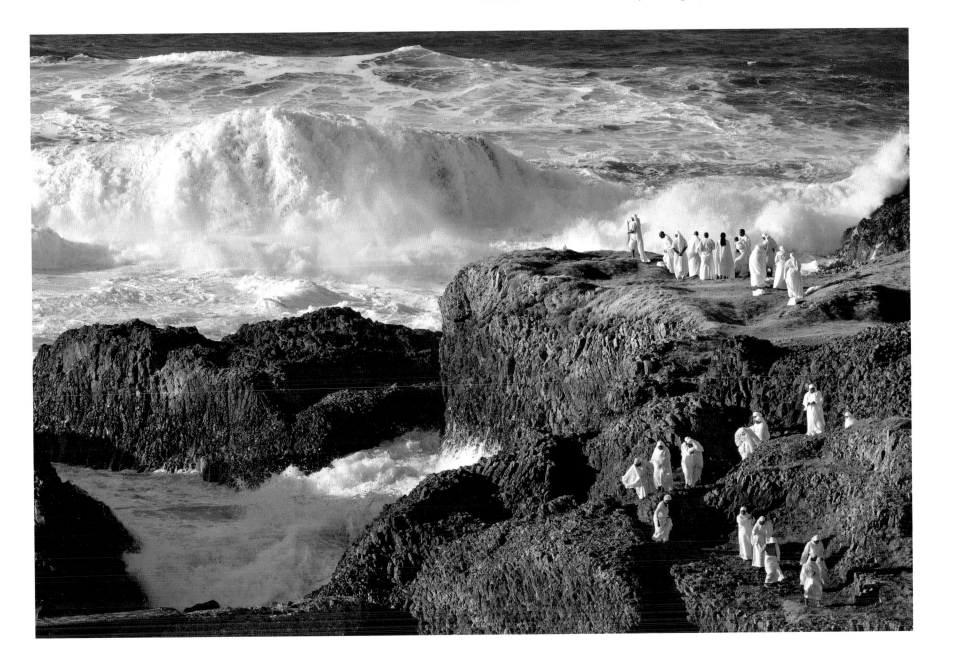

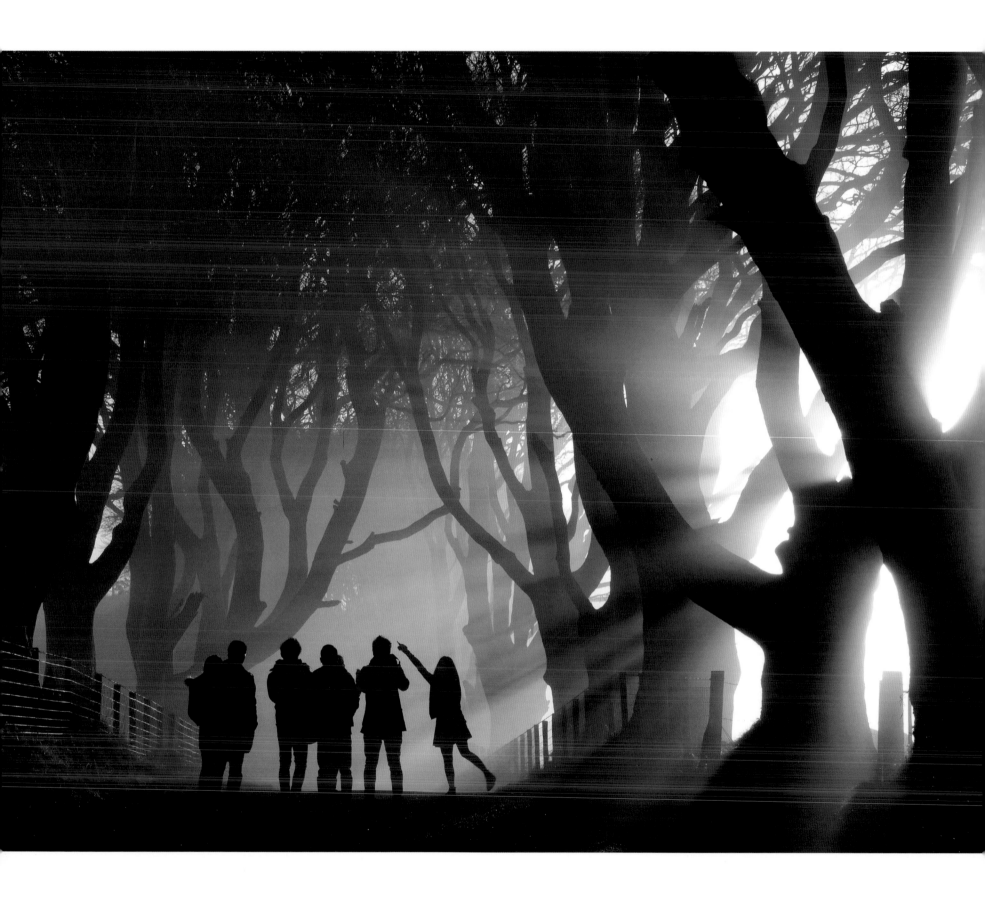

## BOB McCALLION ◀

### Mystical Morning, The Dark Hedges
*County Antrim, Northern Ireland*

This enchanting tunnel of beech trees has become a magnet for visitors from all over the world and it is hard to avoid people at any time of the year. As I pressed the shutter, a slim, almost elfin-like girl broke away from the main group and started pointing, as if to mimic the surrounding branches. I managed to capture her in mid-pose.

## RENATA ARPASOVA ▼       **2011**

### Angel of the North
*Gateshead, Tyne & Wear, England*

I wanted to create a different view of this iconic artwork. As the sky was just clear blue, I opted for an infra-red filter and 'contrasty' look. I wanted to create a time-lapse idea within the photograph, despite the place being empty.

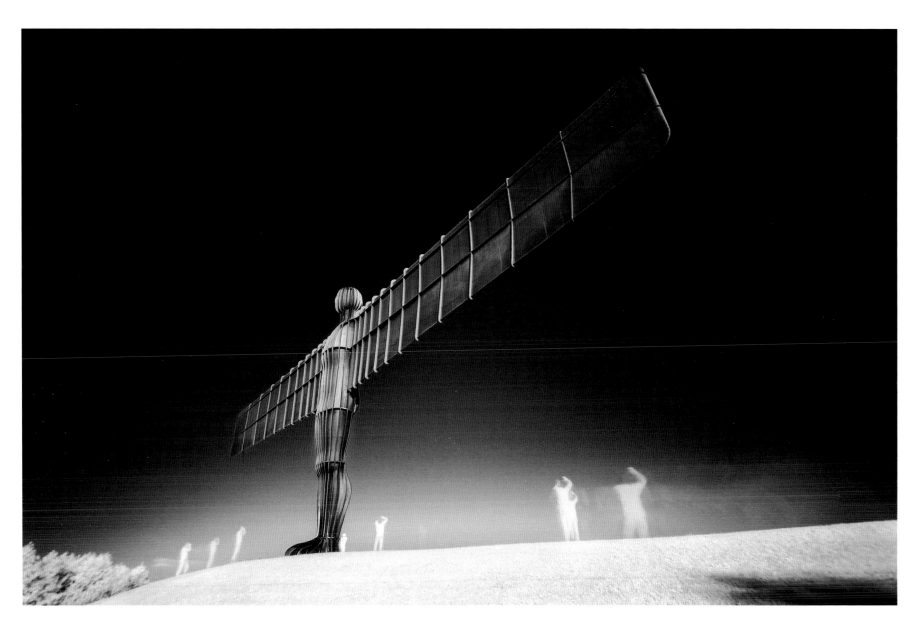

### The Hurting
*Cairngorms, Scotland*

This is one of the hardest trad mixed routes in the world and the first ascent by a female climber. Conditions were truly grim, with strong winds gusting up to 100mph and lots of fresh snow being blasted at you and the lens. Keeping the viewfinder and front element clear of snow was a challenge ...as was jumaring up the rope alongside the climber.

**WINNER**                    2015

**LIZZIE SHEPHERD** ▶

### Zigzag
*Wensleydale, North Yorkshire, England*

An opportune moment if ever there was one. We stopped at the top of a small hill in Wensleydale and, at the same time as a mini blizzard approached, I noticed a wonderfully formed zigzag drystone wall. Even luckier, a tiny figure could be seen walking in the field beyond. I just had time to get one photograph before the walker disappeared behind a little hillock and the moment was gone forever.

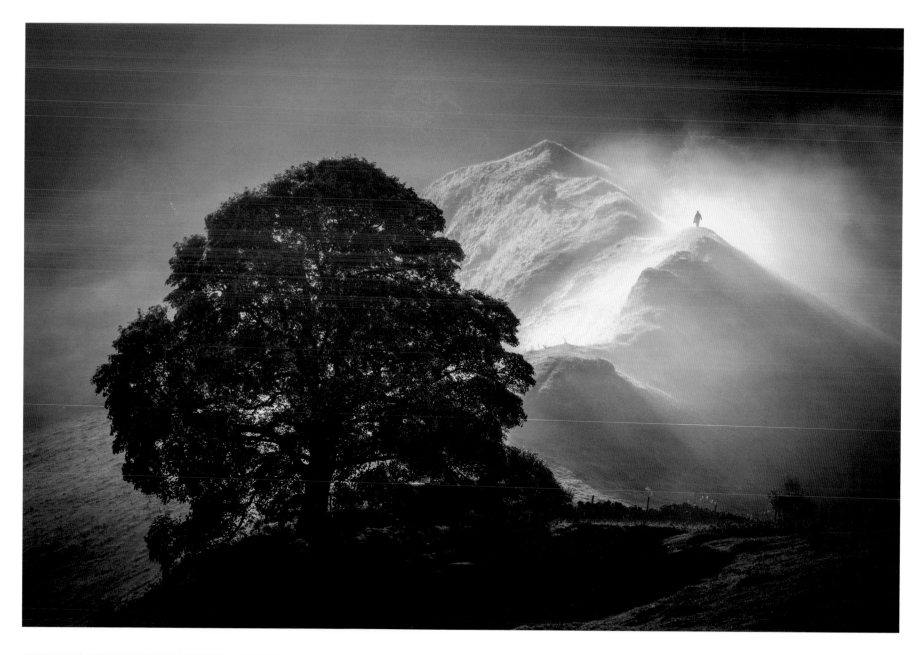

**WINNER** 2016

**MARTIN BIRKS**

Chrome Hill
*Peak District, Derbyshire, England*

The forecast looked good for a misty autumn morning, so I drove across from Lincoln to Chrome Hill in the Peak District. I'd wanted to capture a dramatic sunrise here for a while. It was a stunning view above the fog and there was a group of other photographers who I enjoyed chatting with. This one eventually made his way back down the hill and I liked the scale he added to the scene.

**OMER AHMED**

### Scull Boat on Loch Ard
*Trossachs, Scotland*

The sheltered position of Loch Ard (the High Loch) in the Trossachs National Park allowed a dense morning fog to linger. The isolated forms of tree-covered headlands started to appear and the silence was broken only by the splash of the blades.

## JASON INGRAM ◀

### Gardening at First Light
*Devon, England*

This shot was taken at 5am as the sun rose from behind the hills at Bertie's Cottage, Devon. The gardener, Patti O'Brien, is up with the lark most mornings during the summer months, tending her vegetable plot and enjoying the golden light. As she says, 'This really is the most beautiful time of the day, so silent and full of anticipation.'

## MAGDALENA STRAKOVA ▼ | 2015

### Through London Zoo
*London, England*

Visiting London Zoo for the first time, I was amazed at how large it is. It even spreads across Regent's Canal, which is excluded from the zoo grounds but in fact runs right through the centre. I was fascinated by the geometric shape of this aviary, the lines of the canal and the scale of the tiny human figure on the boat.

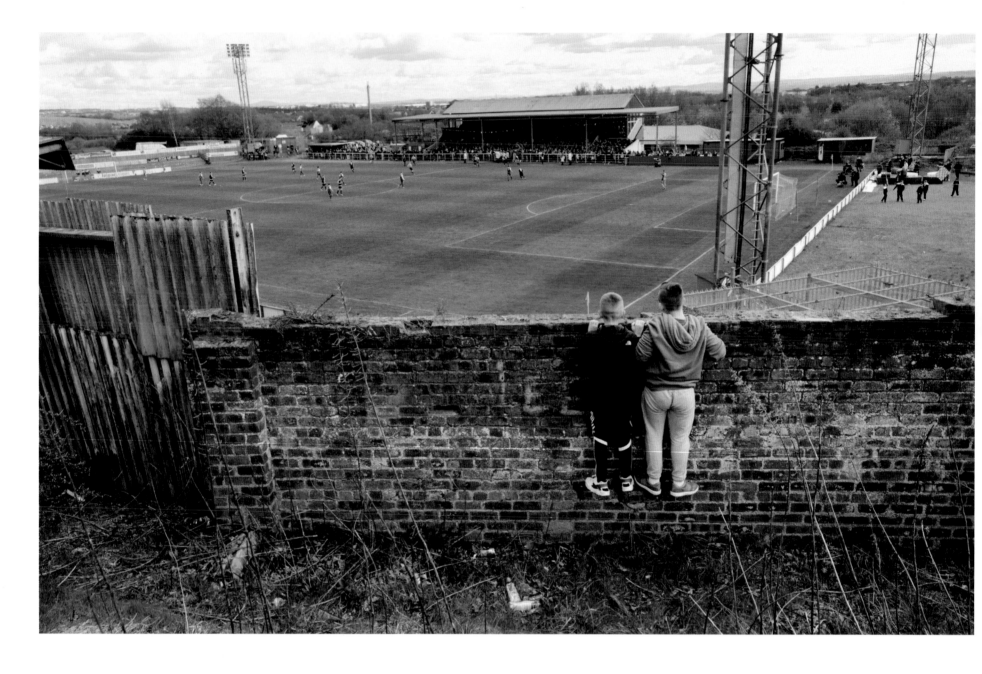

## IAIN McLEAN
2016

### Trophy Presentation Day
*Coatbridge, North Lanarkshire, Scotland*

This picture is part of a long-term project documenting the fans and environment of Albion Rovers Football Club, who play at Cliftonhill Stadium in Coatbridge. This particular occasion in April 2015 was to officially present the Scottish League 2 Winner's Trophy to Rovers and the stadium was bursting at the seams. There are always people watching from the hill outside the ground so, during the game, I left the stadium and approached some of these non-paying spectators. While photographing them, a couple of lads appeared and managed to find footholds in the old wall, allowing them to get a view of the game. The picture has a timeless feeling to it and this wall has been climbed by many youngsters over the years, all eager to get a glimpse of the Coatbridge Wizards.

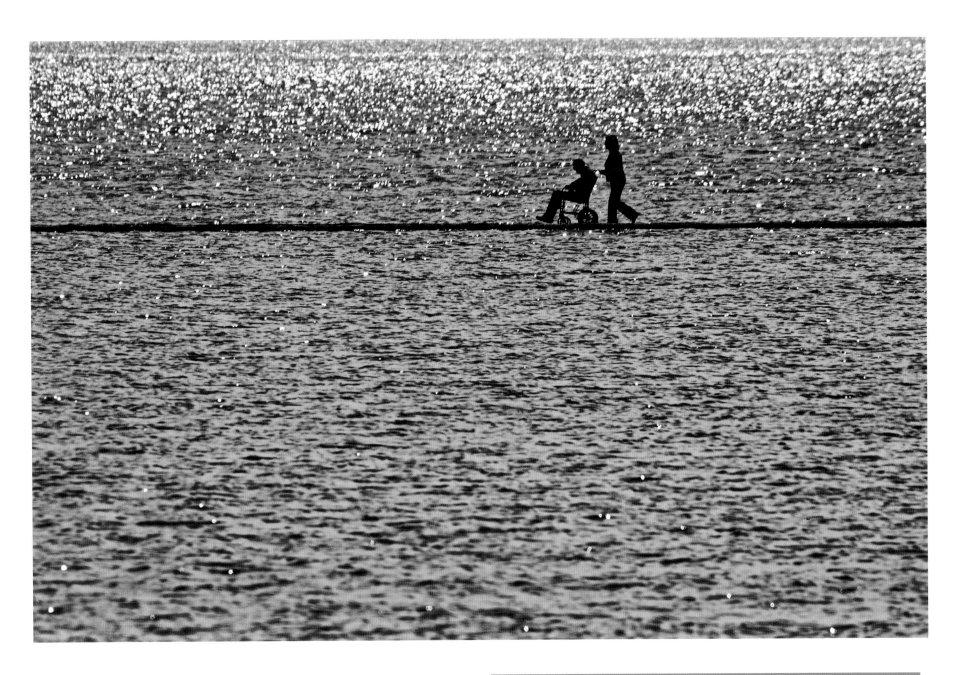

**WINNER**      **2007**

**JOHN DAVIDSON**

**A Stroll along the Seawall**
*West Kirby, England*

A man in a wheelchair is pushed along the seawall between the West Kirby marina and the River Dee on the Wirral in Merseyside.

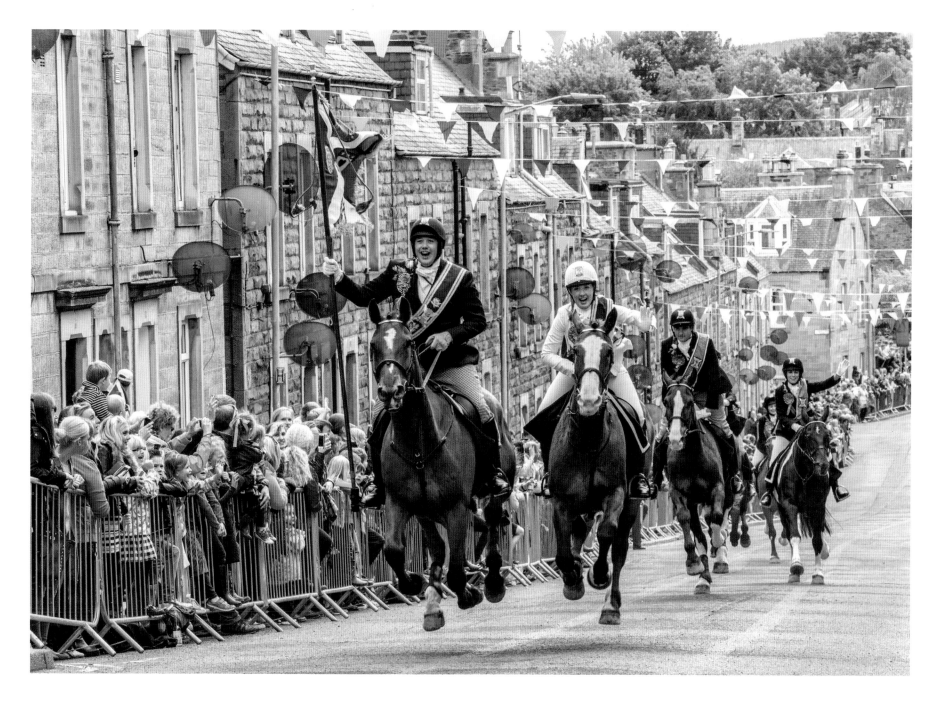

**GARY TELFORD** ◀                                   **2013**

### Comedy Carpet
*Blackpool, Lancashire, England*

I had the chance to visit the top of the Blackpool Tower and knew that this would give me a good view of the Comedy Carpet below. Being a sunny day, there were plenty of people walking on the carpet to help give scale.

**CURTIS WELSH** ▲                                   **2016**

### Charge!
*Scott Street, Galashiels, Scotland*

Final ride-out of Gala Week in Galashiels on the Scottish Borders. The Braw Lad and Braw Lass lead the charge up Scott Street to loud cheering and are followed by hundreds of mounted riders in this annual event.

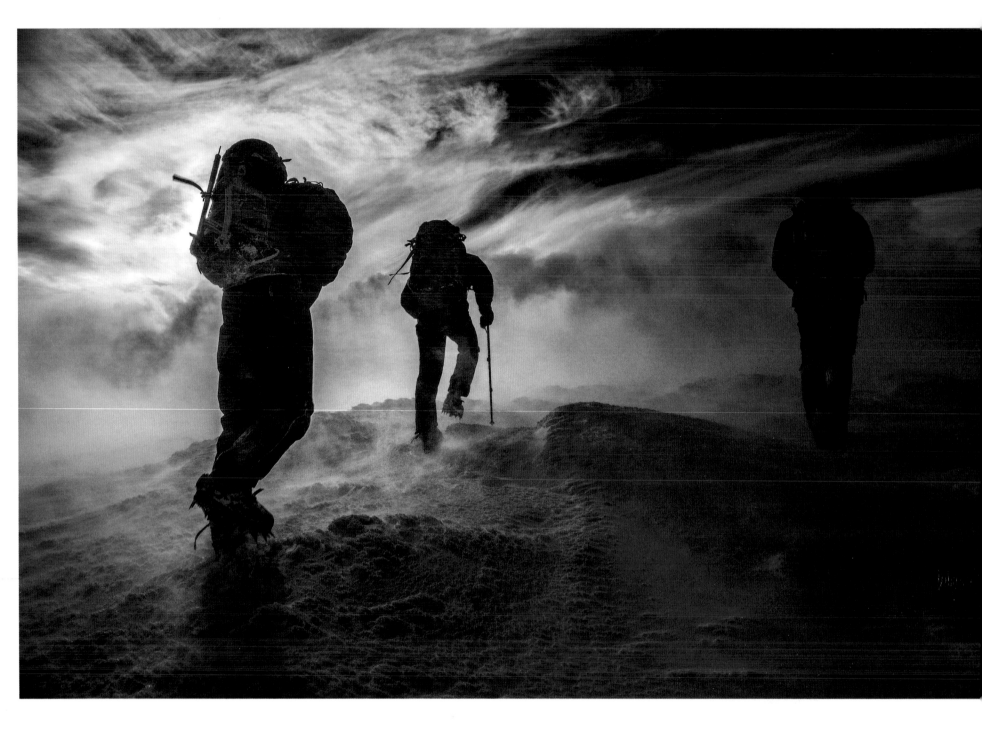

**TIM TAYLOR**                                          **2014**

### Cairngorms National Park in Winter
*Scottish Highlands*

Winter storm: battling high winds and heavy snowfall en route to the summit. Unforgiving conditions,
perfect for team training prior to our Himalayan expedition and a wilderness photographer's muse.

## The Shadow
*Barbican, London, England*

The powerful concrete forms of the buildings offered an imposing, theatrical backdrop to the ebb and flow of Daniel's artful movement – presenting an unexpected harmony of man and structure unforeseen by the architects. The summer's evening was beautiful, creating many shadows, and this particular view struck me, as if a solar projector had been laid on for just this moment.

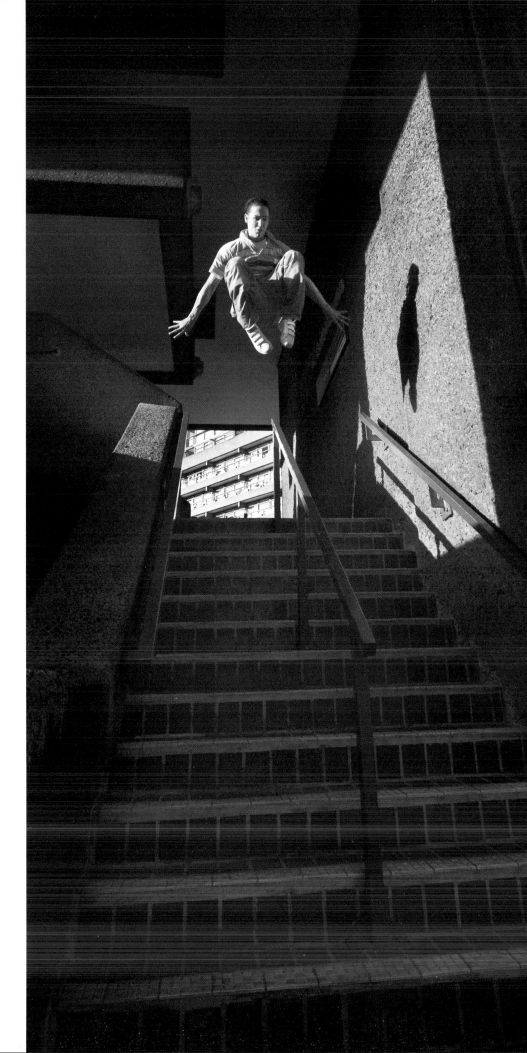

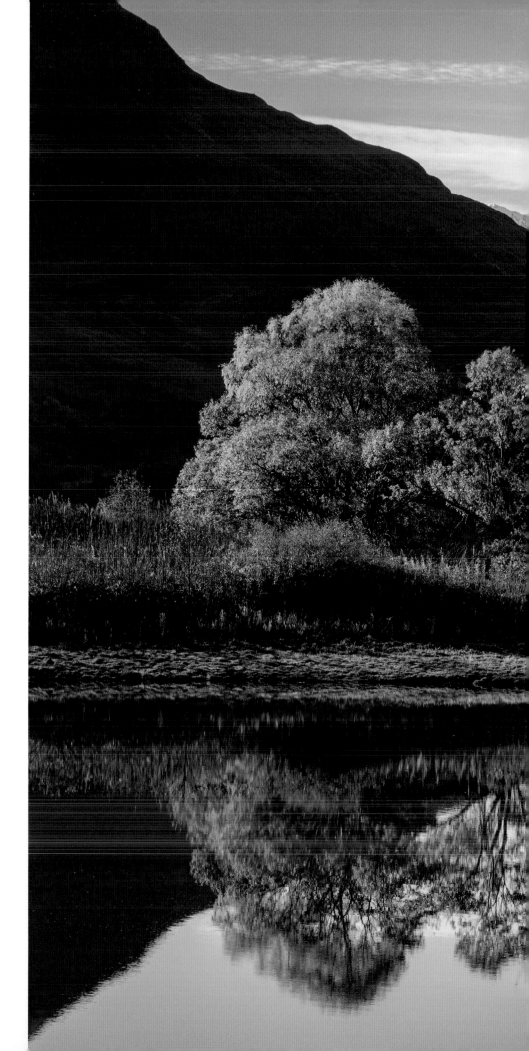

## DAVE BOWMAN                    2015

### Autumn on Loch Leven
*Highlands, Scotland*

I already had a pretty good idea of the image I was after as I travelled to Loch Leven. I'd calculated the time at which the November sun would highlight the autumn colours on the small island in the middle of the loch. However, when I arrived, it became clear the scene wasn't living up to expectations. I had a large area to the right of my frame with no real interest. Out of the corner of my eye I noticed a canoeist leaving the loch bank. Having set up my camera I thought it might be worth waiting to see where he was heading. As luck would have it he paddled straight towards the island tip, just where I needed him! This is one of those occasions when the stars aligned in my favour and I'm grateful to the canoeist, whoever he may be.

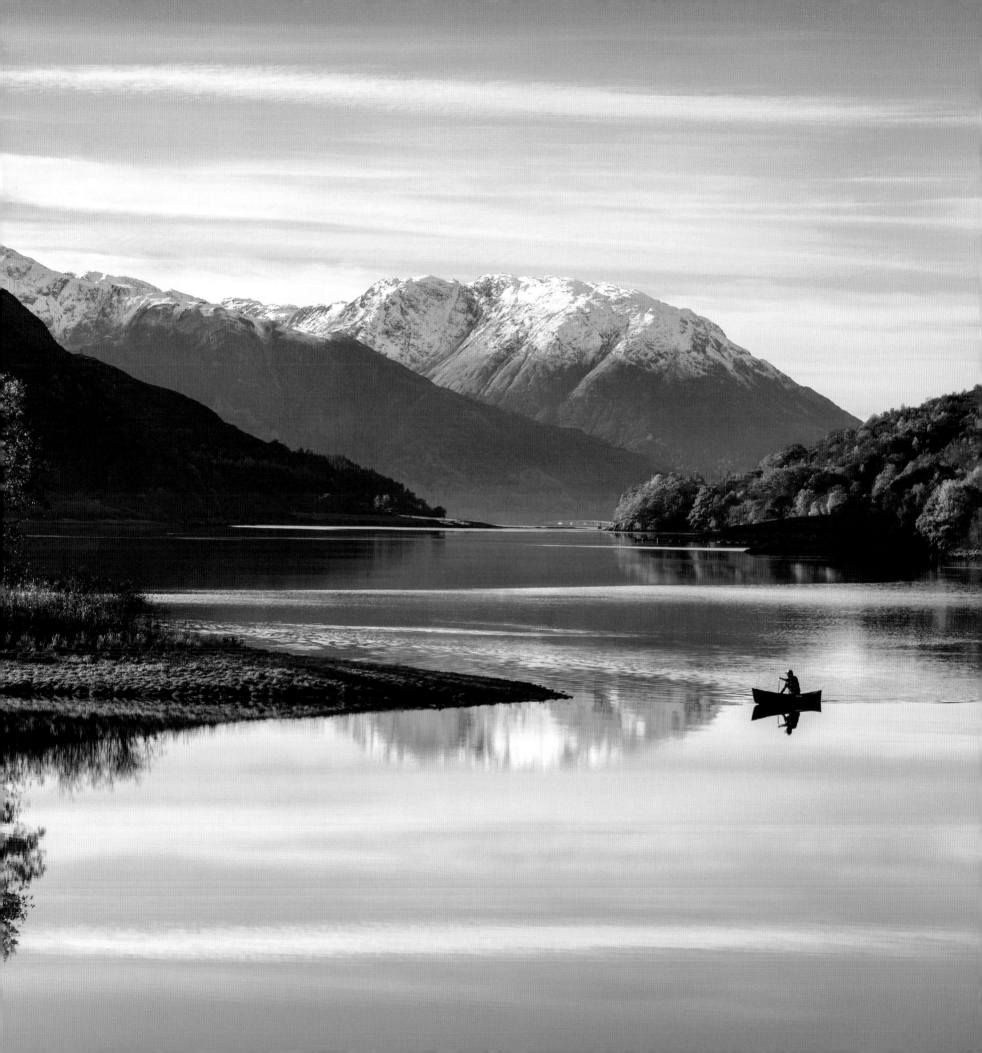

# URBAN VIEW

## TIMO LIEBER                                    2015

### Colour Blocks
*Felixstowe, Suffolk, England*

Taken from a small Cessna aircraft, this photograph is part of an aerial image series depicting man-made landscapes across the world. It shows the port of Felixstowe, Britain's biggest and busiest container port, and one of the largest in Europe. I particularly love the strikingly bright colours of the cargo containers that both contrast with and complement each other.

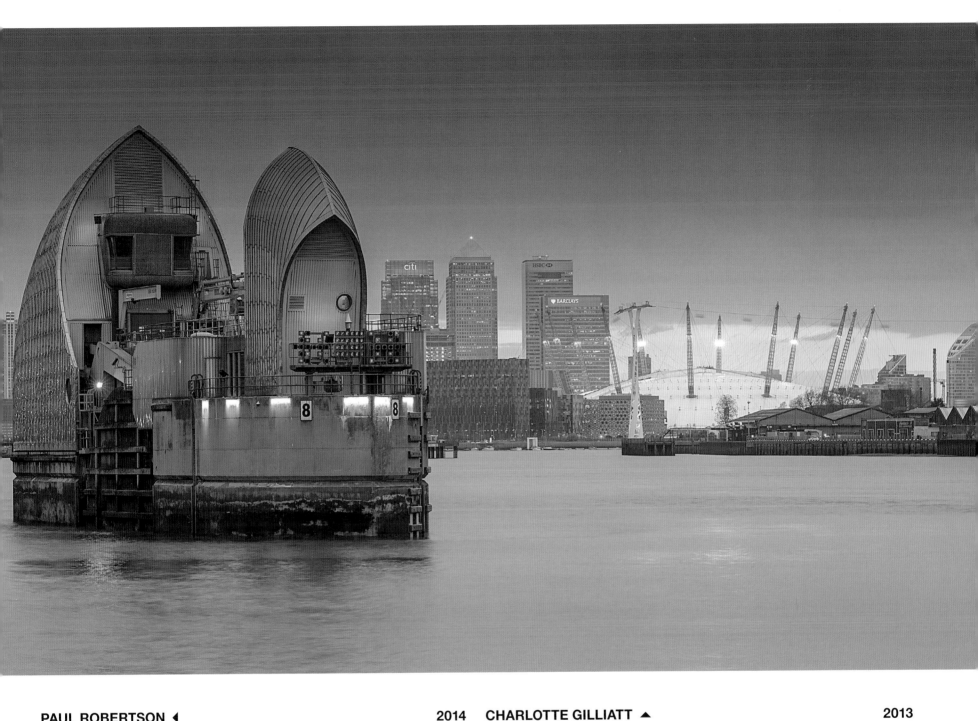

## PAUL ROBERTSON ◀     2014

### Liverpool One Shopping Centre
*Liverpool, Merseyside, England*

Liverpool is a favourite city of mine: vibrant, lively and the architecture is wonderful and diverse. Liverpool One is a fairly modern addition to the cityscape and no less interesting as a photographic subject than perhaps the better known and more frequently photographed Three Graces. I love the strong lines of the escalator and stairwell and waited some time to capture this frame as I was conscious I wanted people in the image to give scale and purpose to the architecture. My patience was rewarded when these two ladies travelled side by side up the escalator, giving the balance I was looking for.

## CHARLOTTE GILLIATT ▲     2013

### City Twilight
*London, England*

One of my favourite haunts along the river from Woolwich in London. A spring evening and a glorious sunset. I waited an age for the lights to finally come on to illuminate the barrier's defences, adding impact to the final image. I was conscious of getting as many of London's iconic buildings in the frame as possible. This was one of the last shots of the evening before the light changed altogether.

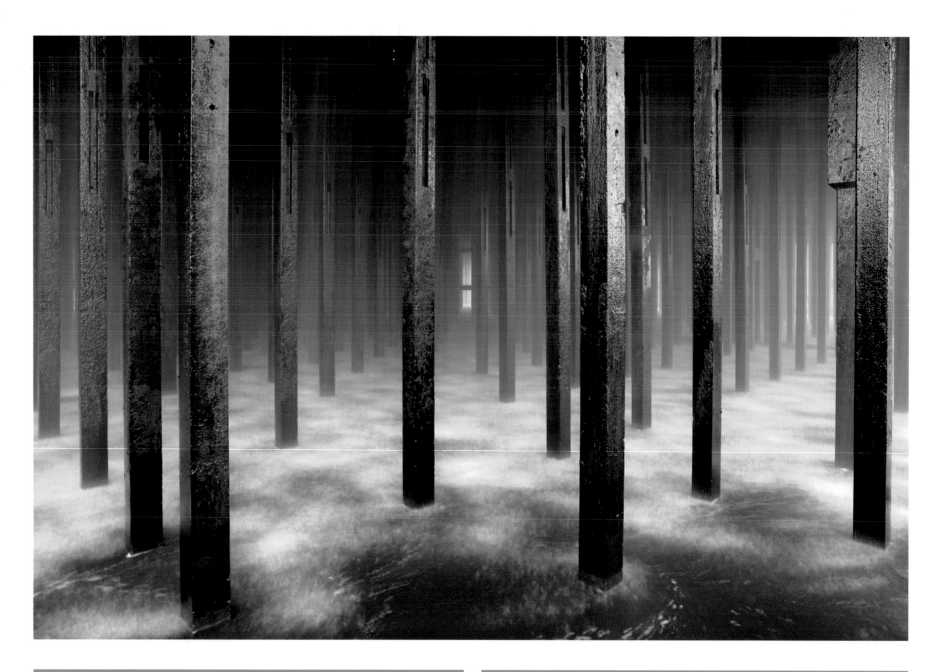

2010

## DARREN CIOLLI-LEACH ▲

### Concrete Rainforest
*Ratcliffe-on-Soar, Nottinghamshire, England*

This was taken underneath a power station cooling tower. I was amazed how such a man-made structure looked so beautiful, reminiscent of a mist-filled forest with snow on the ground.

2016

## LESLEY SMITH ▶

### Demolition
*Red Road Flats, Glasgow, Scotland*

The original demolition had been scheduled for the opening of Glasgow Commonwealth Games in 2014 but public pressure put this back to 11 October 2015. I took up position at the gate at about 10am, as demolition had been scheduled for 1pm. Crowds started gathering about noon and my tripod and I stood still. Finally, at 3.17pm, the siren went and 10 seconds later there was a huge boom as the flats started to collapse. A minute later it was all over. It was about another minute before I plucked up the courage to look at the back of my camera to make sure I had my shot.

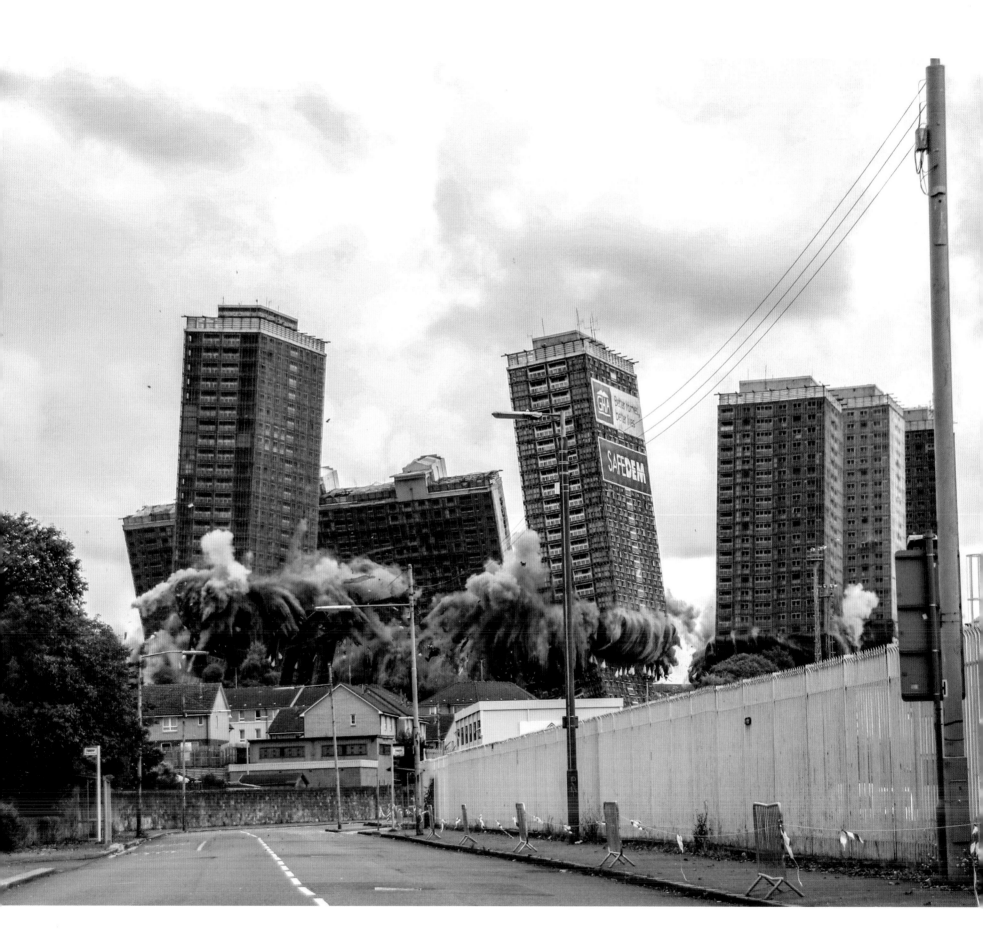

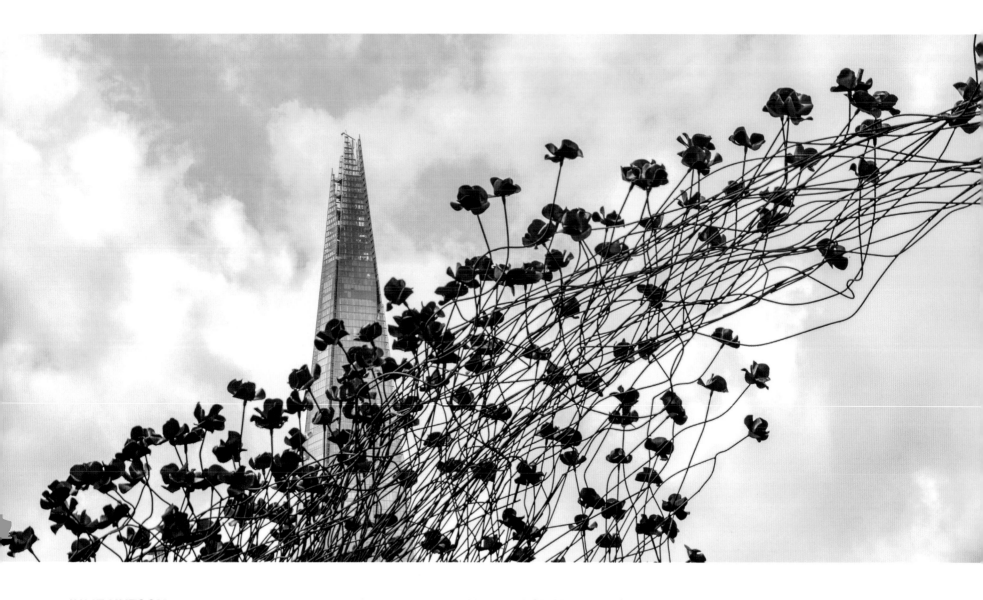

**JULIE HUTSON** ▲ 2015

**A Veil for the Shard**
*London, England*

I visited 'Blood Swept Lands and Seas of Red' at the Tower of London as the installation started and decided to return over the summer to photograph the increasingly reddening moat. One of my goals was to try to find a more unusual perspective for an image – but I knew it would not be easy! I particularly enjoyed the two metallic frames which appeared to catch the poppies in a net – one cascading from a Tower window and the other forming a sinuous semi-arch. The latter offered the potential to get behind it and look towards the Shard. From a contorted position looking up from the ground, the net of poppies reminded me of a veil and I tried to position it diagonally in the frame across the base of the Shard. I wanted to evoke the lacy feel of a veil and the ephemeral nature of it and the poppies.

**MICHAEL DIBLICEK** ▶ 2011

**The Leas**
*Folkestone, Kent*

This shot was taken during the afternoon of a very cold and windy day at the end of January. I was searching for graphics and lines in the few tall buildings in the town and also for a new and different angle. I wanted to capture some movement in the sky so opted to use a Lee 'Big Stopper' 10-stop neutral density filter.

## GILES McGARRY 2011

### Lloyds of London and the Willis Building
*London, England*

Lloyds of London is an iconic building that has been photographed so many times. I've always wanted to capture something a little different and love the way the Willis Building wraps itself around Lloyds, but the reflections make it difficult to capture a clean image, especially with three large trees planted between the buildings. But I persevered and finally managed to get an angle I liked, albeit by lying on the pavement to achieve a view without too much clutter. The shot was taken using a long exposure to slow down the clouds to achieve a cleaner look.

## MALCOLM BLENKEY    2015

### Infinity Bridge
*Stockton-on-Tees, County Durham, England*

The Infinity Bridge at Stockton-on-Tees is a pedestrian and cycle bridge across the River Tees. Its name is derived from the night illumination system which, in calm conditions, creates the appearance of the infinity symbol when the illuminated twin arches and their reflection on the river are viewed from certain angles. This shot is a three-quarters view of the full scene, which allowed me to create a diagonal composition leading in from the corners. It was taken about 15 minutes after sunset when there was still a little light in the sky, but the key to the shot was waiting for the near-perfect flat, calm conditions.

**DAVID STANTON**  **2010**

**Falkirk Wheel at Night**
*Scotland*

The Falkirk Wheel is a fantastic piece of engineering that joins the Forth and Clyde Canal to the Union Canal and it is a photographer's dream. It comes into its own at night and this image was taken from the top end, where it comes out onto the Union Canal. I just loved the arches and the way they reflected in the water. The night was overcast, which was a help as the lights from the Falkirk area lit up the clouds with the warm glow you see here.

**VERITY MILLIGAN**                                                                2016

Intricacies
*Birmingham, England*

Although somewhat divisive in the local community, the facade of the new Library of Birmingham offers plentiful opportunities to capture abstract compositions. This was shot looking directly up through the architecture on a bright spring morning, the various intricacies converging towards the sky. The monochrome conversion helps define the detail and accentuate the harsh morning light.

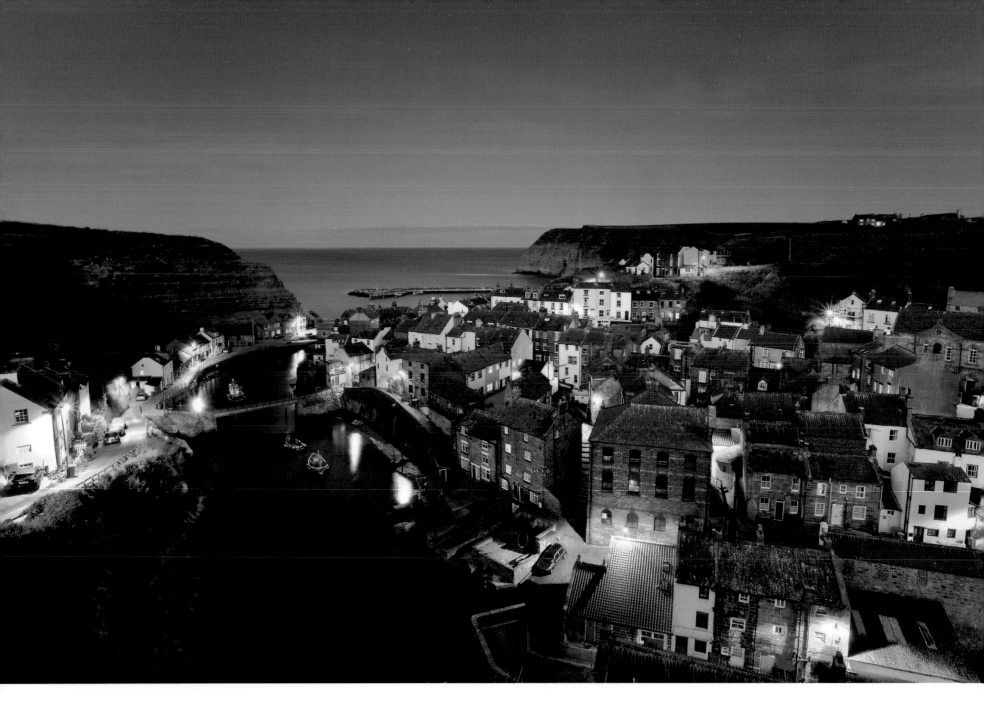

## SIMON ATKINSON ▲     2011

### Staithes at Twilight
*North Yorkshire, England*

I made the long journey up to the small coastal village of Staithes (where Captain Cook served his apprenticeship) ready for sunset and twilight. I spent the afternoon looking for various compositions but not many compare to this popular view which shows the compact village's size and also the sea and cliffs. This was about 20 minutes after the sun had set behind me and just as the street and house lights were coming on ready for the night. It was critical to strike a balance between the artificial light and the ambient light and so even at this time of night, I was still using two graduated neutral density filters!

## GRAEME PEACOCK ▶     2013

### Gateshead Millennium Bridge
*Gateshead, Tyne & Wear, England*

There is a superbly designed kink in the Gateshead quayside metal fence which echoes perfectly the reflection of the Millennium Bridge in the Tyne. For this image to succeed, Mother Nature needs to oblige with a) a calm evening with wind speeds less than 5mph, b) a clear evening (ideally in autumn/winter when air particles are minimised) just after sunset, whereby ambient light matches the intensity of street lighting, and c) a high tide with no discernible current running. No wonder then that it took me 10 visits over a period of two years to achieve the desired result. Who says that landscape photographers don't have patience?

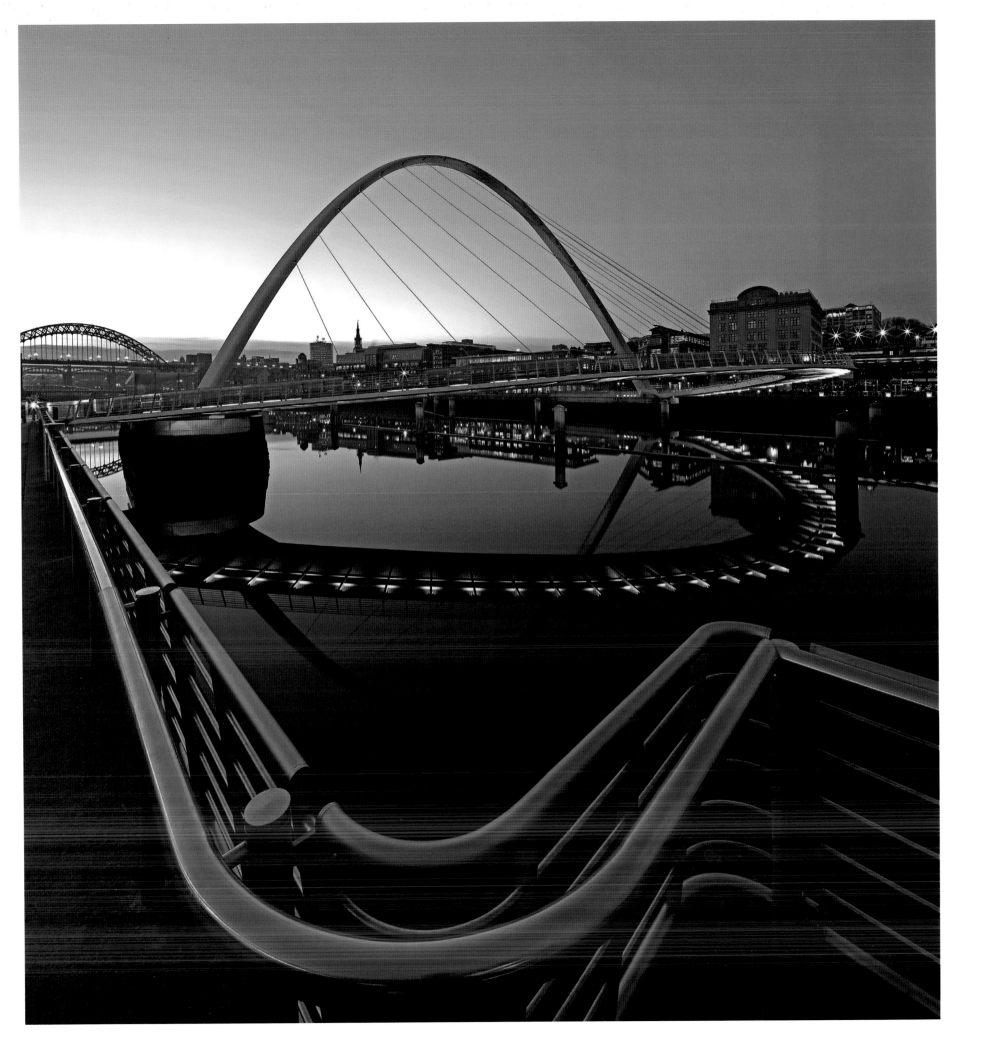

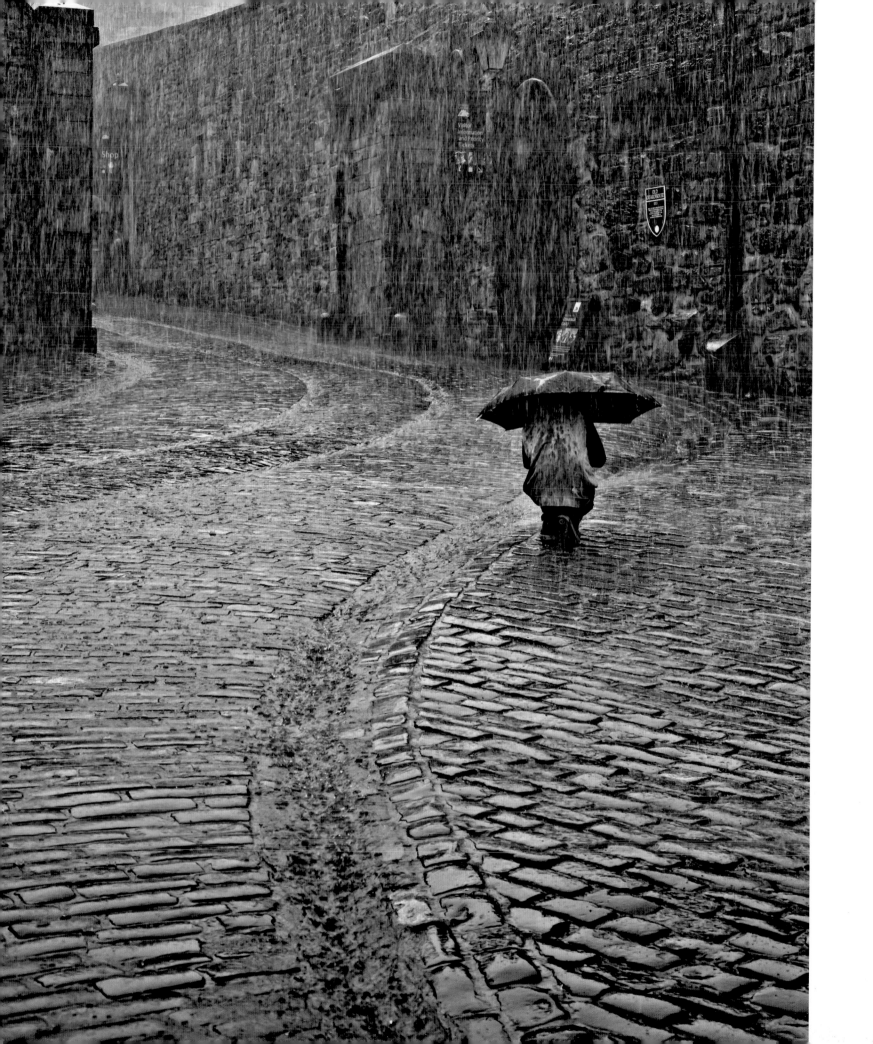

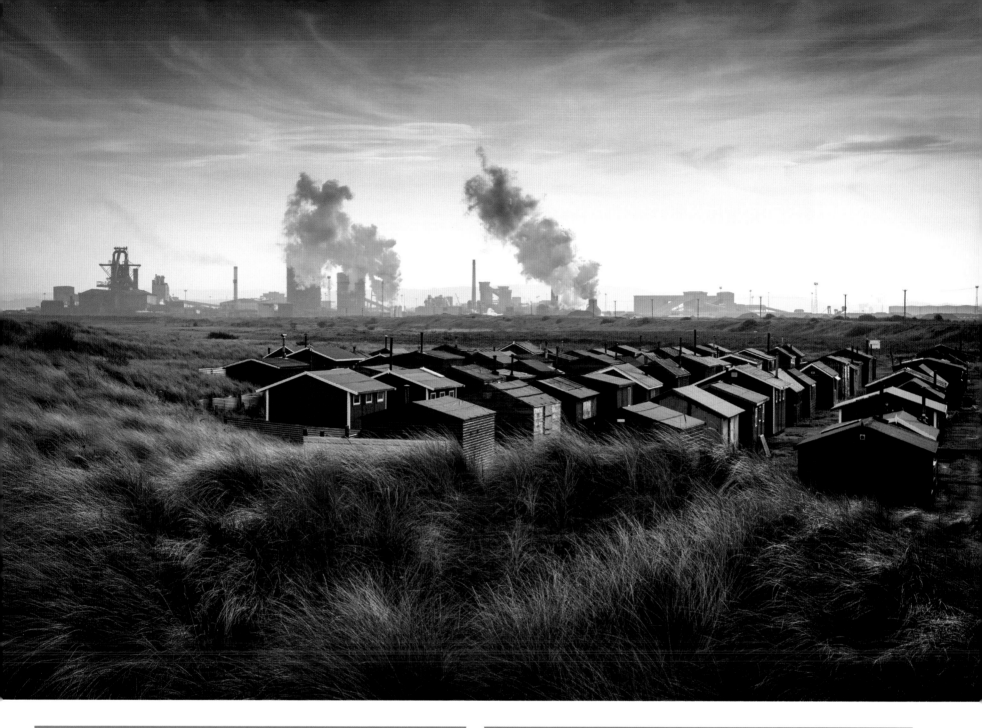

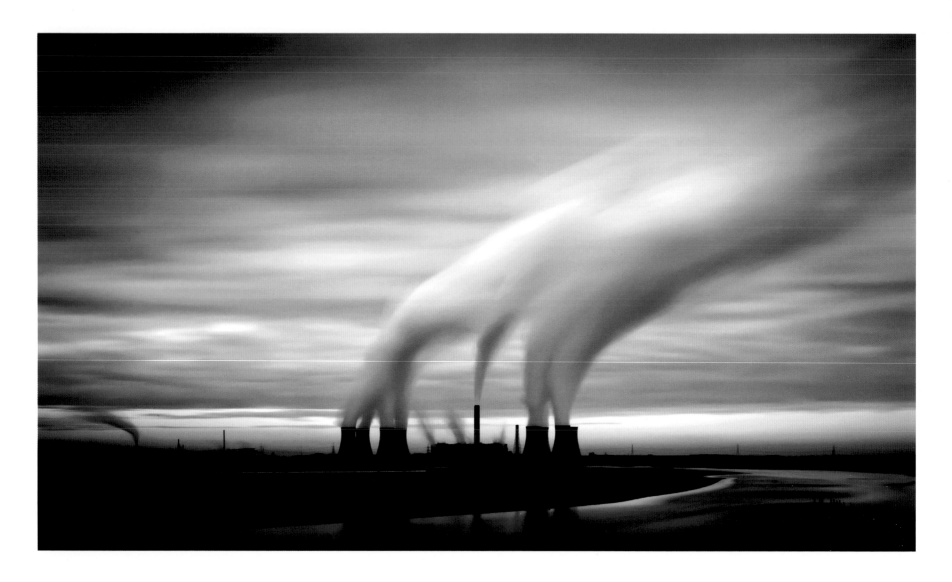

## ANDREW HOWE                                      **2013**

**Fiddlers Ferry Power Station**
*Cuerdley, Cheshire, England*

I was born not far away from Fiddlers Ferry and it has always dominated the skyline in this area. I used
a longer exposure to accentuate the cloud movement and the water vapour from the cooling stacks.

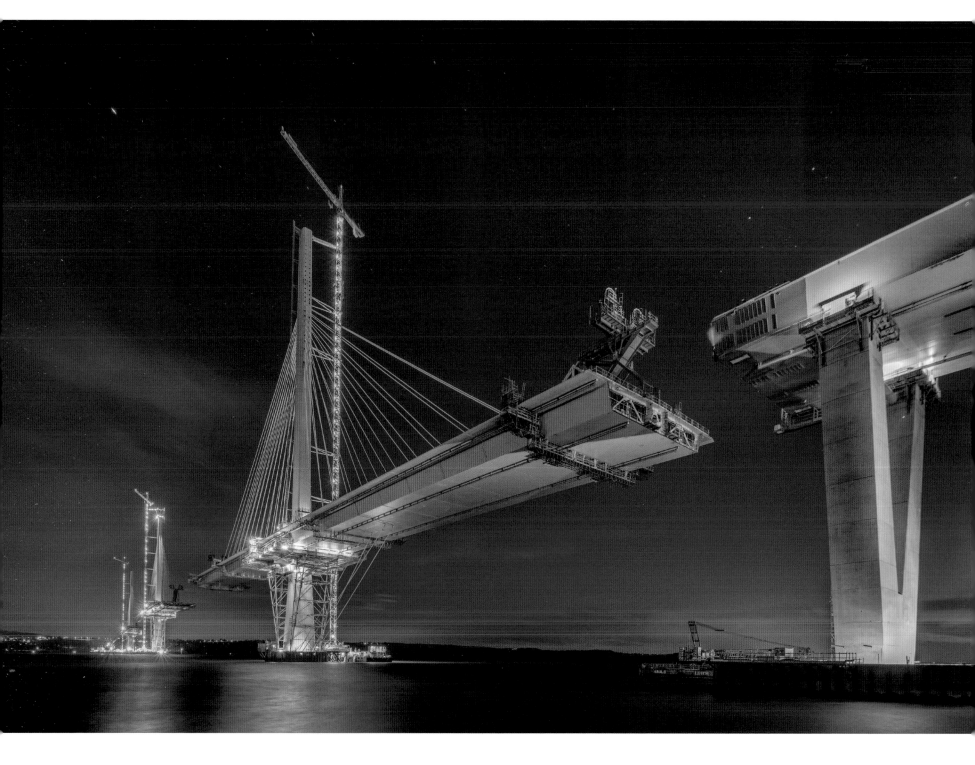

## DAVE STEWART 2016

### Queensferry Crossing during Construction
*Fife, Scotland*

Queensferry Crossing: the third bridge over the Forth Estuary at Queensferry. Having observed the progress over the course of a year, I wanted to capture an image showing the scale of the construction task before its completion. The combination of a virtually clear night sky and the well-lit bridge seemed particularly pleasing to me and so a scramble across the rocky north shoreline was required, all the time keeping one eye on the incoming tide.

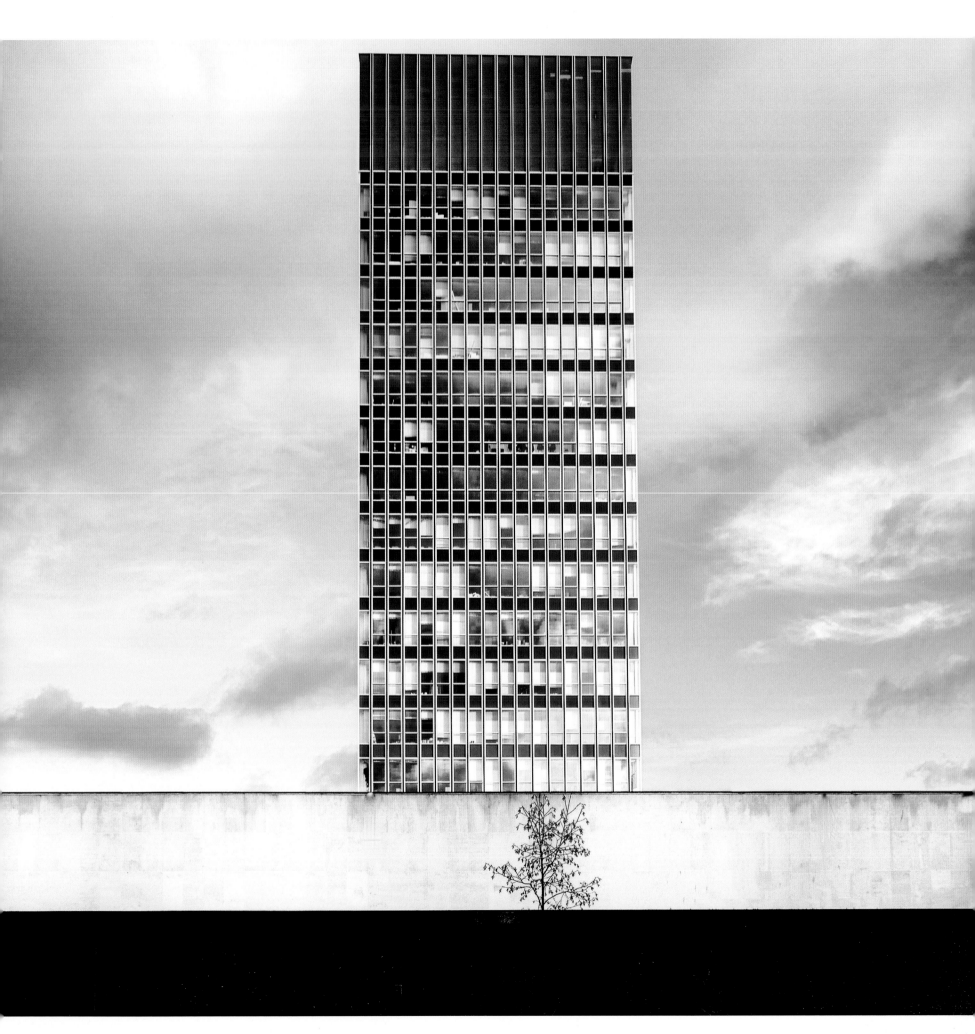

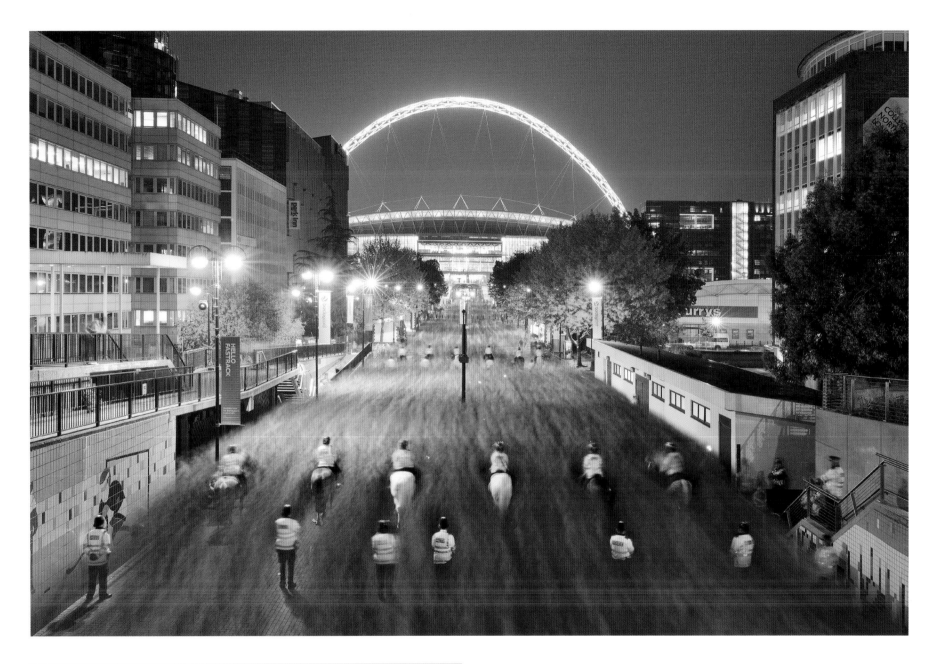

## DANIEL COOK ◄

**The Arts Tower**
*Sheffield, South Yorkshire, England*

The Arts Tower is England's tallest university building. It was built in the 1960s and appears to have been inspired by the New York city skyscrapers. Despite a recent refurbishment, the architecture still conveys a sense of clinical minimalism with square edges and plain patterns. Initially, I tried to capture the tower reflected in the water of the pond but then felt that conveying the clinical feel of the architecture alone would create a stronger image.

## ARPAD LUKACS ▲ 2014

**Wembley Stadium and Olympic Way**
*London, England*

London's Wembley Stadium with its massive steel arch photographed at night. Thousands of fans are captured with a minute-long exposure as they walk towards Wembley Park tube station after a football match, with the on-duty police officers standing still while the shutter was open.

## DOUGLAS BRUCE

**2016**

### Oil Refinery
*Grangemouth, East Stirlingshire, Scotland*

The Grangemouth Oil Refinery covers a large area and allows lots of opportunities for photos. After driving around for about 30 minutes, I found a suitable place to park. I decided to use a long lens and fill the frame with the complex construction of steel and pipework.

**MARK VOCE**

### The Tees Transporter Bridge
*Middlesbrough, England*

As far as bridge designs go, the Tees Transporter Bridge may appear a little strange at first. A framework of steel and rivets reaching upwards then spanning the river, with no obvious roadway or walkway, it is perhaps only when seen in operation that the function of the bridge becomes apparent. Vehicles and pedestrians are whisked across the river on a gondola suspended from the bridge. The idea for the photograph came to me while sitting in my car waiting to cross. I was drawn to the symmetry and intricacy of the structure surrounding me and how it crossed the expanse of water. A rather dull yet tranquil evening provided a nice, simple backdrop to contrast with the complexity of the bridge.

## JON MARTIN                                    2015

### St Paul's Cathedral from the Shard
*London, England*

The Shard provides wonderful sweeping views across the whole of London. For this image, I decided to focus on a small part of the overall scene: the iconic St Paul's Cathedral. I shot at dusk, when some building lights had been turned on but there was still plenty of natural light available. This helped make St Paul's stand out from the surrounding buildings.

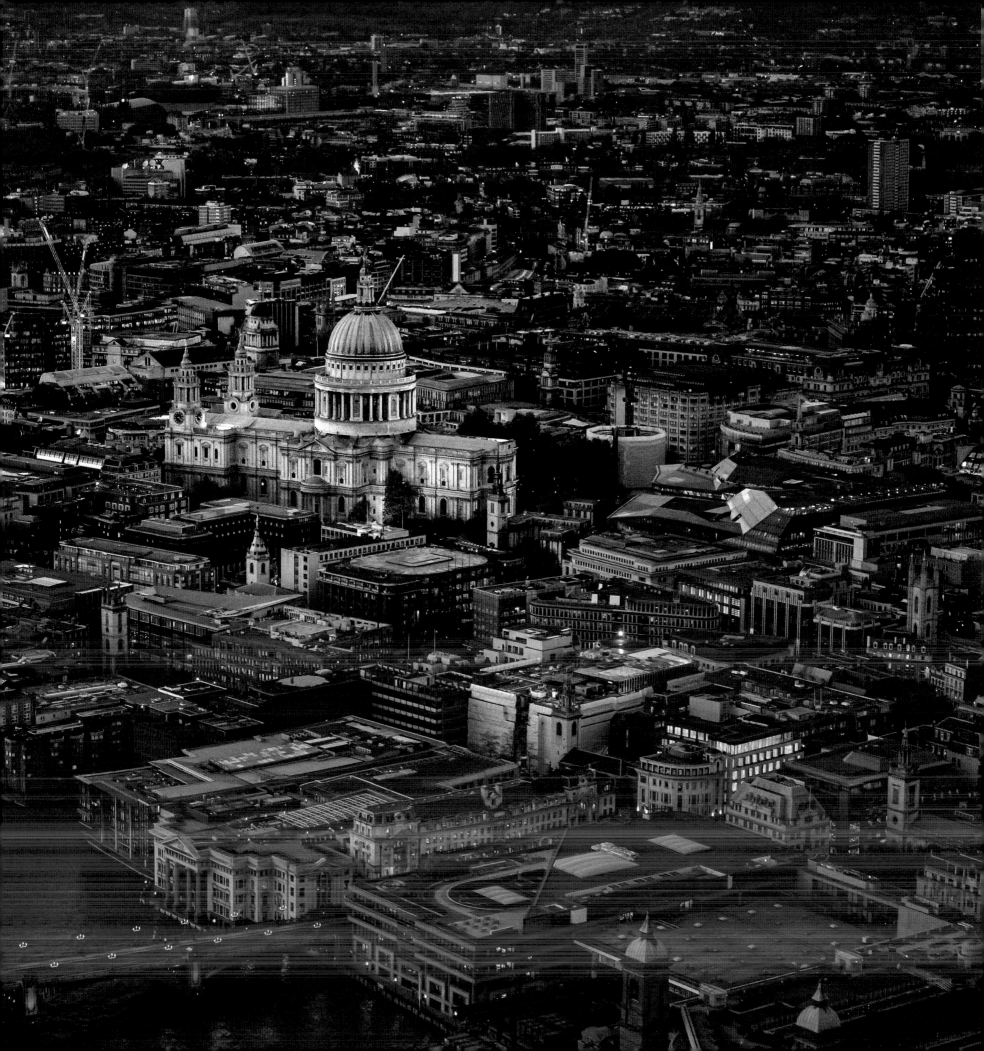

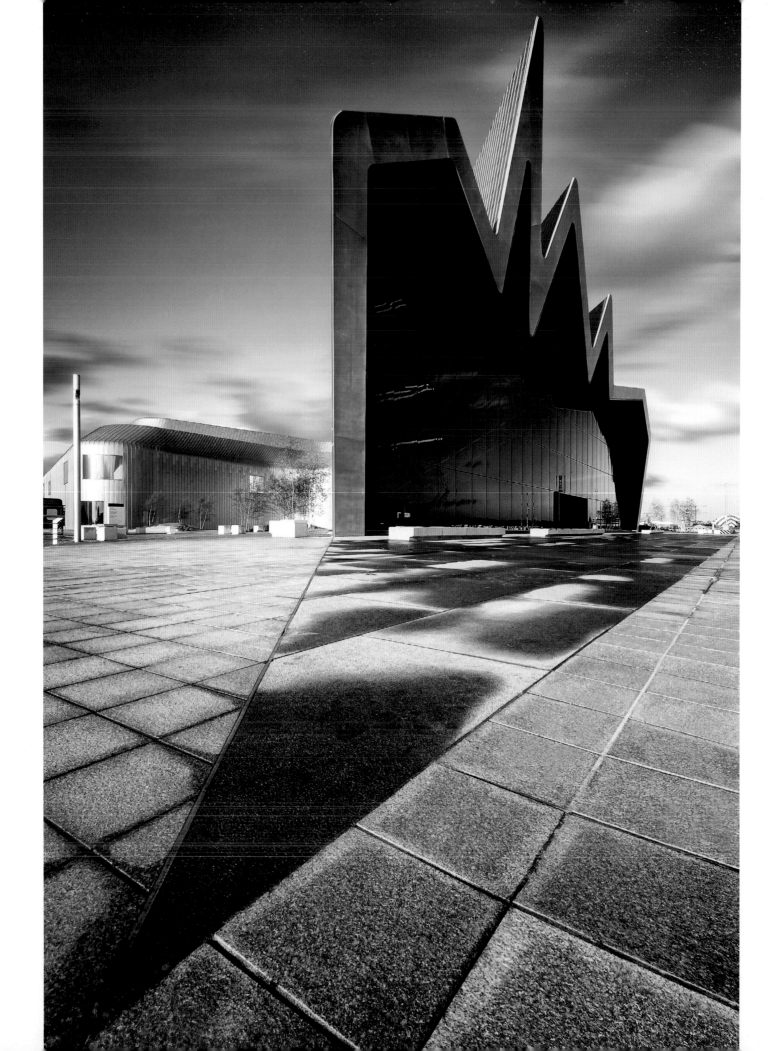

## Glasgow Riverside Museum
*Scotland*

The new Glasgow Riverside Museum opened to the public earlier this year. I went down to see the building a couple of weeks after it opened and was immediately impressed with the unusual but striking design. It was after a heavy downpour that this image was captured. I was attracted to the damp patterns on the paving along with the angled path design leading you into the image, which also matches the rooftop. I thought these elements, along with the low angle of view, gave the image a strong foreground.

## Winter Chalet
*Hemsby, Norfolk, England*

Taken on a cold and snowy January morning, this shot combines two of my interests: holiday villages and freezing weather. The simple architecture and minimalist tones created by the snow seem to blend well with the incongruity of summer holidays and winter conditions.

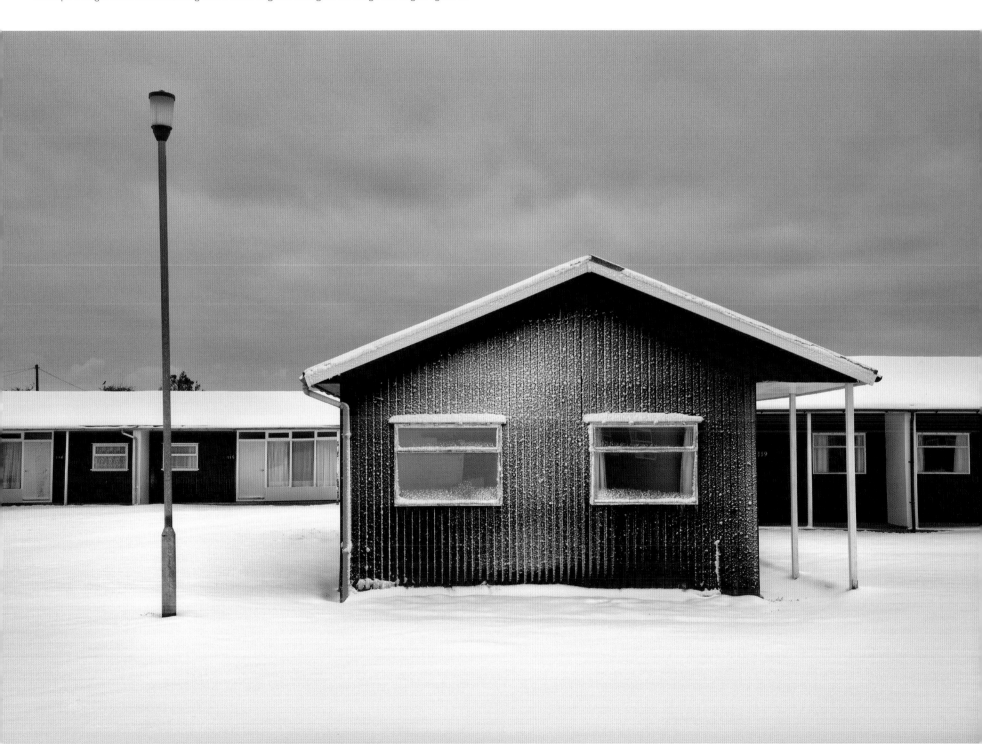

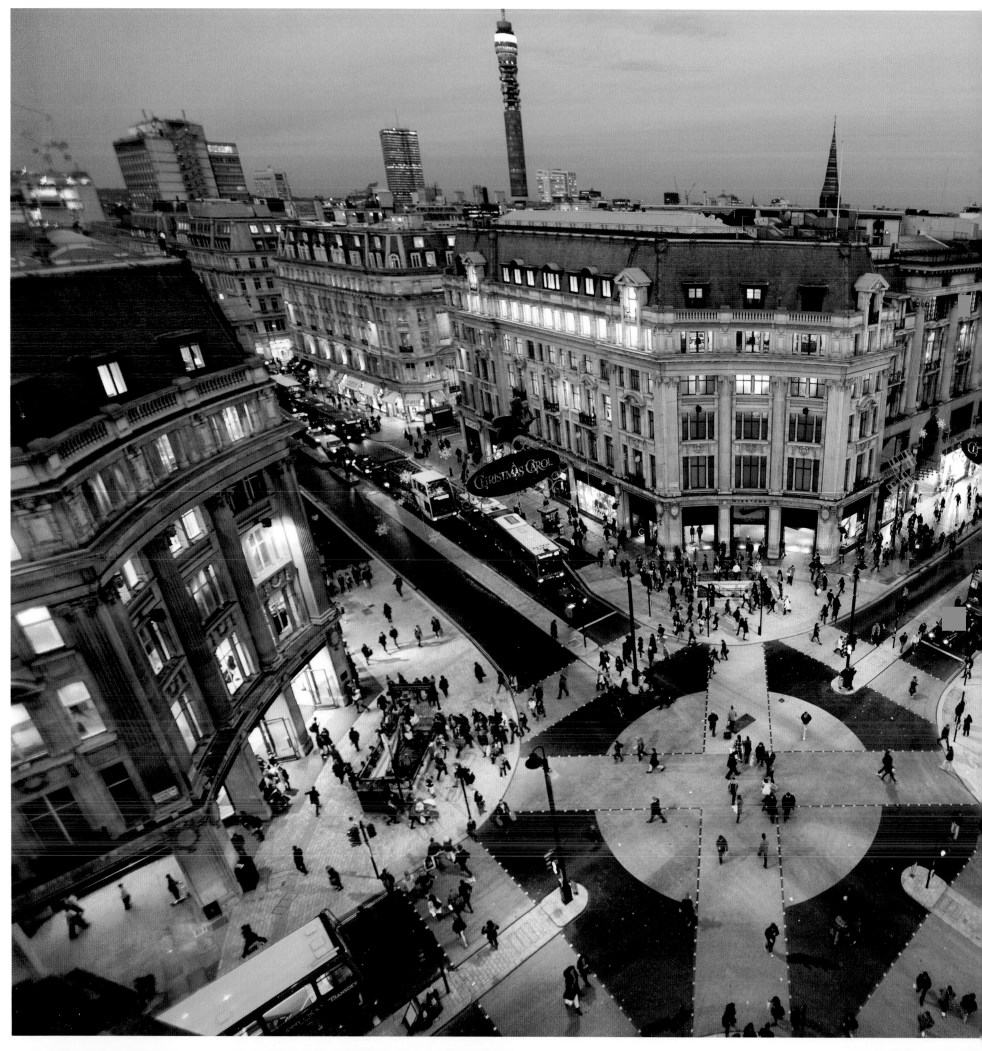

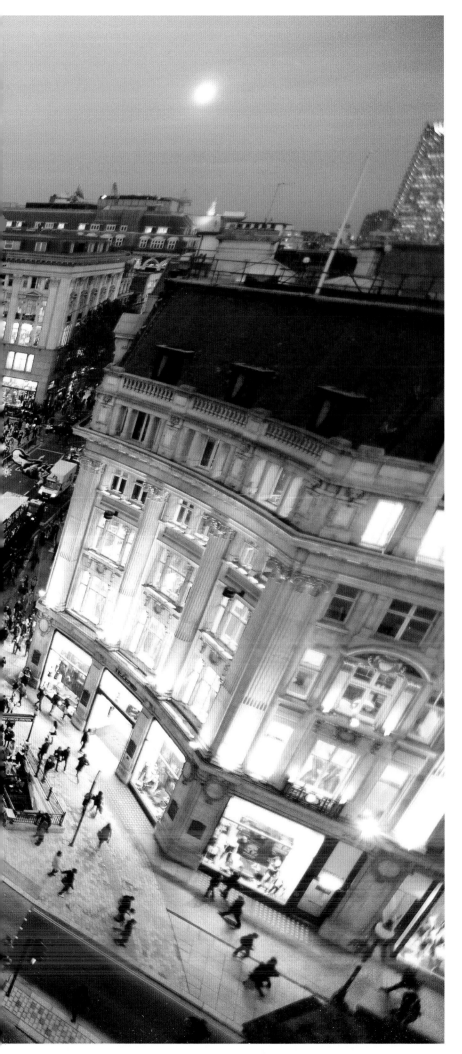

**MATTHEW CHEETHAM**                                 **2010**

### The New Crossing at Oxford Circus
*London, England*

Part of a shoot to capture the opening of the new Oxford Circus crossing for Westminster City Council. Modelled on the infamous Shibuya crossing in Tokyo, its aim is to ease congestion around the Underground entrances and outside the shops.

## HOWARD KINGSNORTH

### The Dark Square Mile
*London, England*

This image was two years in the planning; it took me that long to gain access and clear security. Predicting weather is not an exact science, so there were a few false starts. The rest was easy – secure camera and tripod so that they don't blow away, set the intervalometer to shoot a bracket at one-minute intervals and keep chatting to the security guard so that he doesn't make you retire early.

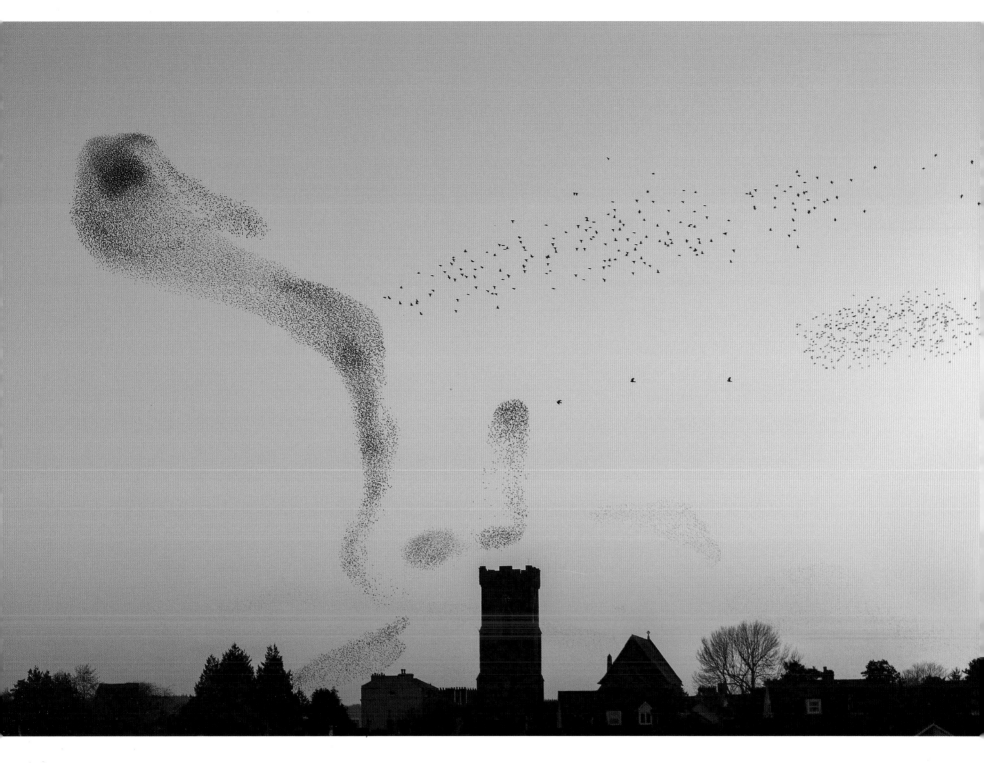

## NIGEL McCALL

### Starlings over Carmarthen
*Southwest Wales*

In January 2011, Carmarthen began to play host to some unusual visitors. Starlings were making part of the town their roost for the night. By early March it was being estimated that in excess of 250,000 birds were arriving every evening. The murmurations were a wonderful sight and this photograph captures probably the most spectacular combination of shapes seen above the urban skyline.

## STEPHEN BRIGHT ▲     2014

### Evening Light on the Shard
*London, England*

Taken about 20 minutes before sunset when the sun appeared below the nearby cloud layer, creating a brilliant shaft of light over west London, which was made all the more striking by a lower band of cloud in the distance. Clearer skies to the east reflected off the Shard, giving it a complementary blue tone. The photograph was taken from Canary Wharf's One Canada Square, the UK's second tallest building.

## STEPHEN CHUNG ▶     2012

### Cyclists Dismount
*London, England*

This image was taken near the O2 centre in North Greenwich on a summer's evening. The aim was to capture photos of London's iconic Canary Wharf skyline on the opposite bank of the River Thames. After taking several images at various locations and from various perspectives, I came across the sign 'Cyclists Dismount'. Since there were no cyclists at that time of night, here was an opportunity to show that photography really does mean 'painting with light', as I decided to add my own bicycle to the urban scene in front of me. After a couple of mental rehearsals, I pointed a small torch at the camera and, with the shutter open for several seconds, drew a parked bicycle. Amazingly, it worked first time.

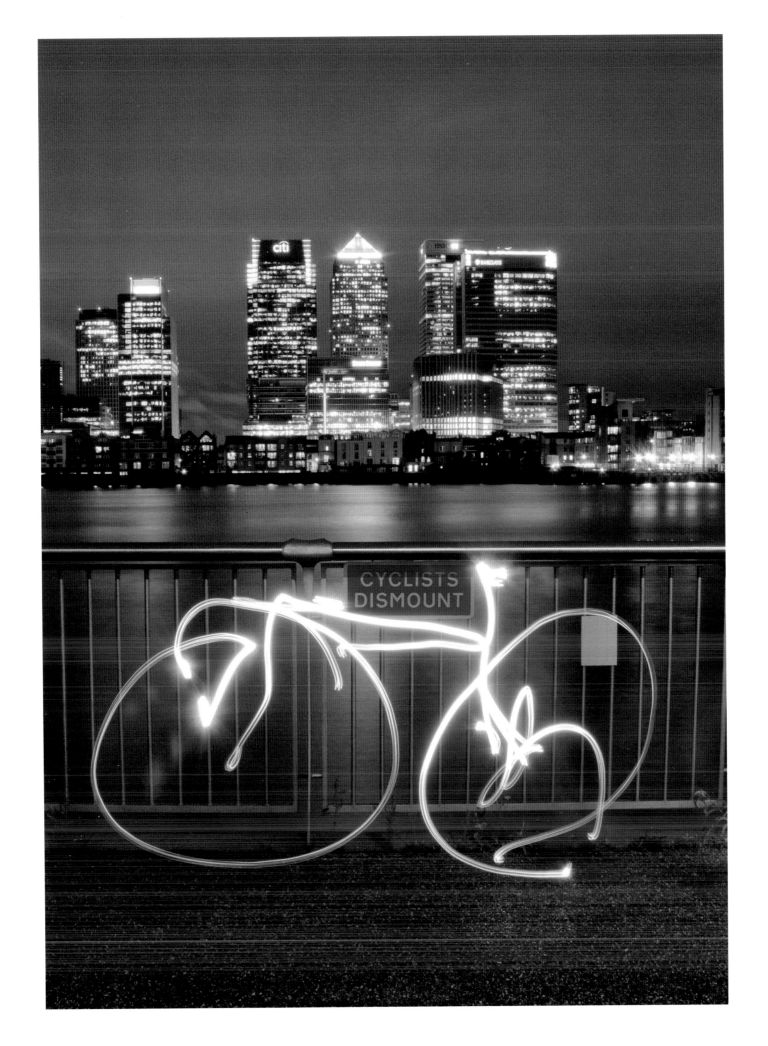

YOUR VIEW

## SIMON PARSONS ◀      2011

### South Downs National Park
*Sussex, England*

Whilst heading to the coast, the light suddenly broke through the autumn mists as I drove past these beech trees. It was the sparkling water droplets that looked like cobwebs which caught my attention at first. Finding somewhere to stop safely was a little awkward but I found a place nearby. I had very little time to set up a tripod, so grabbed this quick, handheld shot before the light disappeared.

### WINNER      2015

## MIKE CURRY ▶

### Middle Dock Reflections
*Canary Wharf, London, England*

A reflection of the yellow Reuters news ticker and white street lighting at Middle Dock, Canary Wharf. A light wind meant that the water's surface was relatively still, enabling me to capture the reflection subtly fragmented but still hand-held, thanks to Fuji's image stabilisation.

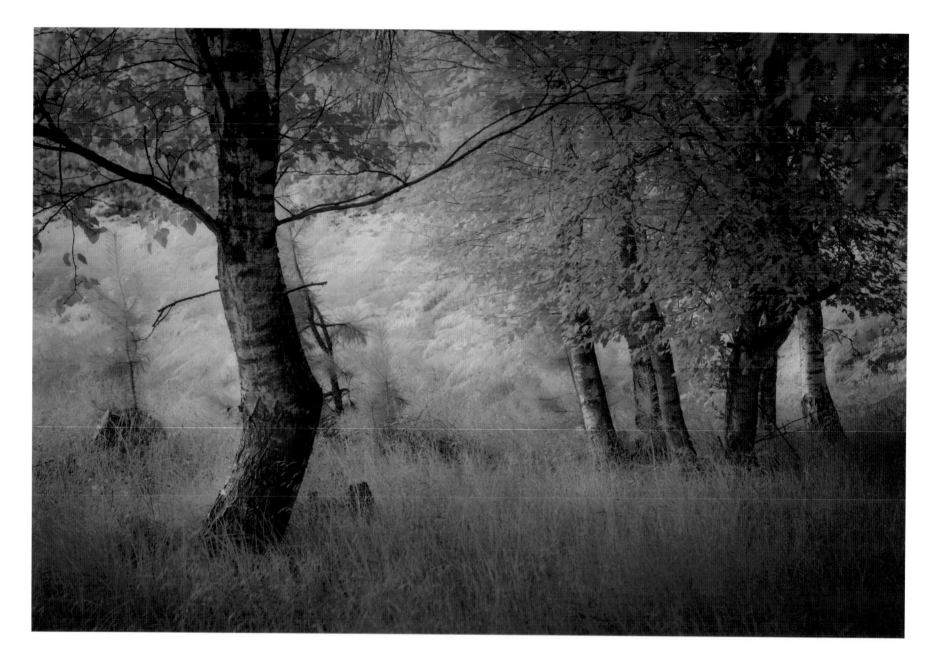

**SIMON BYRNE** ▲        2016

**Showing Off in Thetford**
*Norfolk, England*

Over the last year or so I've become more and more fascinated with photographing trees. Their shapes, contortions and other features are each as different, if not more so, than humans and each has its own character and story to tell. I often end up relating these to scenes from everyday life. I happened across this scene one morning that reminded me of a Friday night outside a nightclub. The male protagonist on the left is showing off after a few too many drinks, with a bit of a belly and thin arms extended to the group of girls on the right laughing at his displays.

**MATT BOTWOOD** ▶        2014

**Travels in a Strange Land:
Dark Spaces I**
*Wales*

A processing experiment with negatives that started me on a new project path: exploring landscapes hidden within the landscape around me. Although images like this look like unbelievable, fantastical alien places, they are relatively straight shots of selective parts of my local environment viewed in negative.

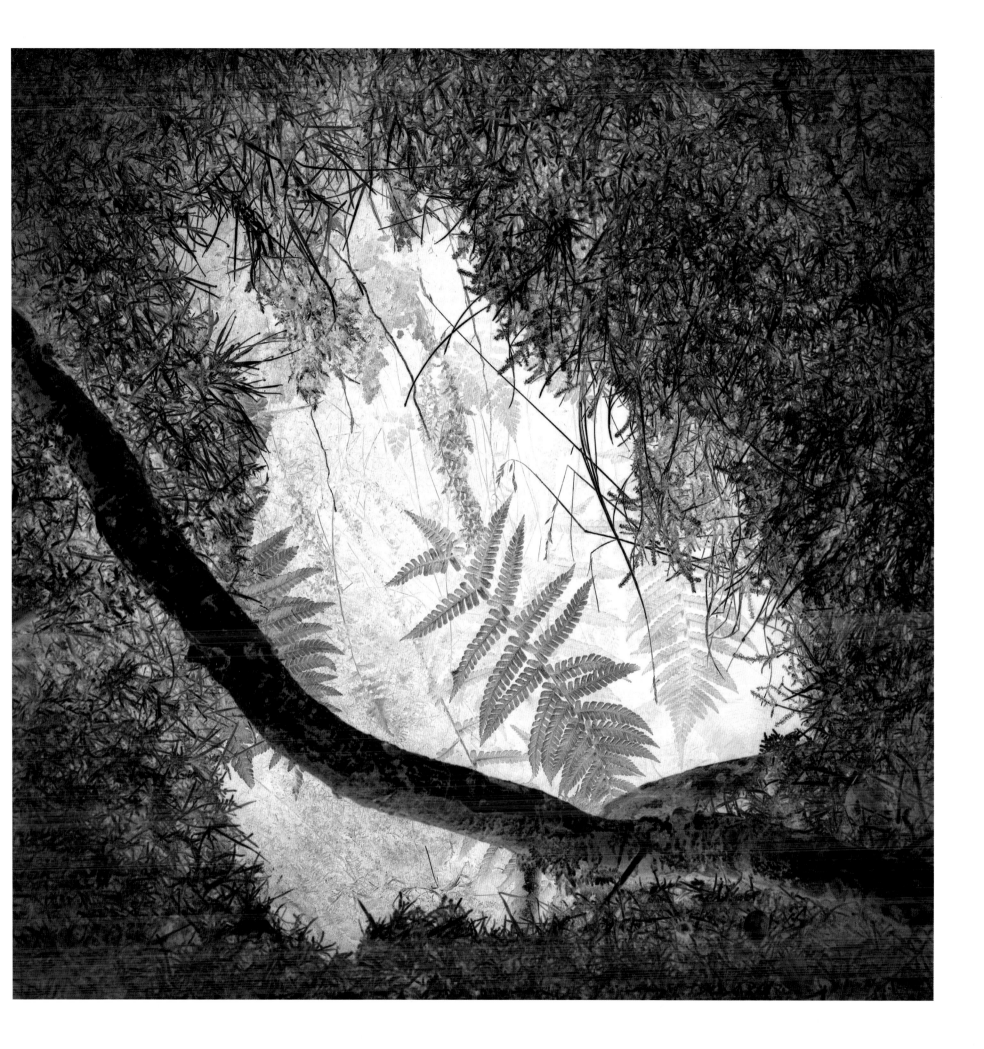

**MICHAEL SWALLOW**          **2013**

**Snowstorm I (Nefyn)**
*Llŷn Peninsula, North Wales*

I saw this dramatic snowstorm coming in over the bay at Nefyn on New Year's Day. I only had minutes to grab a couple of frames before I was engulfed by the storm and plunged into darkness.

### Hove
*East Sussex, England*

It's rare for Brighton and Hove to get snow, let alone thick, deep snow that 'sugar coats' everything. On the morning of 2 February 2009, that's just what happened. Trains and buses were cancelled; roads and schools were shut. There was nothing for it but to go and enjoy it. We all wrapped up – it was still snowing – and went down to Hove seafront to see what was happening. Some people were still struggling in to work on foot, but most had given up and were having fun, throwing snowballs and building snowmen – we built a seven-foot one with some other people. It was a great atmosphere with a very 'Brighton spirit' going on. Someone had added a smiley to a lifebelt cover. It caught my eye, and put a smile on my face too. I eventually met the lady who did it and gave her a copy of the picture.

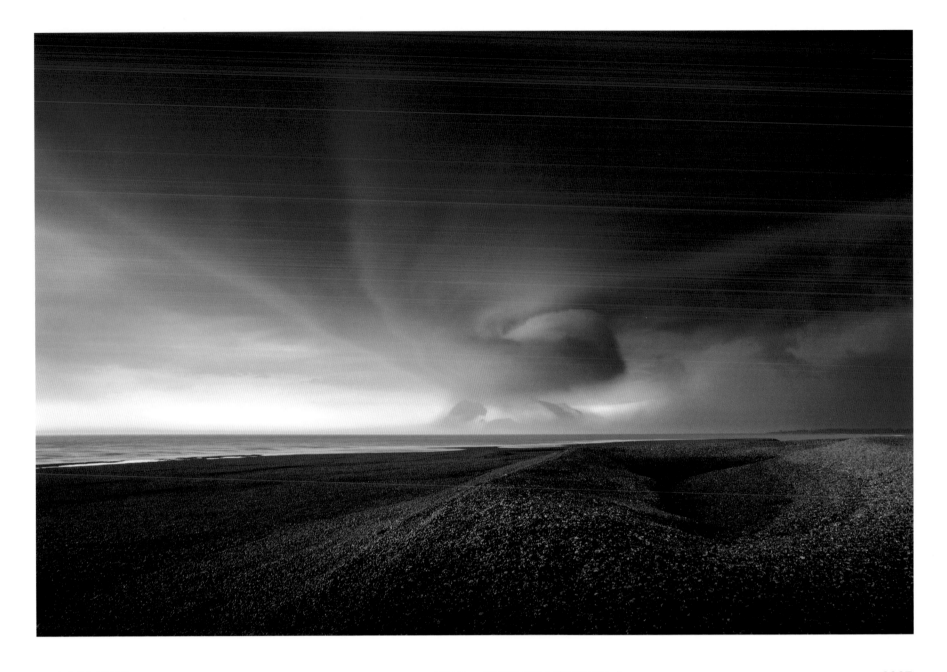

**LEE ACASTER** ▲                                                                2015

### Tempest
*Shingle Street, Suffolk, England*

I had been at Bawdsey to shoot the sunrise but the sky was disappointingly clear and blue. As I was driving home, I noticed a large storm front approaching, so made a quick detour to one of my favourite locations, Shingle Street. It's an otherworldly feeling place anyway but the electricity in the air as the storm hit was tangible. I managed to capture the tempestuous sky and ethereal light just before the hail and rain came down in biblical fashion.

**PETE BRIDGWOOD** ▶                                                            2007

### Extracted
*Riverside, Hull, England*

I was struck by the precarious nature of the rusty metal staircase on the vast outside wall of this derelict building by the riverside in Hull. It makes me shudder to think of the risks taken to spray the graffiti on the wall.

### The 08.30 from Hamworthy Crosses Holes Bay
*Poole, Dorset, England*

Although there are more photogenic wrecks around Poole Harbour, this fibreglass canoe made the right contrast with the sleek trains that cross Holes Bay. I had noticed that the rising sun hits the rail bridge full on in midwinter and the bridge reflects the light dazzlingly. I also knew that the trains left Hamworthy station every half hour – so all I had to do in theory was to get in position on a clear winter's morning before sunrise and wait for a train. The sun was not high enough for the 8am train, but the raking light half an hour later allowed just enough motion blur for the train to make the contrast with the wreck complete without totally blurring out its distinctive livery.

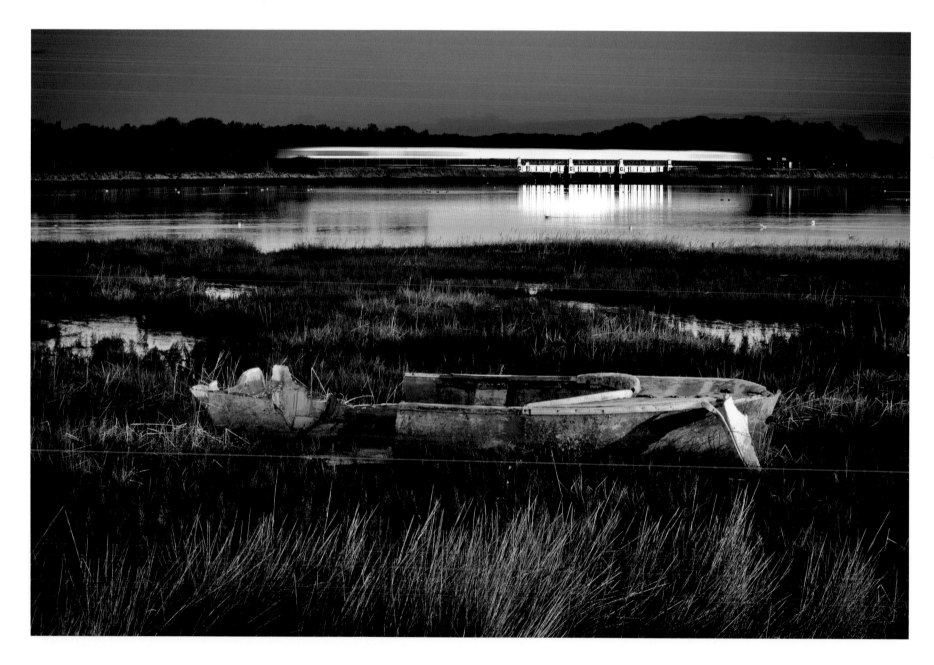

### Calder Weirpool
*West Yorkshire, England*

This motion-blurred capture of a weir is on the River Calder near Halifax. I have always been drawn to flowing water and that probably shows in my work. This particular shot was taken at sunset and the colours of the sun and sky help turn a normally mundane weir into something a little magical.

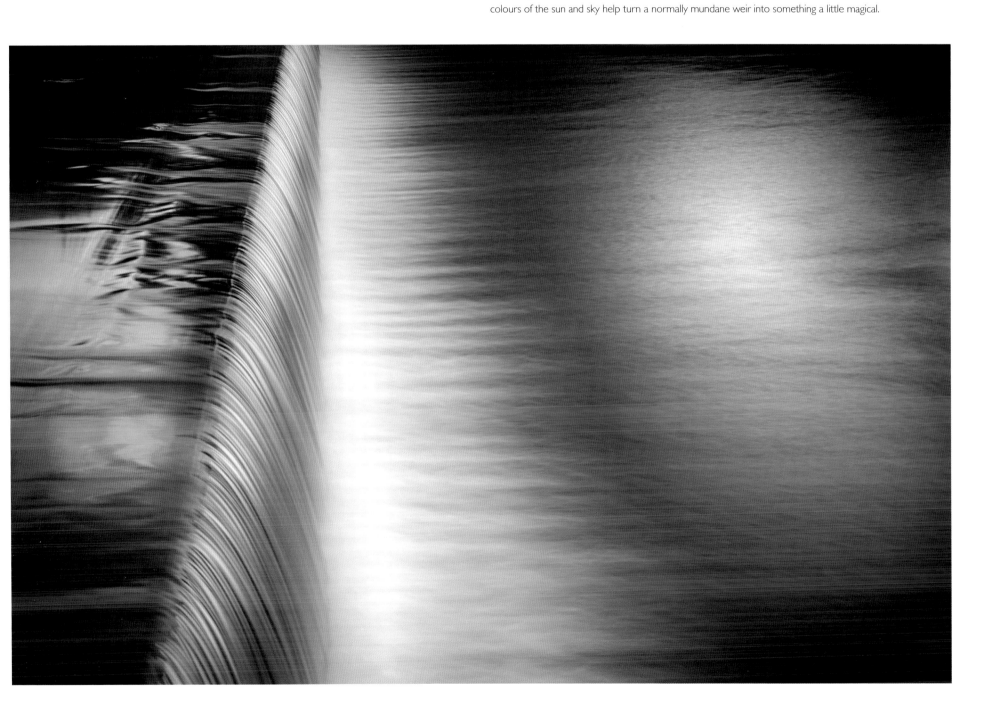

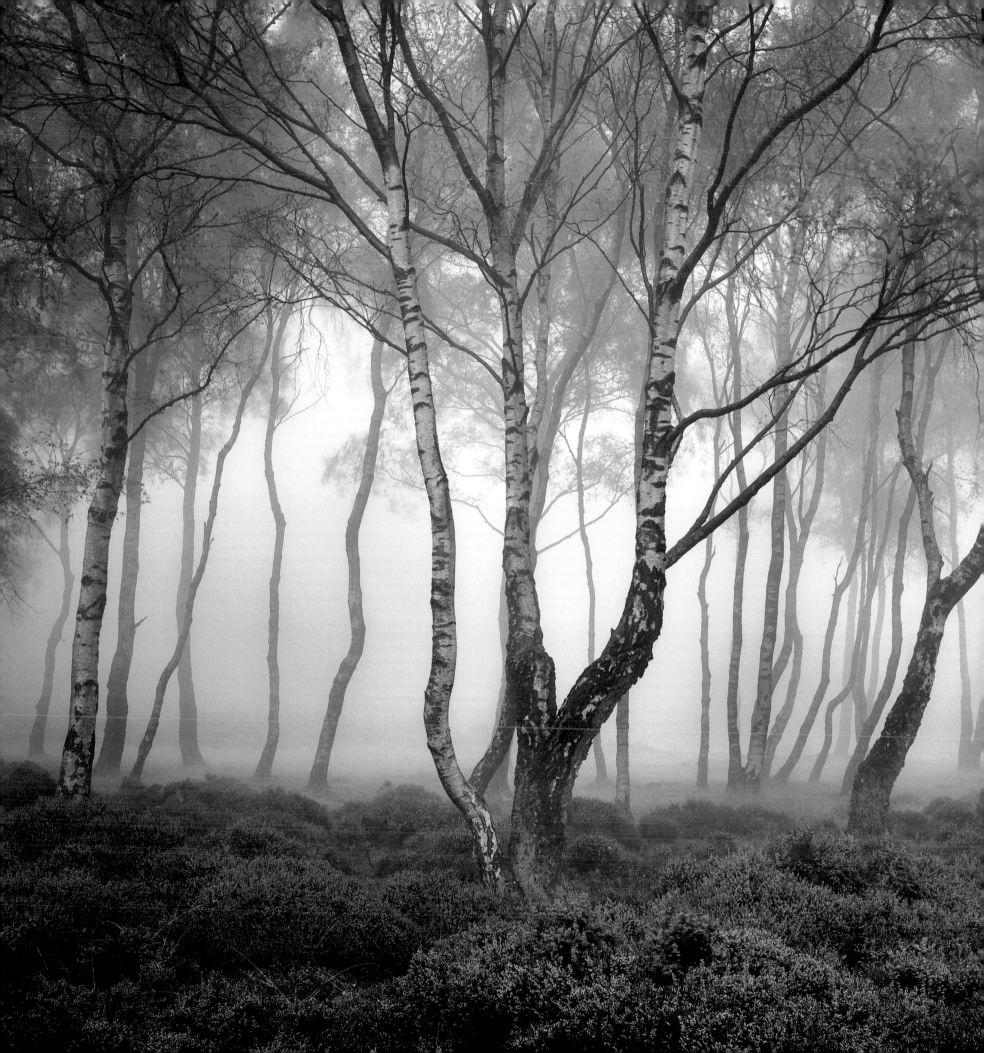

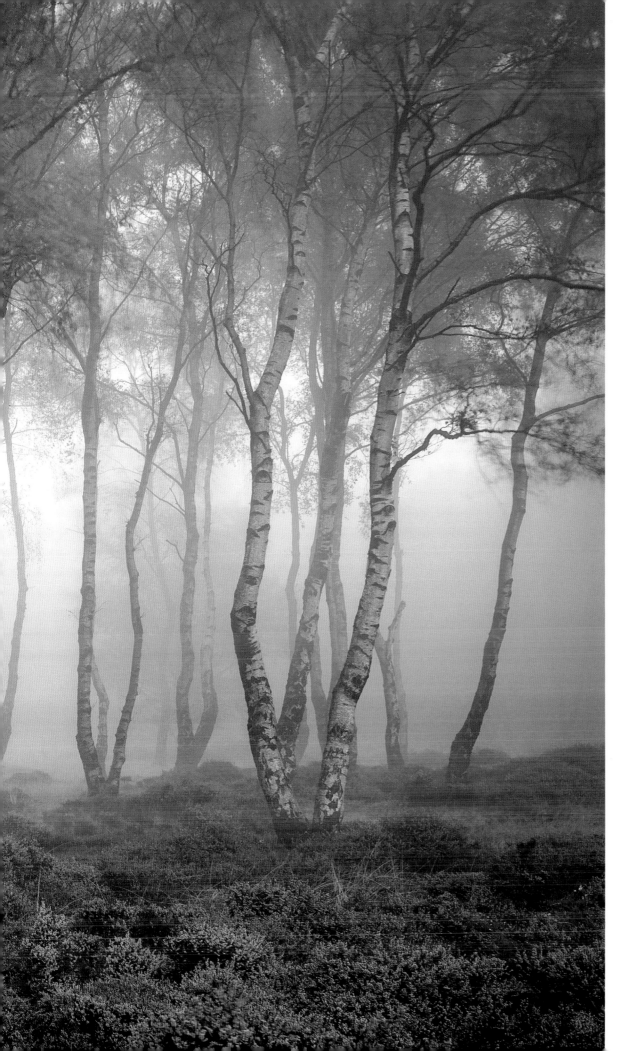

**JAMES MILLS**                            **2015**

### Misty Stanton Moor III
*Peak District, Derbyshire, England*

Stanton Moor is a magical place covered with Bronze Age remains and patches of birch woodland and only 10 minutes from my home. On this day, the combination of mist and purple heather seemed to capture the spirit of the place.

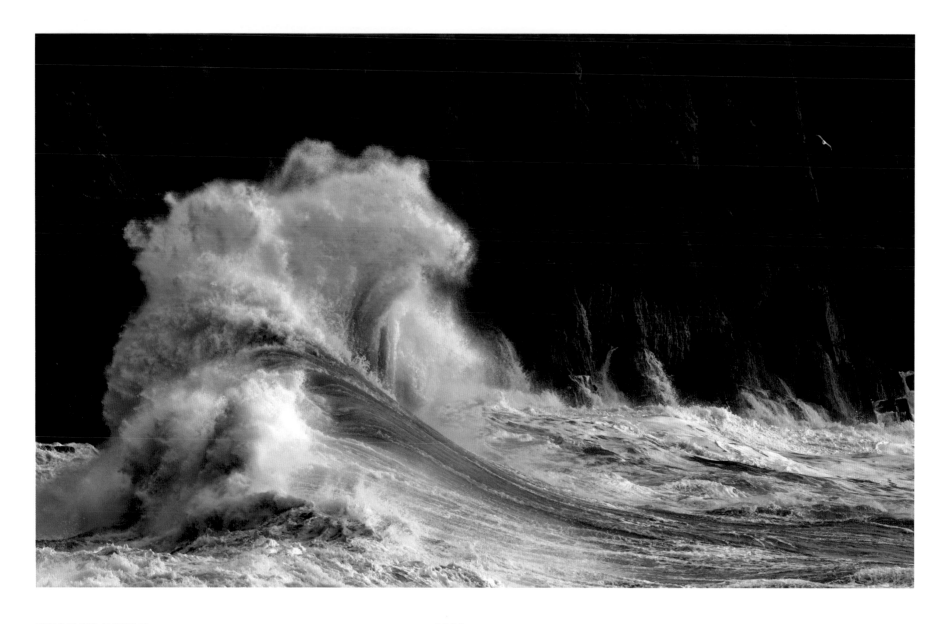

**GRAHAM EATON**                                                    **2014**

### The Wave and the Gull
*Llŷn Peninsula, North Wales*

I was photographing gulls playing in the huge storm waves at Porth Ceiriad, near Abersoch, in December. I noticed how the breaking waves were splitting when a certain section of cliff was impacted. These split waves looked similar to a bird's wings and, in this image, a herring gull mirrored the wave, albeit in miniature.

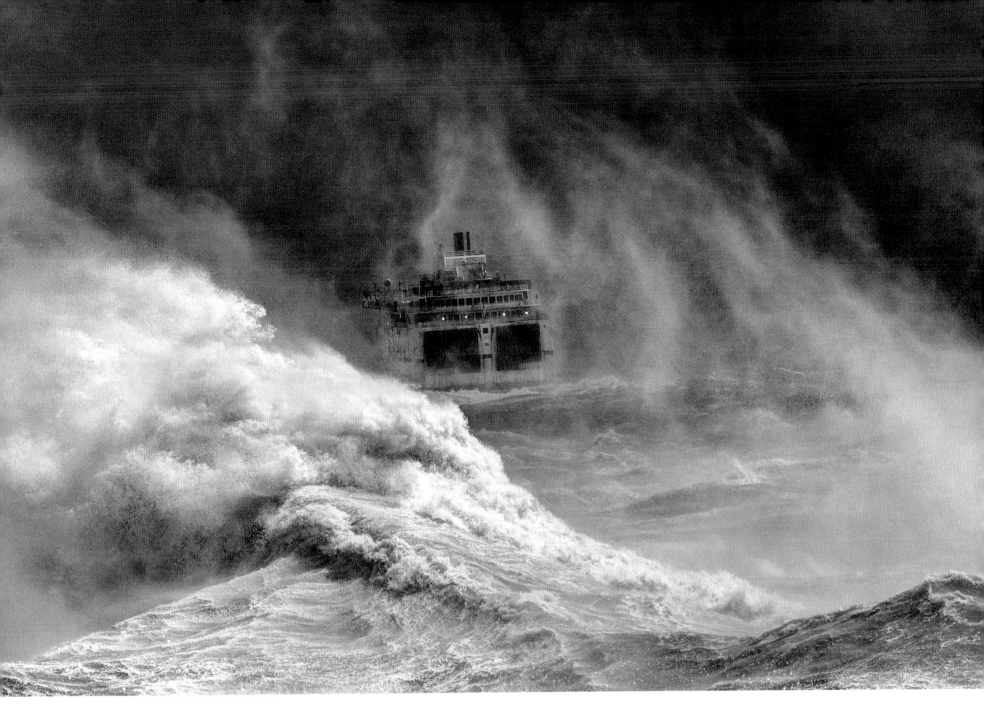

## DAVID LYON

### Ferry Leaving Newhaven Harbour in Storm
*East Sussex, England*

After shooting waves crashing over Newhaven lighthouse for about an hour during a summer storm, I decided to change position and try to get some shots covering the seaward side of the harbour wall from the shingle beach. As I approached the beach, I saw the funnel of the ferry over the sea wall, so I sprinted down the shingle with the camera still attached to the tripod and managed to get a few frames before it disappeared.

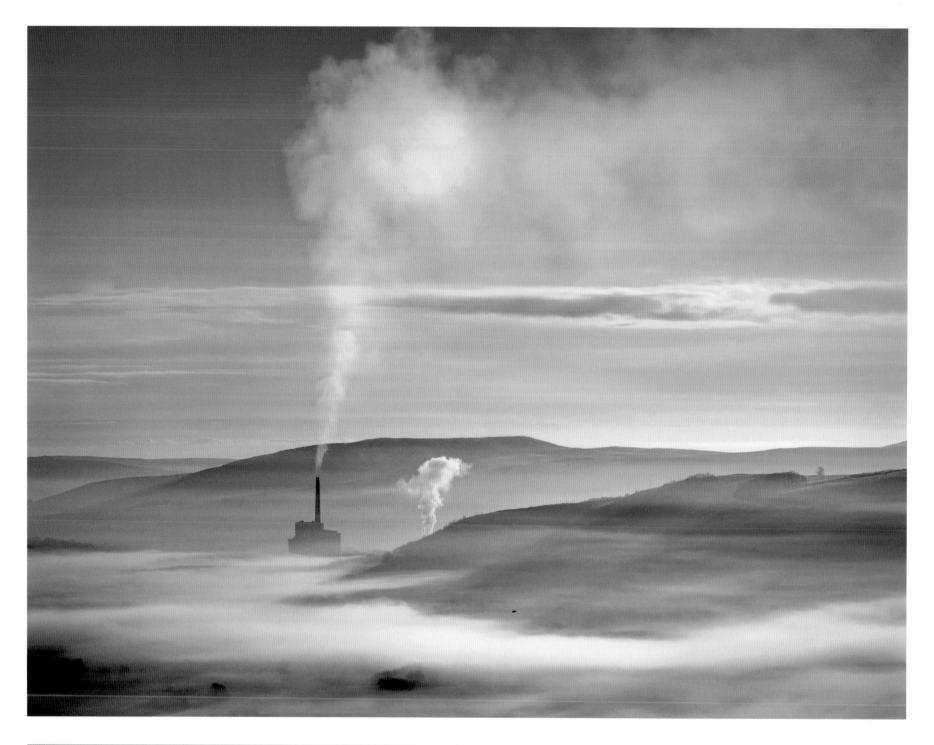

## PETE BRIDGWOOD

### Hope Valley
*near Castleton, Derbyshire, England*

I had been pre-visualising this image for two years and made no less than five trips to Hope Valley in the Peak District to try to achieve it. Every time I arrived (having carefully timed my visit according to the weather forecasts) I had been met with disappointment – no mist. This particular morning, though, I made my image – very satisfying!

**ROBIN WHALLEY**                                                    **2008**

### The Lowry Theatre
*Salford Quays, Manchester, England*

The Lowry Theatre isn't too far from where I live and I had been meaning to do a sunset shoot for some time. On this particular evening there was a wonderful sunset but I decided to extend my shoot and try some night shots using a combined exposure technique (HDR). The night air was wonderfully clear and while there were a few ripples on the water, the long exposures necessary for the low light conditions made it possible to smooth the water's surface into a calm reflection.

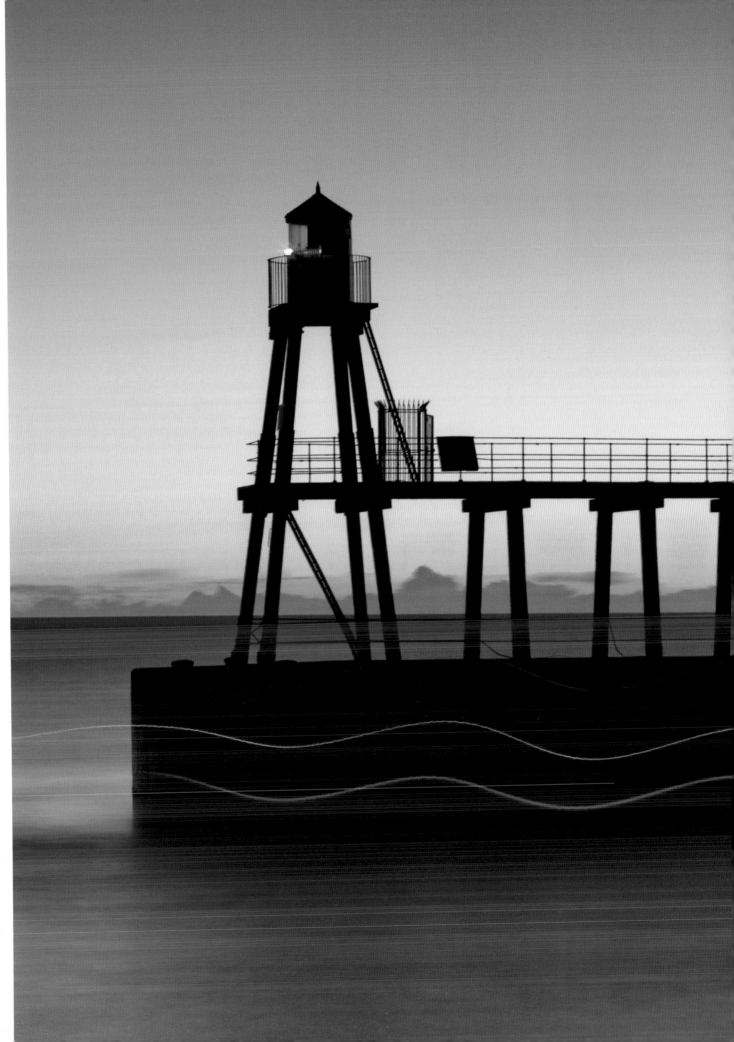

**ANN HOLMES** ◀ 2014

### Pirate's Grooves
*Isle of Arran, Scotland*

I was captivated by the dawn orange, linear textures and verdigris hue of overlying seaweed on these fossilised sand dunes while on Arran for the first time in January. With an incoming tide in Pirate's Cove at Corrie, this beauty was concealed shortly after.

**JOHN POTTER** ▶ 2013

### Gone Fishing
*Whitby, North Yorkshire, England*

A fishing boat setting off to sea just before an October sunrise created some beautiful wave-shaped light trails as it passed on the rising swell.

## ALAN RANGER ▲         2015

### Winter Gold
*Lake Vyrnwy, Powys, Wales*

A fresh layer of snow overnight at the end of January made the trip to Lake Vyrnwy a slow one from the Midlands but worth the time and effort for plenty of untouched scenes and great contrasts. This image stood out for the wonderful colour of the leaves and the sculptural framework of the dark branches against the snow. The diagonal split and space in the top half and overall balance of space and subject give it a Zen-like feel for me.

## PETER LAURENCE DOBSON ▶         2012

### The Elves' Playground
*Scotland*

Taken during a visit to Scotland, this redwood grove blocks most of the surrounding light to virtually silhouette the magical feathered and spidery characteristics of the trees.

## RICHARD SMITHIES                                                    2007

**Blaenau Ffestiniog**
*Snowdonia, Wales*

I had just come out of the local shop when I saw this view. The contrast between the burst of sunlight
and the cold blue slate here in the birthplace of slate struck me forcefully. I ran to the car and managed
to grab my camera just in time.

## JOHN PARMINTER

### Food for Thought
*Aberdeen Harbour, Scotland*

I often go down to Aberdeen's harbour for sunset and, on this occasion, I spotted a discarded shopping trolley at my favourite spot. I thought it would make an unusual foreground interest; then I decided to make it the focus of the image and try to portray a message. I waited for the sun to set, which lowered the ambient light so I could use a longer shutter speed, as I wanted the trolley to be distinguishable from the incoming tide. Maybe it isn't the prettiest landscape image I have taken but I think it has some of its own beauty and hopefully a message as well.

## DAVID BAKER

### The New Forest
*Hampshire, England*

This image was taken in March and is part of a project involving a particular area of the New Forest that I am visiting at dawn, or a little after, on days when there is mist.

**JON MARTIN**                                                          **2016**

### Gunnerside
*Swaledale, North Yorkshire, England*

I stayed at Gunnerside in March this year specifically to photograph this classic Dales scene, hoping for some misty conditions. On the day I took this image, the weather forecast was promising and I was in position at dawn. Initially the mist was too dense and I had to wait for a few hours before the patchwork landscape beneath was revealed as the mist started to clear.

## KAREN ATKINSON                                          **2011**

### The Sage
*Gateshead, Tyne & Wear, England*

The creation of this image of Sage Gateshead was truly a labour of love. The picture in my mind's eye was always going to be black and white. It was going to have stretched clouds sweeping above the curved spine of the Sage, hopefully with some great pockets of light landing on the panels. I'd set up my chosen angle on two previous occasions but the clouds weren't sharing my vision. Then this particular evening, the clouds and my imagination were journeying together. Ninety seconds, and I knew I had something of the essence of the Sage I'd dreamed of.

**ROSS FARNHAM**                                                    **2015**

Electric Web
*near Palterton, Derbyshire, England*

I was returning from a location that I'd spotted on the motorway feeling quite dejected that I hadn't captured what I had pictured in my mind. I had to trek through a number of fields and was sure that I had retraced my steps exactly but found myself in a field that I didn't recognise with an electricity pylon on an unmade track meaning I could stand beneath it. I'd packed away my gear and was tired, thirsty and just wanted to get home but the clouds looked pretty good for a long exposure, so I unpacked everything again and set about lining up the symmetry, with me on my back and the tripod on its absolute lowest setting (literally one inch off the ground). Doing this in full view in bright light and at a very shallow angle took a lot of patience but the result was worth it.

## TIM HARRIS  2014

### Two Hundred and Six Beach Huts
*Norfolk, England*

This is a composite of over 200 separate exposures, one for each of the beach huts along the North Norfolk coast at Wells-next-the-Sea. I wanted to show the diversity of individual styles for the huts – different colours, different designs and different states of repair. I worked along the line of huts one by one, taking separate exposures of each directly from the front to provide the illusion of a consistent viewpoint in the combined image. I made this in May 2013, before the damage wreaked by the tidal surge at the end of the year.

## STUART KERR
**2011**

### Southport Pier
*Merseyside, England*

Southport Pier is a favourite promenade for local residents and visitors alike. I wanted to capture this, and I liked the symmetrical layout of the shelter and the lights. I took countless shots as I waited for a cyclist under the first light and a couple walking under the second light, both going into the frame. The pier is very busy and I only had to wait an hour to get the image I was after.

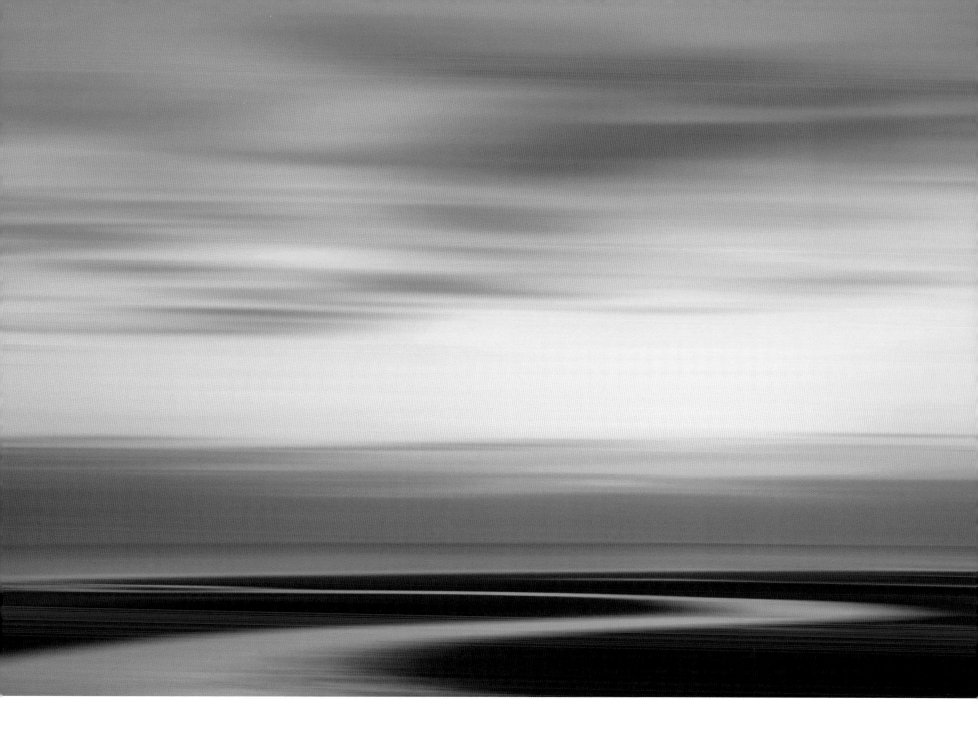

**JUSTIN MINNS** 2012

### Hunstanton at Dusk
*Norfolk, England*

This was my first visit to Hunstanton beach and I had enjoyed a couple of hours photographing the rocks and cliffs in some wonderful evening light. I'd already packed up and was heading back to the car when I noticed this scene, which wasn't visible from further down the beach. The sun had gone down over an hour earlier and the beach was almost dark, but the twilight was lingering and creating a beautiful silver light on this stream of water snaking its way down the beach at low tide. I deliberately blurred it slightly to simplify the scene and add to the sense of motion.

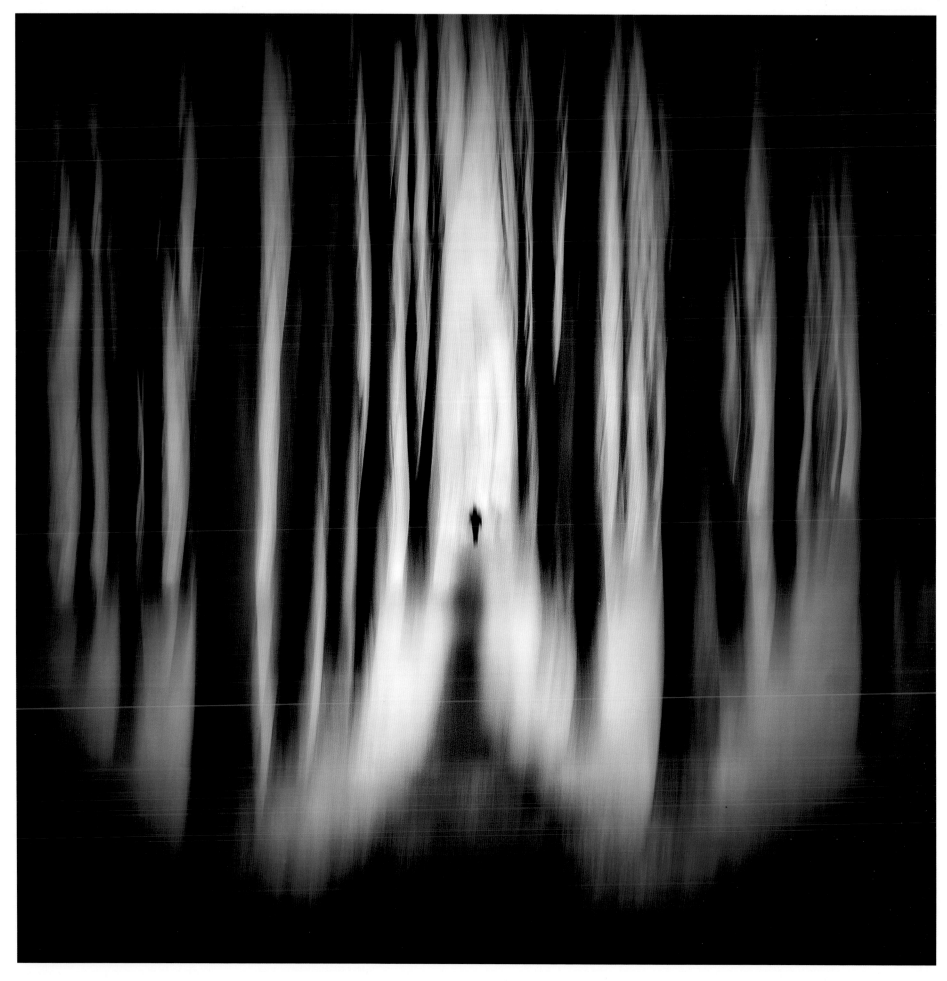

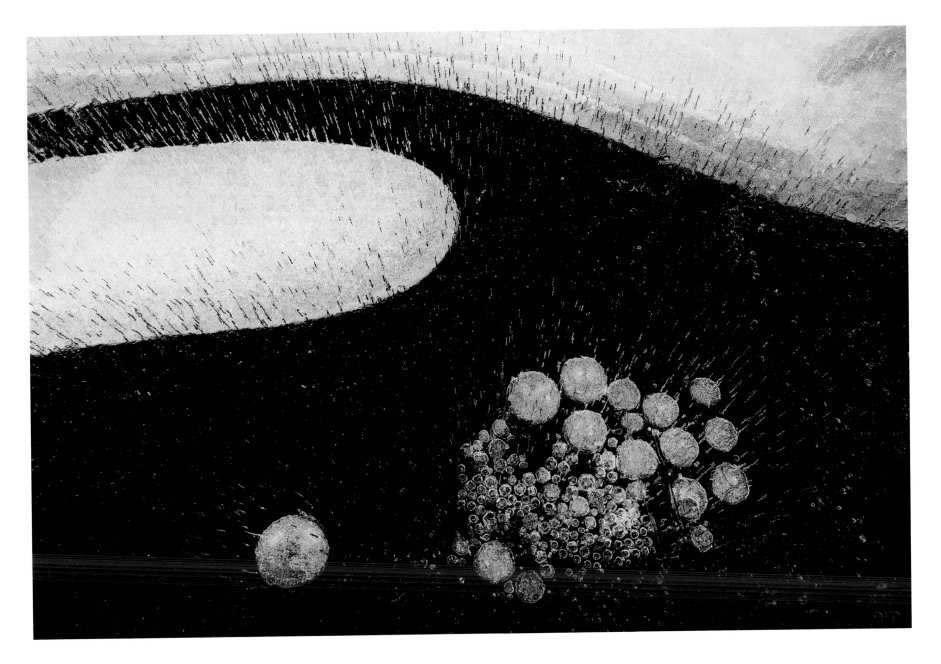

## BOB BISHOP ◀ 2016

### Walk in the Woods
*Wrington, Somerset, England*

I have visited this small local bluebell wood on many occasions and have got many different images from there. On this occasion I took an old DSLR which had been converted to infra-red to get an image that would be different. I deliberately went when the bluebells were out and there would be minimal leaves on the trees, as I wanted a white haze on the ground which I knew the bluebell leaves would give me. Had there been more leaves in the trees, this would have over-complicated the image. ICM (intentional camera movement) was used vertically to blur the trees at the time of capture and to turn the bluebells to the white haze I wanted. I deliberately centred the path to centrally locate the person I knew I wanted to add afterwards.

## WILCO DRAGT ▲ 2010

### Winter on Rannoch Moor
*Scotland*

It was the last day of December on Rannoch Moor and was very cold, with grey and dull skies. The lochs were covered with a thick layer of ice. Because of the bleak skies, I decided to look for forms and patterns in the ice. It didn't take long to find this patch of black ice and lovely air bubbles. At first I started using a macro lens, but then switched over to wide angle, with the front of the lens almost touching the ice. I imagined that the converging lines of the needle-like tiny bubbles would strengthen the composition. While making the images, I thought about the champagne bubbles that would appear later that evening, celebrating the start of the New Year.

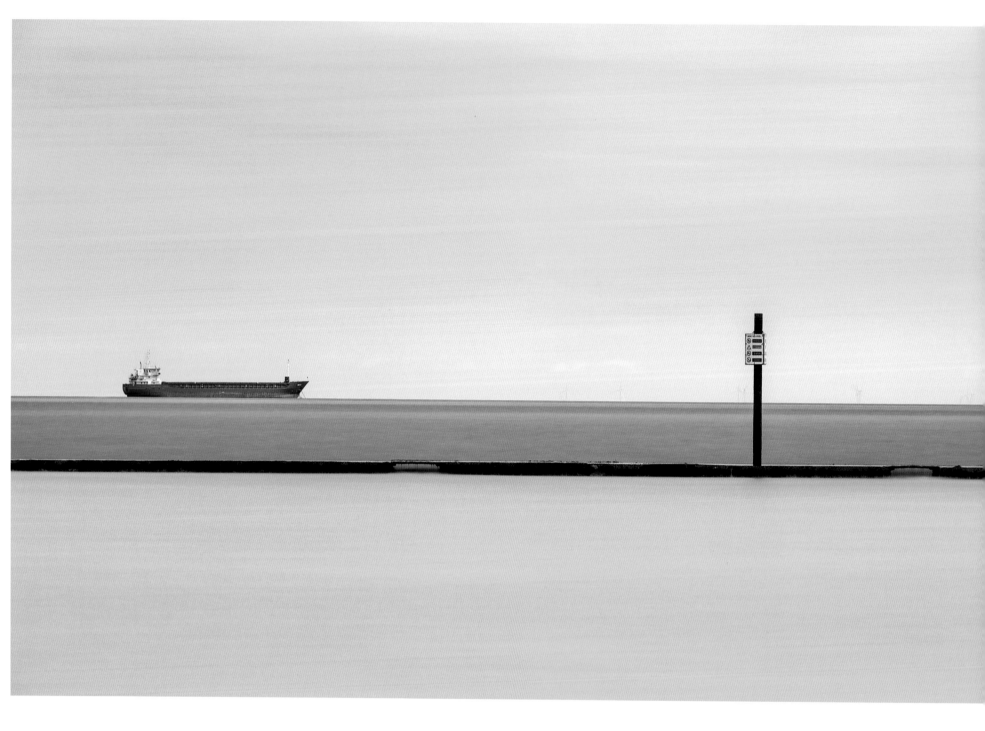

**VALDA BAILEY ▲** 2012

**Gursky Goes to Margate**
*Kent, England*

Not a conscious attempt to emulate Gursky's famous photo of the Rhine, but clearly influences trickle down. Don't suppose anyone is going to give me $4.3m for it any time soon, however.

**DIETMAR HERZOG ▶** 2016

**Black Rain**
*Isle of Skye, Scotland*

The Red Cuillin of Skye reflected in a pond near Torrin.

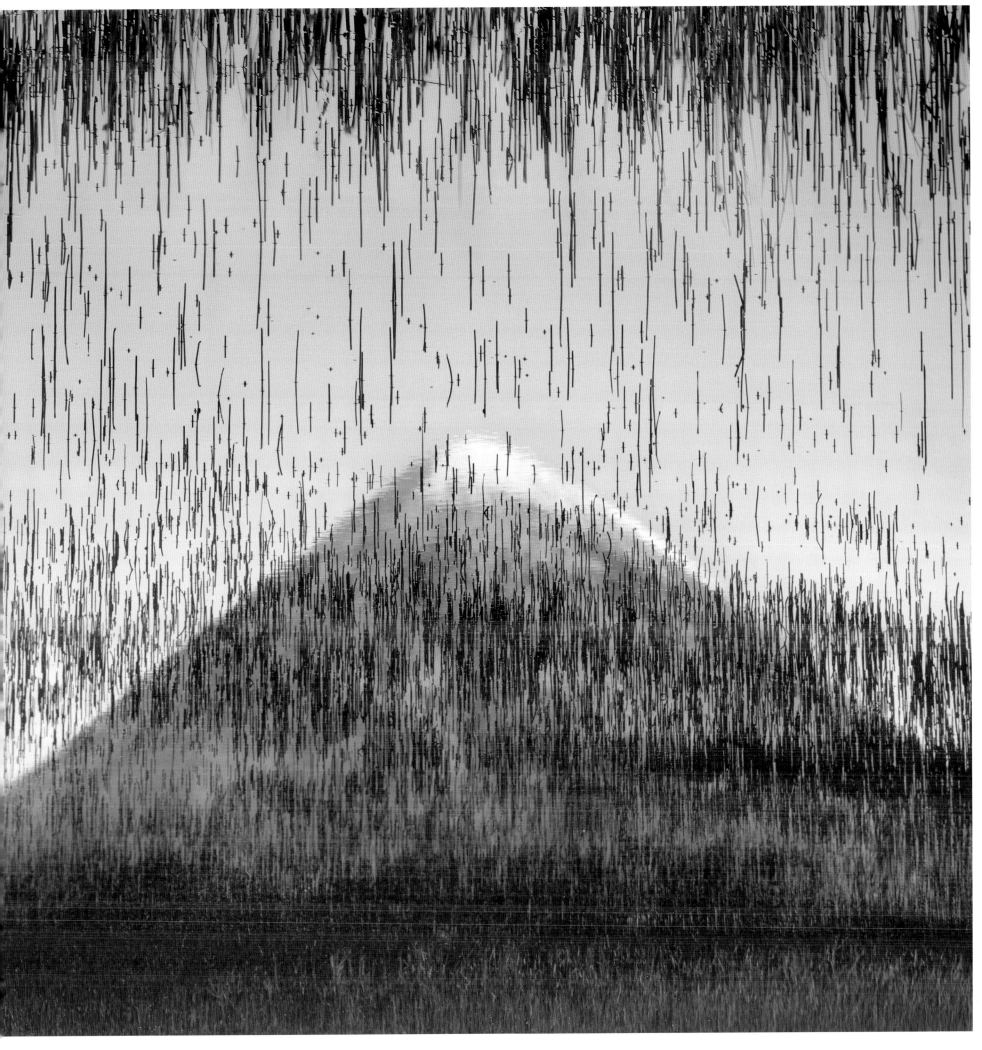

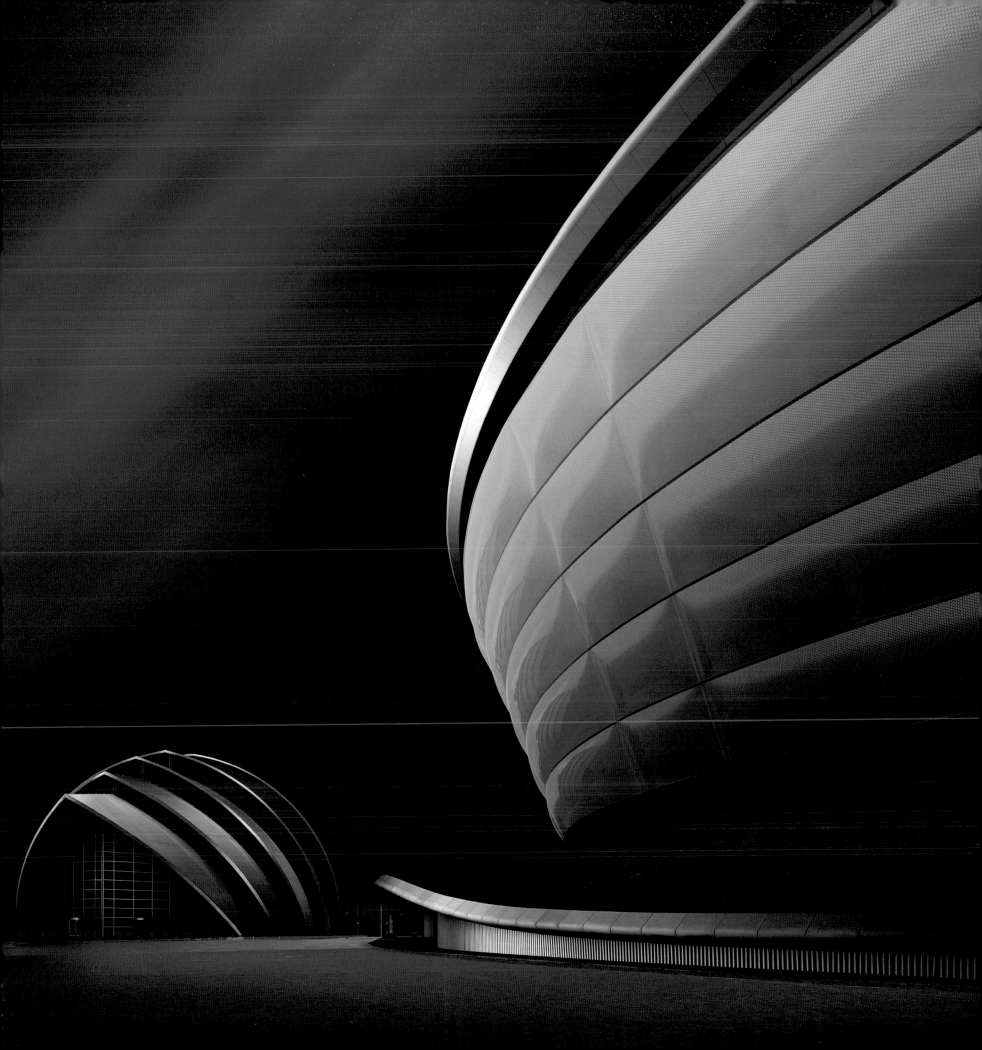

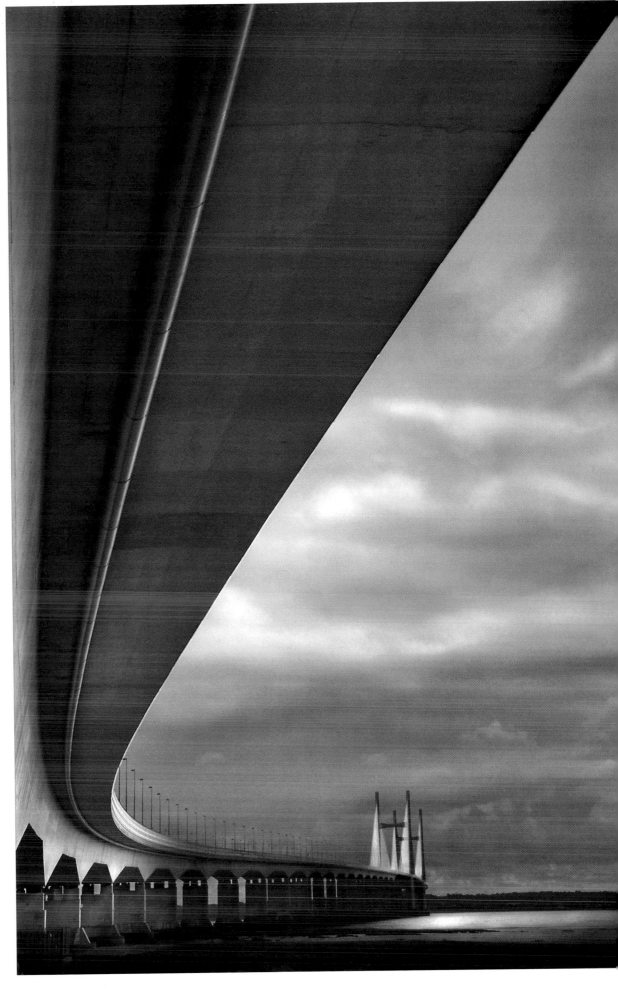

## BILLY CURRIE ◄        2015

### Venues
*Glasgow, Scotland*

The Hydro and the Clyde Auditorium (the Armadillo) are two of the numerous stunning buildings along Glasgow's Clydeside. Although structurally very different, they seem to complement each other in many ways. Perfect companions in architecture.

## BRIAN GRIFFITHS ►        2009

### The Second Severn Crossing
*Between England and Wales*

I waited a long time for the light and clouds to be right; then I lay flat on the ground in order to get the curve of the bridge to fit the frame.

### Magpie Inkcap
*Newnham, Kent, England*

For over 30 years I have been visiting and photographing the very same woods where I first became fascinated with nature. While out in one such woodland last autumn in a village not far from where I live, I came across this solitary magpie inkcap mushroom growing adjacent to the footpath. The sun was setting and cast a warm glow on the background. Inkcaps mature and go over very quickly and I knew that this would be my only opportunity. I worked quickly and had just enough time to set up the camera and make the image before the light disappeared.

**KEITH AGGETT** ►      2013

### Descent
*Babbacombe, Devon, England*

Descent, taken on a rainy morning in Babbacombe. The weather on this day made for a soft, receding backdrop to increase the focal point in the foreground; filters were used to increase the exposure time and smooth out the water. The location can be found by walking the coastal path to Oddicombe and this composition is only possible with the combining of two images to create a vertorama.

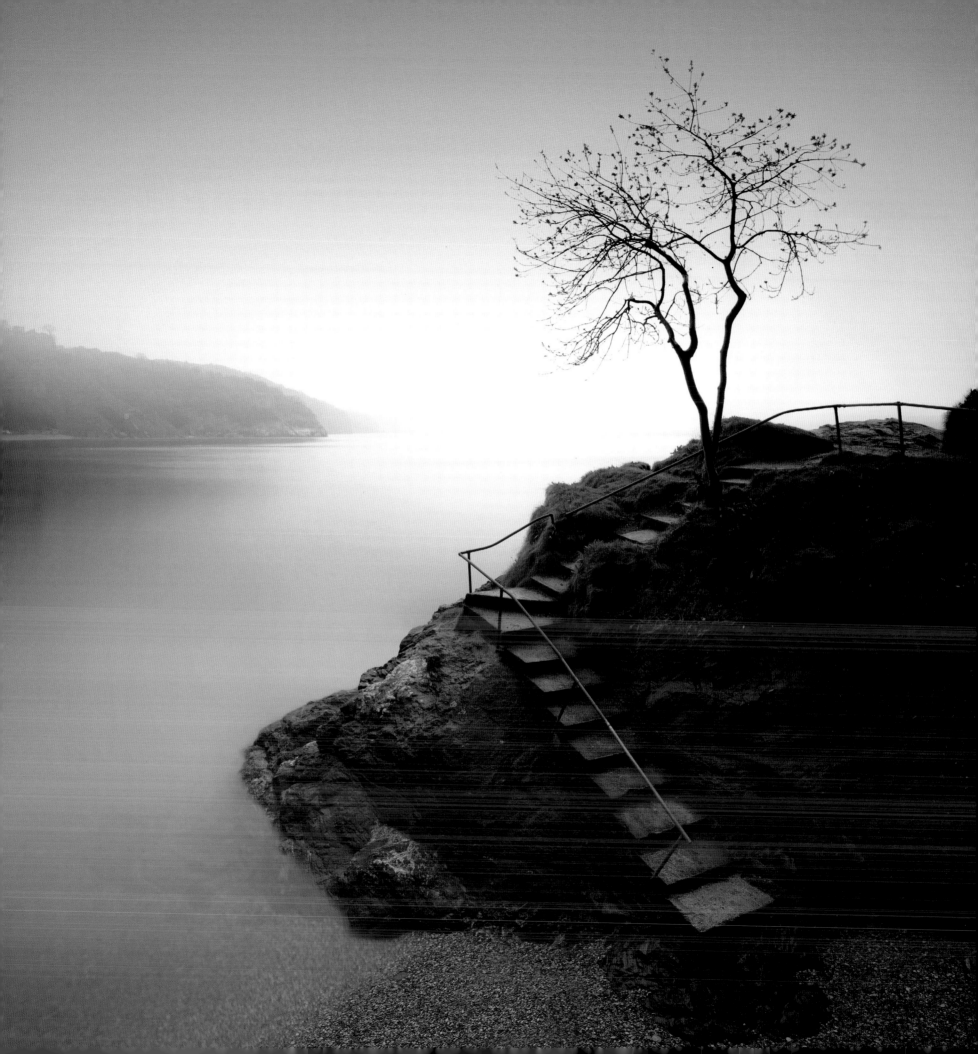

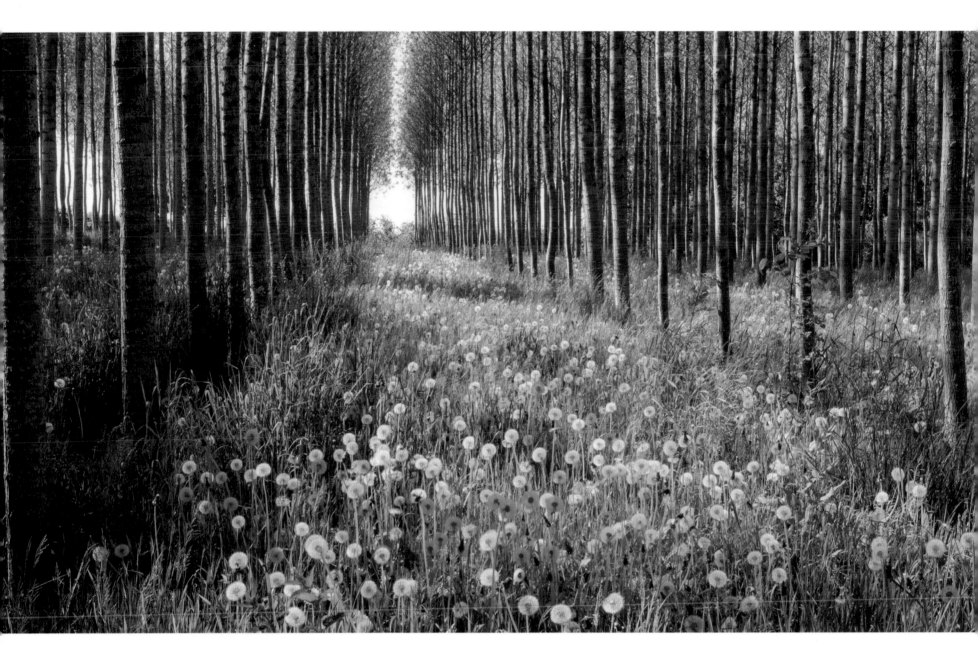

**STEVE GRAY**                                                          **2013**

**Morning Light in the Poplars**
*Herefordshire, England*

I photographed these trees on a July morning with strong sunlight. I particularly liked the dappled pattern of light on the ground, with the dandelions resplendent in the sun. The rows of trees beyond add a sense of depth and the splash of blue sky in the distance completes the picture and breaks up the predominant green.

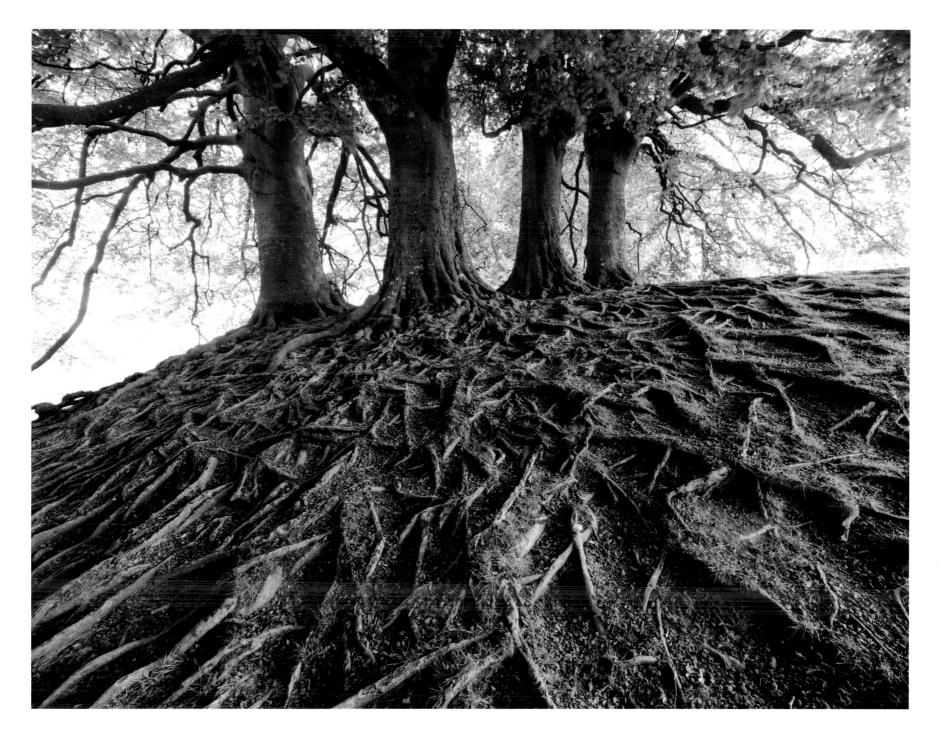

**TONY HOWELL** 2011

### Beech Tree Roots
*Avebury, Wiltshire, England*

I've always loved this group of four beech trees and their twisted exposed roots, and first took this shot about 20 years ago on 35mm slide film. This one was taken with a 39 megapixel camera, and the difference in quality is astounding. The trees are on a small hill, so their roots became exposed as the topsoil washed away over time. Grass struggles to live in between the roots, under the darkened canopy. Two lambs kept coming into the top of the shot and I had to keep chasing them off.

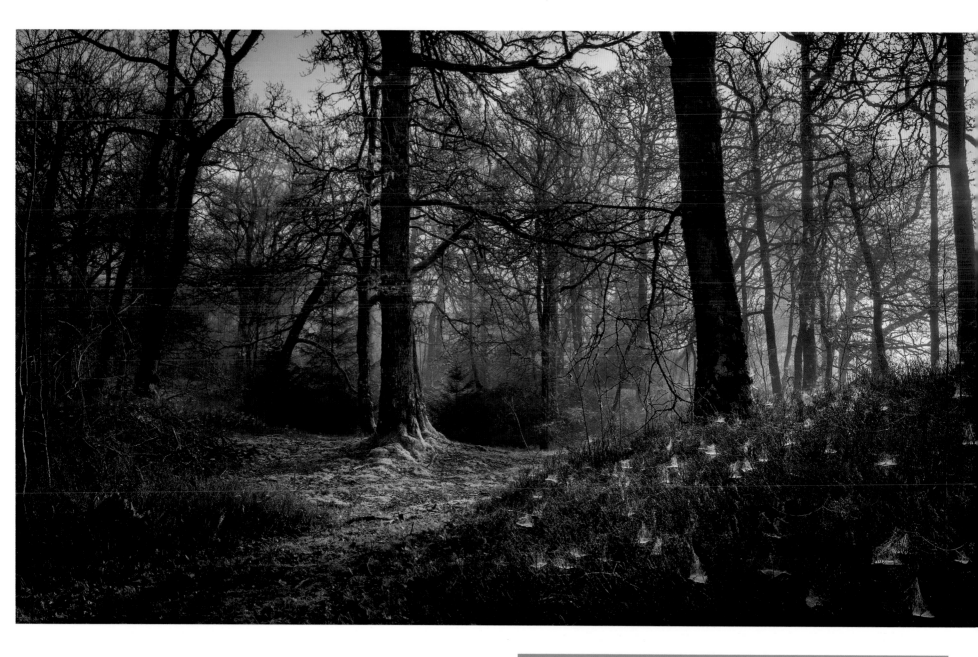

**NEIL BARR** ▲      2015

**Misty Woods**
*Loch Ard, Stirling, Scotland*

Unnamed woods next to Dun Dubh on Loch Ard in the Trossachs, on a misty spring morning just after sunrise.

**PETER CLARK** ▶

**Rawhead Woods**
*Cheshire, England*

I made this image on a cold winter morning in December. My gloved hands were freezing to the metal legs of my tripod and the temperature never climbed above –4°C all day. It shows one of the small woods that line the top of Raw Head on the Cheshire Sandstone Ridge. A thick fog lent the scene an ethereal beauty and the morning sunlight gives the image a deceptive feeling of warmth.

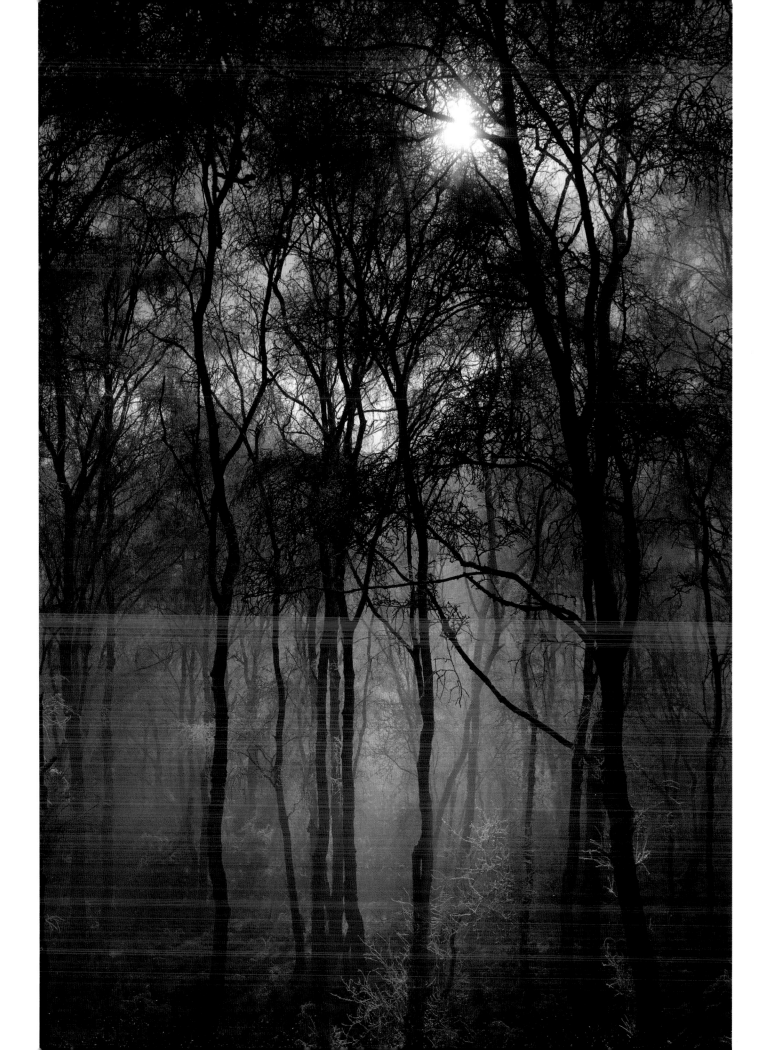

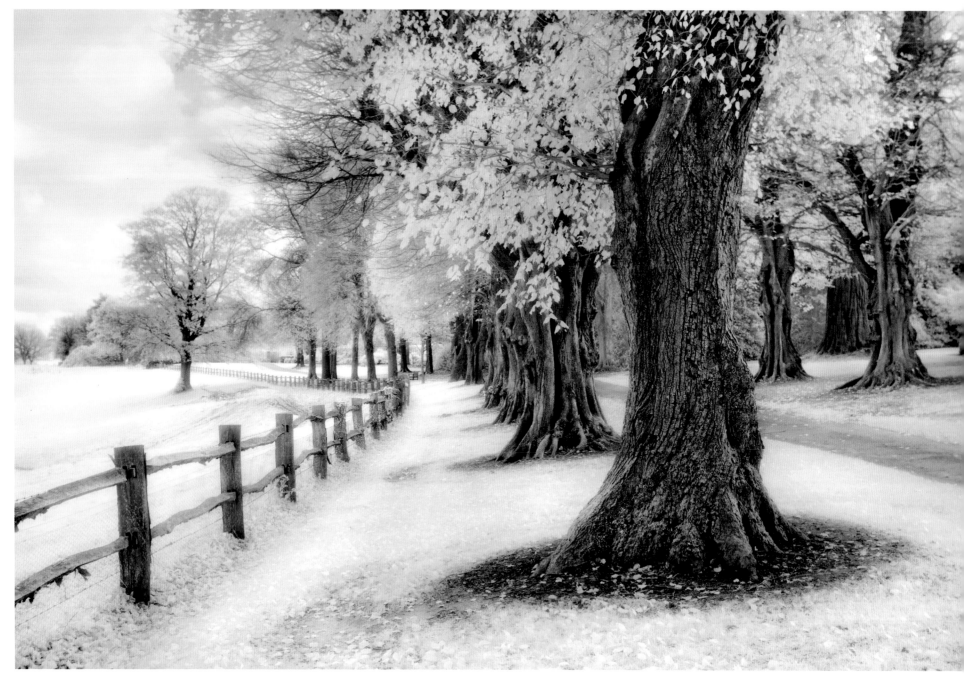

**PAUL KNIGHT**                                                    **2013**

**Autumn Afternoon**
*Haywards Heath, West Sussex, England*

The avenue of trees looked stunning in the low autumnal sunlight but, as there was so much going on in this image, I felt that it would look better in black and white and in flat light with no heavy shadows. I also chose to shoot on an infra-red, rather than conventional, camera.

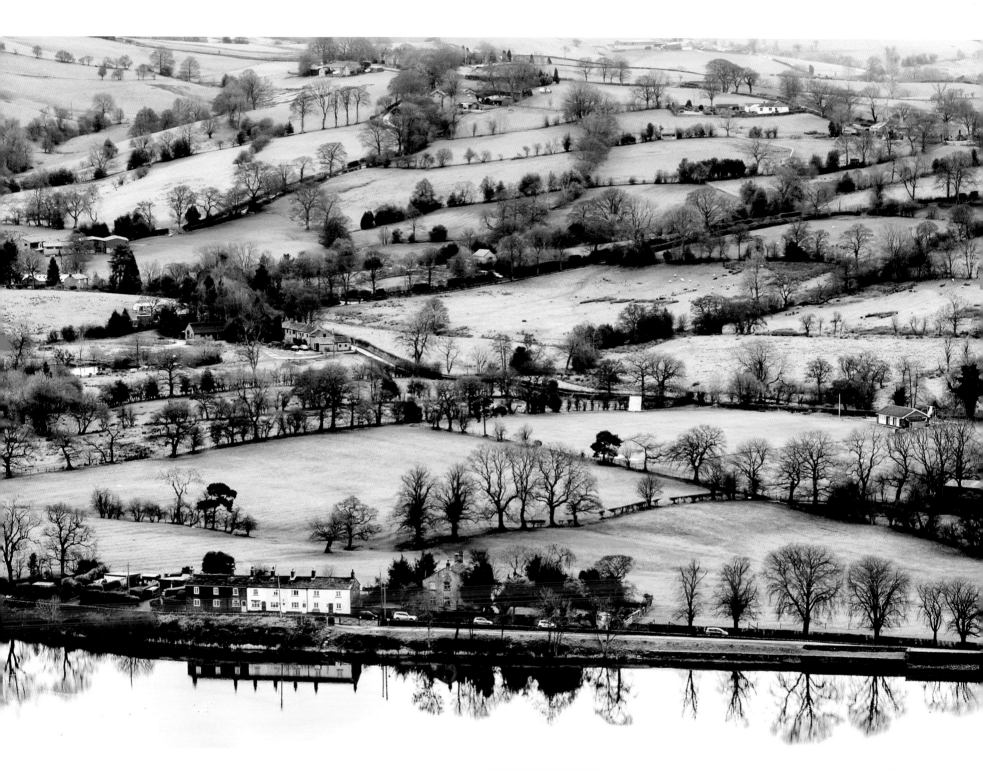

**MARK HELLIWELL**                                                       **2014**

Reflections
*Bottoms Reservoir, Cheshire, England*

I was hoping to capture a wide vista and was waiting for the sun to set to the right. However, on studying the scene in front of me more carefully, I noticed the reflections of the trees and houses in the reservoir and the criss-cross pattern of trees bordering the fields in the distance. So I changed from wide-angle lens to telephoto to emphasise the patterns in the landscape.

**MARK BRADSHAW ▲** 2010

**Newbiggin-by-the-Sea**
*Northumberland, England*

It was still dark when I arrived at this seaside town and, being so early, the snow was unblemished. The dark wood of the seats made a striking contrast with the whiteness below, but it was their curve, which led to the sea and greyness beyond, that most inspired the picture. It's the sort of image I try to look for and photograph, where the focus is on the ordinary, something most of the time passed by and overlooked. I have been back to the same spot but without the snow it just isn't the same. It gave the seats a chance to be seen. This was their day in the sun.

**BILLY CURRIE ▶** 2016

**Accommodation**
*Glasgow, Scotland*

One of the more interesting city centre hotels in Glasgow. The architecture lends itself well to this type of artistic image. The bus also adds some nice scale to the overall scene.

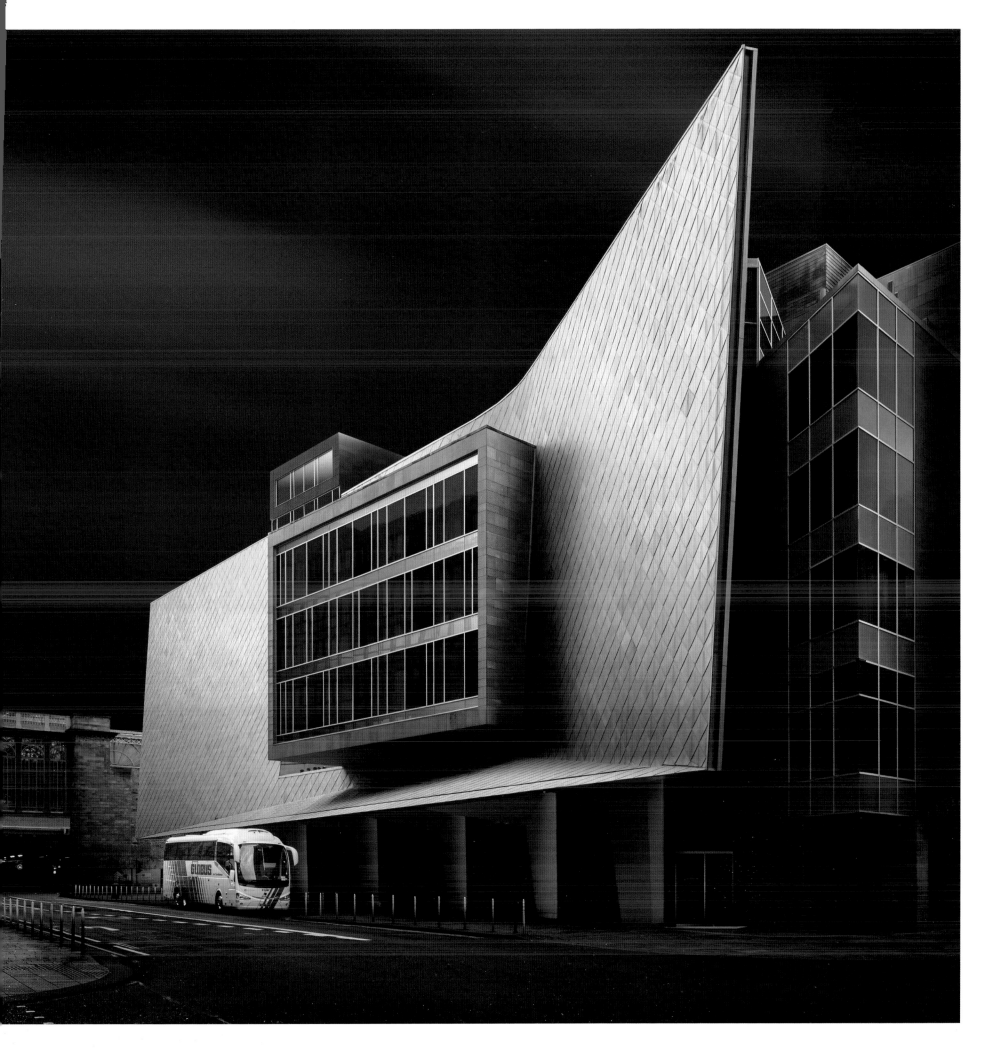

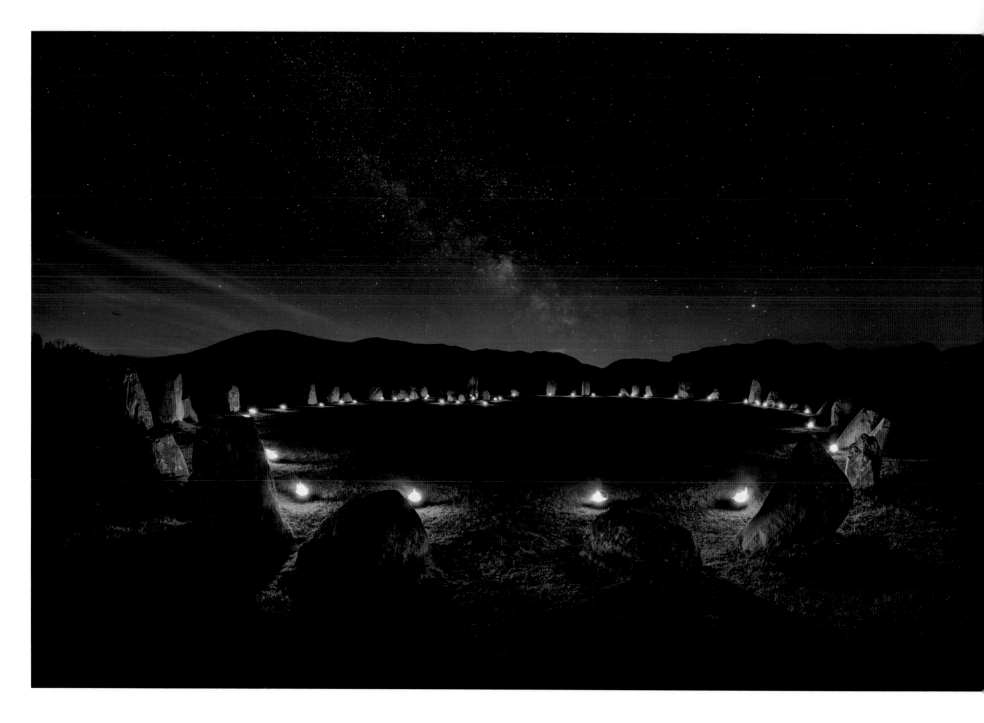

## GARY WAIDSON                                                    2016

### Circle of Fire
*The Carles (Castlerigg), Cumbria, England*

I woke up one morning with a crazy idea. I had already planned to go to Castlerigg with a friend to do some simple light painting shots but the idea behind this was something a little bit different. We had been hoping for a clear sky so that we could include the Milky Way, and the high-pressure system that was holding fine weather over the Lakes served us well this night. The logistics took some working out; it was most important to me not to cause any damage to the site, of course. The processing of all the necessary RAW files took quite some time as well but I was thrilled with the final result.

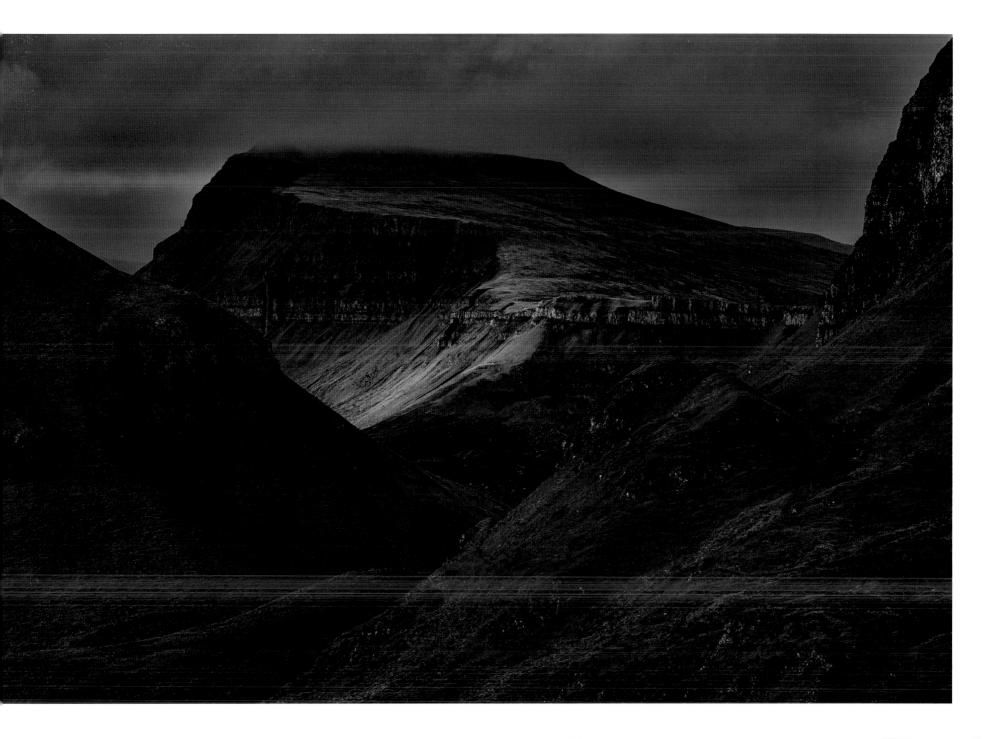

**SHAHBAZ MAJEED**                                                 **2016**

### Fleeting Light at the Quiraing
*Isle of Skye, Scotland*

When I arrived here at 4am, along with a group of participants on my workshop, it didn't look too promising, with thick clouds and then, shortly before sunrise, a hail and rain shower. After that, though, it started to clear up pretty quickly and we were treated to some very dramatic light. After making sure that the participants were making the most of the conditions, I grabbed this shot with my zoom lens to focus on the light hitting the peak in the distance framed by the ones on either side. It's a very simple image but it really shows off the drama of this part of Scotland that draws photographers from across the world.

## ROY MERRIFIELD ◀        2009

### Sheep Dipping at Gatesgarth Farm
*near Buttermere Fell, Cumbria, England*

Herdwick sheep are the native breed of the central and western Lake District and the rightful heirs to the high fells. Much of the beauty and joy of walking in these fells is due to the hill farmers, who have skilfully managed the land for more than 1,000 years. Eking out a living between the bleak and inspiring fells, where their sheep share grazing, they have used, and still use, a traditional type of farming as championed by the late Beatrix Potter 'for her beloved Herdwicks'. Dipping is a necessary procedure to support the health of the sheep, but no doubt is considered by them as a serious (but temporary) loss of freedom from the fells!

## ROBERT OLIVER ▶

### Bowdown Berries
*Newbury, Berkshire, England*

A dank, misty morning turned my local woods into an unfamiliar world. In the past, I'd walked past this spot on numerous occasions and never gave it a second look. However, the relatively subdued colour palette of the lichens, mist and some dew-laden spider webs, together with the vibrant red berries, attracted my attention this time.

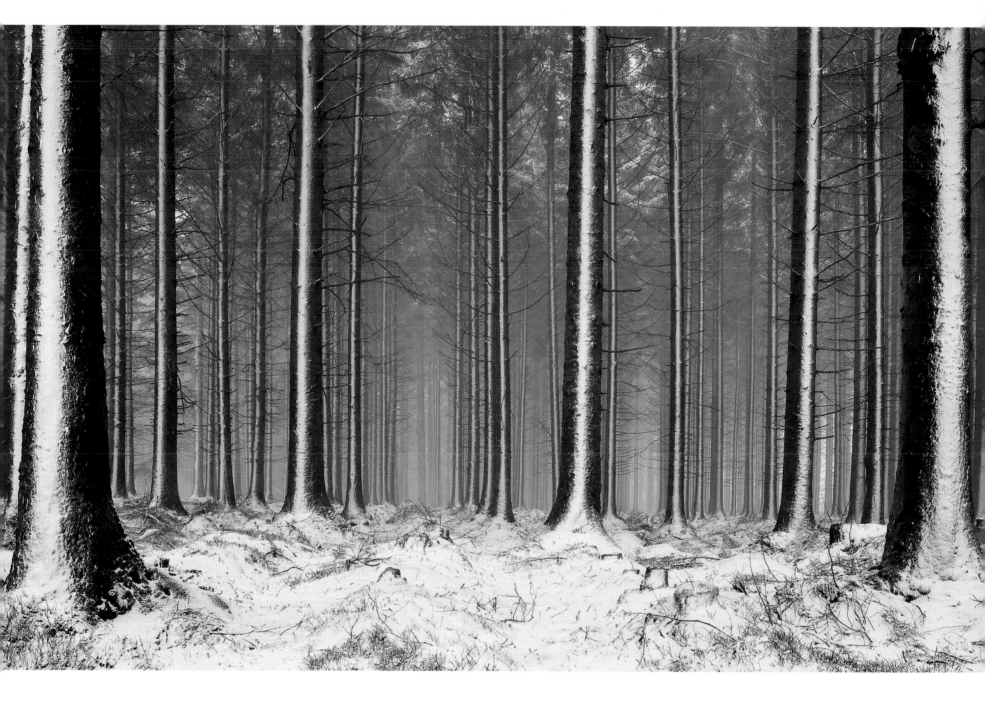

**MARK LAKEMAN**                                          **2009**

**Bellever Binary Barcode**
*Dartmoor National Park, Devon, England*

An ear-shattering crack, shortly followed by a rather loud rumble of thunder as another winter weather front pushed over. I knew what was coming next – a major snow blizzard. Excellent. In the middle of Bellever Woods, quite some distance from the car, my footprints slowly disappearing. Love it.

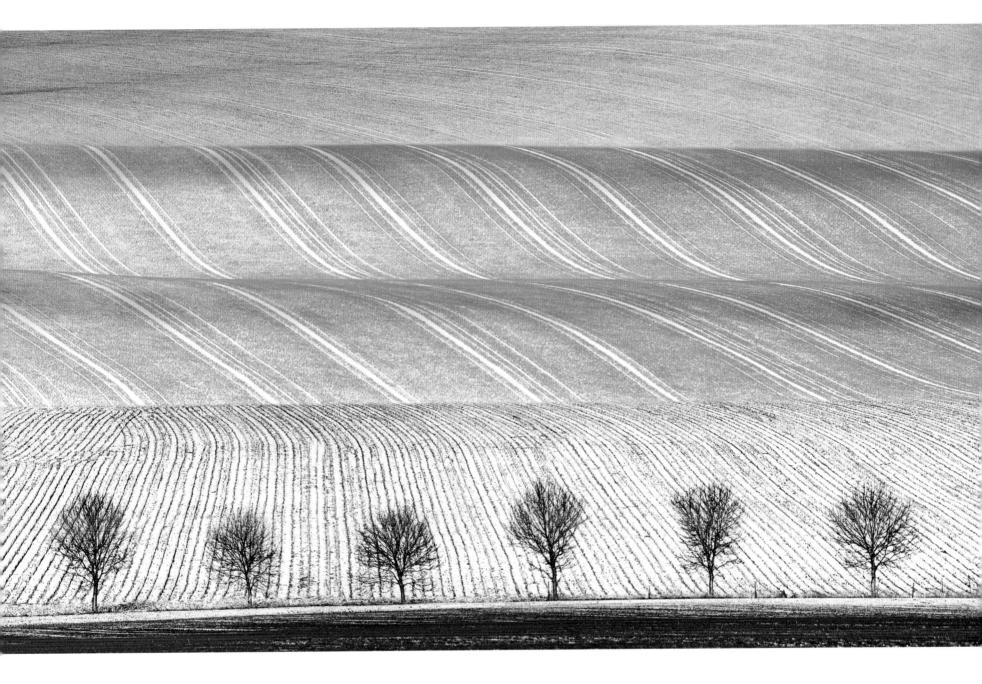

## PETER NORTH

### Snowdust

*Therfield, Hertfordshire, England*

This scene is very popular with local photographers and I have photographed it several times myself at different times of the day and in different seasons. I had never seen it before, however, with such a light dusting of snow. This had settled in the deeper ridges of the fields while still allowing the colour and texture of the soil to be visible but rendered almost pastel-like. The black silhouette of the skeletal trees anchors the scene well, providing a nice contrast. I tried cropping the shot to five trees (magic odd number) but I actually preferred the balance of the shot with six.

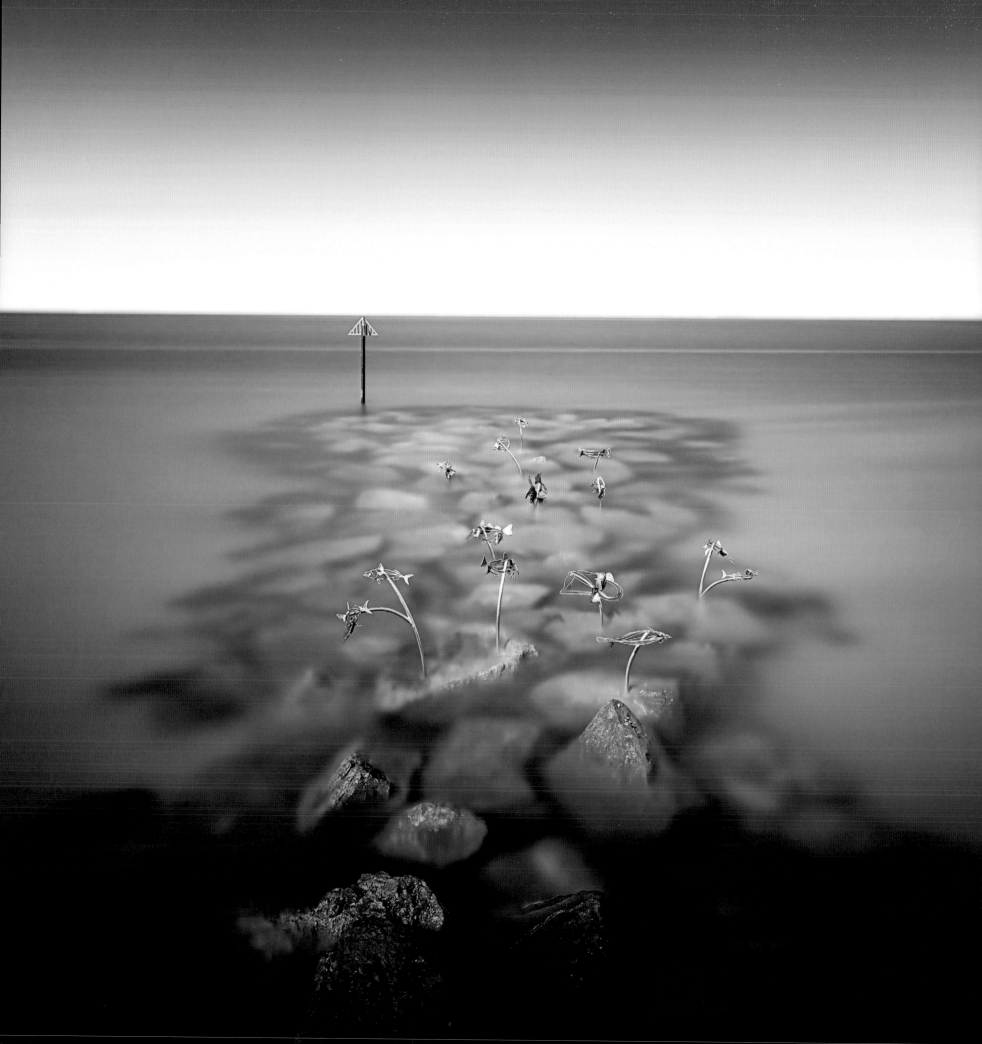

## STEEN DOESSING ◀                                              2008

### Intertidal
*Isle of Wight, England*

With family and work commitments, when I am not on a planned trip, I have to fit shooting in with other obligations and I try to grab every opportunity. This was taken on a family holiday to the Isle of Wight in August. It was late morning, sunny and very hazy.

## MARTIN CHAMBERLAIN ▶                           2012

### From a Hot Air Balloon
*Near Edenbridge, Kent, England*

This image was taken from a hot air balloon drifting directly above two horses grazing near Edenbridge in Kent. The long shadows of dawn created abstract images as we looked down on familiar objects from an unfamiliar angle.

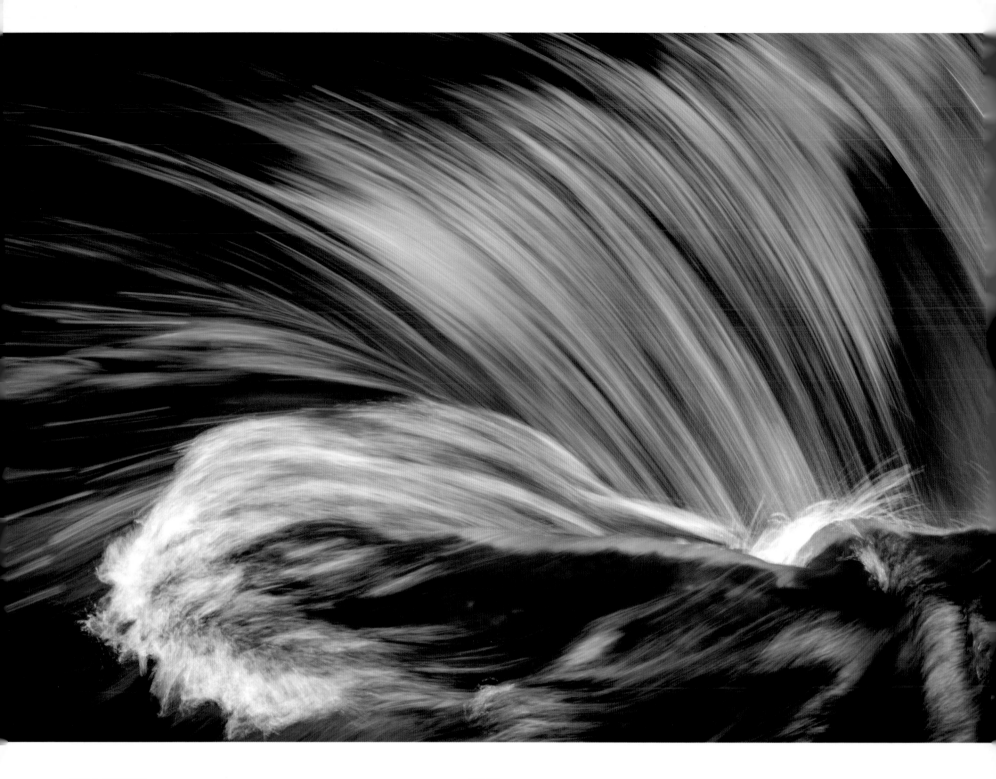

**BILL WARD**                                                              **2015**

### Rainbow Falls
*Kisdon Force, Yorkshire Dales, England*

I'd had a fantastic day in the Yorkshire Dales, walking the circuit from Keld down to Muker and back up again to Keld, a journey of around eight miles or so. I'd had pretty much every kind of weather, including five or six hailstorms, driving rain and bright sunshine (not unusual for the Dales). I decided to take one last detour as I returned to Keld, and caught Kisdon Force in full flow. The peaty water flowing over the falls was composed of almost every colour, some from the reflections of the trees above, some almost backlit by the riverbed beneath. I noticed a standing wave just before the falls, and composed around it ...

## CHRIS FRIEL

**2011**

### Seasalter
*Kent, England*

This was taken on an April afternoon just behind the beach in Seasalter, a couple of miles from where I live. It's an area of reeds and water channels and big empty skies. I used a slow shutter speed and incorrect colour temperature on an old tilt shift lens to try to simplify the landscape.

**DONALD CAMERON**                                                    **2014**

**Your Dark and Your Cold**
*Lunan Bay, Angus, Scotland*

This is quite an abstract take on the traditional seascape, shot on the east coast of Scotland. Combining a long exposure with some fairly extreme levels adjustments, plus a little selective dodging and burning, created this surreal effect with the water and small strip of clouds appearing to float in the darkness. I have been shooting minimalist beach scenes for some time and wanted to see how far I could push the boundaries of that, all the while staying true to the subject in the original image, to produce something stark and hopefully a little original. What makes the British landscape beautiful for me is not just what you can see, but what it can inspire you to create with it.

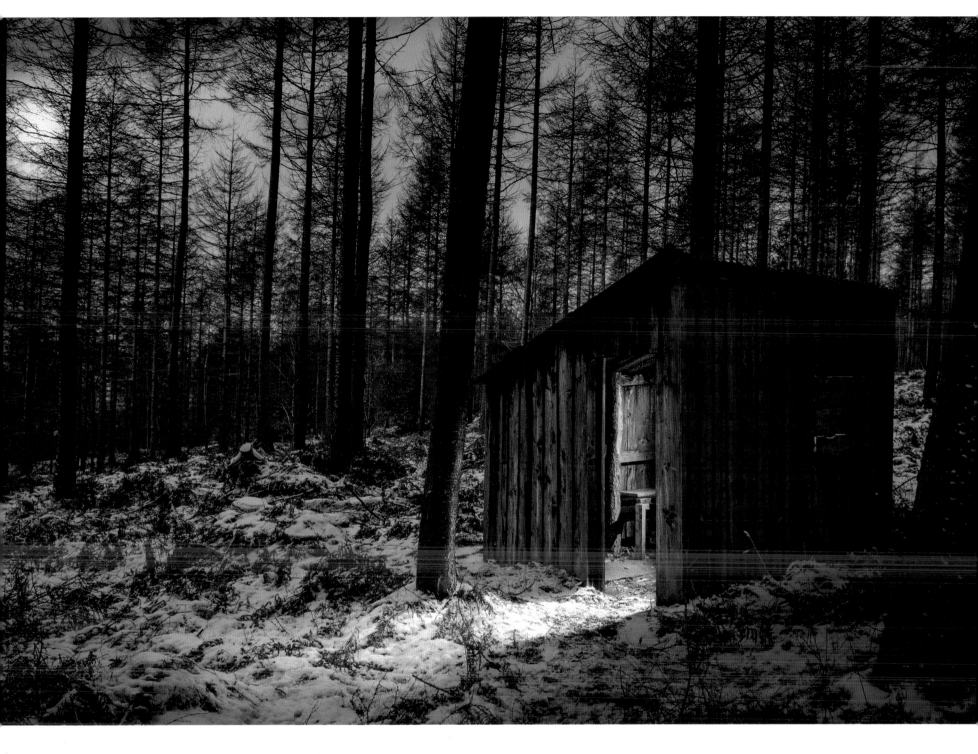

**TOMMY MARTIN**                                                                 **2015**

Portals II
*Penrith, Cumbria, England*

A forester's hut in Beacon Edge Woods, near Penrith. From an ongoing series of images of lit doorways.

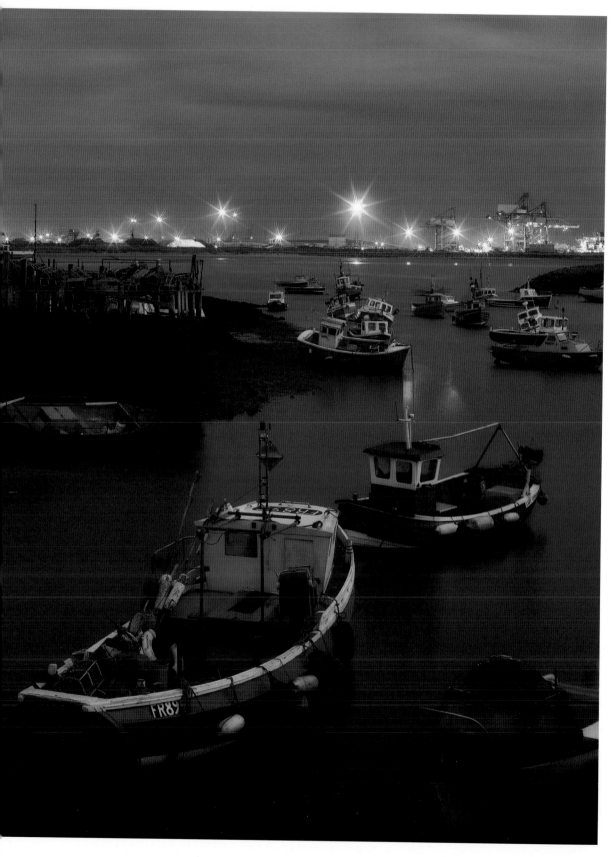

### Paddy's Hole
*South Gare, North Yorkshire, England*

Paddy's Hole, at South Gare, situated at the mouth of the River Tees, is a popular location for photographers. This gentle backwater seems quaintly old fashioned, with its fishing boats, lobster pots and fishermen's huts, seemingly at odds with the more modern heavy industrial environment surrounding it. For this image, taken at dusk, I tried to capture this contrast, using the lights of the steelworks complex as a backdrop to the foreground fishing boats.

**WINNER** **2010**

### PAUL ROBINSON ▶

### Kinder Scout
*Peak District National Park, Derbyshire, England*

One day in January, I went on a solo hike up Kinder starting at Edale. I ventured deep onto the summit plateau, into untrodden terrain, lured in by some amazing, naturally formed snow sculptures, including this cornice. Already out of my comfort zone, I didn't dare get any closer in case the cornice collapsed above me or for fear of falling into the deep grough beneath it. Getting the composition right was tricky, not only because I was waist-deep in snow and sinking but, due to the low angle of the sun, I also had to avoid getting my own shadow in the shot. Once I was satisfied with the shots I'd taken I was then in a bit of a predicament, wading my way back through the snow to relative safety.

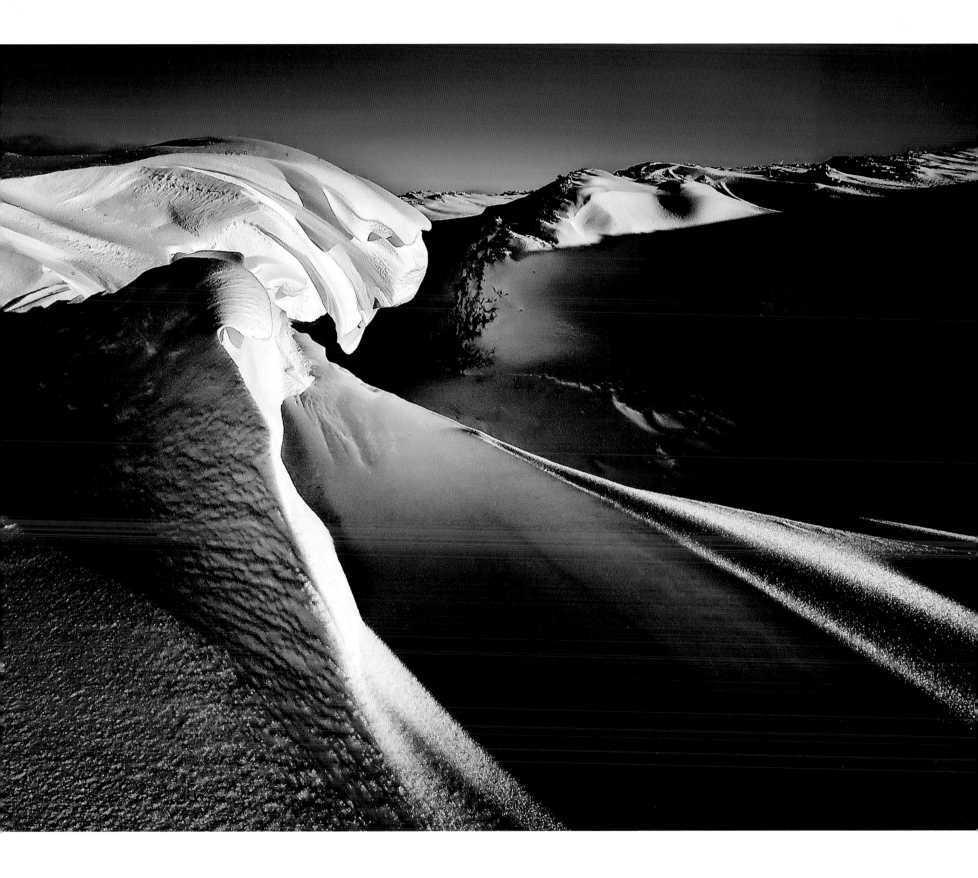

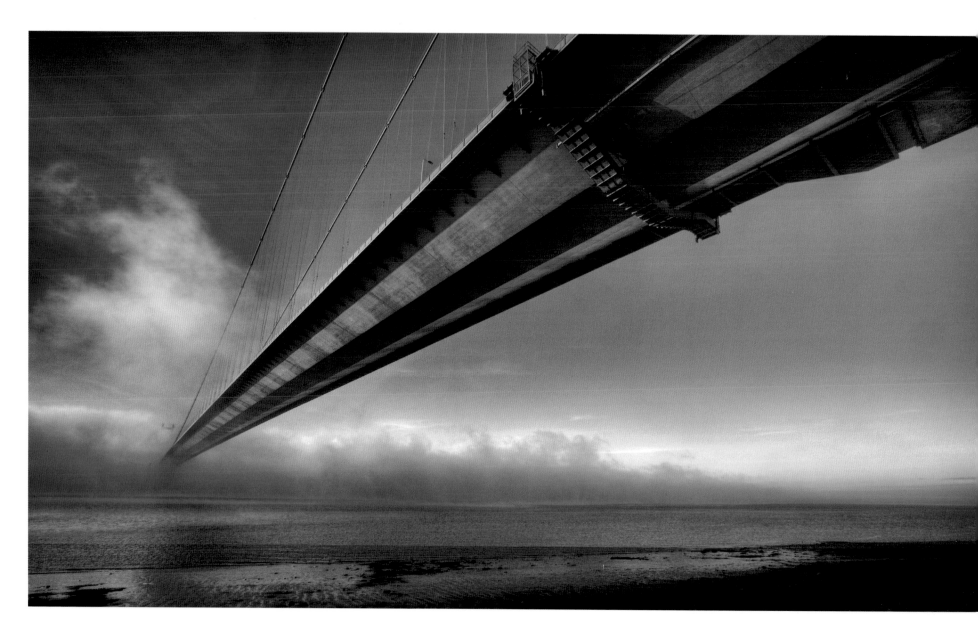

## DUNCAN McMILLAN

**2008**

### The Humber Bridge
*East Yorkshire, England*

Chilly sea breezes undercutting the warmer air above caused this spectacular atmospheric phenomenon over the Humber Estuary early one morning in October. The resulting cloud inversion rolled swiftly up the river, engulfing the Humber Bridge in swirling mists before dissipating as the warmth of the sun took effect.

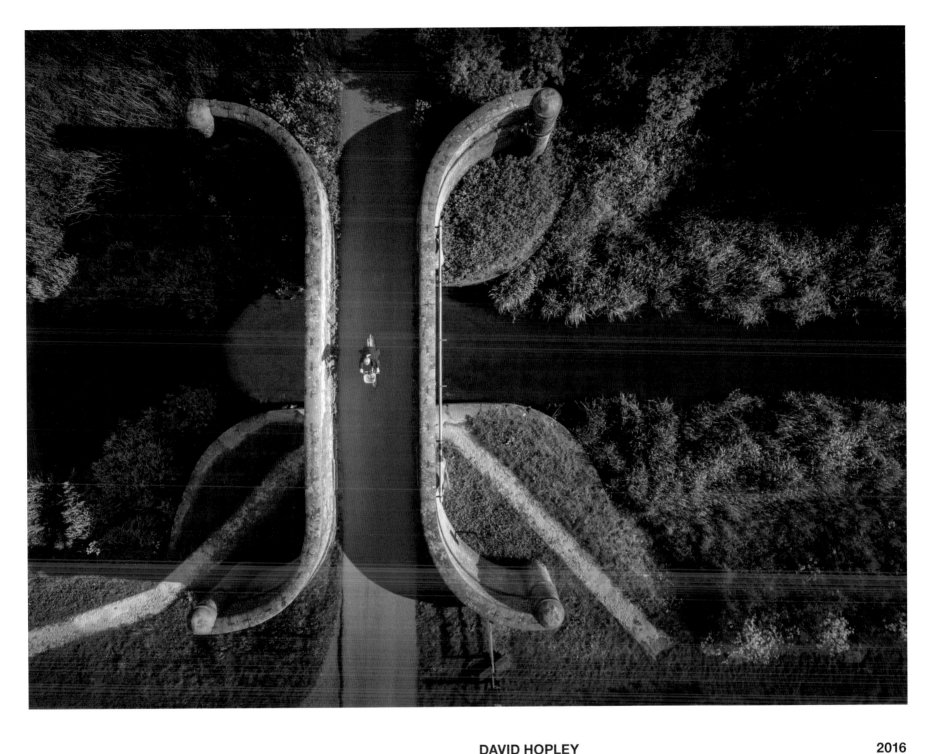

**DAVID HOPLEY**

**2016**

Intersection

*Melbourne, East Yorkshire, England*

This shot is of Church Bridge on the Pocklington Canal. I've had my eye on this composition for a while – I just needed a subject to add some interest. The bridge looks quite modest from ground level but looking downwards on it shows off the beautiful curves of the walls. I purposely shot the scene in the early evening as the sun shone through the bridge to highlight the arch over the canal.

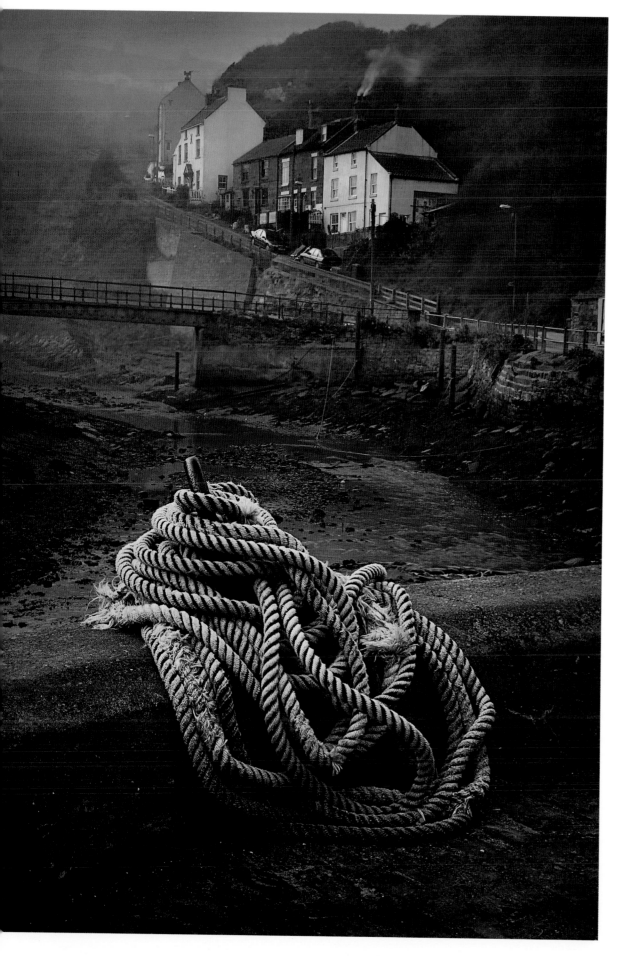

### Fisherman's Rope
*Staithes, North Yorkshire, England*

A little while before this shot was taken, a bank of sea fog had rolled in to occupy the village. The conditions provided an opportunity to photograph Staithes in a subdued light that helped to emphasise the mood of the place on that cold, fog-filled day.

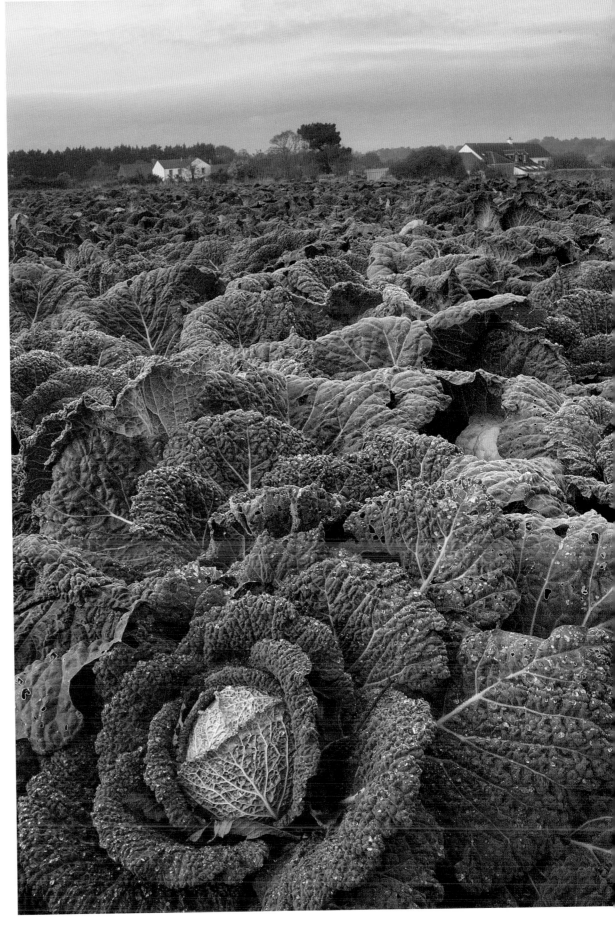

**JAN ISON**                                    2007

## Autumn Crop
*Le Couvant, St Lawrence, Jersey, Channel Islands*

This image was taken in October while I was looking for some autumnal images of Jersey. I was standing at a corner of a field near my parents' house and turned round to find these glorious cabbages in full bloom asking for their picture to be taken! A common landscape in Jersey that often goes unnoticed.

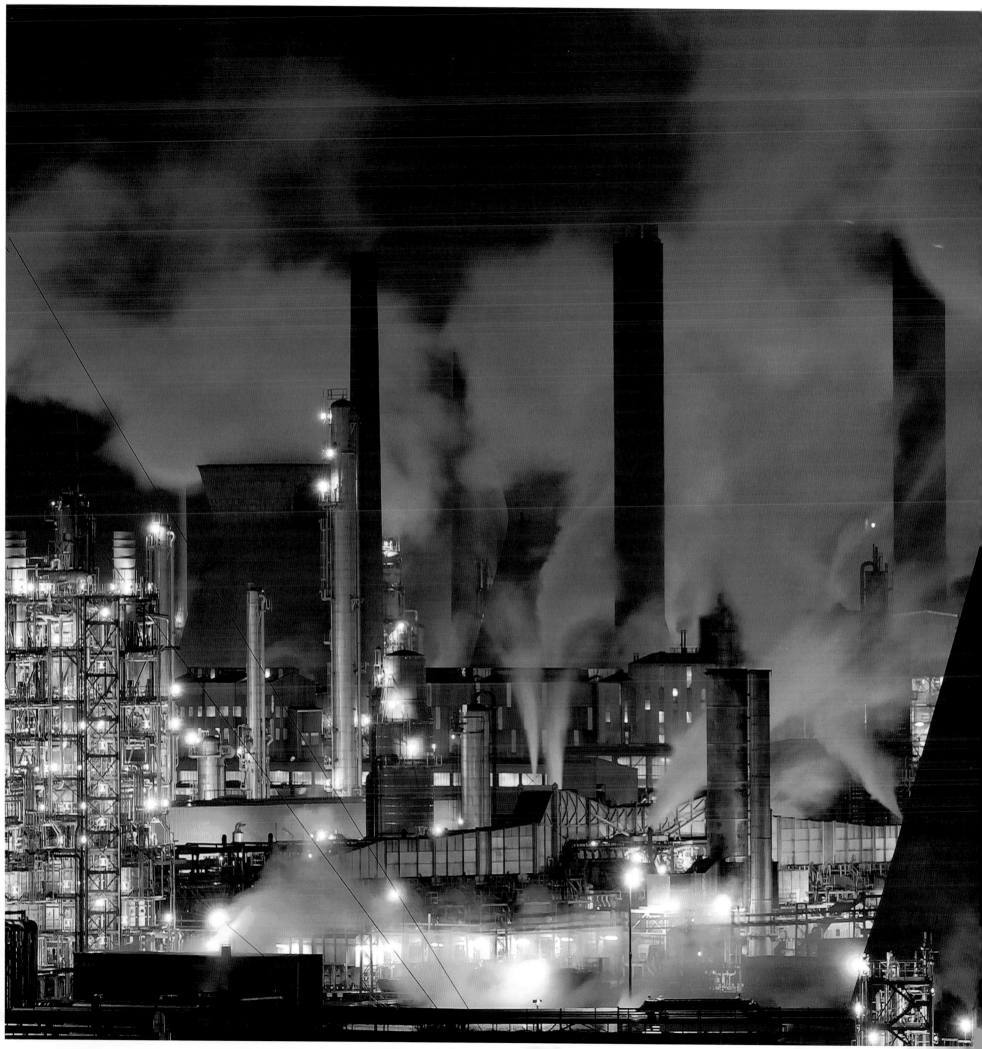

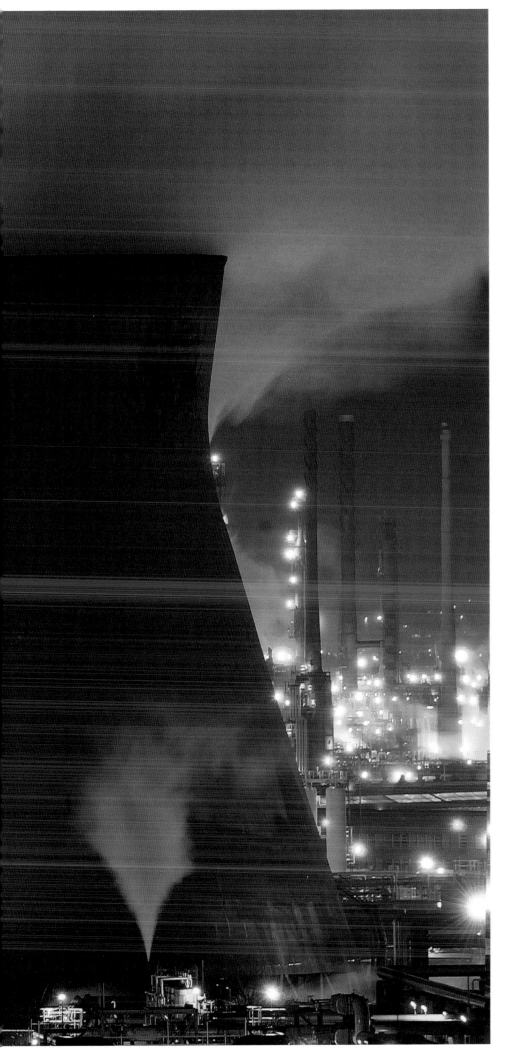

## GRAEME POLLOCK

### Grangemouth Oil Refinery at Night
*Scotland*

I liked this picture because all the elements worked well – the steam, the lights and the composition. Scotland is home to heavy industry as well as incredible scenery, and Grangemouth Oil Refinery exemplifies Scotland's industrial landscape. However, there is beauty in these towering chimneys and machinery. This is one of my favourite views of Scotland.

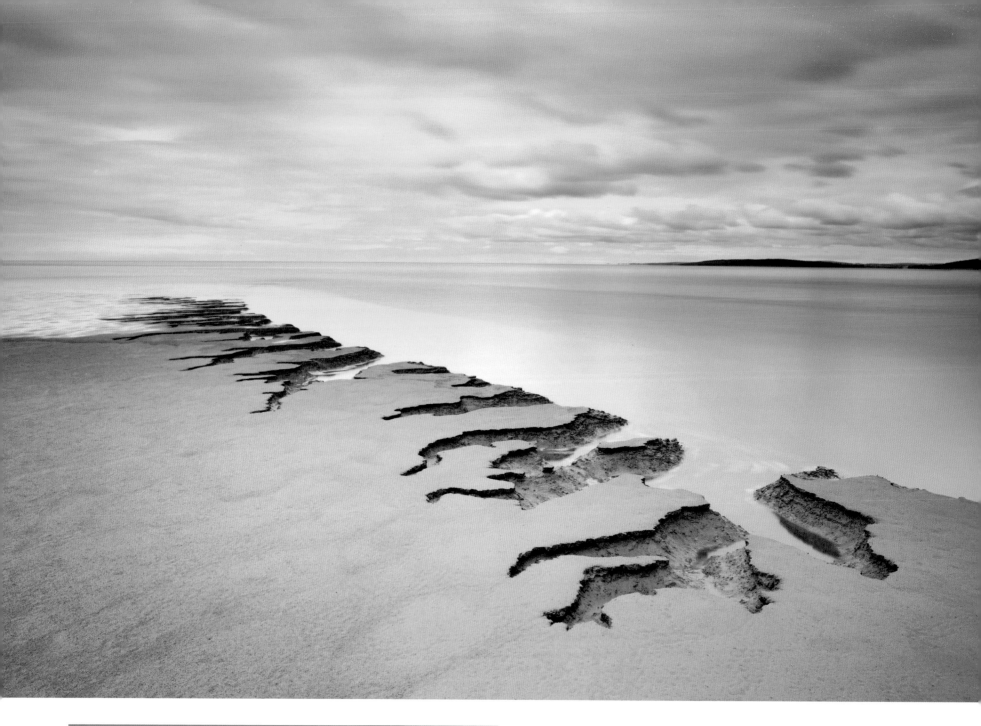

## TONY HIGGINSON

### Shifting Sands
*Silverdale, Lancashire, England*

Late morning on a sunny day in mid-June is hardly a classic time to be photographing the landscape. However, when I arrived at Silverdale Beach on the Lancashire coast, the conditions were unusual as the sea was as flat as a mill pond. I noticed that as the water receded from high tide, it was creating amazing shapes like mini estuaries in the edge of the sand. After spending some time photographing the interesting patterns, I decided to use them as the foreground for this wider landscape. I opted to use filters to smooth out what little texture there was in the sea and to give just a bit of movement to the sky, which added to the surreal quality of the photograph.

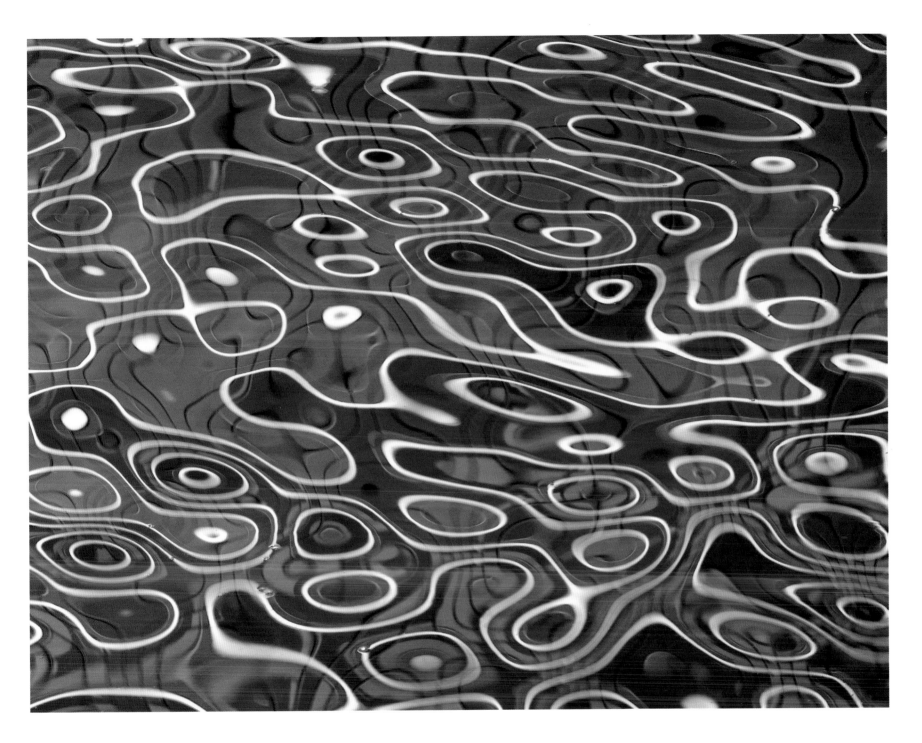

**NICK JOYNER**                                                     **2016**

**Canary Wharf Reflections**
*London, England*

I visited Canary Wharf one cold and foggy winter morning hoping for images of towers disappearing into low cloud. When I arrived, the fog was clearing, leaving a bright day with a wind just strong enough to gently ripple the water, allowing complex and varied reflections of the surrounding buildings on the water's surface. This is one example. I have not seen these conditions replicated subsequently!

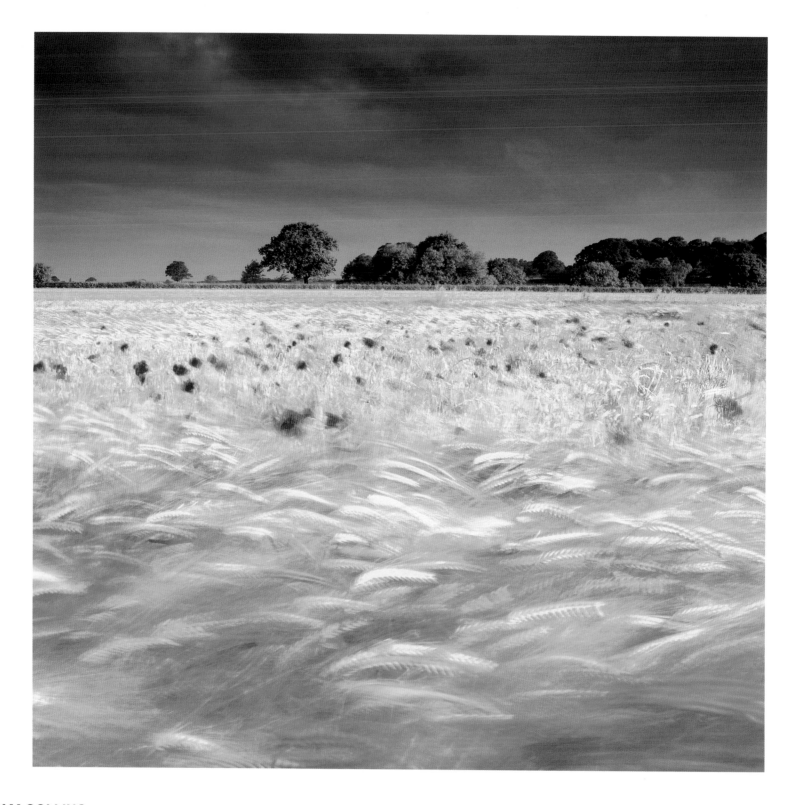

**GRAHAM COLLING** ▲     2012

### Poppies in Barley Field
*near Cannock, Staffordshire, England*

A phone going off in the bedroom at 3.47am sometimes has its advantages. Why my wife's riding partner decided to text her at that time still escapes me, but it allowed me to be in the middle of this barley field as the sun rose and the wind blew, combining to help realise this image.

**SCOTT WILSON** ▶     2012

### Rojo
*near Mansfield, Nottinghamshire, England*

One of a series of dramatic flowerscapes achieved by shooting nature with a grad filter and flash. The consequence of being a committed 'seascaper' who lives nowhere near the coast!

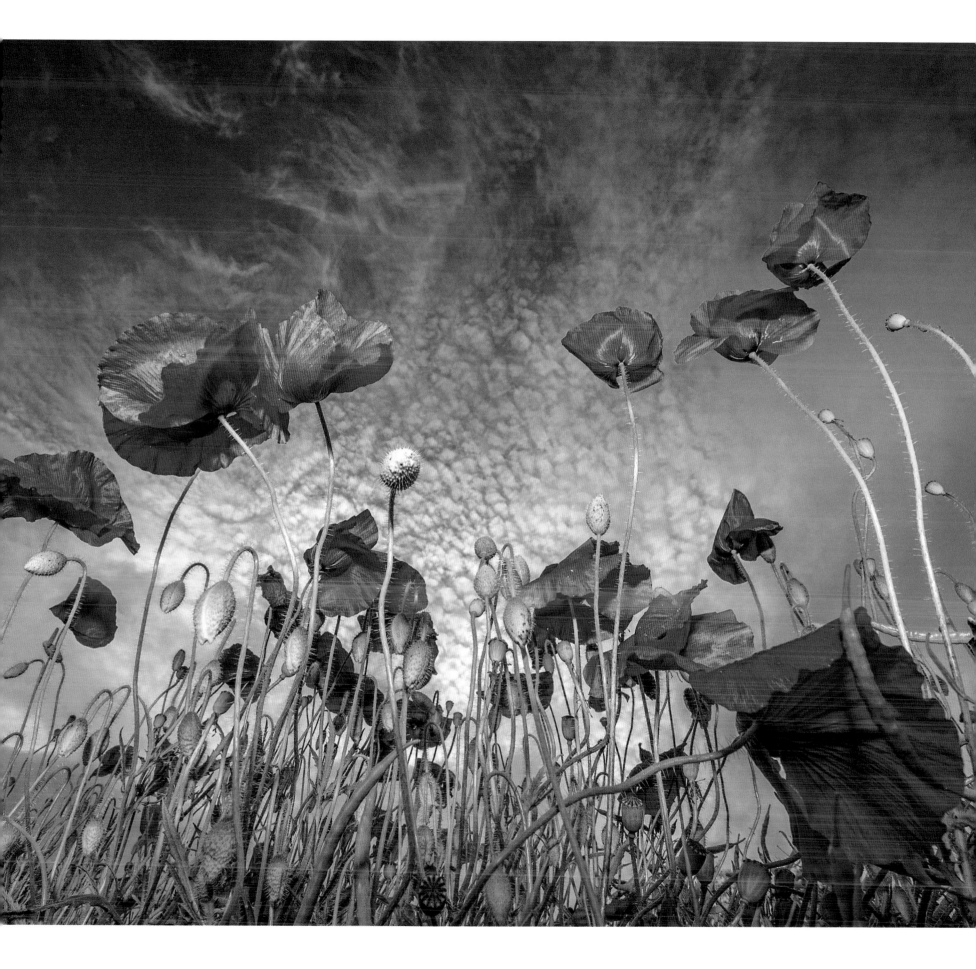

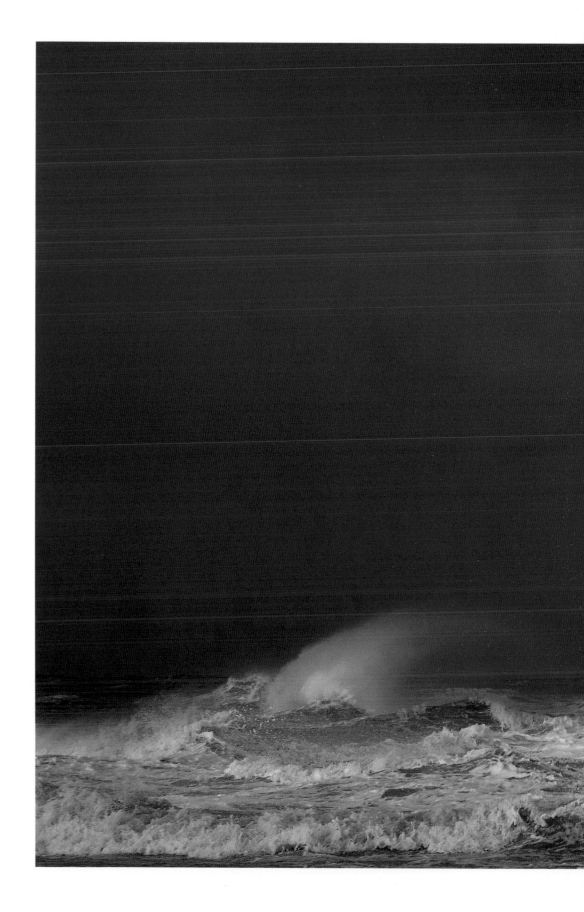

## ROBIN HEPBURN-EVANS                        2012

### New Brighton Storm
*Wirral, England*

On arrival at New Brighton lighthouse, I could see the waves lashing this monument. Armed with my tripod and camera, I waded into the sea in my wellies. The sun was partially obscured by some very thin cloud, which gave a slightly more interesting light than the full-on version, so I took another shot. I ended up thigh-deep in the waves, hanging on to my camera, battling 60mph winds to get this image.

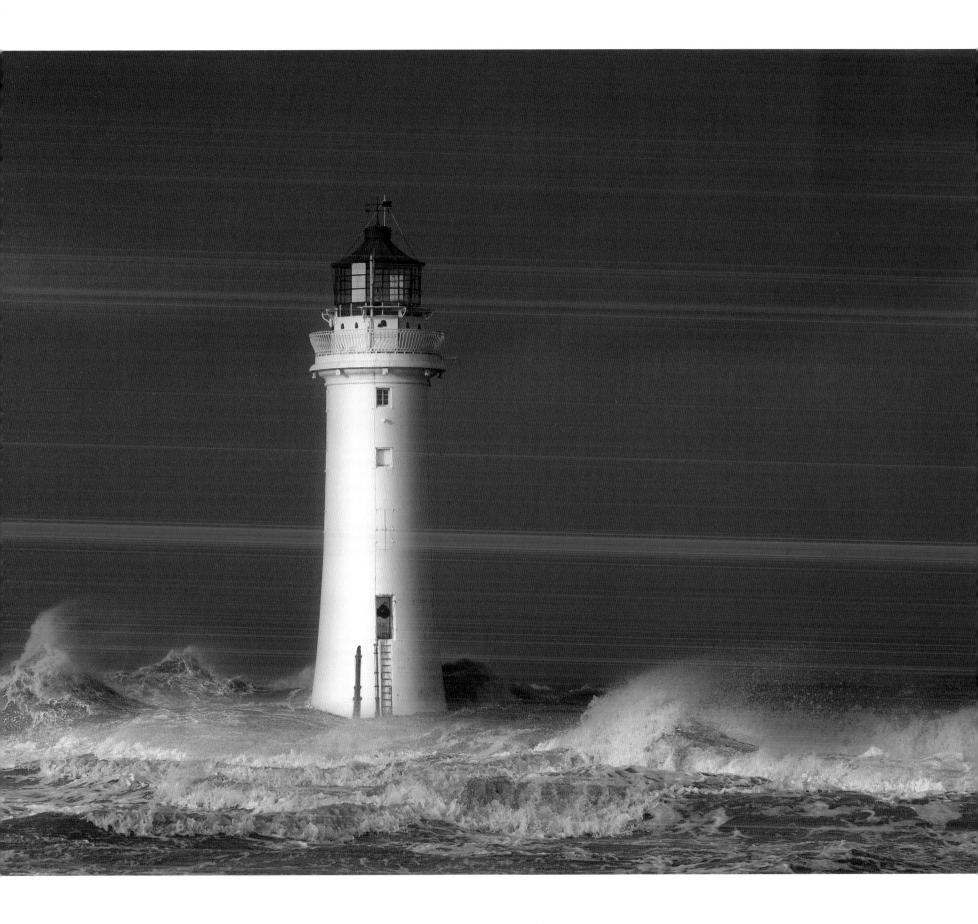

| | | | |
|---|---|---|---|
| Adam Burton | www.adamburtonphotography.com | Dougie Cunningham | www.LeadingLines.net |
| Adrian Bicker | www.adrianbicker.com | Dudley Williams | www.dudleywilliams.com |
| Alan Ranger | www.alanranger.com | Duncan McMillan | humberscapes.com |
| Alex Nail | www.alexnail.com | Emmanuel Coupe | www.emmanuelcoupe.com |
| Alun Allcock | www.flickr.com/photos/alunallcock | Fortunato Gatto | www.fortunatophotography.com |
| Andrew Dunn | www.andrewdunnphoto.com | Gail Johnson | www.gailsgallery.co.uk |
| Andrew Howe | andrewhowe.4ormat.com | Gary Eastwood | www.garyeastwood.co.uk |
| Andrew Midgley | andrewmidgleyphotography.com | Gary Horner | www.eastcoastimages.co.uk |
| Andy Farrer | www.andyfarrer.co.uk | Gary McGhee | www.garymcgheephotography.co.uk |
| Andy Le Gresley | www.andylegresley.com | Gary Telford | www.garytelfordimages.co.uk |
| Angus Clyne | www.angusclyne.co.uk | Gary Waidson | www.Waylandscape.uk |
| Ann Holmes | www.annmholmes.co.uk | Giles McGarry | www.kantryla.net |
| Anna Walls | www.annawallsphotography.com | Graeme Kelly | graemekellyphotography.weebly.com |
| Antony Spencer | www.antonyspencer.com | Graeme Peacock | www.graeme-peacock.com |
| Arpad Lukacs | arpadlukacs.com | Graham Colling | www.grahamcolling.com |
| Bart Heirweg | www.bartheirweg.com | Graham Dunn | www.grahamdunn.co.uk |
| Baxter Bradford | www.baxterbradford.com | Graham Eaton | www.eatonnature.co.uk |
| Bill Allsopp | www.billallsopp.co.uk | Graham Hobbs | grahamhobbs.co.uk |
| Bill Crookston | www.billcrookston.com | Graham McPherson | www.grahammcpherson.com |
| Bill Ward | www.billwardphotography.co.uk | Grant Hyatt | www.granthyatt.photography |
| Billy Currie | www.billycurriephotography.co.uk | Guy Richardson | www.guyrichardson.com |
| Brian Clark | www.brianclarkphotography.com | Howard Kingsnorth | www.howardkingsnorth.com |
| Brian Griffiths | www.brianonwoodside.co.uk | Iain McLean | www.iainmclean.com |
| Charlotte Gilliatt | www.charlottegilliatt.com | Ian Cameron | www.transientlight.co.uk |
| Chris Friel | www.cfriel.com | Ian Flindt | www.ianflindtphotography.co.uk |
| Chris Miles | www.flickr.com/photos/35221756@N02 | Ian Lamond | www.ianlamond.co.uk |
| Chris Prescott | www.chris-prescott.com | Ian Taylor | www.ianctaylor.co.uk |
| Chris Shepherd | www.shepherdpics.com | Jake Pike | www.flickr.com/photos/jakepike |
| Chris Tancock | www.christancock.com | Jake Turner | www.jrturnerphotography.co.uk |
| Colin Grace | www.dartmoorimages.co.uk | James Callaghan | www.jamescallaghan.co.uk |
| Craig Denford | www.craigdenfordphotography.co.uk | James Hourd | www.jameshourd.com |
| Curtis Welsh | www.curtiswelshphotography.co.uk | James Mills | Jamesmillsphotography.com |
| Damian Shields | www.damianshields.com | Jan Ison | www.janisonphotography.com |
| Dan Law | www.danlawphotography.com | Jason Ingram | www.jasoningram.co.uk |
| Daniel Cook | www.dan-scape.co.uk | Jeremy Barrett | vuzephotography.co.uk |
| Darren Ciolli-Leach | www.darrenciollileach.com | Jo Teasdale | joteasdalephotography.com |
| Dave Bowman | www.davebowmanphotography.com | John Davidson | www.johndavidsonphotos.co.uk |
| Dave Fieldhouse | www.davefieldhousephotography.com | John Fanning | www.johnfanning.co.uk |
| Dave Stewart | www.studio2photography.co.uk | John Finney | www.johnfinneyphotography.com |
| David Baker | www.milouvision.com | John Parminter | www.viewlakeland.com |
| David Breen | www.triplekite.co.uk | John Potter | www.jpotter-landscape-photographer.com |
| David Cantrille | www.cantrillephotography.co.uk | Jon Brook | www.benthamimaging.co.uk |
| David Clapp | www.davidclapp.co.uk | Jon Gibbs | www.jon-gibbs.co.uk |
| David Hopley | www.DrawsWithLight.co.uk | Jon Martin | www.jonmartin.co.uk |
| David J White | www.davidjwhitephotography.co.uk | Jonathan Lucas | www.jonathanlucas.com |
| David Lyon | www.davelyonphotography.com | Joseph Wright | www.josephwright.co.uk |
| David Sharp | www.landscapezone.co.uk | Julie Hutson | www.juliehutsonimages.com |
| David Shawe | www.davidshawephotography.com | Justin Minns | www.justinminns.co.uk |
| David Speight | davidspeightphotography.co.uk | Karen Atkinson | karenatkinsonphotography.com |
| David Stanton | www.stantonimaging.com | Keith Aggett | www.flickr.com/photos/keifereef |
| David Streeter | www.davidstreeterphotography.com | Keith Naylor | www.keithnaylor.com |
| David Webb | www.davidwebbweddingphotographer.co.uk | Ken Leslie | www.kenlesliephotography.co.uk |
| Dietmar Herzog | www.scotweb-Photography.com | Lee Acaster | www.leeacaster.com |
| Dimitri Vasiliou | inspiring-photography.com | Les McLean | www.lesmclean.co.uk |
| Donald Cameron | www.monophotography.com | Lesley Smith | m.facebook.com/Lesleysphotos |

| | | | |
|---|---|---|---|
| Liam Leslie | www.mass-observation.co.uk | Rob Oliver | www.robertoliverphotography.co.uk |
| Lizzie Shepherd | www.lizzieshepherd.com | Rob Scamp | www.muddyslippers.co.uk |
| Lukasz Warzecha | www.LWimages.co.uk | Robert Birkby | www.robertbirkbyphotography.co.uk |
| Magdalena Strakova | www.magdalenastrakova.com | Robert Canis | www.robertcanis.com |
| Mairi Eyres | www.mairieyresphotography.co.uk | Robert France | www.flickr.com/photos/rf100 |
| Malcolm Blenkey | www.mblenkeyphotos.co.uk | Robert Fulton | www.rfultonphotos.com |
| Mark Bauer | www.markbauerphotography.com | Robin Hepburn-Evans | www.flickr.com/photos/tornadooo |
| Mark Bradshaw | www.markbradshawphotography.com | Robin Whalley | www.lenscraft.co.uk |
| Mark Helliwell | www.markhelliwell.com | Ron Walsh | www.ronwalshphotography.co.uk |
| Mark Lakeman | marklakeman.weebly.com | Ross Farnham | www.flickr.com/photos/rossd90 |
| Mark Littlejohn | www.markljphotography.co.uk | Roy Merrifield | www.roymerrifieldphotography.com |
| Mark Simpson | www.electriclemonade.co.uk | Russ Barnes | www.russbarnes.co.uk |
| Mark Tierney | www.tierneyphotography.co.uk | Sam Rielly | www.instagram.com/samuelrielly/?hl=en |
| Mark Voce | www.markvoce.com | Scott Robertson | www.scottrobertsonlandscapephotography.co.uk |
| Marshall Pinsent | www.imagepod.com | Scott Wilson | www.facebook.com/wilsonaxpe |
| Martin Birks | www.martinbirksphotography.co.uk | Sebastian Kraus | www.sebastianito.com |
| Martin Chamberlain | www.martinchamberlain.com | Sergey Lekomtsev | www.lekomtsev.com |
| Martin Erhard | martinerhard.smugmug.com | Seymour Rogansky | www.roganskyphoto.co.uk |
| Matt Botwood | www.mattbotwood.com | Shahbaz Majeed | www.framefocuscapture.co.uk |
| Matt Oliver | www.mattoliverphotography.com | Simon Atkinson | www.SimonAtkinsonPhotography.co.uk |
| Matthew Cattell | www.matthewcattellphotography.com | Simon Baxter | www.baxter.photos |
| Matthew Cheetham | www.watchlooksee.com | Simon Butterworth | www.simonbutterworthphotography.com |
| Michael Diblicek | www.michaeldiblicek.com | Simon Byrne | www.simonbyrnephotography.com |
| Michael Swallow | www.michaelswallow.com | Simon Park | www.simonparkvisions.co.uk |
| Mik Dogherty | www.mikdoghertyphotography.com | Simon Parsons | www.sussexlandscapephotography.co.uk |
| Mike Bonsall | www.mikebonsallphotography.com | Slawek Staszczuk | www.photoss.net |
| Mike Curry | www.mikecurryphotography.com | Steen Doessing | www.steendoessing.com |
| Mike Green | mikegreenimages.com | Stephen Bright | www.stevebright.com |
| Mike Shepherd | www.mikeshepherd.co.uk | Stephen Chung | www.stephenchungphoto.com |
| Mirek Galagus | www.maglightscapes.com | Stephen Emerson | www.captivelandscapes.com |
| Nadir Khan | www.nadirkhan.co.uk | Stephen Garnett | stephengarnettphotography.com |
| Neil Barr | www.neilbarr.co.uk | Steve Deer | www.stevedeer.co.uk |
| Neil Williams | www.neilwilliams.co.uk | Steve Gray | www.stevegrayphotography.com |
| Nick Joyner | nickjoynerphotography.com | Stewart Mitchell | www.earthlylight.co.uk |
| Nigel Morton | www.nigelmorton.com | Stuart Lamont | www.stuartlamont.co.uk |
| Omer Ahmed | www.wytchwood.net | Taliesin Coombes | www.flickr.com/photos/robinandtaliesin |
| Paul Bundle | www.paulbundle.com | Tatiana Zigar | www.tatianazigar.com |
| Paul Keene | www.avico.co.uk | Tim Harris | tlhphotography.uk |
| Paul Knight | www.paulknight.org | Tim Harvey | www.timharveyphotography.com |
| Paul Mitchell | www.paulmitchellphotography.co.uk | Tim Parkin | www.timparkin.co.uk |
| Paul Sutton | www.postscriptphoto.co.uk | Tim Taylor | www.timtaylorphotography.com |
| Paula Fernley | www.virtualimage.org.uk | Timo Lieber | www.timolieber.com |
| Pete Bridgwood | www.petebridgwood.com | Timothy Smith | www.timothysmithphotography.co.uk |
| Peter Clark | www.flickr.com/peteclark89 | Tommy Martin | tommymartin.me/portfolios/landscape_collected |
| Peter Jeffreys | www.pjeffreys.co.uk | Tony Bennett | www.inspirational-images.com |
| Peter Laurence Dobson | www.plaurence.co.uk | Tony Gill | tonygillimages.com |
| Peter North | www.peternorthphotography.com | Tony Higginson | anthonyhigginsonphotography.co.uk/landscapes |
| Peter Paterson | www.peterpaterson.com | Tony Howell | www.tonyhowell.co.uk |
| Peter Ribbeck | peterribbeck.com | Tony Winfield | www.tonywinfieldfineartphotography.com |
| Peter Stevens | www.peterstevensphotography.co.uk | Valda Bailey | www.valdabailey.com |
| Philip Bedford | www.philipbedford.co.uk | Verena Popp-Hackner | www.popphackner.com |
| Rachael Talibart | www.rachaeltalibart.com | Verity Milligan | www.veritymilliganphotography.com |
| Rich Hendry | www.richhendry.com | Wilco Dragt | www.wilcodragt.nl |
| Richard Edwards | www.richardedwards.org.uk | Wojciech Kruczynski | www.stroop.pl |
| Richard Johnson | www.monography.co.uk | | |

# INDEX

Image titles are in **bold**.